Cinema 4D:
The Artist's Project Sourcebook
Third Edition

Cinema 4D:
The Artist's Project Sourcebook
Third Edition

Kent McQuilkin

Anne Powers

Focal Press is an imprint of Elsevier
225 Wyman Street, Waltham, MA 02451, USA
The Boulevard, Langford Lane, Kidlington, Oxford, OX5 1GB, UK

© 2011 ELSEVIER INC. All rights reserved.

No part of this publication may be reproduced or transmitted in any form or by any means, electronic or mechanical, including photocopying, recording, or any information storage and retrieval system, without permission in writing from the publisher. Details on how to seek permission, further information about the Publisher's permissions policies and our arrangements with organizations such as the Copyright Clearance Center and the Copyright Licensing Agency, can be found at our website: www.elsevier.com/permissions.

This book and the individual contributions contained in it are protected under copyright by the Publisher (other than as may be noted herein).

Notices

Knowledge and best practice in this field are constantly changing. As new research and experience broaden our understanding, changes in research methods, professional practices, or medical treatment may become necessary.

Practitioners and researchers must always rely on their own experience and knowledge in evaluating and using any information, methods, compounds, or experiments described herein. In using such information or methods they should be mindful of their own safety and the safety of others, including parties for whom they have a professional responsibility.

To the fullest extent of the law, neither the Publisher nor the authors, contributors, or editors, assume any liability for any injury and/or damage to persons or property as a matter of products liability, negligence or otherwise, or from any use or operation of any methods, products, instructions, or ideas contained in the material herein.

Library of Congress Cataloging-in-Publication Data
McQuilkin, Kent.
 Cinema 4D : the artist's project sourcebook / Kent McQuilkin. -- 3rd ed.
 p. cm.
 Rev. ed. of: Cinema 4D / Anne Powers. 2007.
 ISBN 978-0-240-81450-6 (pbk.)
 1. Computer animation. 2. Three-dimensional display systems. 3. Cinema 4D XL. 4. Computer graphics. 5. Rigging (Computer animation) I. Powers, Anne. Cinema 4D. II. Title.
 TR897.7.P69 2011
 006.6'93--dc22
 2011009865

British Library Cataloguing-in-Publication Data
A catalogue record for this book is available from the British Library.

For information on all Focal Press publications
visit our website at www.elsevierdirect.com

11 12 13 14 5 4 3 2 1

Printed in the China

Working together to grow
libraries in developing countries

www.elsevier.com | www.bookaid.org | www.sabre.org

ELSEVIER BOOK AID International Sabre Foundation

Contents

Introduction

Acknowledgements	1
Who This Book Is For and How It's Different	2
The DVD	2
The 4D Environment and Workflow	3
Introduction to the Basics of CINEMA 4D	3
Content Browser	5
Layer Browser	6
Preferences	8

1 The Power of Primitives 9

Ornament Project	10
Greek Pool	15
The Desert Scene Project	29

2 Under the Hood 50

MoGraph Mace	50
City Building	57
Modeling a Spaceship	70

3 NURBS Modeling Tools 89

3D 101: The Vase	89
Skull Mask Extrude	100
Creating a Shovel with a Bezier NURBS	110

4 Deformers and Other Modeling Helpers — **118**
Bend and Boolean Lock Project — 118
Wind Deformer Flag — 127
MetaBall — 133

5 Materials in Depth — **136**
Shaders — 138
Channel Shaders — 140
Planet Texturing Project — 142
Island of Displacement — 156

6 Better under Lights — **167**
Creating and Animating a SearchLight — 167
Intro to GI: Lighting with Objects — 171
Lighting a Product — 177
No GI.....No Problem — 181

7 Animation Basics — **183**
Butterfly Project — 183
Controlling Animation with
 Rail Splines & F-Curves — 196

8 Head Shots — **199**
Modeling a Character Head — 199
Animating a Character with Pose Morph — 229

9 Rigging a Character — **234**
Creating the Joints — 234
Mirroring/Binding/Weighting — 239

10 Cameras in Control — **243**
Setting Up a Camera to Animate
 along a Helix Spline — 244
The Stage Object: Uitlizing Multiple Cameras — 247
Depth of Field — 249
CINEMA 4D in Production:
 An Interview with Chris Smith — 250

11 The Art of Rendering — 252
- Investigating Render Settings — 253
- Multi-Pass Rendering — 268
- CineMan: Integrate Pixar's RenderMan into your CINEMA 4D workflow — 272

12 A Jolt of Xpresso — 275
- School of Fish — 275
- Thinking Particles: PBlurp — 285

13 BodyPaint: The Artist's Connection — 290
- Painting a Book in BodyPaint — 290
- BodyPaint UV Editing — 300
- Projection Man — 320
- **CINEMA 4D in Production:** An Interview with Tom Quach — 325

14 Tips on Type — 328
- Extruding Text — 328
- Deformers on Type — 332
- Sweep Text — 337
- Sweep Along Text — 339
- MoText Introduction — 341
- Animate MoText with the Random Effector — 345
- Making Specialized Fonts with the Spline Mask — 348
- PolyFX — 352

15 More out of MoGraph — 358
- Spline Effector — 359
- MoGraph Tracer — 361
- MoGraph Sound Effector — 364
- MoSpline — 367
- **CINEMA 4D in Production:** An Interview with Rob Garrott — 369

16 After Effects Integration — 372
- Part 1: Setting Up a Simple Scene fo AE Integration — 372
- Part 2: Setting Up Tags and Render Settings — 374
- Part 3: Importing and Compositing in AE — 378

17 Dynamics and Special Effects — 386

Rigid Body Dynamics 386
The Fracture Object 389
Cloth Dynamics 393
Cloner Soft Body Dynamics and Baking the
　Dynamic Calculations 397
PyroCluster 399
Creating a Fantasy Landscape with Hair 402
Headdress Project 404

18 Stereoscopic Content Creation in CINEMA 4D — 414

Creating a Stereoscopic Rig
　in C4D using Xpresso 414
Creating a Stereoscopic Scene 419
Compositing Stereo Images in Photoshop 421
SVI Stereo 3D Editor Plug-in 2.3 423

19 CINEMA 4D and Friends — 427

Vue 9xStream Integration 427

On the DVD

The DVD includes C4D project files for each chapter, completed examples of projects, example files to explore beyond the scope of the text, and rendered movies and stills. There is much more learning to do with hours of additional hands-on instructional resources provided on the DVD including:

- Instructional Quicktime Video Tutorials covering the latest in CINEMA 4D R12. These include: Motor Dynamics, Linear Workflow, Color Profiles, White Balance, Soft and Rigid Body Dynamics and the Camera Deformer.
- Well over one hundred and fifty pages of tutorials in pdf format for printing, or viewing on your computer. Subjects include advanced modeling, texturing, character animation, After Effects integration, RealFlow, ZBrush.
- Background images and texture bitmaps to bolster your texture stock.

Index — 431

Acknowledgements

This book would not be possible without the help, support and knowledge of the following individuals. I owe a great deal of gratitude:

To Dennis McGonagle, Carlin Reagan and Anne McGee of Focal Press, for their insight, support and the opportunity to author this book.
To Anne Powers, for creating a non-technical book series that puts tools to practical uses and has helped spark the imagination of so many 3D enthusiasts and professionals.
To Michael Hewes, Rick Barrett and all of the great team at MAXON, for their incredible knowledge and endless supply of answers and support.
To Ray Davis of Pixar, who went to infinity and beyond in getting RenderMan up and running and up and running again when I fouled things up.
To Ihor Petelycky and Spatial View, for an incredible program and even better support.
To Matt Riveccie of e-on, for all of the extraordinary amount of support in keeping me up to date with Vue.
To Cormac Slevin and Antonio Manfredi at Digital Video S.p.A, for their insight in combining the 2D animation of Toonz with 3D assets.
To Kent Braun of DigiCel, for many great years of support and his amazing knowledge of animation and dedication to bringing 2D animation to students, hobbyists and professionals alike with FlipBook Pro.
To Rosanna Thomson and the team at Next Limit Technologies for their support and help with RealFlow.
To Chris Smith, Tom Quach and Rob Garrott, for taking the time out of their busy schedules to be a part of this book and provide their expert insight into the tools of their respective trades.
To David Gilbert, for introducing me to the teaching profession years ago and allowing me to learn at least as much as I've taught.
To Austin Webb, for his time and expertise in photography and for shooting great shots for textures and scene creation.
To my good friend Fikremarium for his interest and willingness to allow me to build his head in my computer and put it on display.
To my brother, Steven and father, Tom, for all of their support, inspiration and encouragement though out this process.
To my mom, for being the best mother I could ever ask for and all the great texture photos and editing advice she supplied. Thanks for all of the time you put in, and for always being supportive.
To my wife, Sally, and my four precious children, Max, Emma, Samuel, and Khari. You all are my treasures. Thank you for all the sacrifices you've made as I've been in this process.
Above all, I thank God for every second I have on this Earth and the incomparable love, and compassion He has for all mankind.

Introduction to CINEMA 4D

MAXON understands that making a transition into 3D graphics and animation can be a daunting proposition for artists already pressed for time keeping up with the ever evolving progression of more traditional graphics technology. With that in mind, they have crafted CINEMA 4D, a software that is intuitive yet amazingly powerful. Using this application, a traditionally trained artist can instantly create mind-boggling graphics and animation. At the same time, this application has the depth to keep artists challenged and engaged to push the boundaries of image creation. Users will find that anything imaginable is attainable in this software. CINEMA 4D has created a name for itself as a motion graphics and texture painting power house but, as you will see in this book, it is an all-inclusive to tool to create any animation imaginable.
Enjoy!

Who This Book Is For and How It's Different

This book is about creating all kinds of artistic imagery using CINEMA 4D as a tool. It is intended to be an enjoyable, attainable, and thorough introduction to the creatively fluent use of C4D. In addition to being a great start for beginners, it will encourage new ways of working and thinking for more seasoned C4D users. It is especially suited for artists who may feel overwhelmed by the technical complexities of 3D or traditional artists wishing to quickly add professional quality 3D graphics and animation to their skillsets.

Artists of all kinds--illustrators, motion graphics and print graphic designers, as well as those who wish to animate characters, create content for gaming or dynamic force driven simulations --will find engaging step-by-step examples that can be easily adapted to their purposes.

The projects in this book have been created to suit the classroom, provide training for professionals looking to transition into 3D, as well as help the learner at home. The project-based approach of this book quickly rewards the reader with results. The text and DVD examples introduce concepts without restating the extensive built-in Help system included in CINEMA 4D. The focus of this book is to provide step-by-step workflows for creating professional 3D graphics and display the artistic possibilities of CINEMA 4D. Furthermore, this book takes into consideration that, as a beginner you will need a solid foundation in all areas of the entire 3D process. Technical explanations of tools can be found in the built in help system.

The DVD

The DVD included with this book is not simply supplemental, but is actually an extension of this book that was unable to fit in the pages provided. You will find an entire chapter with almost 150 pages of advanced modeling and scene layout in the Advanced Modeling chapter of the DVD alone. You'll also discover how to set up an IK chain and animate a T-Rex. In the After Effects Integration chapter of the DVD, you'll see how to build a scene specifically optimized for output to AE. There are tons of more extras including Vue 9xStream, ZBrush and Realflow integration as well. Be sure to check out the numerous instructional videos included in the DVD_Support_file chapters and the New_in_R12_ Movies folder to find movies covering the latest tools and techniques developed for Release 12.

The 4D Environment and Workflow

The first question many people ask me when they hear about CINEMA 4D is,"What is 4D?" The common reference to 3D encompasses the three spatial dimensions used to create and manipulate objects. The 4th dimension reference in C4D is that of time. How objects and components change over time is, of course, the underlying foundation of animation. When you first open CINEMA 4D and begin to work, the graphical user interface allows you to create and manipulate objects in a virtual 3-dimensional environment within the element of time. The workspace is infinite in size and can be configured with any units of measurement. Numerous tools allow you to create and animate objects that can be viewed through virtual cameras. Along with objects and cameras, you'll find all the elements of a fully functional production house. Lights, backgrounds, virtual skies, effects, foreground elements and mood changing environments can all be found within this one application. To understand how to be successful at creating 3D content, it is vital that you have a grasp on the core areas that make up the 3D process. This new edition of *CINEMA 4D The Artist's Project Sourcebook* aims to give readers a look at how CINEMA 4D can be utilized to meet the demands of the 3D marketplace today. The 3D marketplace is spread into many vast disciplines of which this book will give a glimpse of the workflow and tools to get you on your way to succeed, regardless of where your future in 3D takes you. We will begin by covering the basics of 3D. Rather than separating these into isolated practices, we are going to build complete scenes from the beginning, allowing readers to see the full picture of how these disciplines interrelate to make a successful 3D composition. These principles include, but are not limited to: modeling, texturing, staging, animating, lighting, effects and rendering. Advanced workflows may add rigging and compositing to the process. Regardless of what field an individual enters, the mastering of these core principles is vital to succeed at the top level of any 3D profession.

Introduction to the Basics of CINEMA 4D: DVD Chapter

Be sure to check out the Cinema_4D_ Basics.pdf chapter included on the DVD. It includes charts labeling and explaining the locations and usage of tools and icons within the C4D interface. You'll also find an overview of all the Parametric Primitives, Splines, NURBS and other Modeling helpers and generators that you will use to create 3D scenes.

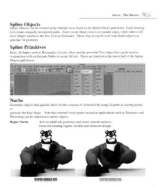
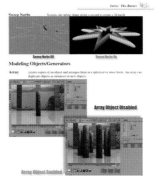
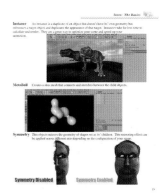

CINEMA 4D: The Artist's Project Sourcebook, Third Edition

Modeling
Modeling refers to the creation of objects and shapes within 3D. Think of it as digital sculpting.

Texturing
Applying materials to models and scene components to control the appearance of objects.

Staging
Framing the scene by moving the objects into the correct position as well as setting up cameras to capture the action.

Animation
Animation consists of any 3D elements and how their appearance changes over a specified time.

Lighting
An infinite number of virtual lights can be added to 3D scenes to create any lighting scheme imaginable.

Effects
In CINEMA 4D, the term "effects" can be applied to anything from fog and smoke to particles, hair and dynamics. Effects often time are incorporated in post.

Rendering
Rendering is the process of taking the 3D environment created in C4D and exporting it to a flat output that can be used as printable stills or sequenced together for animation.

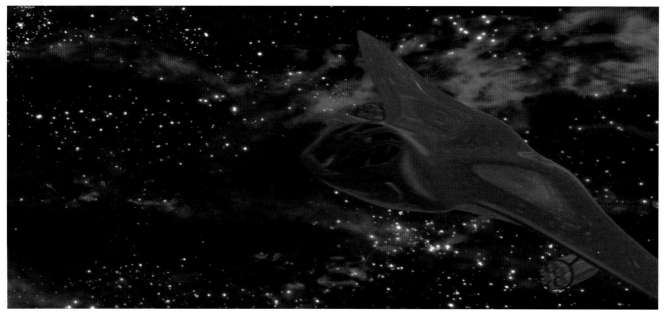

Introduction

Content Browser

The content browser is a great place to find and store materials, models and other assets that can help streamline your creative process. The Presets listing found within the Content Browser is a treasure chest of models, expressions, materials and scenes that can help you reverse engineer how assets are composed or even help you create your own masterpiece. Assets in the Content Browser will vary depending on the version of CINEMA 4D.

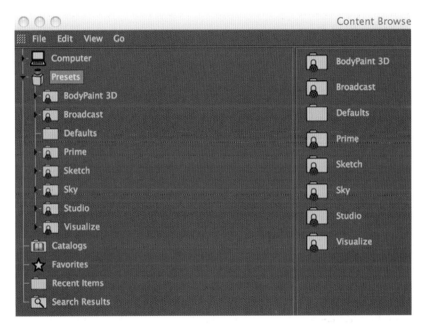
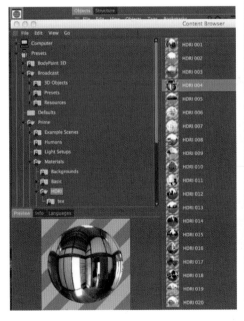

Layer Browser

As with most graphics programs, layers can be an excellent way to organize and arrange elements within a file or scene. In CINEMA 4D, you have a lot of options as to how layers are displayed in the editor and renderer. In this quick exercise, we will look at the basics of using layers within C4D. Open the **Layer_Browser_Start.c4d** file in the DVD_Support_Files folder on the DVD.

Step 1 You can access the Layer Browser in three ways. The first option is to choose Window>Layer Browser. *Figure Layer_Browser_01*

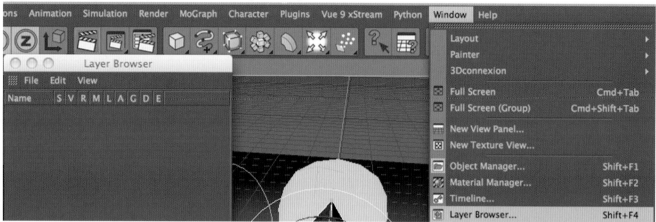

Figure Layer_Browser_01

Step 2 You can also click on the large rounded rectangle to the right of an object in the Objects Manager. Click on the rounded rectangle to the right of the Light at the top and choose, Add to New Layer.
Figure Layer_Browser_02

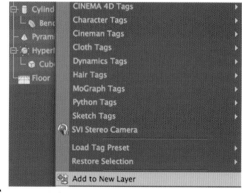

Figure Layer_Browser_02

Step 3 The third option is to click on the drop-down arrow to the right of the Layer field in the Basic tab of the Attributes Manager. Select the Floor object and choose Add to Layer to drop into the existing Layer 1. *Figure Layer_Browser_03*

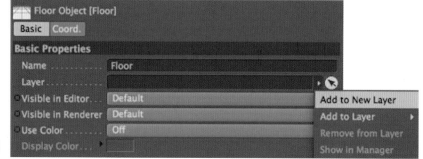

Figure Layer_Browser_03

Introduction

Step 4 Now, add both of the lights to this layer by clicking on their Layer buttons.
Figure Layer_Browser_04

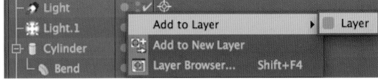

Figure Layer_Browser_04

Step 5 Click on one of the Layer buttons to the right of a parametric object in the scene and create a new layer.
Figure Layer_Browser_05

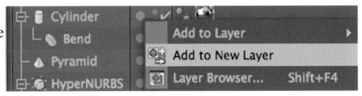

Figure Layer_Browser_05

Step 6 Open the Layer Browser, rename Layer 1, Scene Elements and rename Layer 2, Objects. Click on the **S** column for the Objects layer and you'll see that all of the objects not on this layer will disappear from both the Viewport and Object Manager. This is called the Solo Column.
Figure Layer_Browser_06

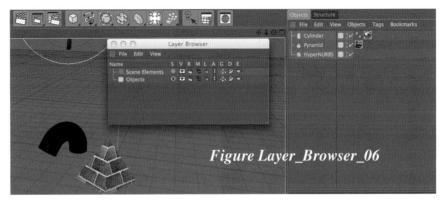

Figure Layer_Browser_06

See the Layer Browser breakdown below

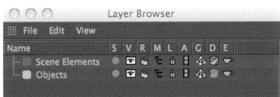

S Solo (Hides all other layers)
V Visibility (Toggles visibility)
R Render (Toggles visibility in rendering)
M Managers (Toggles visibility in Managers)
L Lock (Lock Toggle)
A Animation (Enables/Disables animation)
G Generator (Enables/Disables generators*)
D Deformer (Enables/Disables deformers)
E Expressions (Enables/Disables expressions

(Arrays, HyperNURBS, Atom Arrays, Booles, etc. are examples of generators*)

Preferences

The Preferences within CINEMA 4D are extremely customizable. From the level of Undos and memory allowed, to color scheme and units of measure, the Preferences panel gives you the flexibility to optimize C4D for your workflow.

One of the first things you may be interested in doing is raising the level of Undos. Press CMD+E Cntrl + E (PC) or go to Edit>Preferences. Scroll down to the Memory settings and raise the Document Undo Depth to a value suitable for the type of scene you are working on. If you are doing heavy modeling, I suggest this number be at least 50 and you may wish to take it up toward 100. Notice that there is a separate Undo for BodyPaint textures which is crucial when texture painting. It would probably be sufficient to set this number equal to that of your typical Photoshop Undo level. Again, I recommend this number be set no less than 50.

Another parameter of interest is the Units settings. Depending on the project, you may wish to change the unit display to reflect the real world application of your scene. In this book, some of the projects use Meters while others use Centimeters; in no circumstance is it necessary for you to alter the defaults to match my settings. If you do wish to change the units, simply click on the Unit Display dropdown and choose the desired display unit.

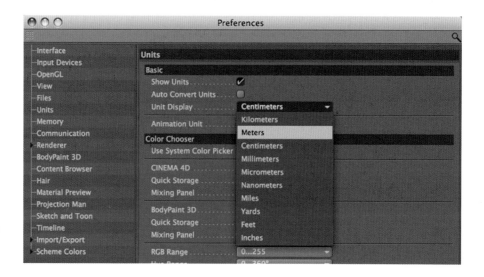

Chapter 1: The Power of Primitives

The Power of Primitives

Like most 3D programs, CINEMA 4D has a set of primitive building blocks that are parametric. Basic parameters of a primitive, or critical dimensions such as, height and radius, are defined mathematically. Because the program only has to remember a few bits of information, parametric primitives are efficient. The parametric values for an object may be manipulated live in the Editor Window using the orange parametric handles, but the object's surface has no points, polygons or edges that may be pushed and pulled into more complex forms. In the parametric state, the surface and axes of an object are not editable. Notice that every time you choose a primitive, it appears at the same place in the center of the 3D world. This is called the origin and sits at (coordinates 0,0,0), and it has a set of red (X), green (Y), and blue (Z) object axes that show how the object is oriented.

Ornament Project

Step 1 Our first project will be a simple use of basic geometric shapes combined with some advanced shaders that will give a high level look to our scene. Begin by adding a Sphere primitive from the Polygonal Primitive drop down. **Figure Ornament_01**

Figure Ornament_01

Step 2 Secondly, add a Cylinder and move it up into position by setting its P.Y = 97.5 in the Attribute Manager. Adjust the Cylinder's shape by setting the Radius to 35, the Height to 10 and raise the Rotation Segments to 72. Lastly, we'll round the edges of the shape by enabling Fillet Caps in the Caps tab of the Attribute Manager. Match my example by lowering the Segments to 3 and the Radius to 1. *Figure Ornament_02*

Figure Ornament_02

Step 3 Add a Torus to our scene by choosing it from the Primitives drop down. *Figure Ornament_03*

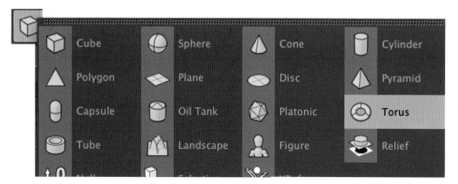

Figure Ornament_03

Chapter 1: The Power of Primitives

Step 4 Move this object up so that its P.Y=107, set the Ring Radius = 10, Pipe Radius = 2, and change the Orientation to +Z. ***Figure Ornament_04***

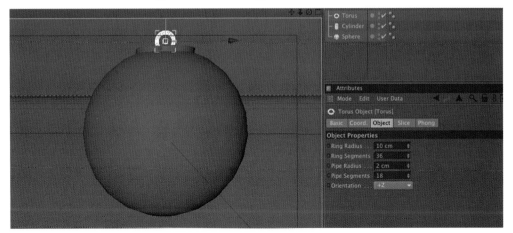

Figure Ornament_04

Step 5 With modeling completed, we'll move onto the materials for these shapes. We will use some powerful shaders that are built in to CINEMA 4D to bring realism to this scene. In the Material Manager, choose File>Shader>Danel. ***Figure Ornament_05***

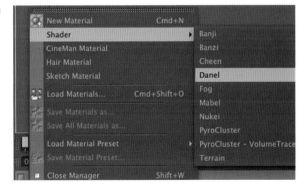

Figure Ornament_05

Step 6 Double click on the Danel thumbnail in the Material Manager to bring up a floating window. In the Diffuse Channel, double click on the white color thumbnail to open the ColorPicker and set the color to a Red. ***Figure Ornament_06***
Navigate down to the Anistropy Channel and click on its checkbox to enable it. Click on the red x at the top left of this floating panel to close it. Drag the Danel thumbnail and drop it on the Sphere object in the Object Manager or right inside the Viewport. Press Cmd/Cntrl (PC) + R to render a quick preview in the Viewport.

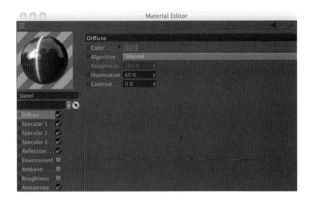

Figure Ornament_06

Step 7 Create our second material by again going to Material Manager and navigating to File>Shader>Danel. Double click on the new thumbnail and, in the resulting floating panel, rename the material Metal. The only change we need is to activate the Anistropy Channel by clicking on its checkbox.
Figure Ornament_07

Figure Ornament_07

Step 8 Drag the Metal material and drop it on both the Torus and the Cylinder objects. Press Cmd/Cntrl(PC)+R to see the updated preview. Now we will add some light to bring out the detail in our textures. Click on the Light Icon at the top to drop a light into our scene. ***Figure Ornament_08***

Figure Ornament_08

Step 9 Rename this light Key and move it into position by setting its coordinates to P.X = - 1500, P.Y = 1000, P.Z = - 2000. Click on the tab to the left of Shadow and change it from None to Shadow Maps (Soft).
Figure Ornament_09

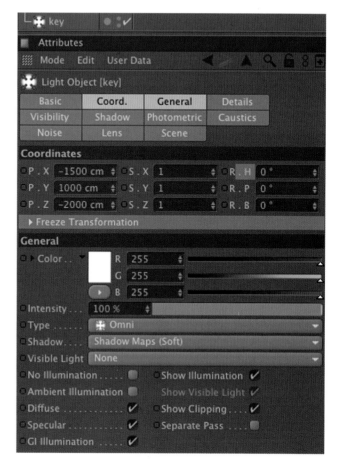

Figure Ornament_09

Chapter 1: The Power of Primitives

Step 10 Add a second light and name it Fill. Adjust its parameters to P.X = 3000, P.Y = 1000, P.Z = 400, set the Intensity to 40% and set the color to R = 155, G = 160, B = 255.
Figure Ornament_10

Figure Ornament_10

Step 11 We will now create our first animation by spinning the ornament. The first order of business is to group the shapes that make up the ornament. In the Object Manager, select the Torus, Cylinder, and Sphere and now press Option(Alt PC)+G to group. Double click on the new Null Object and rename it, Ornament. With Ornament selected, go down to the Coordinates Manager. Click on the H beside the R.H parameter. ***Figure Ornament_11***

Figure Ornament_11

Step 12 This makes it easier to set a keyframe exclusively on this parameter. To set a keyframe, control+click on the black outlined open ellipse. It will turn red to indicate that a keyframe has been set. *Figure Ornament_12*

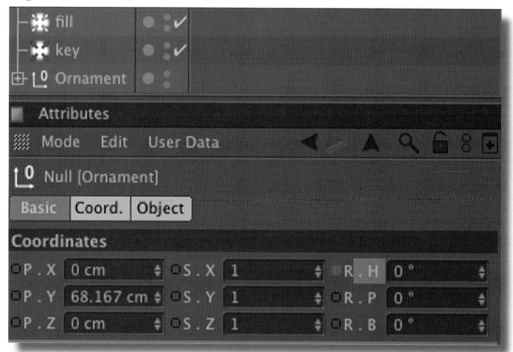

Figure Ornament_12

Step 13 In the timeline, click on the Goto last frame button. *Figure Ornament_13*

Figure Ornament_13

Step 14 Type 360 in the R.H value and control+click on the red open ellipse to set an ending keyframe. The red open ellipse indicates that there is a keyframe on the parameter but not on the current frame. *Figure Ornament_14*

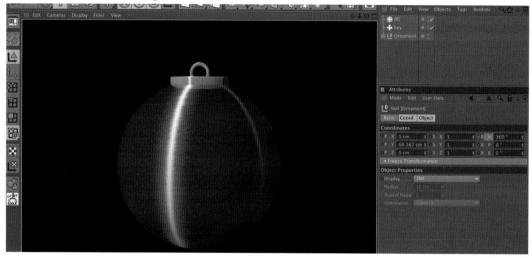

Figure Ornament_14

Chapter 1: The Power of Primitives

Greek Pool

Step 1 We are going to start this project by adding a cylinder object to our scene from the Polygonal Primitive drop down (***Figure Greek_01***) Double click on its name in the Object Manager and rename it Base.

Figure Greek_01

Step 2 In the Attribute Manager, make sure that the Object tab is selected. Set the Radius to 500 and the Height to 20. Raise the Rotation segments to 108 to get a smooth outer edge.
Figure Greek_02

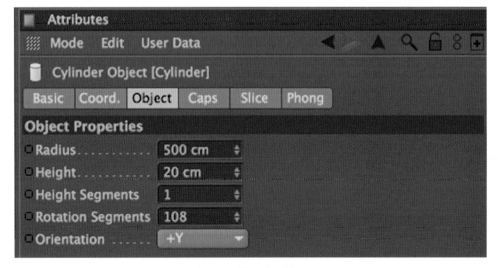

Figure Greek_02

15

Step 3 Now control drag on the name Base in the Object Manager and release the mouse button to duplicate the Base object. Rename the copy, Step. With the Step object selected, lower the radius to 475. Keep in mind that you can have multiple tabs open in the Attribute Manager by shift clicking on the tabs you would like displayed. I've chosen to display the Coordinate and the Object tabs. Move the Step object up on the Y axis by setting the P.Y. value to 19.9. *Figure Greek_03*

Figure Greek_03

Step 4 We will now move on to creating a column. Add another Cylinder primitive from the Polygonal Primitives drop down and change its name to Column Middle. In the Object tab, set the Radius to 30, the Height to 500 and the Rotation Segments to 72. *Figure Greek_04*

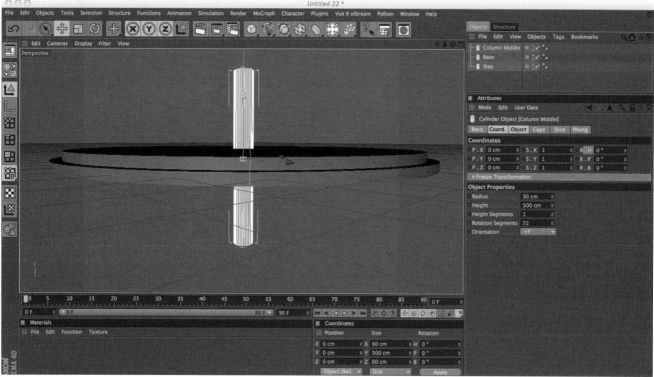

Figure Greek_04

Step 5 Control drag on this object to duplicate and rename the copy, Column Top. Set the Height to 5 and the Radius to 35. In order to see this object more clearly, Hide the Base and Step objects by clicking on the checkboxes to their right in the Object Manager. *Figure Greek_05*

Figure Greek_05

Step 6 Control drag on the Column Top object and change the properties of the new Cylinder Top.1 object to Radius = 45 and move the object up by setting its P.Y value to 4.99. *Figure Greek_06*

Figure Greek_06

Step 7 In the Object Manager, drag the Column Top.1 object and drop it as a child of the Column Top object. *Figure Greek_07*

Figure Greek_07

Step 8 With Column top selected, hold the Option/Alt (PC) and add a Symmetry object from the Modeling menu. *Figure Greek_08*

Note: Holding the Option/Alt key while adding an object automatically subordinates the selected object as a child of the new object being added.

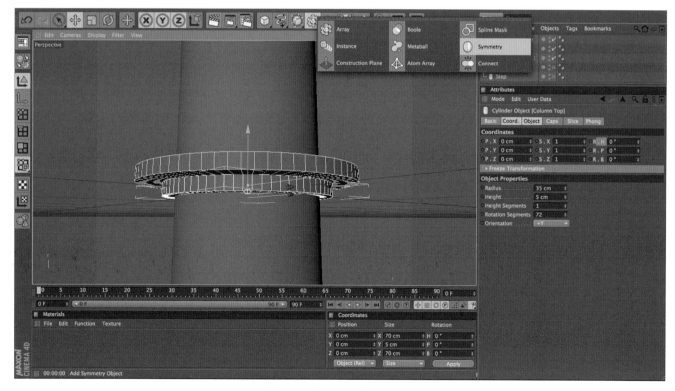

Figure Greek_08

Chapter 1: The Power of Primitives

Step 9 With the Symmetry selected, change the Mirror Plane to XZ in the Attribute Manager. *Figure Greek_09*

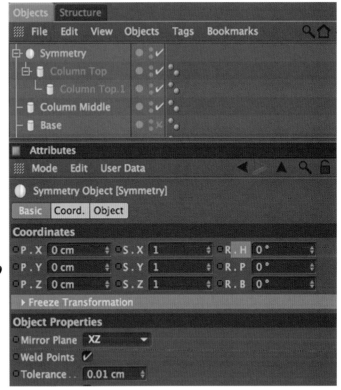

Figure Greek_09

Step 10 Select the Cylinder Top object and move it up on the Y so that its P.Y value = 252. *Figure Greek_10*

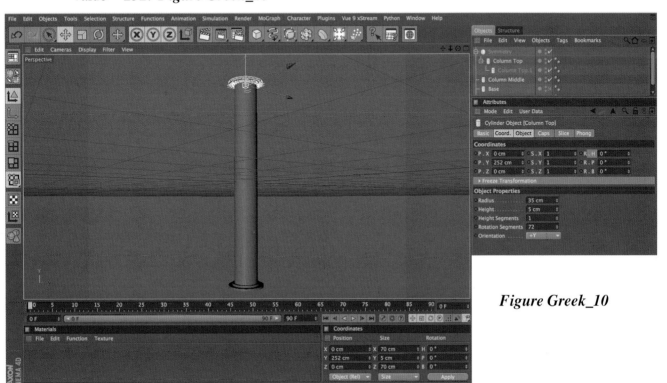

Figure Greek_10

Step 11 Now drag the Symmetry group and drop it as a child of the Column Middle object.
Figure Greek_11

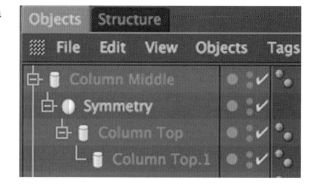

Figure Greek_11

Step 12 Unhide the Base and Step objects and move the Cylinder Middle group up to Y = 290.
Figure Greek_12

Note: Click on the red x to unhide an object.

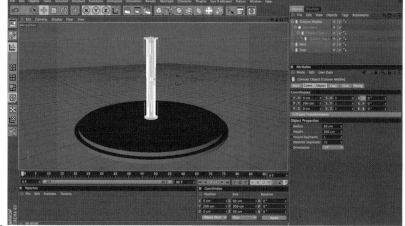

Figure Greek_12

Step 13 With the Column Middle group selected, hold the Option/Alt (PC) key and add an Array Object to our scene. In the Object tab of the Attributes Manager, set the Array's Radius to 425 and the Copies to 12.
Figure Greek_13

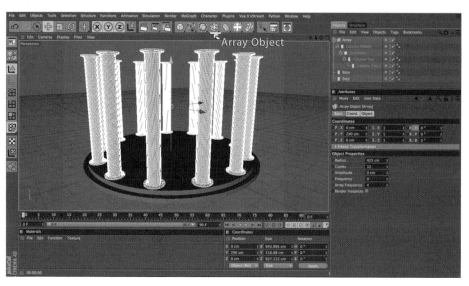

Figure Greek_13

Chapter 1: The Power of Primitives

Step 14 With the bottom sections complete, add a Tube object from the Polygonal Primitive drop-down. Rename the Tube Top. Set the Outer Radius to 475, the Inner Radius to 275, the Rotation Segments to 72 and lower the Height to 20. In the Coordinates tab change the P.Y to 555. *Figure Greek_14*

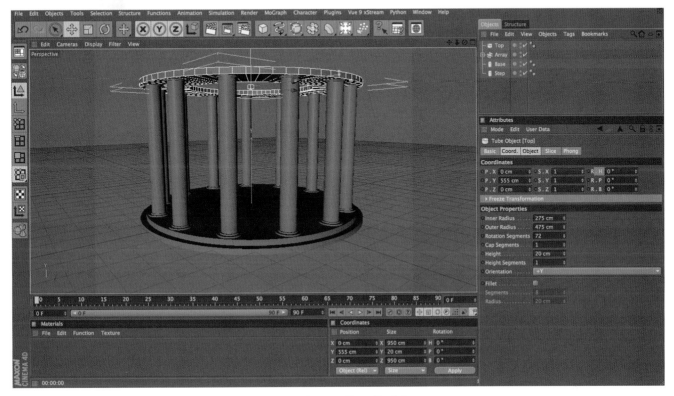

Figure Greek_14

Step 15 Now duplicate the Top object by Control+dragging on its name in the Object Manager. Change the P.Y value of Top.1 to 574 and its Outer Radius to 425. *Figure Greek_15*

Figure Greek_15

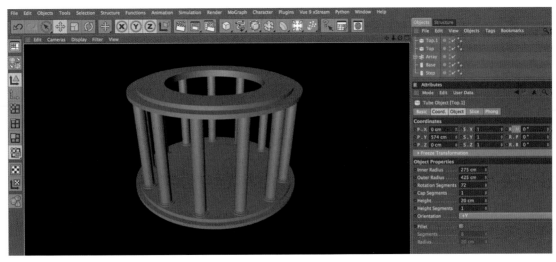

Step 16 The outer structure is complete and now we will create the pool itself. Control+Drag on the Base object to Duplicate it in the Object Manager. Double click on its name and change it to Pool Step. Adjust its values to P.Y = 35, Radius = 300.
Figure Greek_16

Step 17 Copy the Pool Step object in the Object Manager and rename it Pool Water. Set the P.Y = 75, set the Radius to 250 and the Height to 100. *Figure Greek_17*

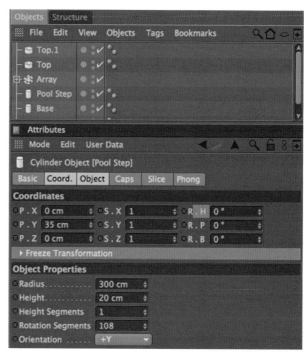

Figure Greek_16

Step 18 Finally, choose a Tube object from the Polygonal Primitive drop down and rename it Pool Wall. Set the Outer Radius to 270 and the Inner Radius to 250. Now set Rotation Segments to 72 and set the Height to be 110. Add a curved lip by checking the Fillet checkbox, and move the Pool Wall object up so the P.Y value = 95.
Figure Greek_18

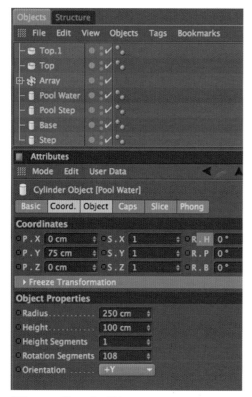

Figure Greek_17

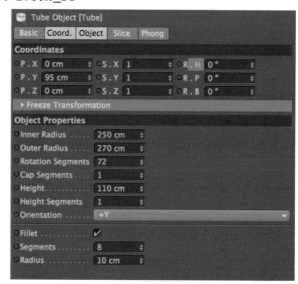

Figure Greek_18

Chapter 1: The Power of Primitives

Step 19 Lastly, add a Floor object from the Light drop down menu. *Figure Greek_19* Set it below our structure by setting its P.Y = -9.9.

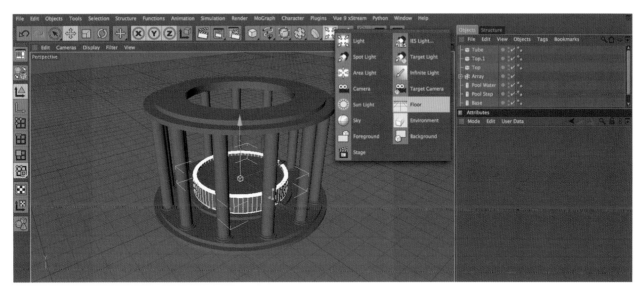

Figure Greek_19

Step 20 Select all of the objects in the Object Manager with the exception of the Floor. Press Opt/Alt (PC) + G to group these objects and rename the new Null Object, Greek Pool. Click on the plus icon to the left of the Greek Pool object to expand it in the Object Manager. *Figure Greek_20*

Figure Greek_20

Step 21 The modeling of our project is complete so it is time to create our materials. In the Material Manager, go to File>Load Material Preset>Prime>Materials>Basic>Marble002. Drag the Marble002 material and drop it on the Greek Pool group in the Object Manager.
Figure Greek_21

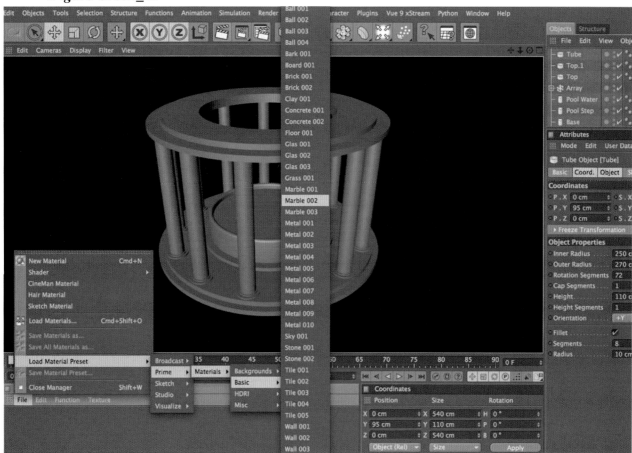

Figure Greek_21

Step 22 Now, double click in an empty area of the Material Manager to create a new material. This will be the material we use for our water, so rename it Water Mat. In the Color Channel, set the color with these values: R =170, G = 225, B = 255.
Figure Greek_22

Figure Greek_22

Chapter 1: The Power of Primitives

Step 23 Click on the checkbox to the left of the Reflection Channel to enable it. Check the additive box to lower the influence of the reflection. We will further weaken the reflection by lowering its brightness to 45%. We'll also use the reflection to alter our color by setting its color to R = 20, G = 135, B = 110.
Figure Greek_23

Figure Greek_23

Step 24 Now check the box beside the Bump Channel to enable it. We will load a water surface for this bump by clicking on the texture drop-down arrow and navigating to Surfaces>Water.
Figure Greek_24

Figure Greek_24

Step 25 Click on the grey Water Tab. Double click on the black knot to the right of the gradient to open its color setting. Set the R, G and B sliders all to 155 to make a medium grey. ***Figure Greek_25***
Notice that this has minimized the bump. ***Figure Greek_26***

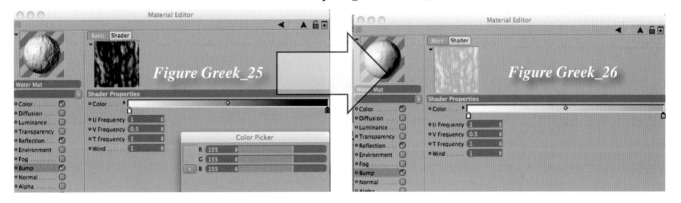

Figure Greek_25 *Figure Greek_26*

25

Step 26 Back out to the main Bump Channel and lower the Strength to 10%. Drag the Water Mat and drop it on the Pool Water object in the Object Manager. ***Figure Greek_27*** Press Cmd/Cntrl (PC) + R to see the results.

Figure Greek_27

Step 27 We will create the final look of this scene by adding lights. Add a Light to the scene and place it at P. X = 0, P.Y = 1500 and P. Z = - 900. Change the Shadow from None to Shadow Maps (Soft). ***Figure Greek_28***

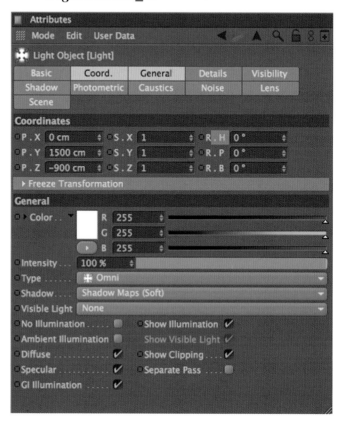

Figure Greek_28

Chapter 1: The Power of Primitives

Step 28 Add another light and name it, Fill Light. Set it to a blue color in the General tab by setting the values to something like R = 180, G = 182 and B = 255. Lower the intensity to 30%. In the Coordinates tab set the P.X = 0, P.Y = 800 and Z = 1700.
Figure Greek_29

Press Cmd/Cntrl(PC)+R to render the viewport and see the results of our lights.

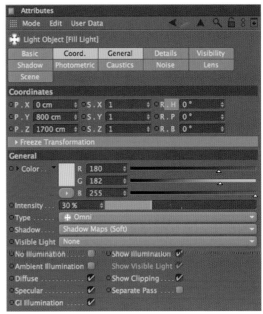

Figure Greek_29

Step 29 We should add a Sky object to give us better reflection off the water and structure. Add a Sky object from the Scene drop down.
Figure Greek_30

Figure Greek_30

Step 30 Double click in an empty space of the Material Manager to create a new material and change its name to Sky Mat. Uncheck the boxes to the right of the Color and Specular Channels to disable them. In the Luminance Channel, click on the drop-down arrow beside Texture and choose Load Image. Navigate to the The Power of Primitives Folder on the companion DVD and choose the **Greek_Clouds.tif** file. Apply this material to the Sky object.
Figure Greek_31

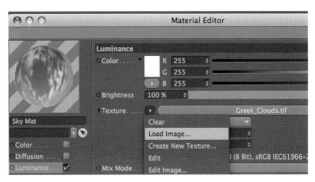

Figure Greek_31

CINEMA 4D: The Artist's Project Sourcebook, Third Edition

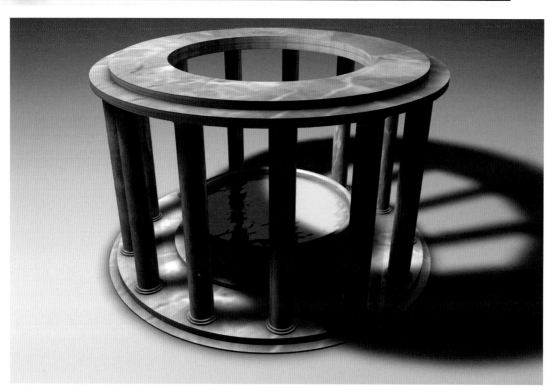

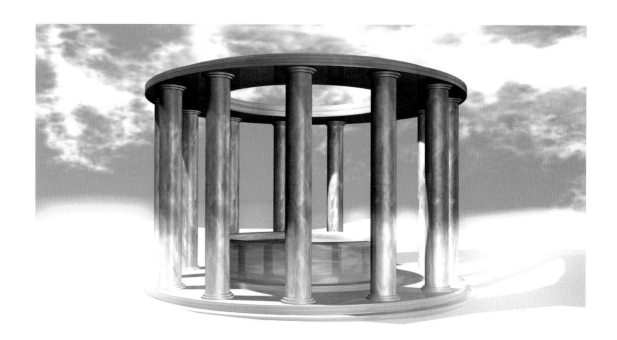

Chapter 1: The Power of Primitives

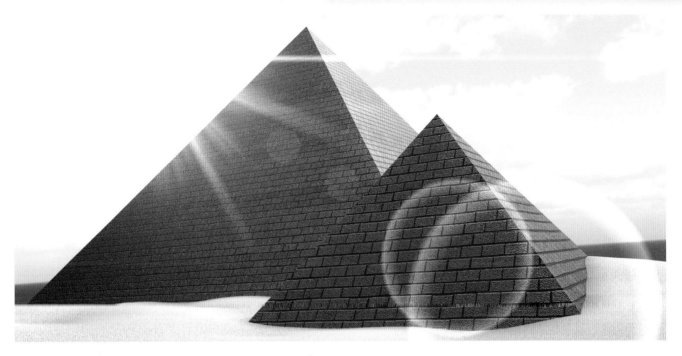

The Desert Scene Project

In the scene, we will put all of the disciplines together to create an animation from start to finish. We are going to do primitive modeling and texturing, add some standard lighting, a simple camera move for animation, one quick post effect and go through the render settings to render and view our first animated movie. Note to R12 users: This project was done using meters for the measurement parameters, you can substitute centimeters if you prefer since there are no Dynamic Calculations involved.

Step 1 Begin with the creation of the desert geometry, by adding a landscape object to our scene.
Figure Desert_01

Figure Desert_01

Step 2 By default the Landscape primitive creates a mountain style shape, so let's adjust this for our scene. In the Attribute Manager you will see the parameters that we can adjust to get our desired shape. Despite not being labeled, the size order will always be: X, Y and Z. To start, simply add another 0 to the X and Z size values, making them each 6000 respectively. Now set the Y size to 300. For the sake of keeping our poly count low, set the height and width segments to 60. We want to raise the number of undulations, so set the rough and fine farrows to 89% each. Since we prefer more rolling hills to represent dunes rather than sharp mountain peaks, uncheck Multifractal. *Figure Desert_02*

Figure Desert_02

Step 3 With the Desert object selected, hold the Alt key (PC) or Option key (Mac) and click once on the HyperNURBS icon at the top. This will put a heavy smoothing on our landscape. *Figure Desert_03*

Figure Desert_03

Chapter 1: The Power of Primitives

Step 4 Add a Pyramid from the polygonal primitive drop-down. The Attribute Manager will update to show the settings for this new primitive. Using the orange handles on the pyramid in the viewport, scale the X to be around 850, the Y to 550 and the Z to 850 or if you would prefer, set these values numerically in the Attribute Manager. *Figure Desert_04*

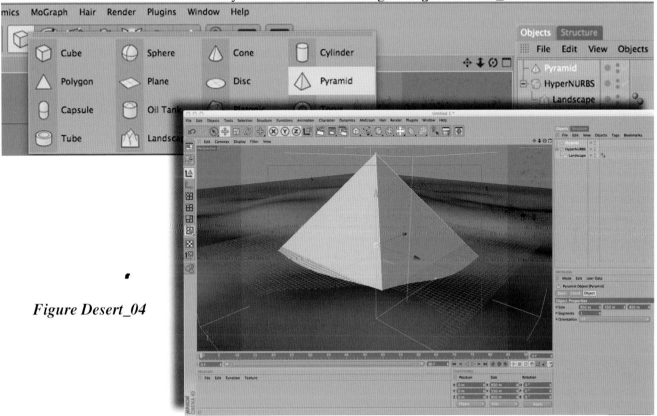

Figure Desert_04

Step 5 Now that the shape is acceptable, click on the Coordinates tab in the Attribute Manager and move the object into a more appealing spot by setting the P.X to - 266, P.Y. 183, P.Z. 335.
Figure Desert_05

Note that holding the Shift key as you click on tabs in the Attribute Manager will allow you to access multiple tabs at once.

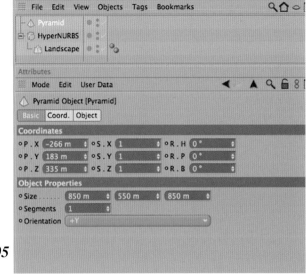

Figure Desert_05

Step 6 Finish off the basic geometry by adding a Sky object to this scene. The Sky object is grouped in the scene section of objects. It is an infinite sphere that exists around a scene. This ensures that you'll have a Sky projected in the background regardless of how you choose to arrange your cameras. Click and hold over the light icon at the top right and choose the Sky object. *Figure Desert_06*

Figure Desert_06

Step 7 The objects are in place so let's move on to texturing. Double click in the empty space within the Material Manager at the bottom left. You will see that a new material has been created. Its attributes will be displayed in the Attribute Manager on the right, but I like to pull out a floating material panel by double clicking on the new material's thumbnail within the Material Manager. *Figure Desert_07*

Figure Desert_07

Chapter 1: The Power of Primitives

Step 8 We'll start with the desert floor; highlight the name Mat, and change it to Sand. Below on the left hand side you will find a list of channels. These channels are the building blocks for creating great materials for your 3D scenes. The first is the Color Channel where we will set up the tone of the sand. With color selected, change the sliders to R 255, G 255, and B 219 and the brightness to 110%. *Figure Desert_08*

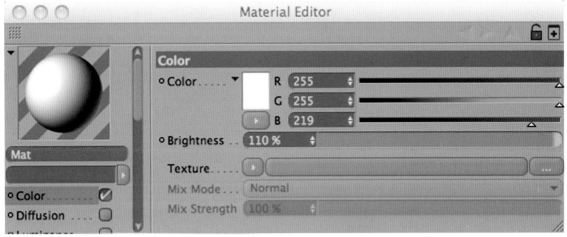

Figure Desert_08

Step 9 Now we want to give this material the appearance of the fine grit associated with sand. This is achieved by setting up a bump channel. Click the checkbox to the right of the name Bump to enable it. Click on the arrow to the right of Texture and choose Noise from the drop-down menu. Notice the change in the thumbnail preview. *Figure Desert_09*

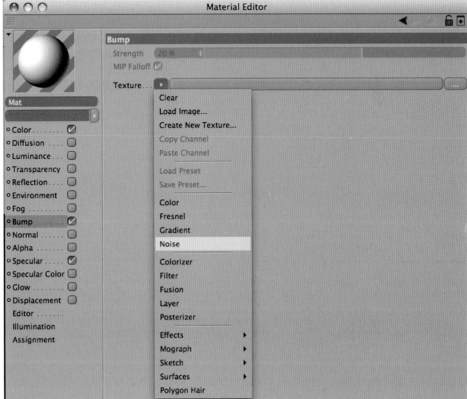

Figure Desert_09

Step 10 This noise is way too large to represent fine sand, so click on the grey bar labeled Noise. The change we need to make is to the Global Scale value. Change it from 100% to 2.5%.
Figure Desert_10

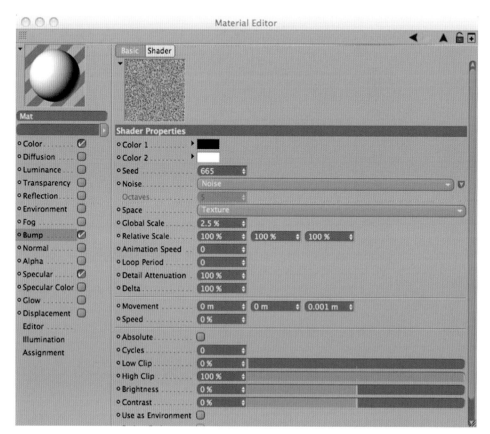

Figure Desert_10

Step 11 Finally, we need to adjust the light bounce that hits off the material by adjusting the Specular channel. Broaden the width percentage from 50 to 100% and lower the height to 15%.
Figure Desert_11

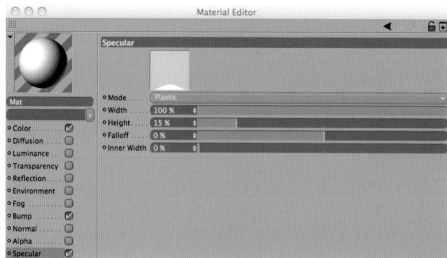

Figure Desert_11

Chapter 1: The Power of Primitives

Step 12 With the Sand material set up, we now need to apply it to the Landscape, which is acting as our desert object. This can be achieved by dragging the Sand thumbnail from the Material Manager and dropping it on the desert object (Landscape) inside the viewport, or on its name in the Object Manager. I prefer to drop it on the object name within the Object Manager because in many situations you will have overlapping objects that will make it impossible to drop within the viewport. ***Figure Desert_12***

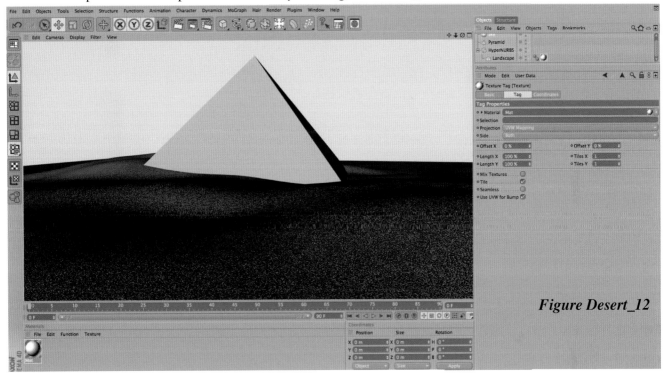

Figure Desert_12

Upon completing the material placement, the viewport will update and a small texture tag will appear to the right of the Landscape object in the Object Manager. Press Control+R (PC) or CMD+R (Mac) to render a quick preview within the viewport. That sand is way too dark, but don't worry, our lights will correct that in a minute.

Step 13 Time to texture the pyramid. For this material we will want to use some of CINEMA 4D's preset texture images to help us create the look for the pyramid. In the Material Manager, click File>Load MaterialPreset>CINEMA 4D>Materials>Basic>Brick001 ***Figure Desert_13***

Note: R12 users choose File>Load MaterialPreset>Prime>Materials> Basic>Brick001

Figure Desert_13

35

Step 14 Double click on this new material and change its name to Pyramid Mat. In the Color Channel set the R and G values to 255 and the B value to 219. Change the Mix Strength to 17%. (Located below the Texture drop down and preview.) *Figure Desert_14*

Figure Desert_14

Step 15 In the Specular Channel, change the width to 88% and the height to 100%. Drag the Pyramid Mat and drop on the Pyramid object. *Figure Desert_15*

Figure Desert_15

Chapter 1: The Power of Primitives

The results are not so good, as the stones look way too large. We will need to adjust how this material is mapped on our object. When you first drop a material onto an object, the Attribute Manager will update to give you the parameters controlling how that material is applied to the object you've dropped it on. If for some reason you lose these parameters in the Attribute Manager, they can always be accessed by clicking on the texture tag thumbnail to the right of the object in the Object Manager.

Step 16 In the Attribute Manager, change the Projection type from UVW to Cubic. Raise the Y percentage from 100% to 120%. ***Figure Desert_16*** *R12 Users: Raise the Length V to 120%.*

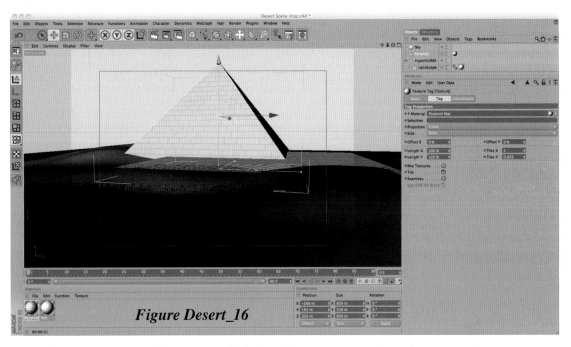

Figure Desert_16

Step 17 Create our sky texture to set this scene off right. I'm not crazy about the preset sky texture provided by MAXON, so I've included a few of my own for you to use throughout these exercises. Double click in an empty space of the Material Manager to create a new material. Change its name to Sky Mat. In the Color Channel, click on the drop-down arrow beside Texture and choose Load Image. ***Figure Desert_17***

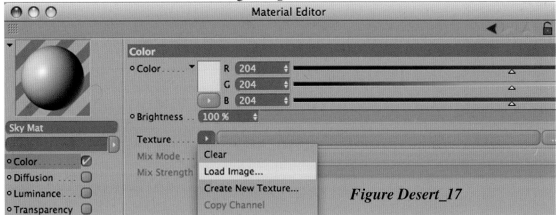

Figure Desert_17

37

Step 18 Navigate to the Power of Primitives folder on the companion DVD and choose the **DesertSky.tif** file. *Figure Desert_18*

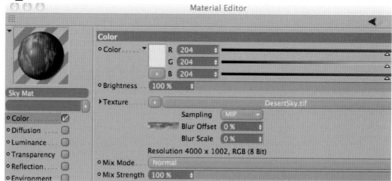

Figure Desert_18

Step 19 Now click on the drop-down arrow again and choose Copy Channel. Click the checkbox to enable the Luminance Channel, click on the Texture drop down and choose Paste Channel. *Figure Desert_19*

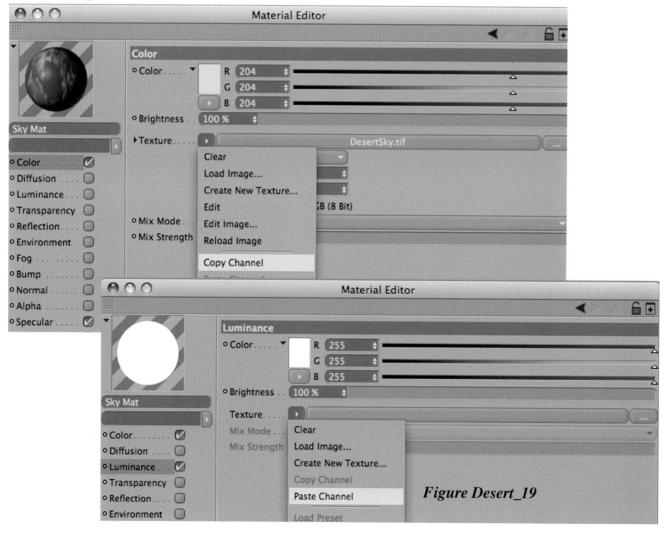

Figure Desert_19

Step 20 Lower the Brightness setting to 20% and the Mix Strength at the bottom to 50%. Uncheck the box to the right of the Specular Channel as skies do not have light bounce. Apply this material to the Sky object. *Figure Desert_20*

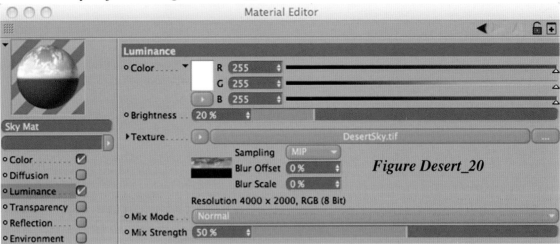

Figure Desert_20

Step 21 Time to light the scene. Click once on the Light Icon at the top to add a basic light. At first the scene will go fairly dark as the light will have been placed at the origin (0,0,0) which happens to rest beneath our dunes and pyramid. We'll move this light into place by changing it's P values in the Coordinates tab of the Attribute Manager. In order to display multiple tabs at once, simply Shift+click on the tabs you want visible. Set the P.X to - 2000, P.Y to 3000 and P.Z to 1000.
Figure Desert_21

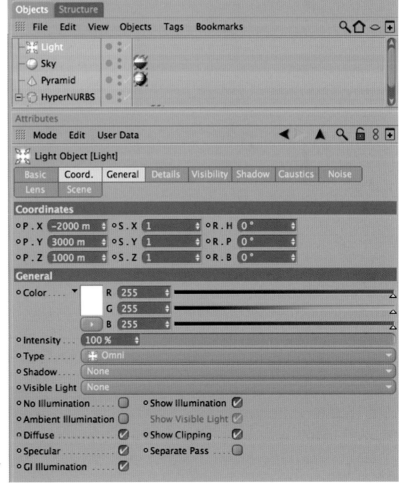

Figure Desert_21

Step 22 This will be our key light for our scene so we want it to cast a shadow. You can enable shadows by changing the Shadow parameter from None to Shadow Maps (Soft) under the General tab. *Figure Desert_22*

Figure Desert_22

Step 23 We will want to further adjust the shadow by clicking on the Shadow tab and lowering the Shadow Density to 75%. Name this light Key. *Figure Desert_23*

Figure Desert_23

Press Control+R (PC), CMD+R (Mac) to render the viewport and see the results.

Chapter 1: The Power of Primitives

Step 24 Now we need to add secondary lights to complete the lighting of the scene. Click again on the Light icon at the top. Place this light at P.X 800, P.Y 1500 and P.Z - 800. Set the Color to R = 201, G = 213, B = 255 and lower the Intensity to 25%. Name this light Backlight.
Figure Desert_24

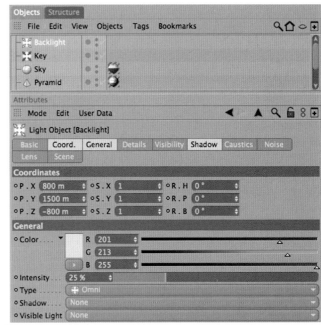

Figure Desert_24

Step 25 Lastly, we will add a light to be our visible Sun for the scene. Click on the light icon at the top and name this light, Sun. In the Coordinates tab within the Attribute Manager, type in these values to get the right position: P.X - 1600, P.Y 1400, P.Z - 2000. ***Figure Desert_25***

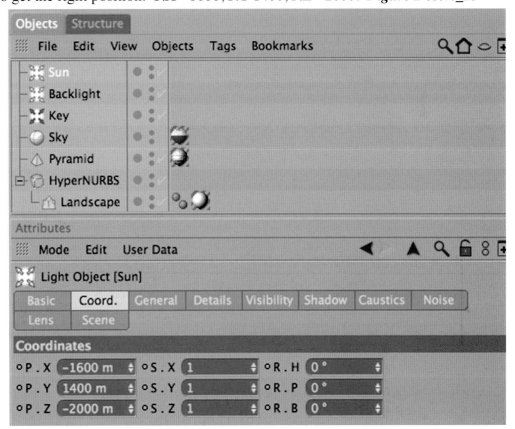

Figure Desert_25

Step 26 Now under the General tab, check the No Illumination checkbox. This will prevent this light from actually lighting the scene. *Figure Desert_26*

Figure Desert_26

Step 27 Click on the Lens tab and click on the grey bar beside the Glow parameter that reads inactive. Select Sun 1 from the drop down. *Figure Desert_27*

Figure Desert_27

Chapter 1: The Power of Primitives

Step 28 Now click on the grey bar reading inactive beside the Reflexes parameter and choose Artifact from the drop down. Press Control (CMD Mac)+R to render the view.
Figure Desert_28

Figure Desert_28

Step 29 Before adding a camera to capture this environment, let's make it a little more interesting by adding a second larger pyramid. We won't need to start from scratch as we already have a textured pyramid in our scene. In order to copy our pyramid, simply Control+ drag on its name in the Object Manager. You'll notice a plus contained within a box shows up at your cursor to let you know that you are in fact duplicating the object. Make sure that you drag it to an empty space and not on top of another object within the Object Manager. If at any time you make a mistake, remember Cmd/Control (PC)+Z will undo previous steps. Now with the new Pyramid selected, change its P.X to - 1200, P.Y to 500 and P.Z to - 600. Under the object properties, change the pyramid's Size to 2000, 1350 and 2000.
Figure Desert_29

Figure Desert_29

CINEMA 4D: *The Artist's Project Sourcebook, Third Edition*

Now, let's add that camera.

Step 30 To add a camera, click and hold on the Light icon and choose the camera thumbnail. By default this camera will assume the orientation of the current editor camera that you are using to build your scene. Double click on its name and change it to Pyramid Camera.
Figure Desert_30

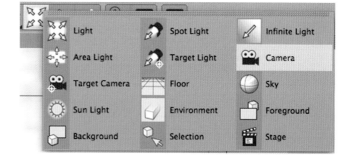

Figure Desert_30

Step 31 To match my initial camera setup, type in these values for the position values in the Pyramid Camera's Coordinates tab. P.X 1880, P.Y -50, P.Z 1250. Now set the correct rotation of the camera to R.H 117, R.P 5 and R.B 0. In the Object tab, set the Field of View to 53.13.

Figure Desert_31

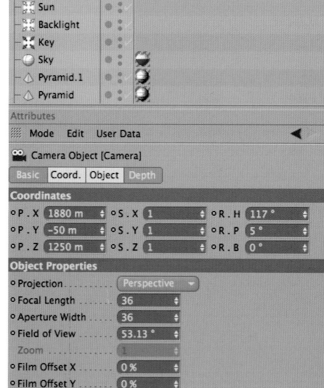

Figure Desert_31

Chapter 1: The Power of Primitives

Step 32 With the Pyramid Camera setup, we will want to set a keyframe for its parameters at frame 0. Ensure that the green playback indicator is at frame 0, and that the Pyramid Camera is selected in the Object Manager (highlighted white), then click on the red ellipse with the black key. This will set keyframes for the Position, Scale and Rotation of our Pyramid Camera. ***Figure Desert_32***

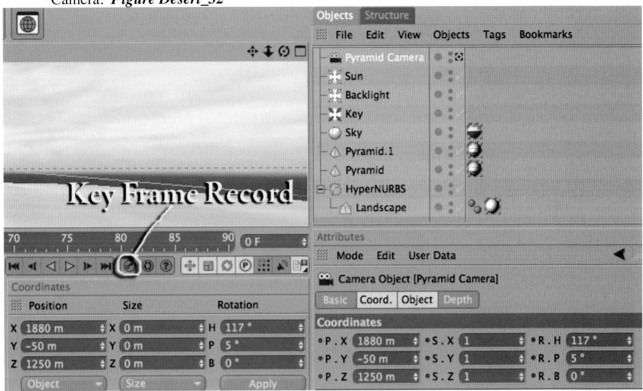

Figure Desert_32

Step 33 To take control of the movement of this camera, we need to be looking through it. The quickest option is to simply click on the black crosshair to the right of the camera in the Object Manager. The crosshair will turn white, letting you know that it is the active camera. A second option is to click on the Cameras menu in the viewport and choose Scene Cameras>Pyramid Camera. ***Figure Desert_33***

Figure Desert_33

Step 34 In the playback timeline you will see that the last frame is 90. At 30 frames per second we would only have a three second animation. Let's expand this by changing the 90 to 180. You will now need to drag the right grip on the grey band below the timeline to extend it to show all 180 frames. *Figure Desert_34*
Now go to the end of the animation by either typing 180 in the current frame box to the right of the timeline or click the "go to end of animation" button below the timeline.

Figure Desert_34

Step 35 Using the viewport controls (Pan, Zoom and Rotate), place the camera to your desired end point and click the red ellipse with the black key to set a new keyframe. You can also type the numbers that were used for this exercise into the Coordinates tab of the Pyramid Camera. P.X 211, P.Y 463, P.Z 53, R.H 120, R.P 10, R.B 13. You will still need to click the keyframe button to have these changes recorded. *Figure Desert_35*

Figure Desert_35

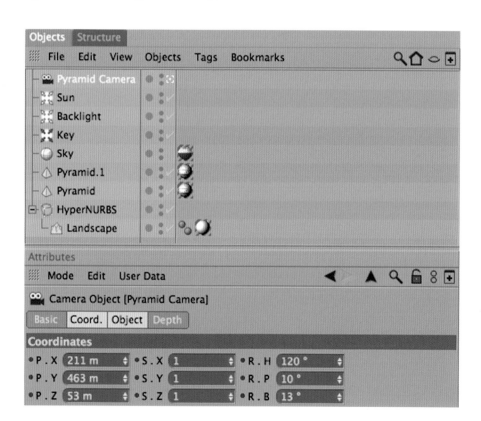

Step 36 Now click the green play forward button in the playback controls to see the animation in the viewport. *Figure Desert_36*

Figure Desert_36

Chapter 1: The Power of Primitives

Step 37 With everything staged, it is now time to render the animation. Click on the render settings icon at the top to open the render settings. Select the Output tab and click the preset arrow and choose Film/Video>HDV 1080 29.97. ***Figure Desert_37***

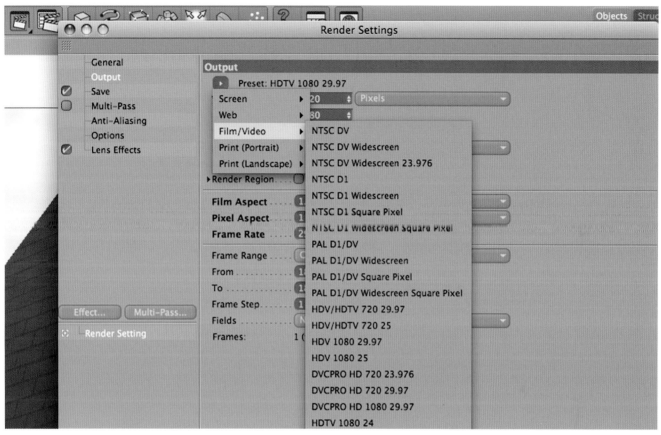

Figure Desert_37

Step 38 In the same tab, scroll down and change the Frame Range from Current Frame to All Frames. ***Figure Desert_38***

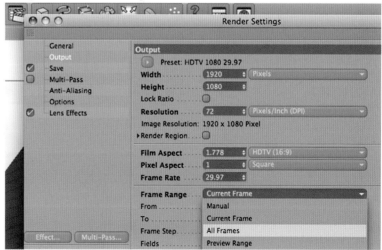

Figure Desert_38

Step 39 Go to the Save tab and in the name space to the right of File, type Desert Scene. Under format, change from TIFF (PSD Layers) to QuickTime Movie. *Figure Desert_39*

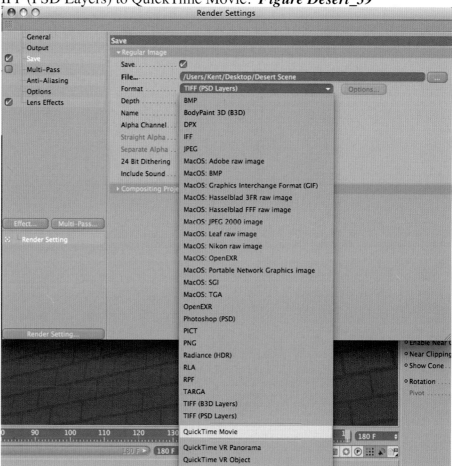

Figure Desert_39

Step 40 Once you're done there, go to the Anti-Aliasing tag on the left. Change the Anti-Aliasing from Geometry to Best and the Filter from Still Image to Animation.
Figure Desert_40

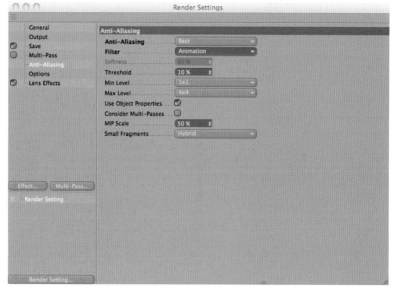

Figure Desert_40

Chapter 1: The Power of Primitives

Click on the top red x to close the render settings. We are now ready to render!!!

Click once on the middle render button to render to the Picture Viewer. This will start the final render of our animation. You can now watch the picture viewer as it renders each frame and can even playback as it renders. When it's completed, you've got a pretty good-looking animation. You will notice a little flicker as the animation plays. This would be easily corrected using scene motion blur, which we will cover later on. Save this scene by going to File>Save Project and name this project Desert Scene. Now you'll have this scene and can always go back and add objects or more advanced camera moves and render all new animations. Always use the Save Project option if you've used images outside CINEMA 4D for texturing. It creates a Tex folder that holds all the images you've brought in. Now you can take this project folder anywhere and not worry about texture link errors.

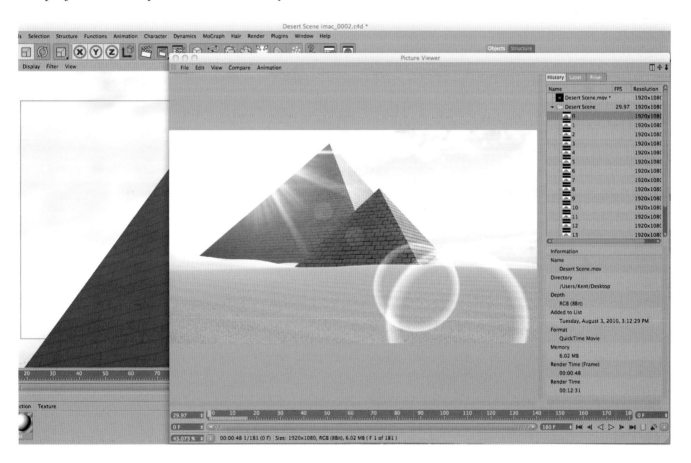

CINEMA 4D: The Artist's Project Sourcebook, Third Edition

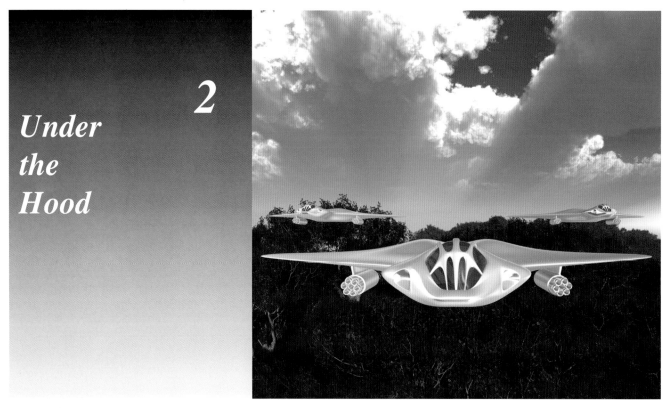

Under the Hood 2

Under the Hood is about going inside the shapes and objects we've looked at, to expand the complexities and possibilities of what these models can become. By opening up the components of a shape, every point, polygon and edge, is at your command. Not only that, but you can build new components from the originals, thus exponentially raising the detail and control at your fingertips. This chapter hits at the core of what modeling in 3D is all about.

MoGraph Mace

Step 1 Add a Sphere primitive and set the segments to 5. *Figure MoGraphMace_01*

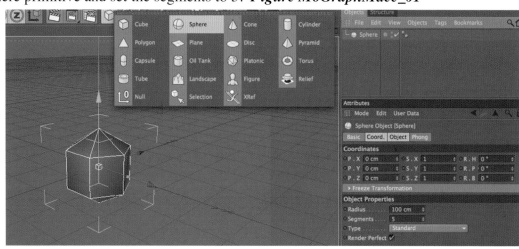

Figure MoGraphMace_01

Chapter 2: Under the Hood

Step 2 Add a Cone Primitive with a Top Radius of 0, Bottom Radius of 65, Height of 200. Keep the Height Segments at 8 but increase the Rotation Segments to 72. Set the Orientation to +Z. ***Figure MoGraphMace_02***

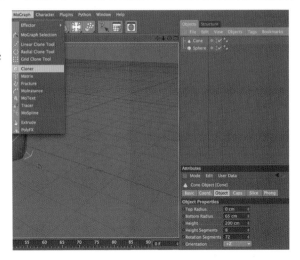

Figure MoGraphMace_02

Step 3 With the Cone object selected, hold the option key (Alt PC) and select Mograph>Cloner object. Inside the Cloner, set the Mode to Object and drag the Sphere object from the Object Manager and drop it into the Object Reference Field. Change the Distribution to Polygon Center. ***Figure MoGraphMace_03***

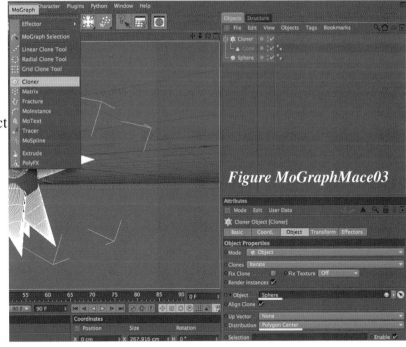

Figure MoGraphMace03

Step 4 With the Cloner object selected, add a Random Effector from the Mograph Menu. (having the cloner selected when adding effectors automatically assigns those effectors to the selected cloner) ***Figure MoGraphMace_04***

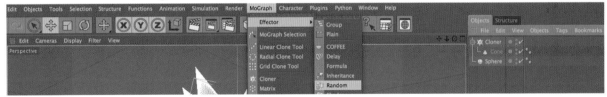

Figure MoGraphMace_04

51

Step 5 With the Random Effector selected, click on the Parameter tab in the Attribute Manager. Disable Position by unchecking its box and enable Scale. Set the S.X to 0.1, S.Y to 0.1 and the S.Z to 0.25 to vary the size of our spikes. *Figure MoGraphMace_05*

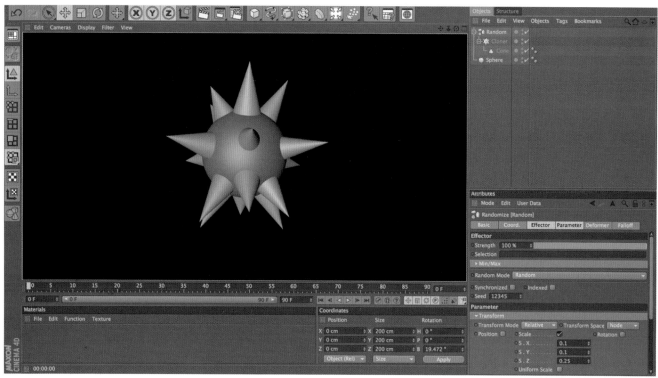

Figure MoGraphMace_05

Step 6 Select the Sphere and the Cloner group in the Object Manager and press Option (Alt PC) +G to group these as one object. Name the new Null, Head.
Figure MoGraphMace_06

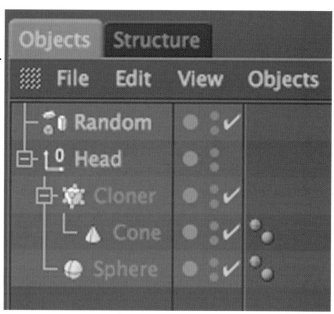

Figure MoGraphMace_06

Chapter 2: Under the Hood

Step 7 Add a Cylinder object and change its name to Staff. Set its Radius to 15, the Height to 480 and the Rotation Segments to 72. Move this object down to P. Y -275.
Figure MoGraphMace_07

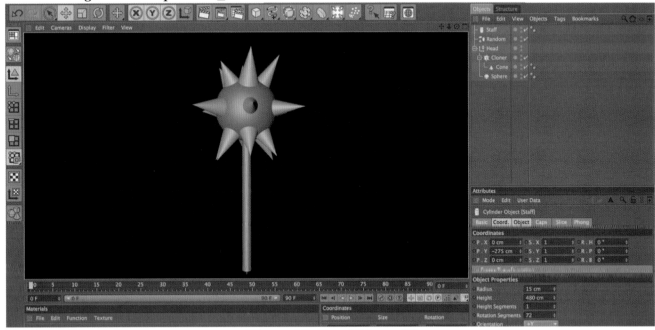

Figure MoGraphMace_07

Step 8 Cntr+Drag on the Staff in the Object Manager to duplicate it and rename it Handle. Up the Radius to 17.5 and lower the Height to 200. Move this object down to - 600.
Figure MoGraphMace_08

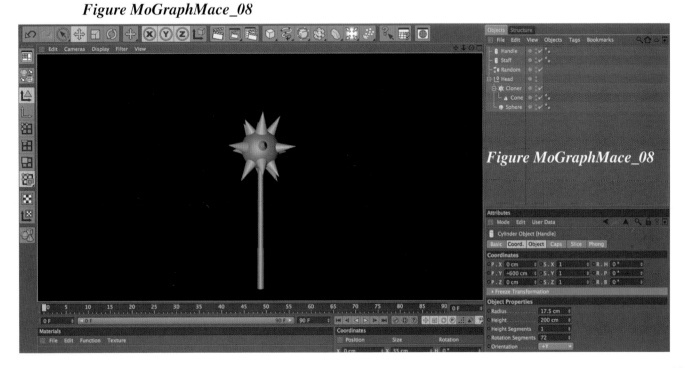

Figure MoGraphMace_08

53

Step 9 Double Click in the Material Manager to create a new material. Name this material, Metal Mat. In the Color Channel, set the Color to R 28, G 28, B 28. *Figure MoGraphMace_09*

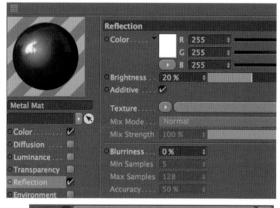

Figure MoGraphMace_09

Step 10 Enable the Reflection Channel, set the Brightness to 20% and check the Additive box. *Figure MoGraphMace_10*

Figure MoGraphMace_10

Note: If your color picker slider is set to a different method, click the dropdown arrow below the thumbnail preview to access slider options.

Step 11 In the Bump Channel, choose Texture>Sufaces>Rust. *Figure MoGraphMace_11*

Click on the Rust Shader to edit the components. Set the left knot and set its color to R 230, G 230, B 230. Set the other knot to R 65, G 65, B 65. Set the Rust to 58%.

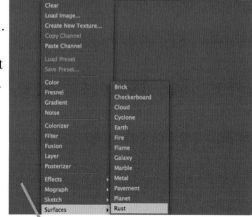

Figure MoGraphMace_11

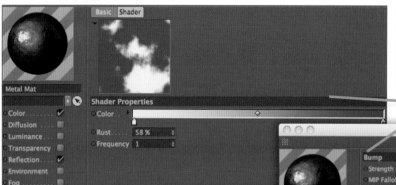

Back out to the main Bump Channel window and set the Strength to - 35%.

Chapter 2: Under the Hood

Step 12 Activate the Specular Color Channel and set it to R 210, G 225, B 255. Drag this material on the Handle and Head objects. *Figure MoGraphMace_12*

Figure MoGraphMace_12

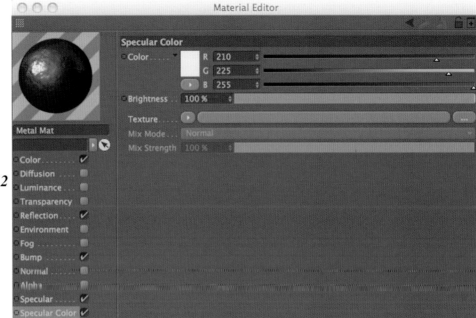

Step 13 In the Material Manager, choose Load Material Preset>Visualize>Materials>Wood>Wood - Bubinga. Drag this material onto the Staff. *Figure MoGraphMace_13*

*Note: If you do not have the Visualize materials, choose one of the wood presets under **Load Material Presets>Prime>Basics**.*

Figure MoGraphMace_13

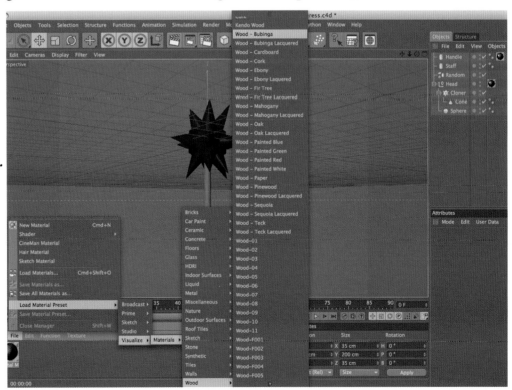

Step 14 Add a light, set the Color to R 255, G 225, B 180 and enable Shadows by setting it to Shadow Maps (Soft). Position the light by moving it to P. X = - 10000, P. Y = 20000 and P. Z = - 15000. In the Shadow tab, lower the Density to 50%. *Figure MoGraphMace_14*

Figure MoGraphMace_14

Step 15 Add a second light and name it Back Light. Set the Color to R 165, G 190, B 255 and lower the Intensity to 45%. Position it at P.X = 15000, P.Y = 0, P.Z = 10000. *Figure MoGraphMace_15*

Figure MoGraphMace_15

Chapter 2: Under the Hood

City Building

Note to R12 users: This project was done using meters for the measurement parameters; you can substitute centimeters if you prefer since there are no Dynamic Calculations involved.

Step 1 We will begin again with a cube polygonal primitive and rename it, Building. Set the Size to be X = 800 with 9 subdivisions, Y = 2250 with 9 subdivisions, and Z = 800 with 9 subdivisions. *Figure 01C_01*

Figure 01C_01

With the proper divisions set, press the C key to make the object editable. Click the Polygon tool on the left so that we may proceed to make selections and transformations.

Polygon Tool

Step 2 To make quick and precise selections and adjustments, the orthographic views give us the most accurate presentation of our scene. The only downside to these views is that they only display two dimensions and thus fail to give users any degree of perspective. By pressing F5 you will access the 4-up view. This splits the viewport into the four default camera views. This can likewise be accomplished by clicking the fourth icon on the upper right of the viewport. *Figure 01C_02*

Press this icon in any of the four views to maximize that view. Similarly, F1 will load the perspective view, F2 the top, F3 the right, F4 the front view and F5 to see the four up view. For our first selection, press the F4 button to access the front view.

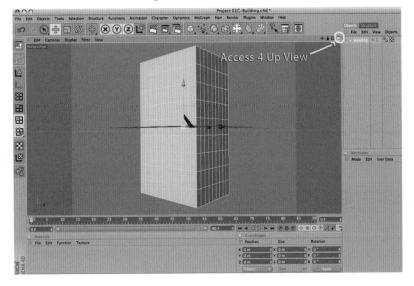
Figure 01C_02

Step 3 Zoom out so that the entire object is within view. Choose the Selection tool and uncheck the Only Select Visible Elements option. With this option disabled, we will be able to select the polygons on both sides of the model at one time. You may also wish to lower the radius of the Selection tool to 2. Select the polygons as done in *Figure 01C_03*.

Note: You will need to hold the shift key in order to retain and add to selections. If you select a polygon by accident, simply Control click to remove that one individually.

Step 4 Now we want to hit F3 or choose the Right view using the view icon. Again, zoom out to fit the entire model in the viewport. Remember to hold the Shift key as you add to the previous selection. Your selection should now look like *Figure 01C_04*.

Figure 01C_03

Live Selection Tool with Only Select Visible Elements Disabled

Figure 01C_04

Chapter 2: Under the Hood

Step 5 Navigate to the Perspective view or simply press F1. Rotate your view around to make sure the polygon selections have indeed gone through the model. Now with these established, go to Selection>Set Selection. *Figure 01C_05* Click on the Orange Triangle Selection tag to the right of building in the Object Manager. Rename this selectionWindows.

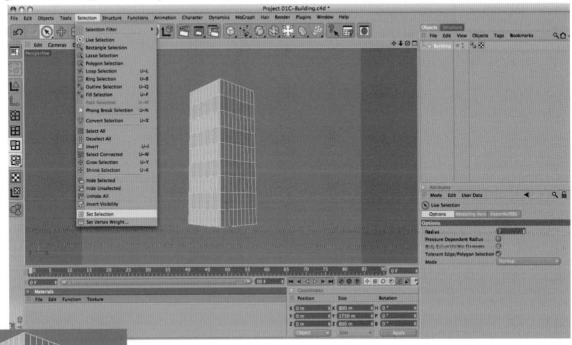

Figure 01C_05

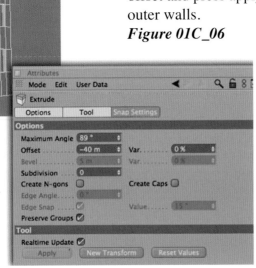

Step 6 Press the D key to access the Extrude tool. Type - 40 in the offset and press apply to extrude these windows back from the outer walls.
Figure 01C_06

Figure 01C_06

59

Step 7 With the windows ready, we need to create another selection set for the door. Simply click in an empty space in the viewport using the Selection tool to deselect all polygons. Press F4 or navigate to the front view and select the bottom center polygons as seen in *Figure 01C_07*. Press F1 to go back to the perspective view and rotate around the scene to ensure both sides are selected correctly. Before creating a new selection set, you must deselect any other selection tags or you will override them. Do this by clicking in a blank area of the Object Manager to deselect the building and its selection tag. Now just reselect the building object and go to Selection>Set Selection. You should see a second selection tag show up to the right of the building object. Rename the new tag, Doors.

Figure 01C_07

Step 8 Press the D key and type - 35 as the offset and press apply. *Figure 01C_08*

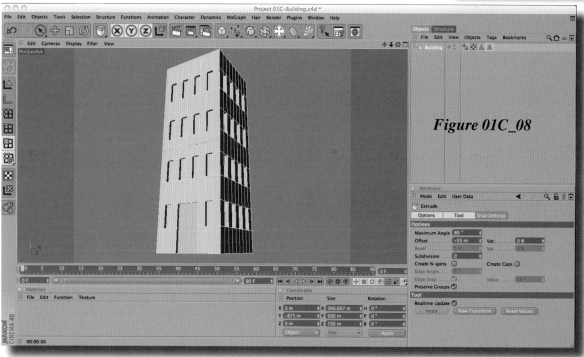

Figure 01C_08

Chapter 2: Under the Hood

Step 9 Rotate your view so that the top of the model is visible. Choose the Selection tool and check the Only Select Visible Elements box to enable it. Select all the top polygons. ***Figure 01C_09***

Figure 01C_09

Step 10 We want to create a thin edge around the roof top, so we will use the Inner Extrude tool to make new polygons. Press the I key and drag to create a new set of polygons similar to ***Figure 01C_10***. You can likewise type in 30 for the offset and click apply.

Figure 01C_10

Step 11 With this selection still active, press the D key, set the offset to -35 and click Apply. ***Figure 01C_11***

Figure 01C_11

CINEMA 4D: The Artist's Project Sourcebook, Third Edition

Step 12 Again, we want to create a selection tag for texturing purposes. Click in an empty section of the Object Manager to ensure that no previous tags are selected. Reselect the building and go to Selection>Set Selection. Click on the new tag and rename it Roof. *Figure 01C_12*

Figure 01C_12

Step 13 With our model complete, it is time to shift our attention to the Material Manager. The first material we will use is a preset. In the Material Manager, click File>Load Material Preset>CINEMA 4D>Materials>Basic>Brick002. *Figure 01C_13*

Note: R12 users, click File>Load Material Preset>Prime> Materials>Basic>Brick002.

Figure 01C_13

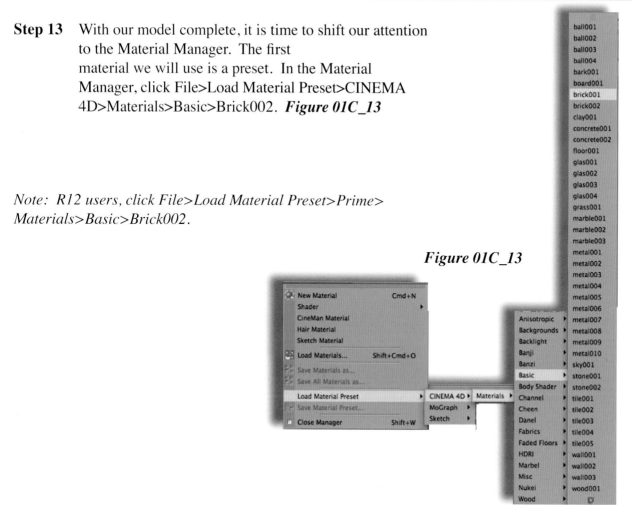

62

Chapter 2: Under the Hood

Step 14 Place the brick002 material on the building object. In the Attribute Manager, change the Projection type from UVW Mapping to Cubic. ***Figure 01C_13a***

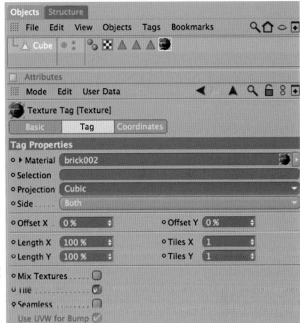

Figure 01C_13a

Step 15 Now create a new material by double clicking in an empty section of the Material Manager. Rename this material Windows. In the Color Channel, set the values R = 190, G = 230, B = 255 and lower the brightness to 35%. ***Figure 01C_14***

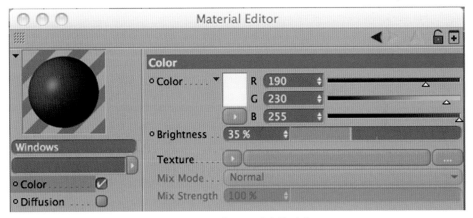

Figure 01C_14

Step 16 Enable the Reflection Channel by clicking on its checkbox. Turn the Brightness down to 55% and make sure Additive is enabled. ***Figure 01C_14a***

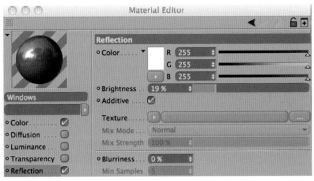

Figure 01C_14a

63

Step 17 Drag this material and drop it on the building. This time we need to restrict this material to the Windows selection. When a texture tag is selected (as it is when first placed on an object), the Attribute Manager updates to display not the attributes of what makes up the texture, but how the texture is applied to that object. The Selection field is the area that designates which selections of an object receive this material. Drag the orange triangle Window and drop it into the Selection box in the Attribute Manager.
Figure 01C_15

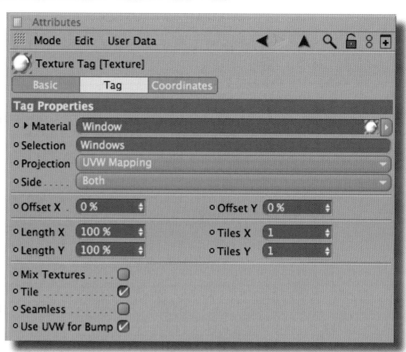

Figure 01C_15

Step 18 Now, let's grab another preset material from the Material Manager drop down. Go to the File Menu in the Attribute Manager and navigate to File>LoadMaterial Preset> CINEMA 4D> Materials> Basic> concrete001. Drag its thumbnail from the Material Manager and drop it on the building in the Object Manager. As we did with for the window material, take the Roof selection and drag it into the Selection box of the concrete001 material in the Attribute Manager.
Figure 01C_16

R12 users, click File>Load Material Preset> Prime>Materials>Basic>Brick002.

Figure 01C_16

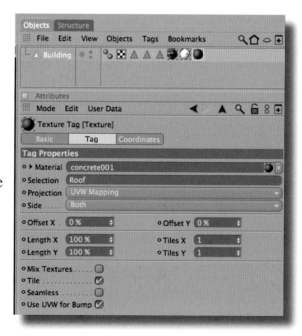

Chapter 2: *Under the Hood*

Step 19 Lastly, double click in an empty space in the Material Manager to create our final material. Name this material Door. In the color channel, you'll need to navigate to the **doorimage.jpg** provided in the Under the Hood folder of the DVD. Click on the texture drop down arrow and choose, Load Image.

Step 20 Now check to enable the Bump Channel. Click the texture drop down and choose Load image. Navigate to the **doorcroppedbump.tif** in the same tex folder.

Step 21 Enable the reflection channel, check the additive box and lower the brightness to 8%.

Step 22 As with our previous materials, drag the Door Mat and drop it on the building. Drag the Door Set selection tag and drop it into the Selection field of the texture tag in the Attribute Manager.

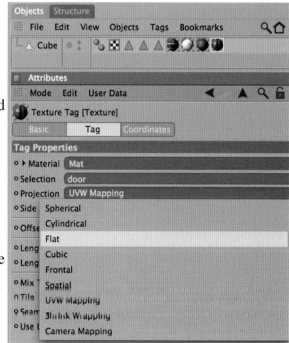

Figure 01C_17

Step 23 Immediately you'll see that the texture does not fit well on our selection. In the Attribute Manager, change the Projection from UVW Mapping to Flat.
Figure 01C_17

Step 24 Use the Offset and Length values to size the texture correctly. For my scene, the correct values are Offset U = - 17%, Offset V 90%, Length U = 135%, Length V = 270%.
Figure 01C_17a

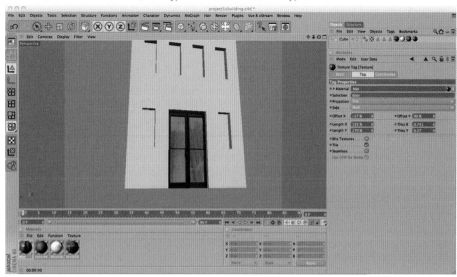

Figure 01C_17a

65

Step 25 The model looks good and now we need to stage the scene to bring out the best of the model and textures we've applied. We'll start the staging by altering the position of our axis for the building. The reasoning behind this alteration is the ability to scale from the ground up. If we were to rescale this building to be larger or smaller, it would occur from the center. This would require repositioning the model to the desired position every time we scale. We are going to set the axis to be at the bottom of this model to alleviate this problem. Go to the Object Axis tool. **Figure 01C_18**

Figure 01C_18

Step 26 Since we set the Y size to 2250, we know that half of that value was above 0 and half below. With that knowledge, type in -1125 for the Y position in the Coordinates Manager (not in the Coordinates tab of the Attribute Manager) and press apply. **Figure 01C_19**

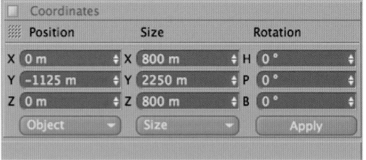

Figure 01C_19

Notice that the model did not change position as the primary function of the Object Axis tool is to allow separation of the axis from the geometry. This is what allows for independent movement of the axis from the model. The axis handles may also be used to manually transform an axis.

Model Tool

Step 27 Switch back from the Axis tool to the Model Tool which is located directly above it. With the Model Tool enabled, set the Y position back to 0. This action can be done in the Coordinates Manager or the Coordinates tab under the Attribute Manager. *Figure 01C_20*

Figure 01C_20

Chapter 2: Under the Hood

Step 28 Now add a floor object to the scene by clicking and holding on the Light Icon at the top and choosing floor from the pulldown. *Figure 01C-21*

Figure 01C_21

Step 29 It is time now to move on to putting some light in this scene. Click on the Light Icon once to add a light to our scene. Rename this light Key Light. In the General tab, adjust the color values to R = 255, G = 255, B = 180. Change the position to P. X 6500, P.Y 8500, P. Z 4500. Change the Shadow from None to Soft. Click on the Shadow tab and set Density from 100% to 65%. Change the Shadow Map from 250x250 to 500x500.
Figure 01C_22

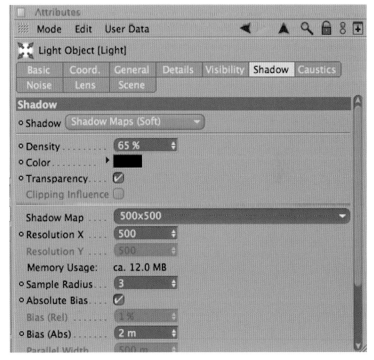

Figure 01C_22

Step 30 Add a second light and name it Blue Fill Light. In the General tab change its color values to R = 100, G = 150, B = 255. and lower the Intensity to 60%.
Change its Position to X = - 22000, Y = 4500 and Z = - 40000.

CINEMA 4D: The Artist's Project Sourcebook, Third Edition

Step 31 This scene looks good but take it one step further by adding a basic sky object by choosing from the Light Object drop-down menu.
Figure 01C_23

Figure 01C_23

Step 32 Double click in an empty section of the Material Manager to create a new material and name it Sky Mat. Click on the Texture arrow in the Luminance Channel and Navigate to the Under the Hood folder on the companion DVD and choose the **Greek_sky.tif** file. Disable the Color and Specular Channels. Apply this material to the Sky object. Rotate your view around the scene pressing Cmd/Cntrl (PC)+R to render the views in order to get a look at the final quality.

Step 33 Now, Cntrl+Drag on the Building object in the Object Manager to copy it. Move the new Building.1 object over to X = 1000. *Figure 01C_24*

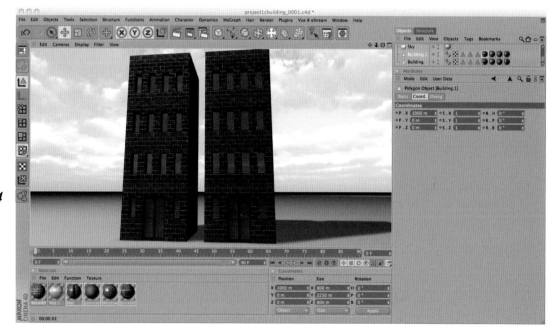

Figure 01C_24

Chapter 2: *Under the Hood*

Step 34 Go to the Material Manager and choose File>Load Material Preset>CINEMA 4D>Materials>Basic>Brick001. Drag this new brick material and drop it on the original brick texture tag to the right of the Building.1 object in the Object Manager. ***Figure 01C_25***

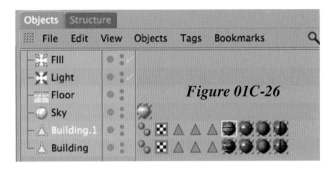

Figure 01C-26

R12 users, click File>Load Material Preset>Prime>Materials>Basic>Brick001.

Step 35 Notice that it substitutes our new texture for the original without affecting the placement of any other material. It likewise automatically preserves the texture tag settings including projection type, offset and tiling. In this case, it tiles the textures a little too much and an obvious pattern emerges on the object when we render. Select the new brick texture tag and change its Length settings in the Attribute Manager to Length U = 200%, Length V = 200%. Press Cmd/Cntrl(PC)+R to render the changes we've made. With simple alterations such as this and a few other short cuts, you can quickly and effectively populate an entire city.

Modeling a Spaceship

Step 1 Start by adding a cube to the scene.

Step 2 Hold the Shift key and add a MoGraph Extrude object from the MoGraph menu.
Figure ssmgextrude_01

Figure ssmgextrude_01

Chapter 2: Under the Hood

Step 3 Under the Object tab, set the steps to 21. In the Transform tab, raise the P.Z from 5 to 242 and lower the Scale to X = .69, Y = 0.51 and Z = 0.69. ***Figure ssmgextrude_02***

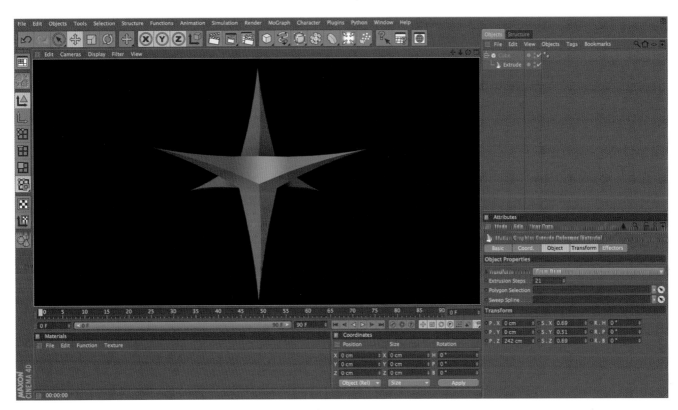

Figure ssmgextrude_02

Step 4 With the Cube group selected, go to Functions>Current State to Object. ***Figure ssmgextrude_03***

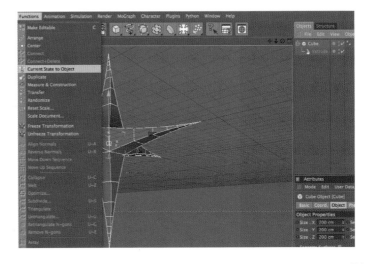

Figure ssmgextrude_03

Step 5 Hide the original group by clicking on the check to its right in the Object Manager. Switch to points mode and grab the Rectangle Selection tool; make sure Only Select Visible Elements is turned off. Select the points comprising the bottom spike and press Delete. *Figure ssmgextrude_04*

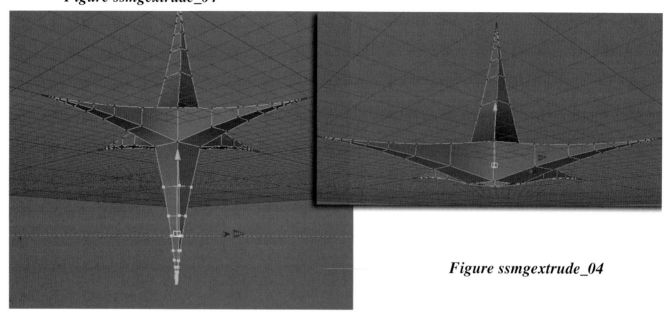

Figure ssmgextrude_04

Step 6 Use the Bridge tool (Structure>Bridge, shortcut = b key) to reconnect the opening at the bottom. *Figure ssmgextrude_05*

Figure ssmgextrude_05

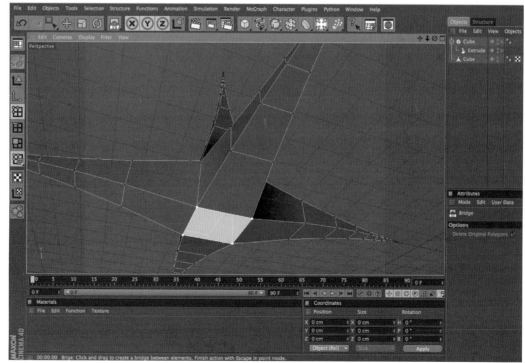

Chapter 2: Under the Hood

Step 7 Choose the Right view (F3). With the rectangle selection tool, select all of the points of the back spike with the exception of the first segment and press Delete. *Figure ssmgextrude_06*

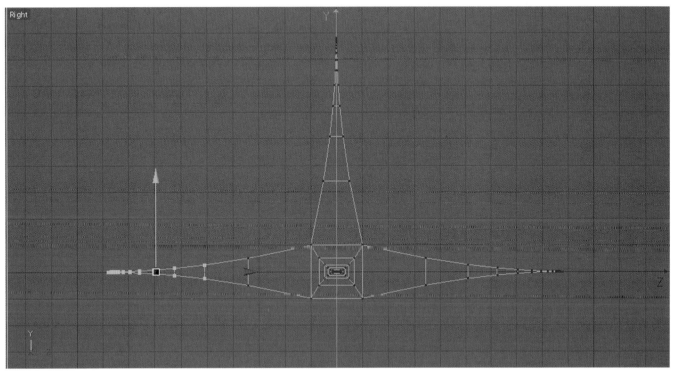

Figure ssmgextrude_06

Step 8 Back in the Perspective view, use the bridge tool to close the opening.
Figure ssmgextrude_07

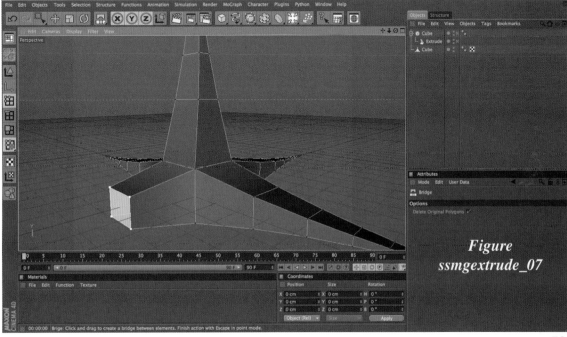

Figure ssmgextrude_07

73

Step 9 Use the Orthographic views to help you precisely select the points at the top of the upper spike and the points on the end of the left and right spikes *Figure ssmgextrude_08*

Figure ssmgextrude_08

Step 10 Activate the Move tool and enable Soft Selection. Using 700 cm as the Radius, drag these points back to make the proper shapes. You might want to turn off soft selection at this point. *Figuressmgextrude_09*

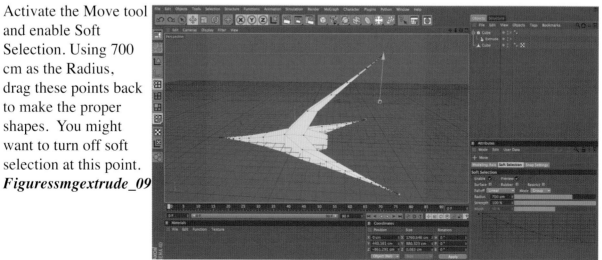
Figure ssmgextrude_09

Chapter 2: Under the Hood

Step 11 With the cube selected, Opt+click on a HyperNURBS to see how the mesh is coming along. Disable the HyperNURBS by clicking on the check to its right in the Object Manager. Switch to polygon mode, and select the back facing polygon. Press the I key to enable the Inner Extrude tool. Drag to create the new polygons. *Figure ssmgextrude_10*

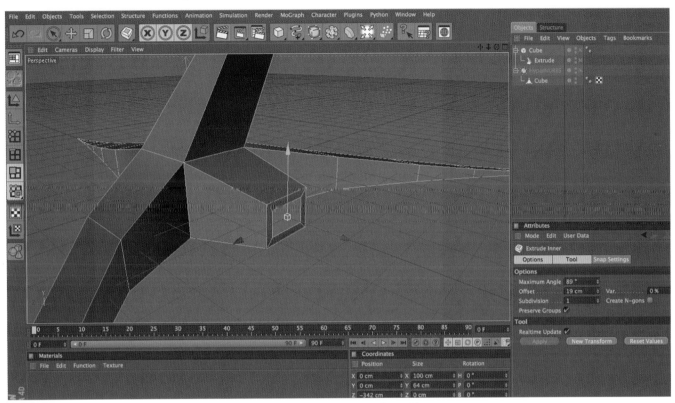

Figure ssmgextrude_10

Step 12 Now press the D key to activate the Extrude tool and extrude this polygon back into the model. Perform two extrusions to make higher detail. *Figure ssmgextrude_11*

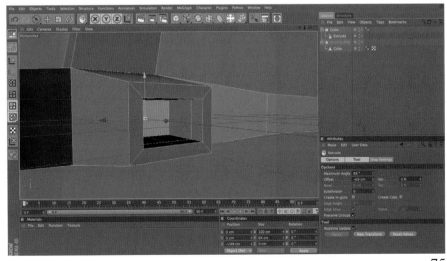

Figure ssmgextrude_11

Step 13 To Create the Windshield, select the top polygon in front of the top spike and then use the inner extrude tool. *Figure ssmgextrude_12*

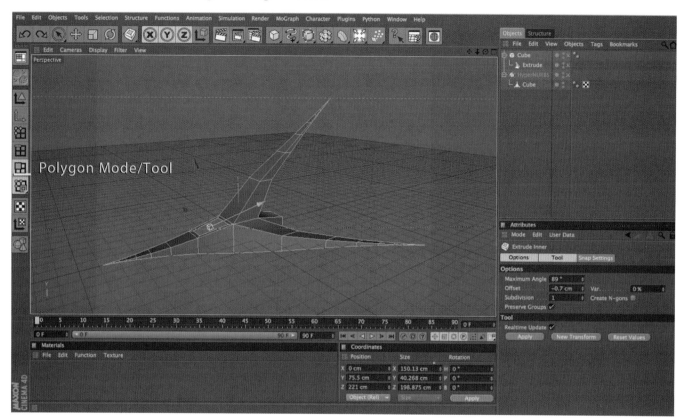

Figure ssmgextrude_12

Step 14 Press D to activate the Extrude tool and extrude this polygon 75 cm. *Figure ssmgextrude_13*

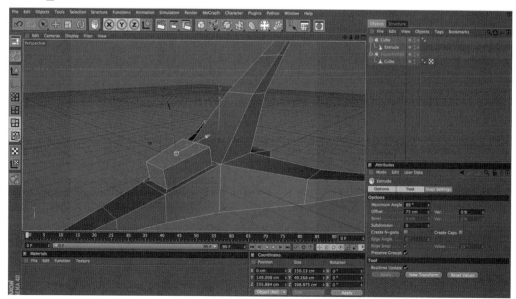

Figure ssmgextrude_13

Chapter 2: Under the Hood

Step 15 Activate the Scale tool and disable the Soft Selection. Use the Scale tool to scale this on the Y with the modeling axis set to 40%. Perform the scale until you get a shape similar to *Figure ssmgextrude_14*.

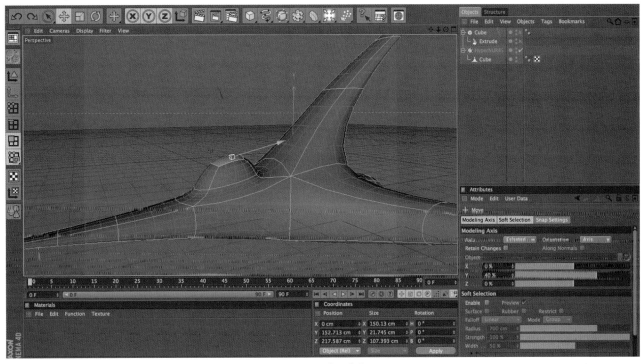

ssmgextrude_14

Step 16 In order to make the widshield slightly more sleek, use the Rotate tool and rotate the polygon about - 15 degrees using the X rotation band. *Figure ssmgextrude_15*

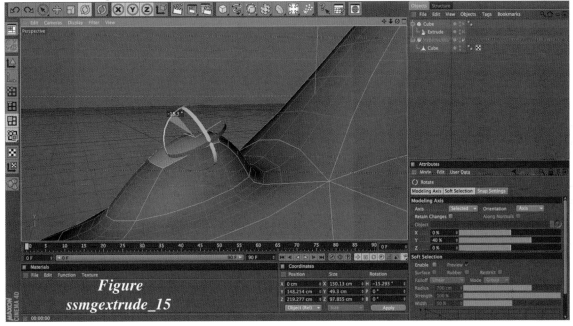

Figure ssmgextrude_15

CINEMA 4D: The Artist's Project Sourcebook, Third Edition

Step 17 Switch to Polygons and choose Select>Loop Select to select the polygons around the windshield and press the D key to extrude these polys back into the model -3 cm.
Figure ssmgextrude_16

Figure ssmgextrude_16

Step 18 Press the K key to pull up the knife tool and set its mode to Loop. Cut a new division at about 50% of this loop. *Figure ssmgextrude_17*

Figure ssmgextrude_17

Chapter 2: Under the Hood

Step 19 Select the large wing polys to each side of the windshield and set the Z size for these polys to 200 in the Coordinate Manager. *Figure ssmgextrude_18*

Figure ssmgextrude_18

Step 20 Press the I key to perform an Inner Extrude and set it to 30 cm. *Figure ssmgextrude_19*

Figure ssmgextrude_19

Step 21 Press the D key to Extrude these polys back into the model by - 120 cm
Figure ssmgextrude_20

ssmgextrude_20

Step 22 Loop Select the new polygons, use the Knife tool set to loop, and cut the new loops on each side of the wing to increase definition. Do this for both sides. *Figure ssmgextrude_21*

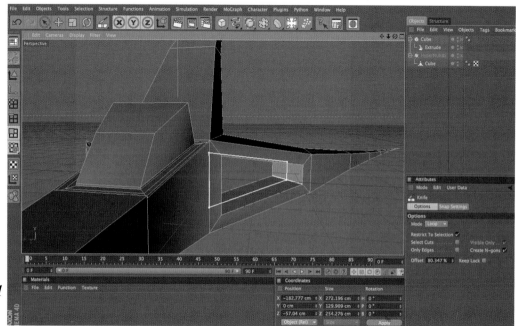

Figure ssmgextrude_21

Chapter 2: Under the Hood

Step 23 Select the back loop of polygons and use the Knife tool set to loop to cut a new loop close to the very back. *Figure ssmgextrude_22*

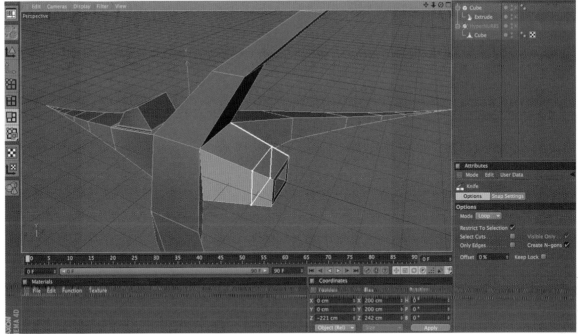

Figure ssmgextrude_22

Step 24 Double click in the Material Manager to create a new material in the Color Channel, set the color to R = 160, G = 0, B = 0. *Figure ssmgextrude_23*

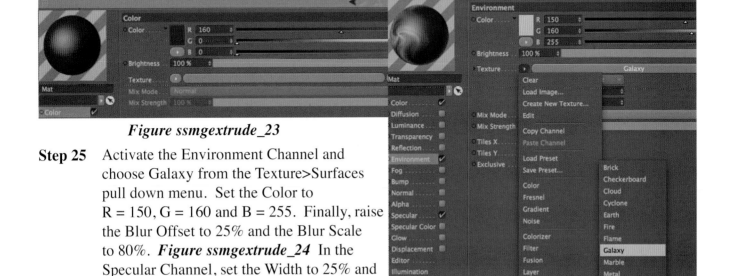

Figure ssmgextrude_23

Step 25 Activate the Environment Channel and choose Galaxy from the Texture>Surfaces pull down menu. Set the Color to R = 150, G = 160 and B = 255. Finally, raise the Blur Offset to 25% and the Blur Scale to 80%. *Figure ssmgextrude_24* In the Specular Channel, set the Width to 25% and the Height to 70%. Name this material Red Metal and drop it on the cube in the Object Manager.

Figure ssmgextrude_24

Step 26 Control+Drag on the Red Metal material and rename it, Metal. Set the Color to R = 230, G = 230, B = 255.
Figure ssmgextrude_25

Figure ssmgextrude_25

Step 27 In the Environment Channel, change the Mix Mode to Normal.
Figure ssmgextrude_26

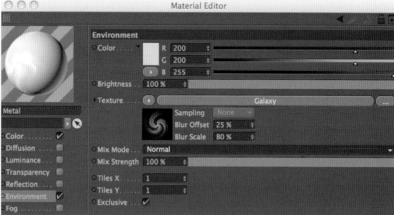

Figure ssmgextrude_26

Step 28 We'll need to create a selection set for this material. Use Loop Selection to select the polygons around the base of the windshield. Use the Selection>Grow selection to get the next loop of polys. Hold the Shift key as you loop select the polys on the back of the ship. Again, hold Shift and use Loop Selection to grab the very back-facing polygons as well as one loop on the inside of the exhaust port. Finally, go to the front of the ship and select the loop two down from the windshield and select the remaining polys all the way to the point of the nose.
Figure ssmgextrude_27

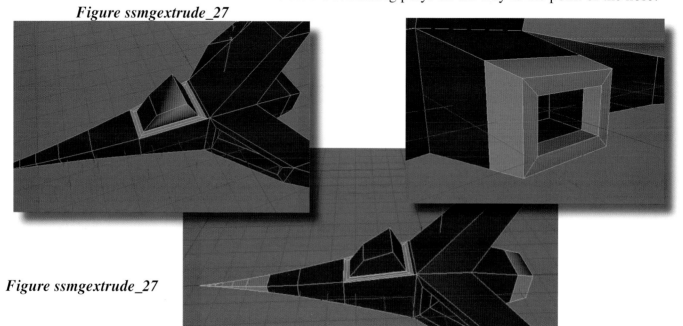

Figure ssmgextrude_27

Chapter 2: Under the Hood

Step 29 With all of these polygons selected, drag the new Metal material and drop it on any of the highlighted polys in the viewport to make a new selection set. *Figure ssmgextrude_28*

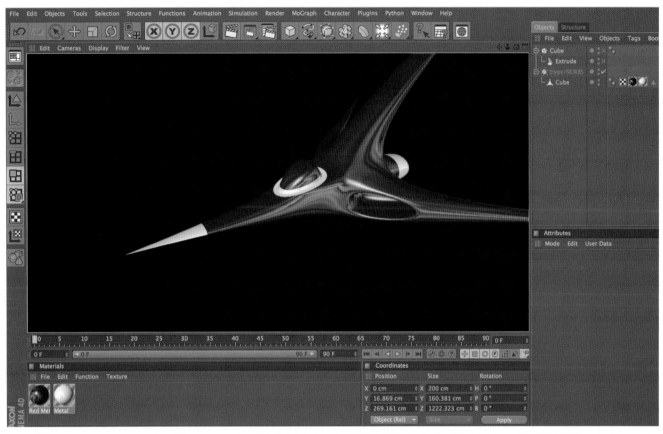

Figure ssmgextrude_28

Step 30 Create a new material and rename it Glow. In the Color Channel, set R = 160, G = 185, and B = 255. Activate the Luminance Channel and set its color to the same. Lastly, activate the Glow channel.
Figure ssmgextrude_29

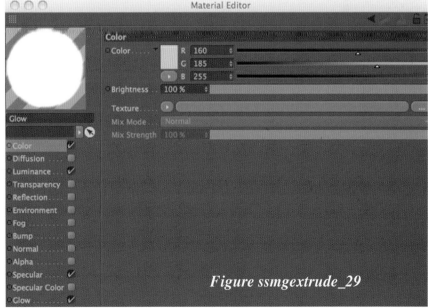

Figure ssmgextrude_29

83

Step 31 Select the inner two rows of the front wing indentions and the inside loops within the back exhaust. *Figure ssmgextrude_30*

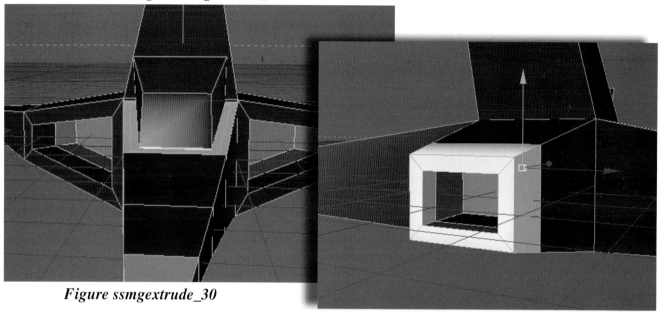

Figure ssmgextrude_30

Step 32 Drag the Glow material and drop it on any of the highlighted polygons and that will become a new selection set. *Figure ssmgextrude_31*

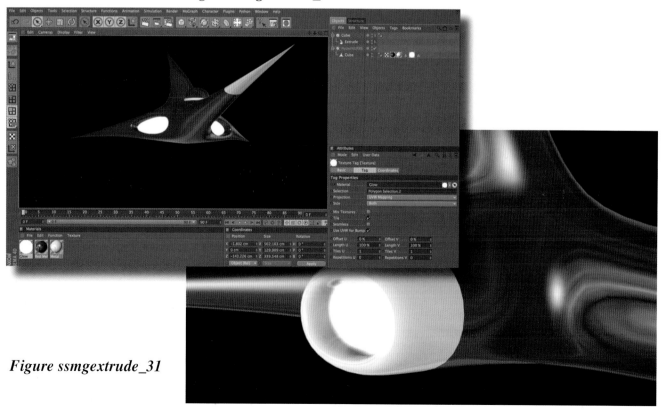

Figure ssmgextrude_31

Chapter 2: Under the Hood

Step 33 Create another material and name it Windshield. Turn off the Color Channel and activate the Environment Channel. Click on the Texture drop down and choose Surfaces>Starfield. In the Specular Channel, set the Width to 50% and the Height to 65%.
Figure ssmgextrude_32

Step 34 Select the loop of polygons at the base of the windshield and then select the remaining polygons at the top. Drag the new Windshield material and drop it on the orange selected polys in the viewport
Figure ssmgextrude_33

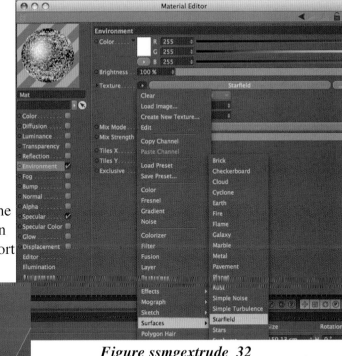

Figure ssmgextrude_32

Figure ssmgextrude_33

Step 35 Now we'll light the engine for the ship. Add a light and drag it back to Z = 325 so that it rests in the exhaust port. Set the Color to R = 190, G = 180 and B = 255.
Set the Visible Light to Volumetric.
Figure ssmgextrude_34

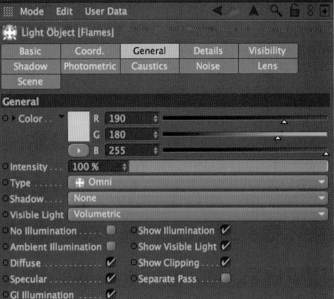

Figure ssmgextrude_34

Step 36 In the Visibility Tab, set the Inner Distance to 36 and Outer Distance to 70. For the Relative Scale values, Lower the Y Scale to 70% and raise the Z Scale to 500%. Increase the Brightness to 305%, the Dust to 40% and Dithering to 70%. *Figure ssmgextrude_35*

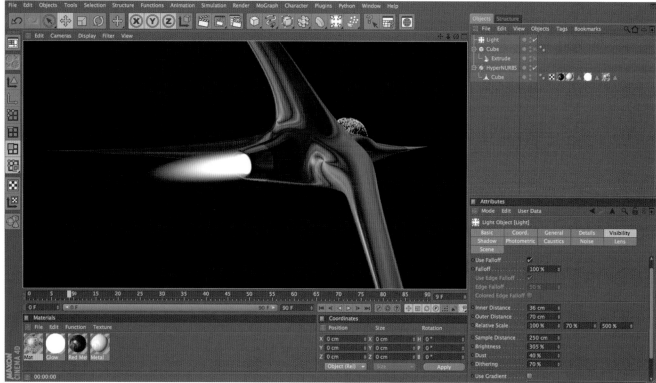

Figure ssmgextrude_35

Step 37 Go to the Noise Channel and set it to Both, Type to Hard Turbulence, Velocity 225%, Brightness 50% and change the Wind to 0,0, -20.
Figure ssmgextrude_36
Rename this light, Flames, and drop it as a child of the cube.

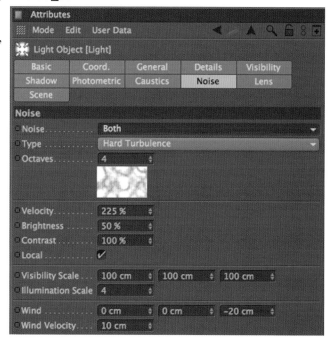

Figure ssmgextrude_36

Chapter 2: Under the Hood

Step 38 Create a new light and name it, Ship Light. Set its colors as R = 220, G = 220, B = 255 and position the light at P.Z = 15,000.
Figure ssmgextrude_37

Step 39 Create a Sky object and make a new material. In the Color Channel, click on the Texture drop down and choose Surfaces>Starfield. Choose Copy Channel and paste it into the Luminance Channel. Turn off the Specular Channel. Place this texture on the Sky object.
Figure ssmgextrude_38

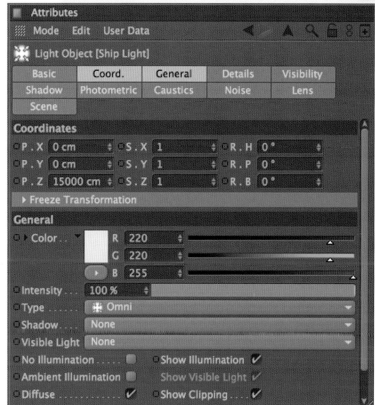

Figure ssmgextrude_37

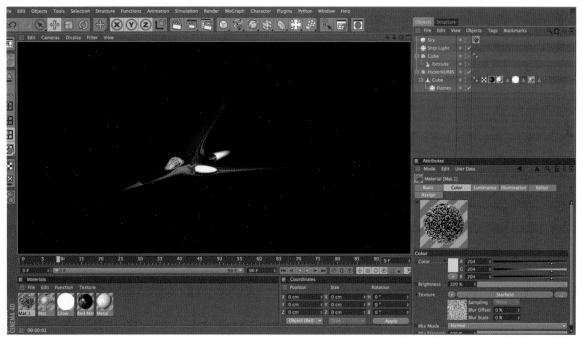

Figure ssmgextrude_38

Step 40 Later we'll use this ship for an animation and add pyroclusters to create a vapor trail behind the ship. For a still image, set the size that you wish and turn Anti-Aliasing to Best. Add Ambient Occlusion from the Effects drop down and render out the final still. You may also want to select the HyperNURBS and raise the Subdivision Renderer to 4.
Figure ssmgextrude_39

Figure ssmgextrude_39

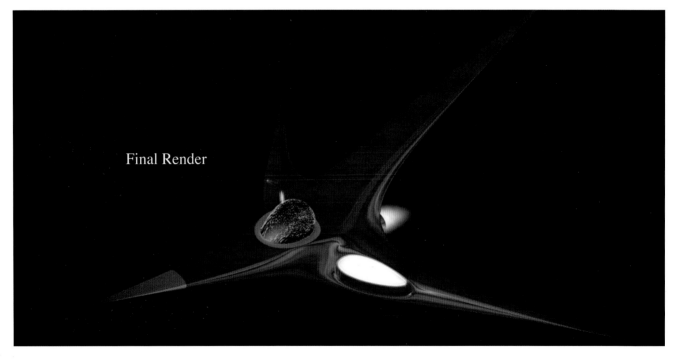

Final Render

Chapter 3: NURBS Modeling

NURBS Modeling Tools

3

It's time to explore CINEMA 4D's powerful NURBS modeling tools, all but one of which create new geometry by making a spline or splines a child of the NURBS modeling object. The splines inside this generator define certain profiles of the object and may be changed at any time, giving you an amazing amount of editing capabilities. Be sure to check out the Advanced Modeling exercises on the DVD, where you will see most of these objects used together to create the scene shown above.

Note: You may find that the Axis handles get in the way as you add and manipulate points and handles during spline editing. Click on the Filter tab and click the check next to Axis Handles to hide them in the viewport.

3D 101: The Vase

Step 1 Choose the Linear Spline tool from the Create Splines pull down. **Figure Vase_01**

Figure Vase_01

89

Step 2 Switch to the Front view (F4) and click to add points in the order and locations listed in *Figure Vase_02*. You can go back after completing the shape and move the points to the exact location by selecting them and setting their position values in the Coordinates Manager below the viewport.

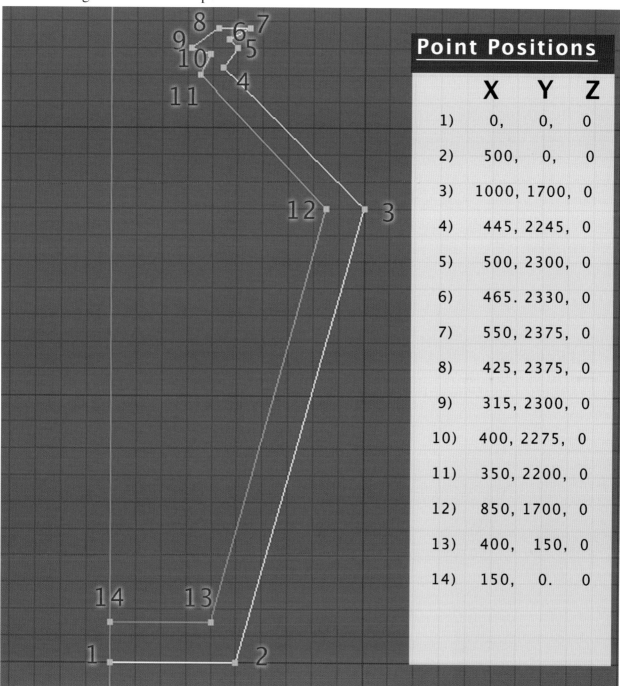

	X	Y	Z
1)	0,	0,	0
2)	500,	0,	0
3)	1000,	1700,	0
4)	445,	2245,	0
5)	500,	2300,	0
6)	465.	2330,	0
7)	550,	2375,	0
8)	425,	2375,	0
9)	315,	2300,	0
10)	400,	2275,	0
11)	350,	2200,	0
12)	850,	1700,	0
13)	400,	150,	0
14)	150,	0.	0

Figure Vase_02

Chapter 3: NURBS Modeling

Step 3 Select points 3 through 12 and go to Structure>Edit Spline>Soft Interpolation.
Figure Vase_03

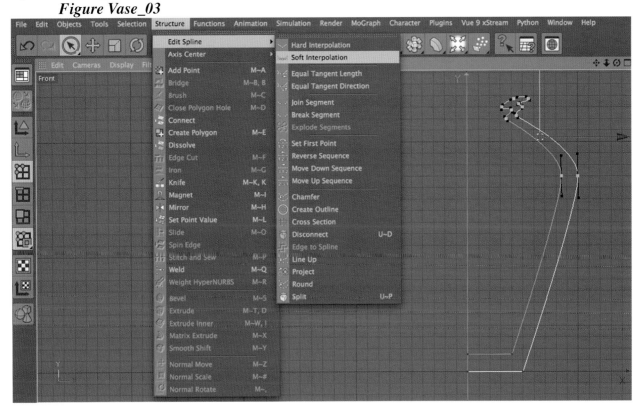

Figure Vase_03

Step 4 Press F1 to go to the Perspective view. With the Spline selected, hold the Option (Alt PC) key as you add a Lathe NURBS from the NURBS menu. *Figure Vase_04*

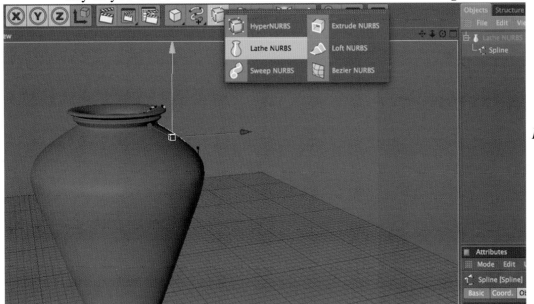

Figure Vase_04

Step 5 Select the Lathe NURBS to view its parameters in the Attribute Manager. In the NURBS Object tab, set the Subdivision to 108. ***Figure Vase_05***

Step 6 Now it's time to add a material. In the Material Manager, choose File>Shader>Mabel. ***Figure Vase_06***

Figure Vase_06

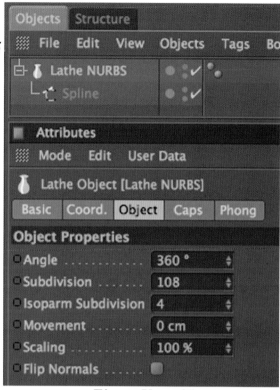

Figure Vase_05

Step 7 Drag the material onto the Lathe NURBS object in the Object Manager. Double click the material in the Materials Manager. You will have two channels of surfacing to control this shader. The first is surface A, which holds our white veining. Set its illumination to 120%. ***Figure Vase_07***

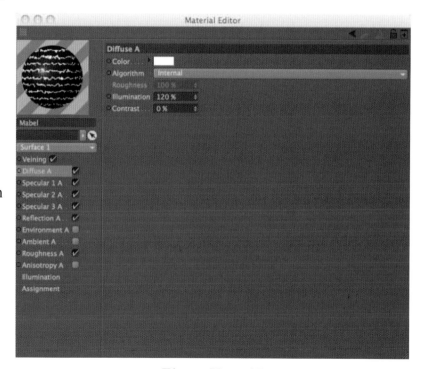

Figure Vase_07

Chapter 3: NURBS Modeling

Step 8 Click on the veining parameter. Change the Veining Turbulence to Displaced Turbulence. Set the Veining Stirring to 64%, the Veining Scale to 25%, Veining Octaves 20, Veining Size 10%, Veining Contrast 60%, Variance Octaves to 20 and Variance Scale to 50%. Finally, set the Seed value to 0.
Figure Vase_08

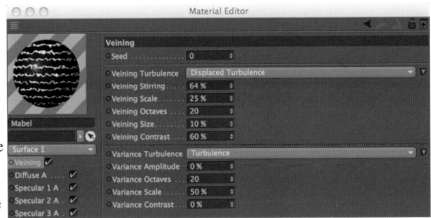

Figure Vase_08

Step 9 Click on the Reflection A Channel and raise the Intensity to 25%.
Figure Vase_09

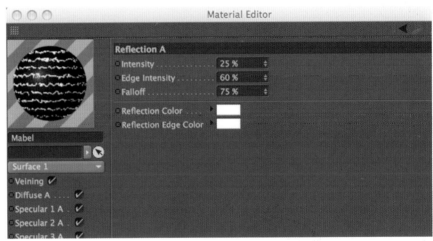

Figure Vase_09

Step 10 Add a Sky object.
Figure Vase_10

Figure Vase_10

Step 11 In the Material Manager, choose File>Load Material Preset>Prime>Materials>HDRI> HDRI026. *Figure Vase_11*

Figure Vase_11

Step 12 Place this material onto the Sky object. *Figure Vase_12*

Figure Vase_12

Chapter 3: NURBS Modeling

Step 13 We only want to use this image to cast a reflection onto the vase. To limit its visibility, Right click on the Sky object and choose CINEMA 4D Tags>Compositing. *Figure Vase_13*

Step 14 Click on the Compositing tag to the right of the Sky object in the Object Manager. Uncheck Receive Shadows and Seen by Camera. *Figure Vase_14*

Figure Vase_13

Figure Vase_14

Step 15 Add a Light to the scene. In the Coordinates tab, position the light to P.X 2000, P.Y 4500, P.Z -2800. In General tab, set the Color to R 245, G 225, and B 210. Set the Intensity to 90% and the Shadow to Area.
Figure Vase_15

Figure Vase_15

Step 16 Click on the Details tab, and set the Falloff to Inverse Square (Physically Accurate) with a Radius/Decay of 6000. *Figure Vase_16*

Figure Vase_16

Chapter 3: NURBS Modeling

Step 17 In the Shadow tab, set the Color to a dark red, almost black. Lower the Density to 50%. *Figure Vase_17*

Figure Vase_17

Step 18 To get the most out of this object, we should add a flooring for shadow reception. Add a Plane primitive and set its Width to 35000 and Height to 25000. Set its position to P.Z 7000. *Figure Vase_18*

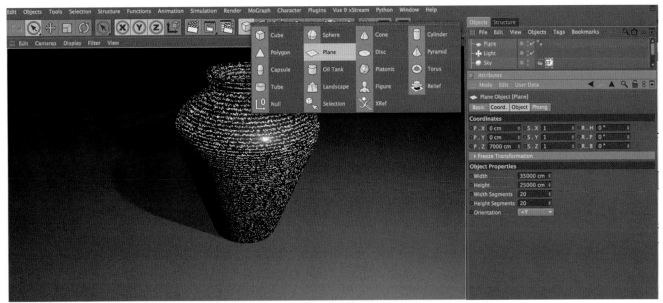

Figure Vase_18

Step 19 Now add a material to floor by choosing File> Load Material Preset>Prime>Basics> Wood 006. *Figure Vase_19*

Step 20 Double click on the material thumbnail to pull up its channels. Enable the Reflection Channel and set its Brightness to 13%. *Figure Vase_20*

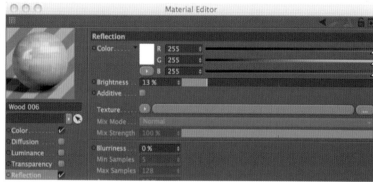

Figure Vase_20

Step 21 Drag the Wood 006 material onto the Plane object. In the Attribute Manager, set the Length U and Length V to 15% each. *Figure Vase_21*

Figure Vase_21

Chapter 3: NURBS Modeling

Step 22 Open the Render Settings and change the Anti-Aliasing from Geometry to Best.

Figure Vase_22

Figure Vase_22

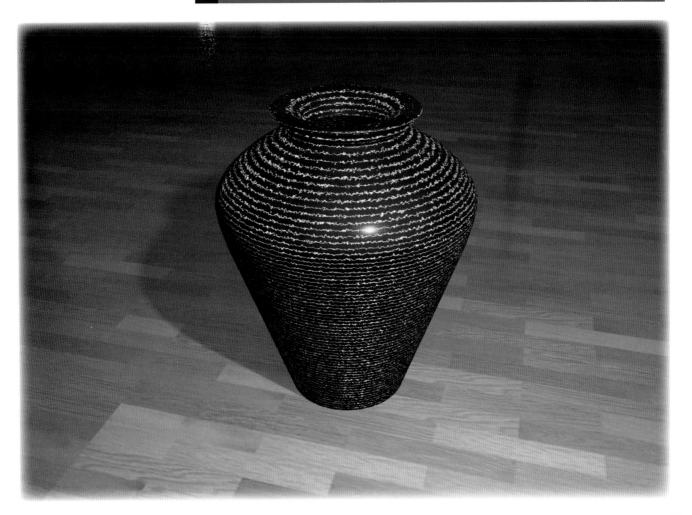

 CINEMA 4D: The Artist's Project Sourcebook, Third Edition

Skull Mask Extrude

This scene is an example of pulling in paths from Illustrator to use in conjuction with CINEMA 4D's NURBS modeling tools in order to build 3D shapes. Note that when saving the Illustrator files, you must choose to save them as Illustrator 8 files for them to be readable by C4D. Once saved in this fashion, they do not need any special importing. Simply open CINEMA 4D and choose Open from the File menu. It will recognize the Illustrator 8 file and open it. Remember that the paths saved from Illustrator are two dimensional and will not render without being placed as a child of a NURBS object.

Step 1 Open the Skull_Mask_Extrude file located in the NURBS Modeling folder of the disk. *Figure Skull_01*

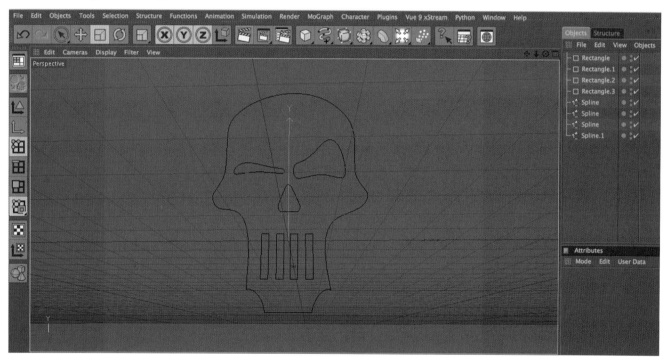

Figure Skull_01

Chapter 3: NURBS Modeling

Step 2 You will find several spline shapes within the Object Manager. Turning these shapes into 3D objects simply requires an Extrude NURBS. The hiccup in this workflow is that we need certain elements (eyes, nose and mouth) to be cut out of the skull shape. In order for this to work, we will need to connect the splines into one shape. All of the splines must be editable shapes for this to work. Select the Rectangle objects at the top of the Object Manager and press the Make Editable Button on the top left toolbar. *Figure Skull_02*

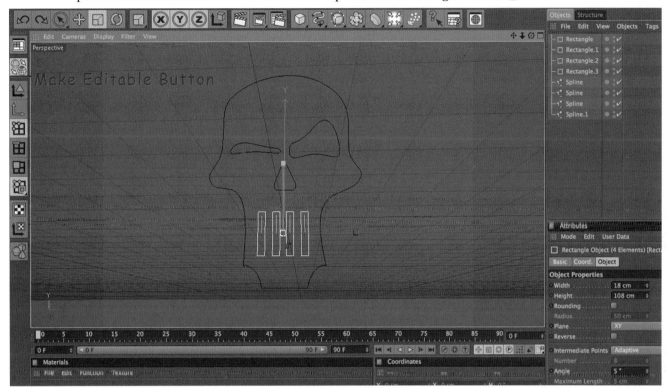

Figure Skull_02

Step 3 Select all of the spline shapes and choose Functions>Connect+Delete. *Figure Skull_03*

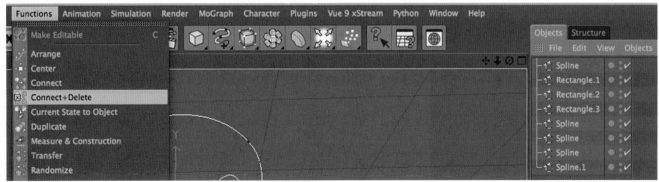

Figure Skull_03

101

Step 4 Select the new shape, hold the Option (Alt key PC) and add an Extrude NURBS from the NURBS menu. *Figure Skull_04*

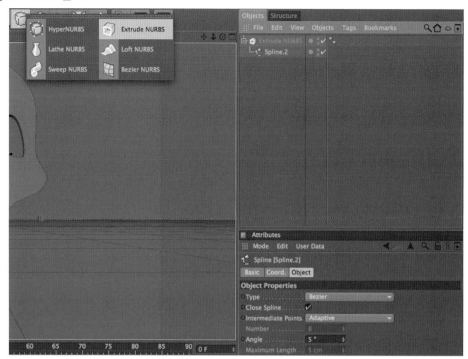

Figure Skull_04

Step 5 Add a light. Set the P.Y to 225, P.Z to 40 and set the Heading Rotation to 180 degrees. Set the Type to Square Parallel Spot and the Visible Light to Volumetric. *Figure Skull_05*

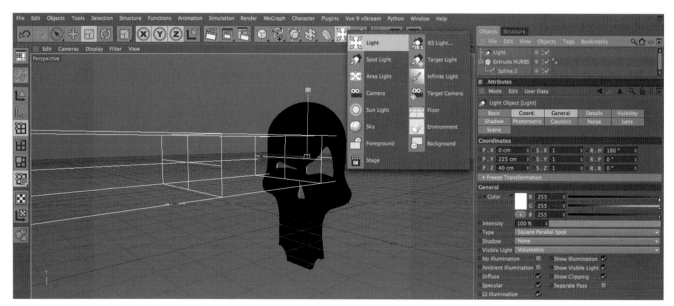

Figure Skull_05

Chapter 3: NURBS Modeling

Step 6 In the Details tab, set the Outer Radius to 155, Aspect Ratio 0.45 and Falloff to Linear with a Radius/Decay value of 500.
In Visibility, check Use Falloff and Use Edge Falloff. Both values should be 100%.
Set the Inner Distance to 120 and Outer Distance to 950.
Set the Sample Distance to 15 and raise the Brightness to 200% and Dithering to 100%.
Figure Skull_06

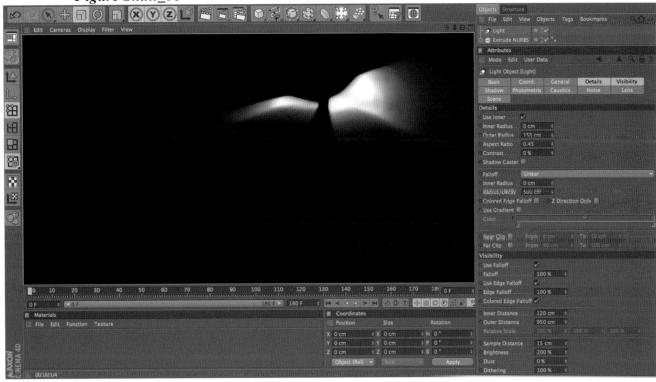

Figure Skull_06

Step 7 Control+Drag on the Light to duplicate it. Set the P.Y to 107. In the Details tab, lower the Outer Radius to 35, and change the Aspect Ratio 1.15. *Figure Skull_07*

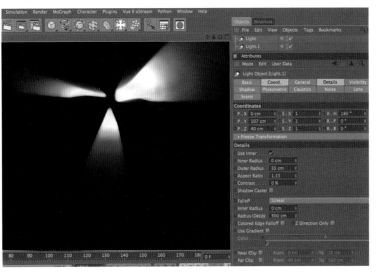

Figure Skull_07

103

Step 8 Control+Drag on the second light to duplicate it. Set the P.Y to -35. In Details, set the Outer Radius to 72 and change the Aspect Ratio to 0.85. *Figure Skull_08*

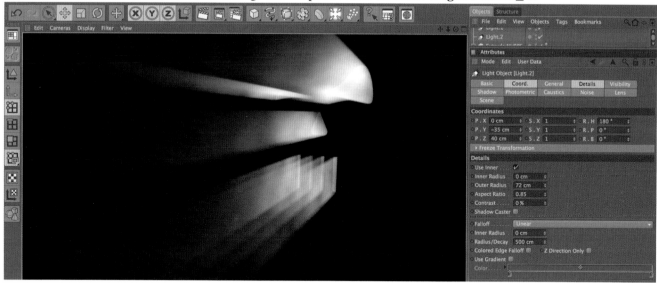

Figure Skull_08

Step 9 Select the three lights and press Option (Alt PC)+G to group the lights. Rename the Null, Lights.
Figure Skull_09

Figure Skull_09

Step 10 Below the timeline, change the end Frame from 90 to 180. *Figure Skull_10*

Figure Skull_10

Chapter 3: NURBS Modeling

Step 11 Rename the lights according to their position: Eye Light, Nose Light, Mouth Light.

Step 12 For the Eye Light, scroll to Frame 0, and set the Heading Rotation to - 12.75 degrees. Click on the H to highlight it and then Control click on the R to its left. *Figure Skull_11*

Figure Skull_11

Step 13 Select the Nose Light, and set a keyframe with an R.H value of - 15 degrees. *Figure Skull_12*

Figure Skull_12

105

Step 14 Select the Mouth Light, and set a keyframe at 0 with an R.H of - 20 degrees. *Figure Skull_13*

Step 15 Scroll to Frame 180, set the R.H to 15 degrees and set another keyframe for the Mouth Light. *Figure Skull_14*

Figure Skull_13

Figure Skull_14

Step 16 At Frame 180, set the R.H to 15 degrees and set a keyframe for the Nose Light as well. *Figure Skull_15*

Figure Skull_15

Chapter 3: NURBS Modeling

Step 17 Finally, set a keyframe for the Eye Light's R.H to 15 degrees at Frame 180. *Figure Skull_16*

Figure Skull_16

Step 18 With the animation set for the rotation, now we will focus on the brightness of the lights.
Select all three lights, and in the Visibility tab, set a keyframe at Frame 120 for 950 in the Outer Distance and set the Brightness to 200%. *Figure Skull_17*

Figure Skull_17

Step 19 Scroll to Frame 0, and set the Outer Distance to 0 and the Brightness to 0%. *Figure Skull_18*

Figure Skull_18

Step 20 Scroll to Frame 180 and set keyframes for these same parameters and values. *Figure Skull_19*

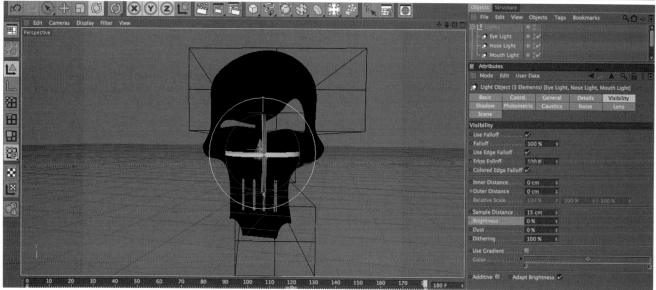

Figure Skull_19

Chapter 3: NURBS Modeling

Step 21 In the Render Settings, set the Anti-aliasing to Best and the Min Level to 2 x 2.
Figure Skull_20

Figure Skull_20

Creating a Shovel with a Bezier NURBS

Step 1 Add a Bezier NURBS object to the new scene *Figure beziershovel_01*

Figure beziershovel_01

Step 2 Set the Subdivision X to 15, leave the remaining parameters at default.
Figure beziershovel_02

Figure beziershovel02

Step 3 Press F4 to pull up the Front view. Switch to Points and move the upper Right control point out to P.X 600. *Figure beziershovel_03*

Figure beziershovel_03

Chapter 3: NURBS Modeling

Step 4 Grab the left top control point and drag it to P.X - 600. *Figure beziershovel_04*

Figure beziershovel_04

Step 5 Press F1 to return to the Perspective View. Select all three top control points and set their position to P.Y - 250, P.Z 185. *Figure beziershovel_05*

Figure beziershovel_05

111

Step 6 Select the top center control point and move it to P.Y 300, P.Z 2000. *Figure beziershovel_06*

Figure beziershovel_06

Step 7 Select the bottom three control points and set their X size down to 200 in the Coordinates Manager. Set the Y position of these points to an even - 400. *Figure beziershovel_07*

Figure beziershovel_07

Chapter 3: NURBS Modeling

Step 8 Add a Cylinder primitive to the scene. Set the Radius to 47, Height to 3000 and enable the Fillet with a Radius of 47 for the Cap. In the Coordinates tab, set the position to P.Y - 1466, P.Z - 857 and correct the rotation to R.P - 32.5. *Figure beziershovel_08*

Figure beziershovel_08

Step 9 With the handle in place, select the outside bottom points of the bezier and move them to wrap around the handle. *Figure beziershovel_09*

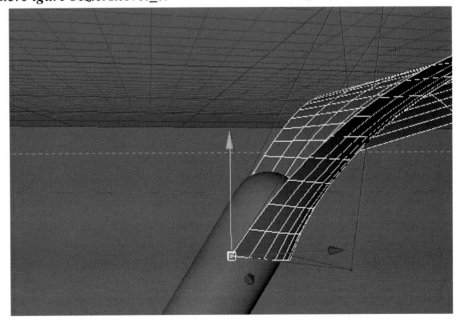

Figure beziershovel_09

Step 10 In the Material Manager, choose File>Load Material Preset>Prime>Materials>Basic> Wood 001. Drag this and drop it onto the Cylinder. *Figure beziershovel_10*

Figure beziershovel_10

Step 11 In the Material Manager, choose File>Load Material Preset>Visualize>Materials> Metal>Metal - Iron Painted Blue. Drag and drop this material onto the Bezier NURBS. *Figure beziershovel_11*

Figure beziershovel_11

Chapter 3: NURBS Modeling

Step 12 Finally, to smooth the Bezier and give it thickness, select the Bezier NURBS, hold the Option key (Alt key PC) and add a Cloth NURBS from the Simulation>Cloth menu.
Figure beziershovel_12

Figure beziershovel12

Step 13 In the parameters of the Cloth NURBS, set the Subdivisions to 0 and the Thickness to 4.
Figure beziershovel_13

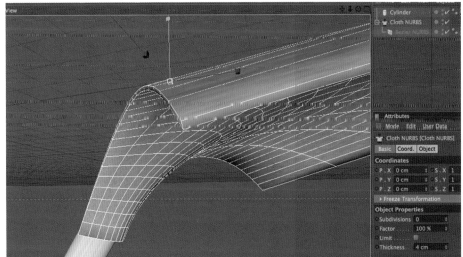

Figure beziershovel_13

Step 14 With the Cloth NURBS selected, hold the Option (Alt PC) key and add a HyperNURBS. In the HyperNURBS, set the Subdivision Editor to 3. *Figure beziershovel_14*

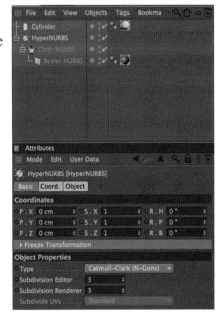

Figure beziershovel_14

115

Step 15 Add a Sky object. *Figure beziershovel_15*

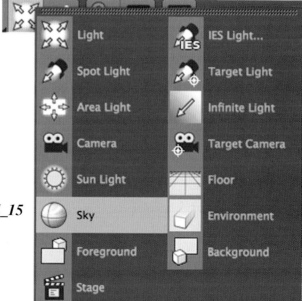

Figure beziershovel_15

Step 16 In the Material Manager, choose File>Load Material Preset>Prime>Materials>HDRI>HDRI 001. *Figure beziershovel_16*

Figure beziershovel_16

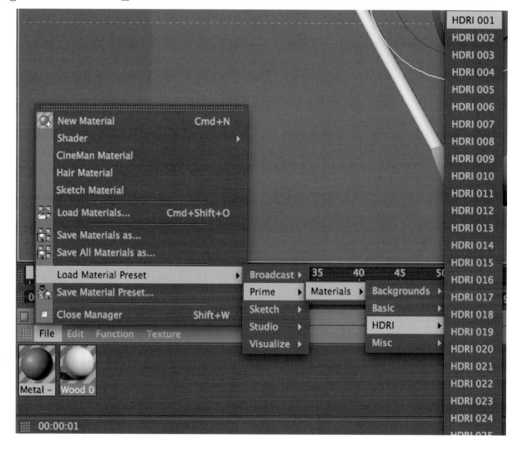

Chapter 3: NURBS Modeling

Step 17 We don't want the Sky object to render. Right click on the Sky object and choose CINEMA 4D Tags>Composite Tag. *Figure beziershovel_17*

Step 18 In the Composite tag, uncheck Seen by Camera and Receive Shadows.

Figure beziershovel_17

Step 19 Open the Render Settings, under Effects, and turn on Global Illumination. Change the GI mode to Sky Sampler and render the scene. *Figure beziershovel_18*

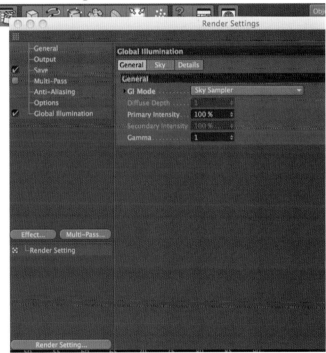

Figure beziershovel_18

If you like, select HyperNURBS group and the Cylinder, press Option (Alt PC)+ G to group. Rename the group, Shovel. You can then rotate the Shovel group to the orientation you prefer for rendering.

Final Render

117

CINEMA 4D: The Artist's Project Sourcebook, Third Edition

Deformers and the modeling helpers available in CINEMA 4D are not only great for helping us build models, but to animate them as well. Powerful modeling objects such as Booles, allow users to control how objects relate to one another to create complex models from simple shapes. In this chapter we'll look at how you can take your modeling skills up a notch using these in combination.

Bend and Boolean Lock Project

Step 1 Add an n-Side object. Set it's sides to 6. Enable Rounding and set the Radius to 97. Change the Plane to XZ. Set the Intermediate Points to Subdivided.
Figure BB_Locks_01

Figure BB_Locks_01

Step 2 With the n-Side object selected, add an Extrude NURBS. Set the Movement to 0, 300 and 0. Raise the Subdivisions to 10. In the Caps tab, set the Type to Quadrangles with Regular Grid enabled and set at a Width of 20. *Figure BB_Locks_02*

Figure BB_Locks_02

Step 3 That concludes the base of the lock; now create a Cylinder for the latching mechanism. Set its Radius to 20 and Height to 750. The segments should be increased to 55 for the Height and 72 for the Rotation. In the Coordinates tab, set the position to P.X 80, P.Y 400. *Figure BB_Locks_03*

Figure BB_Locks_03

Step 4 With the Cylinder selected, hold the Shift key and drop a Bend deformer into the scene. Move the Bend to P.X 0, P.Y 135 and set the Strength and Angle to 180 degrees each. Check the Keep Y-Axis Length box. *Figure BB_Locks_04*

Figure BB_Locks_04

Step 5 Switch to the Front View (F4). Add a Circle spline set to a Radius of 25 and a Y position of 225. *Figure BB_Locks_05*

Figure BB_Locks_05

Chapter 4: Deformers and Other Modeling Helpers

Step 6 Follow up by adding a Rectangle spline with a Width of 50 and Height of 100. Move it up on the Y axis to P.Y 170. *Figure BB_Locks_06*

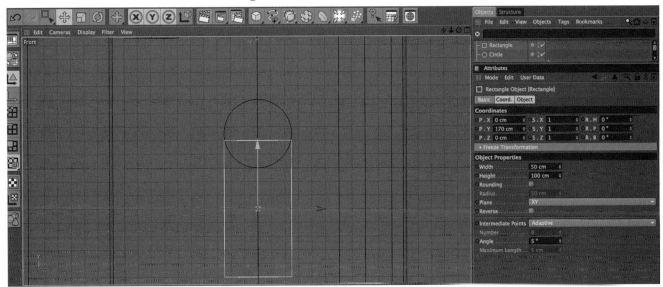

Figure BB_Locks_06

Step 7 Make the Rectangle editable by clicking the C key. Switch to points and use the Live Selection tool to select the top two points. In the Coordinates Manager, set their X Size to 25 and position them at P.Y 35 in the Coordinates Manager. *Figure BB_Locks_07*

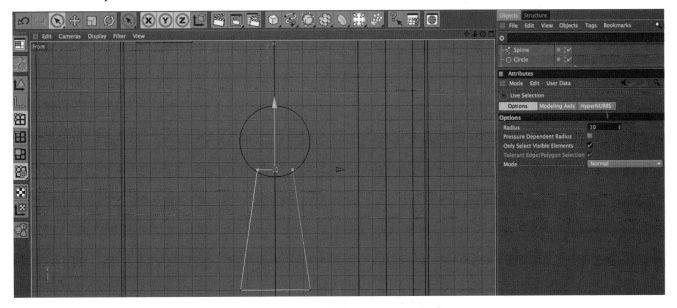

Figure BB_Locks_07

Step 8 Add a Spline Mask from the Modeling menu and drop the Rectangle and Circle splines as children of the Mask. *Figure BB_Locks_08*

Figure BB_Locks_08

Step 9 With the Spline Mask selected, hold the Option (Alt PC) key and add an Extrude NURBS. Raise the Z Movement to 80 and rename it Keyhole Extrude NURBS. Move it into place by setting its P.Z to 100.
Figure BB_Locks_09

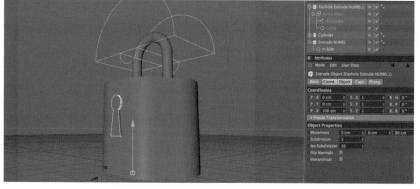

Figure BB_Locks_09

Step 10 Add a Boole object to the scene and drop both the Extrude NURBS and Keyhole Extrude NURBS groups into the Boole. The Keyhole Extrude NURBS should be at the bottom of Boole. *Figure BB_Locks_10*

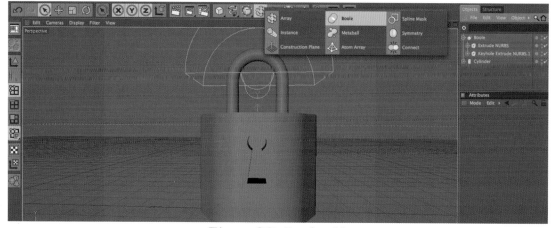

Figure BB_Locks_10

Chapter 4: Deformers and Other Modeling Helpers

Step 11 For the materials, we will begin with an existing preset. In the Material Manager, choose File>Load Material Preset>Visualize>Metal>Metal-Lead. ***Figure BB_Locks_11***
If you don't have access to these presets, use a dark gray material with a Noise shader in the Bump and a slight reflection.

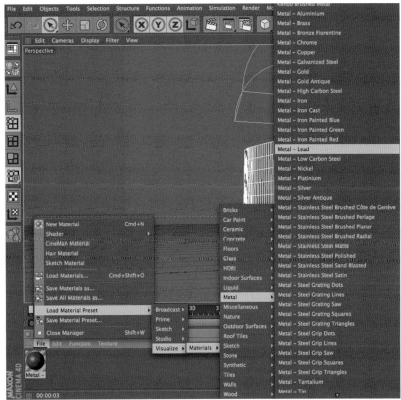

Figure BB_Locks_11

Step 12 Drop the Metal-Lead mat onto the Cylinder and the Extrude NURBS object within the Boole. ***Figure BB_Locks_12***

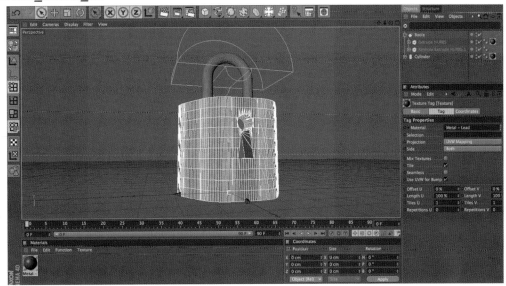

Figure BB_Locks_12

123

Step 13 Control+Drag a copy of the Mctal-Lead material and rename the copy Keyhole Mat. Double click it to open its settings and lower the Brightness parameter to 20%.
Figure BB_Locks_13

Figure BB_Locks_13

Step 14 Drag this material onto the Keyhole Extrude NURBS. *Figure BB_Locks_14*

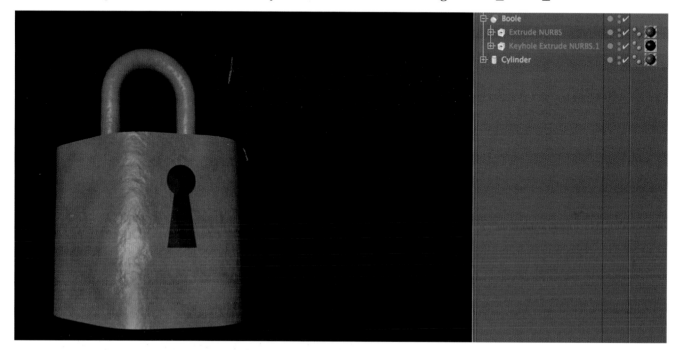

Figure BB_Locks_14

Chapter 4: Deformers and Other Modeling Helpers

Step 15 Finally, add a light to the scene. Enable Shadows set to Shadow Maps (Soft). In the Coordinates tab, place the light at P.X 20000, P.Y 500, P.Z 10000. *Figure BB_Locks_15*

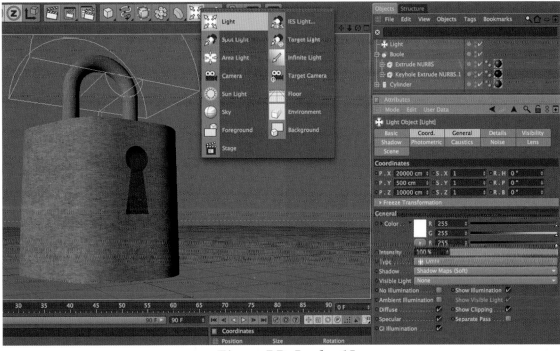

Figure BB_Locks_15

Step 16 In the Shadow tab, set the Shadow Density to 30% and raise the Shadow Map to 2000x2000. *Figure BB_Locks_16*

Figure BB_Locks_16

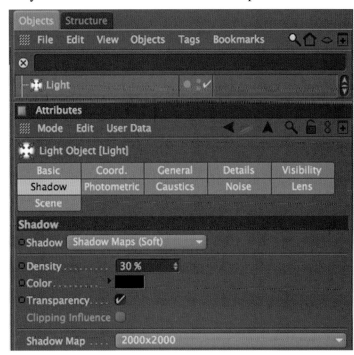

125

Step 17 In the Render Settings, turn on Ambient Occlusion listed under Effects to darken the areas of the surface that should receive the most shadow. *Figure BB_Locks_17*

Figure BB_Locks_17

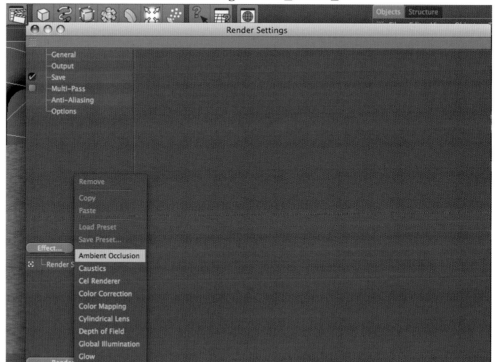

Final Render

To shine up the metal, add some kind of background photo to the Environment Channel of the material.

Chapter 4: Deformers and Other Modeling Helpers

Wind Deformer Flag

Step 1 Add a Plane primitive to the new scene. For its parameters, set the Width to 400 m, Height to 180, with 1 Width Segment and 2 Height Segments. Set the Orientation to +Z.
Figure Flag_01

Figure Flag_01

Step 2 Press the C key to make it editable and go into Points.

127

Step 3 Select the 3 right points and set their Y size to 50 in the Coordinates Manager.
Figure Flag_02

Figure Flag_02

Step 4 Select the center right point and move it to P.X 115.
Figure Flag_03

Figure Flag_03

Chapter 4: Deformers and Other Modeling Helpers

Step 5 Rename the Plane, Flag. Choose Functions>Subdivide and set the subdivision level to 3. *Figure Flag_04*

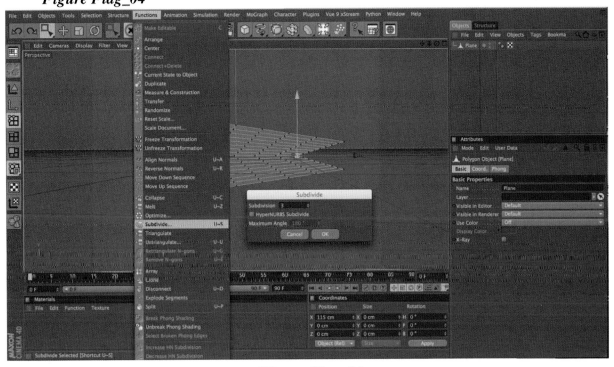

Figure Flag_04

Step 6 With the Flag selected, hold the Shift key and add a Wind Deformer. Set its parameters to: Amplitude 18, Size 100, Frequency 5.86, Turbulence 59%, fx 2.04, fy 4.48. Set its Position to P.X - 250. *Figure Flag_05*

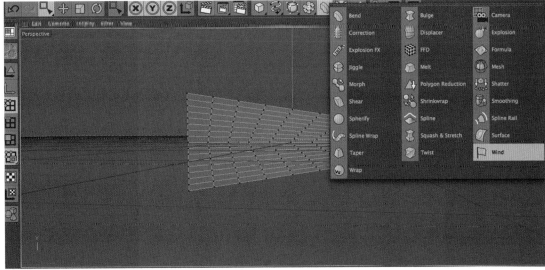

Figure Flag_05

Step 7 Double click in the Material Manager to create a new material. In the Color Channel, choose the texture drop-down and choose, Surfaces>Checkerboard.
Figure Flag_06

Figure Flag_06

Step 8 In the Bump Channel, click on the texture drop-down and choose Surfaces>Tiles.
Figure Flag_07

Figure Flag_07

Chapter 4: Deformers and Other Modeling Helpers

Step 9 Click on the Tile bar. Set all of the Tile colors to white. Set the Grout Width to 1% and the Bevel Width to 2%. Set the U and V scales to 10% each. Finally, back out into the main Bump Channel parameters and set the strength to 2%. *Figure Flag_08*

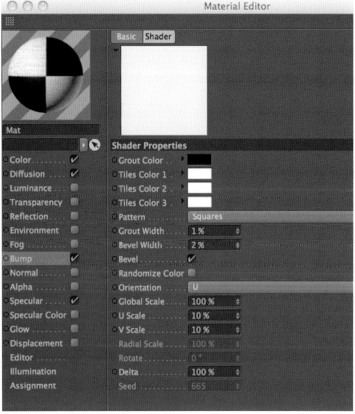

Step 10 In the Specular Channel, Set the Width to 45% and the Height down to 10%. Drag the material onto the Flag object.

Step 11 Deactivate the Wind Deformer by clicking on its checkbox in the Object Manager. Click on the checkerboard texture tag. Choose Cubic for the Projection.
Figure Flag_09

Figure Flag_08

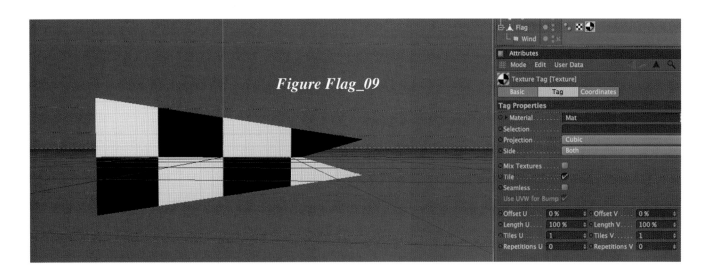

Figure Flag_09

Step 12 In order for the material to stay intact on the model during animation, you must right click on the Plane and choose CINEMA 4D tags, Stick Texture. *Figure Flag_10*

Figure Flag_10

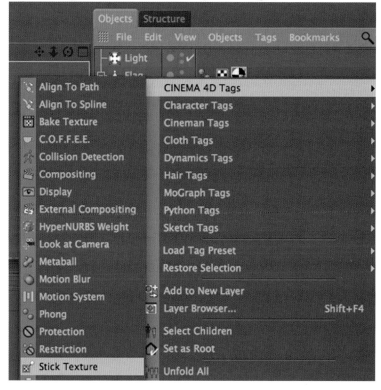

Step 13 Select the Flag object, and hold the Option (Alt PC) key as you add a HyperNURBS.

Step 14 Add a Sky background to see the flag. Click the red X by the flag until it turns into a green check and watch the animation.

For even more on deformers be sure to check out the Tips on Type chapter.

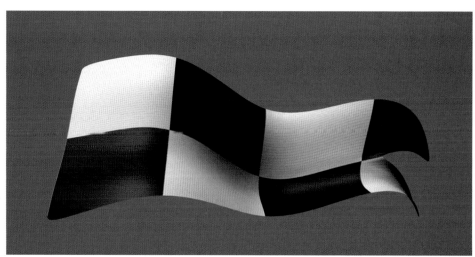

Chapter 4: Deformers and Other Modeling Helpers

MetaBall

In this project we will simulate water flow using the combination of an Emitter, a Metaball and finally, a HyperNURBS to smooth the shapes.

Step 1 Add an emitter to the scene. Set the Birthrate Editor and Birthrate Renderer to 200. Set the Start Emission to 0 and Stop to 300. Set the Speed parameter to 1000 with a variation of 32%. In the Emitter tab, lower the X and Y Sizes to 100. ***Figure Metaball_01***

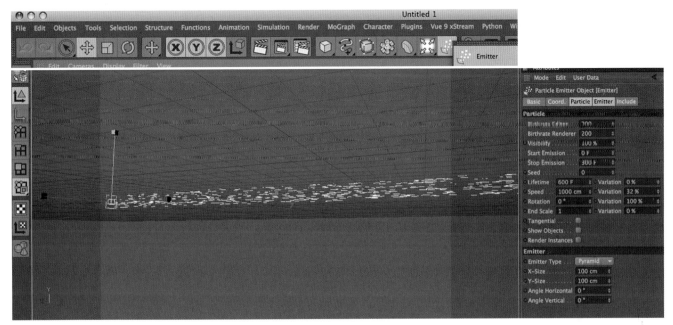

Figure Metaball_01

Step 2 With the Emitter selected, hold the Shift key and add a Sphere. Set the Radius for the Sphere to 21 and the Segments to 60. Change the Type to Hexahedron. ***Figure MetaBall_02***

Figure MetaBall_02

133

Step 3 We would like the flow to have a realistic arch. To accomplish this, add a gravity effector. Set the Acceleration parameter to 550. *Figure MetaBall_03*

Figure MetaBall_03

Step 4 With the Emitter selected, hold the Option (Alt PC) key and add a Metaball object. Set the Hull Value to 75% with the Editor and Render Subdivisions to 28. *Figure MetaBall_04*

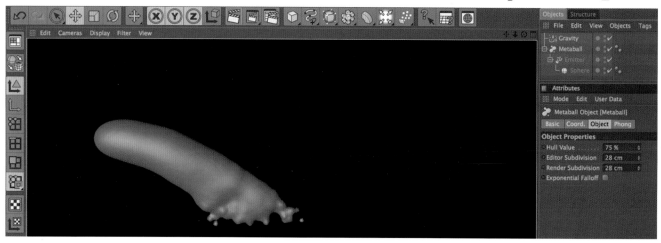

Figure MetaBall_04

Step 5 Extend the animation length by setting the end frame to 300. *Figure MetaBall_05*

Figure MetaBall_05

Chapter 4: Deformers and Other Modeling Helpers

Step 6 Add a Banji Shader from the Material Manager Shader presets. In the Diffuse Channel, set the Surface and Volume Colors to light blues. Apply the material to the Metaball.
Figure MetaBall_06

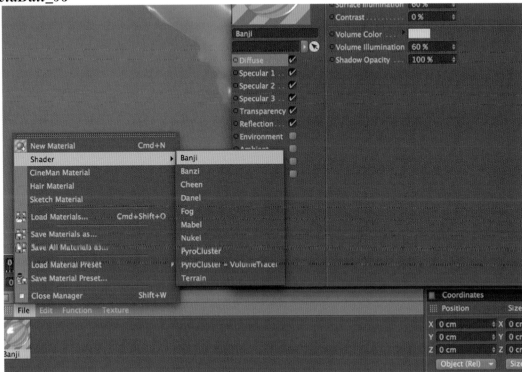

Figure MetaBall_06

Step 7 Add a Sky object to the background and render the animation. Be sure to experiment with the Hull value and size of the spheres to get the different looks. The Emitter can be ramped up in speed and variation to make different looks as well. If you have any rough corners, place the Metaball beneath a HyperNURBS to smooth the shape. *Figure MetaBall_07*

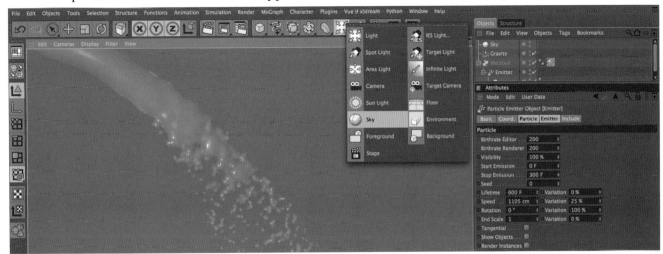

Figure MetaBall_07

135

CINEMA 4D: The Artist's Project Sourcebook, Third Edition

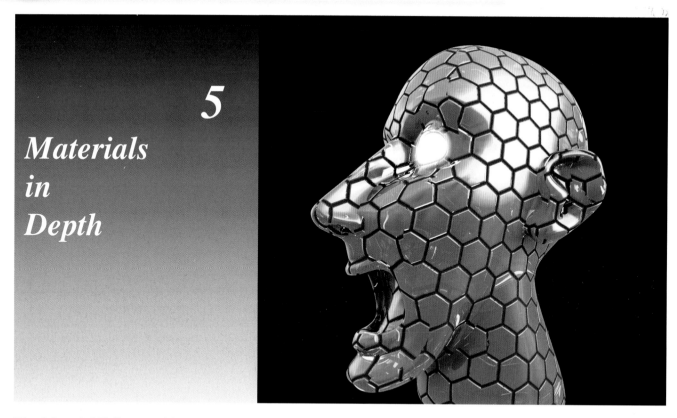

5
Materials in Depth

The Material Editor enables you to edit the materials used in your scene. Each material will contain parameters nested in Channels. These Channels work together to create the final appearance of the material. The Channels can be enabled or disabled by clicking the checkbox to the left of its name. Most of the parameters contained within the Channels are keyframe supported, allowing the creation of incredible animations inside the materials alone.

The Figure on the bottom right of this page is a modified version of the Material Channels table provided in the help system of CINEMA 4D.

Be sure to check Animating Letters in the Tips on Type folder of the DVD where you'll see how to animate material parameters to raise the quality of an animation.

Color	Color of surface
Diffusion	Greyscale maps alter the way light is diffused on a surface
Luminance	Luminescent color (Can be used as light source in GI)
Transparency	Transparency (includes the ability to set refraction to distort how light passes thru the material)
Reflection	Reflection (Can be set to additive which will work more to blend with the Color Channel)
Environment	False reflection (Allows the loading of a bitmap to simulate a reflection at much faster render speeds)
Fog	Fog Simulation
Bump	Virtual bumps on a surface (Only affects appearance of geometry)
Normal	Works similar to the bump channel but allows a better result for export by calculating each point in 3 dimensional space rather than in just Z space like the bump channel
Alpha	Alpha masks can be loaded using bitmaps or built in shaders within C4D
Specular	Highlight or light bounce
Specular Color	Highlight Color
Glow	Halo around an object (Inner and outer glows can be simulated)
Displacement	Realistic bumps on a surface (Actually deforms the geometric mesh of an object)

Chapter 5: Materials in Depth

Placing and Adjusting Materials

Materials can be mapped with different types of projections onto the 3D model. The figure to the right illustrates how, in general, the projection style is similar in form to the object itself. Many excellent diagrams illustrating the different types of mapping can be found in the built-in help system of CINEMA 4D.

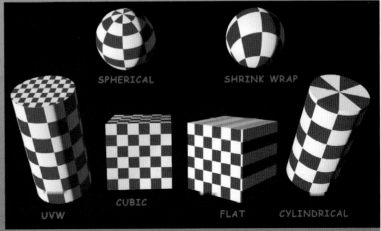

A material's placement may be edited with numeric values in the Attributes Manager. Offset moves the texture side to side or vertically; the U and V lengths determine how far the texture is stretched in a direction; Tilling determines how many times the texture is repeated in each direction. In addition, materials can be adjusted interactively by using the Texture and Texture Axis tools in conjunction with the Move, Scale, and Rotate tools. Cages appear to give you an idea of how the material is positioned in relation to the object. With projection types other than UVW, a texture can be coaxed to fit an object by choosing Tags>Fit to Object from the Object Manager>Tags Menu.

Texture Tool

Notice that the Texture tag is independent from the material itself. Once mapping is defined in a tag, it can be copied to many objects.

Texture Axis Tool

You may remember from earlier projects that you can apply a material to specified selections or selection tags. To limit a material to a specified selection, simply select the polygons you want the texture to project on, and drag the material onto that selection in the Viewport. This will automatically create a selection tag. Secondly, you can select polygons and go to the Selection menu and choose Selection>Set Selection. As you'll see in the Tips on Type section, you can also limit materials to Caps and Rounding areas by entering C1 or C2 (Start and End Caps) and R1 and R2 (Start and End Rounding) in the Selection box in the Tag properties.

Interactive Editing Cage

The default projection type, UVW, "sticks" the material to UVW coordinates inherent in Primitives and NURBS objects. UVW projection has certain advantages and disadvantages. A great advantage is that UVW materials stick to an object's surface as it is animated or deformed. The downside is that adjusting UVW materials on complex objects delves into the realm of UV mapping. UV mapping is vital as overlaps and uneven polygons result in distorted projections. In the Bodypaint chapter you'll see the technique used to unwrap a UV mesh and edit it in preparation for painting a character head.

SHADERS

Shaders are procedural textures that are more complex and powerful than typical raster image based textures. Similar to the fractal mathematical formulas that create landscape parametric primitives, shaders are driven by formulas and guarantee high quality regardless of how close to the camera they appear.

Shaders prevent a texture painter's worst nightmare: seams. Seams appear where a texture may be tiled along an object and destroy realism in renders.

CINEMA 4D has two categories of Shaders, two-dimensional and three-dimensional shaders. 2D shaders are mapped similarly to typical materials whereas 3D shaders consider an object's volume and are affected by traditional projection methods.

All parameters of 2D and 3D shaders can be animated, giving them an even wider range of uses.

VOLUMETRIC SHADERS

Banji Shader A glass type shader utilizing a Diffusion channel and several Specular Channels as well as Transparency and Reflection Channels. This shader allows for incredible control over light bounce as well as clarity and refraction settings for transparency.

Banji Shader

Banzi Shader A wood shader that allows for innumerable combinations for the purpose of simulating wood types.

Cheen Shader An excellent biological class shader that is a standard in medical renders. Great for simulation of microscopic organisms and objects such as a virus or blood cell. Parameters such as roughness, can be changed to give this shader a life outside of its standard genre.

Banzi Shader

Cheen Shader

Chapter 5: Materials in Depth

Danel Shader This shader is the one-stop shop for metallic materials. Ornaments, car paint and any metal surface are great uses of this shader.

Danel Shader

Mabel Shader The name Mabel, reminds me of an old lady or someone saying marble with a mouth full of marbles. Marble makes more sense with this shader because its main purpose is to generate marble and stone textures. Veining is a unique parameter to Mabel that allows the weaving of multiple colors, creating patterns.

Mabel Shader

Nukci Shader Think of this shader as the weathered material creator. The Fusion Channel separates this shader from others, allowing two surfaces to be combined. Furthermore, the Fusion Channel allows flexibility to expand the use of this shader to unconventional uses. The inclusion of an Alpha Channel also allows extra control of how this material is projected on 3D objects.

Nukei Shader

CINEMA 4D: The Artist's Project Sourcebook, Third Edition

Fog Shader Its all in the name. Animating the Turbulence parameter can be rewarding for effects and atmosphere.

Terrain Shader This shader is the material version of the Landscape primitive. Fractal landscapes are shaped using the formulas built into this shader.

Fog Shader

Terrain Shader

CHANNEL SHADERS

Bitmap Shader The typical loading of images to be used to create the material. If you desire to work in a scene on multiple machines, be sure to choose >File>Save Project, to ensure your images go with you.

Pavement Shader The names says it all, but this is one of two very useful new additions to C4D.

Noise Shader Greyscale values are used to calculate where the mesh will be pushed in and pulled out. This shader is often used in both the Bump and Displacement Channels.

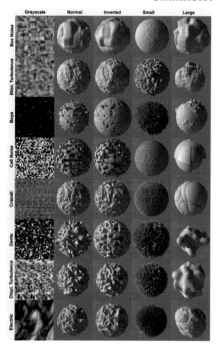

Chapter 5: Materials in Depth

Gradient Shader Besides the obvious gradient, this shader allows the use of extra parameters that generate some cool effects and simulation such as clouds or fire. There are also many options for types of gradient.

Gradient shader set to 3D spherical with turbulence

Fresnel Shader This shader allows the control of reflection, color and specularity based on the angle of the view. Other parameters, such as transparency, can also be set using the Fresnel Shader.

Filter Shader Used primarily to allow the adjusting of bitmaps. Similar to an adjustment layer in Photoshop.

Fusion Shader Fusion combines two textures with a mask using standard photo editing blending modes.

Layer Shader One of the most powerful shaders in all of C4D. This shader incorporates the power of an application like Photoshop allowing the combining of shaders and bitmaps.

Colorizer Shader Remaps a color based on a gradient placed within this shader.

ChanLum Shader As a character development artist, this material is a favorite of mine. This shader creates a Subsurface Scattering effect, which gives the objects a translucency. Some light will pass through, some will be absorbed and some will be reflected. Light sources must be set to cast shadows for this shader to work.

Distortion Shader	Works similar to a distort effect in Illustrator or Photoshop in distorting the bitmap or shader loaded in the input channel using a bitmap or shader loaded in the distorter channel.
Ambient Occlusion Shader	A render-friendly alternative to Global Illumination. This shader is limited as far as results but in many cases may get you the quality you need at a fraction of the render time. AO controls the level of exposure to lighting based on each surface point and then applies the correct color. This is a great way to get nice deep shadows on areas that are receded in your models. This shader should be placed in the Diffusion Channel of the material. Ambient Occlusion is also a global setting that can be created under the Effects tab in the Render Settings.
Ripple Shader	When placed in the bump channel, this shader will generate ripple animation across the designated surface.
Brick Shader	As with the Pavement Shader, the function of this shader is in the name and it is new to Release 12.
All the Rest	The order and inclusion of shaders in this section is not necessarily a reflection on the importance of each. In fact, we will cover many more in the following pages as well as projects scattered throughout the book. For more information about shaders not included in this section, as well as deeper explanations of all shaders in C4D, please refer to the built-in help system accessible from the Windows Menu.

Planet Texturing Project

Step 1 Add a sphere and set the Radius to 2500 cm and Type to Hexahedron. Change the name to Earth. *Figure ES_01*

Figure ES_01

Chapter 5: Materials in Depth

Step 2 Double click in the Material Manager to create a new material, rename it, Earth Mat.

Step 3 Add a Fusion shader to the Color Channel. *Figure ES_02*

Figure ES_02

Step 4 For the Base Channel, choose the Earth surface. *Figure ES_03*

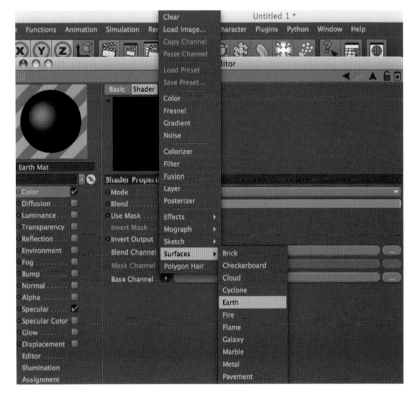

Figure ES_03

143

Step 5 Click on the Earth tab and set the Sea to R = 0, G = 35, B = 225; Land to R = 0, G = 127, B = 0; Mountains to R = 191, G = 191, B = 191, Frequency; .43, and Level to 50%. *Figure ES_04*

Figure ES_04

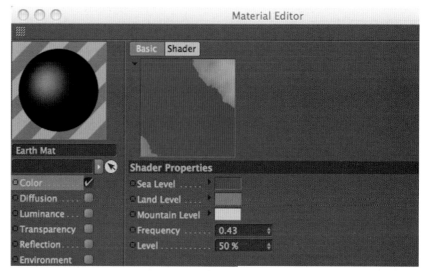

Step 6 In the Blend Channel, add the Cloud surface. Inside the Cloud surface, set the Level to 43%. *Figure ES_05*

Figure ES_05

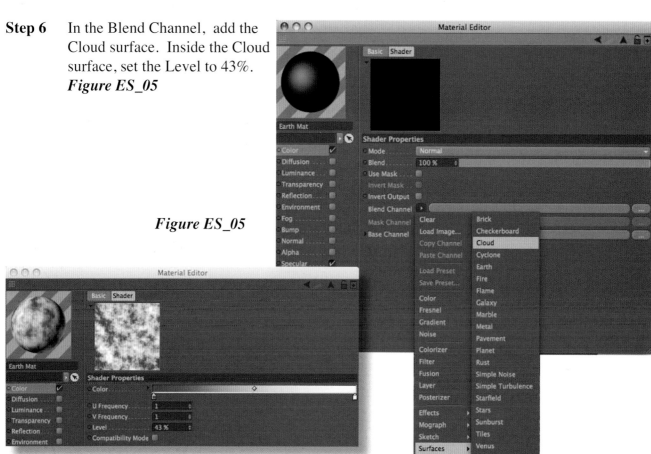

Chapter 5: Materials in Depth

Step 7 Check Use Mask, copy and paste the cloud surface from the Blend Channel to the Mask Channel. Change the blue knot to black.

Figure ES_06

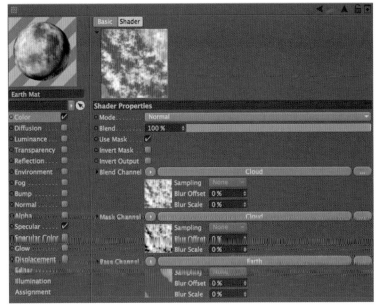

Figure ES_06

Step 8 For the Diffusion Channel, copy the Earth Shader from the Base of the Fusion Shader and paste it into the Diffusion Channel. *Figure ES_07*

Then add a Filter Shader. Inside the Filter, set the Hue to 206, the Saturation to - 47, the Lightness to 59% and check, Colorize.
Figure ES_08

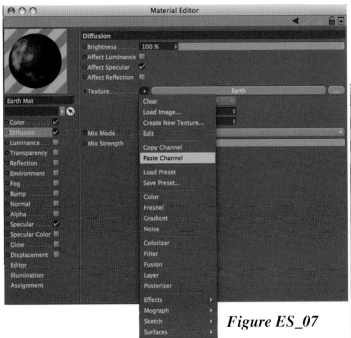

Figure ES_07

Figure ES08

145

Step 9 Copy the Fusion from the Color Channel and paste it into the Luminance Channel.

Step 10 To set up the Bump Channel, copy the Earth layer of the Fusion Shader and paste in the bump channel. *Figure ES_09*

Figure ES_09

Step 11 Open the Earth settings and set the color for the Sea Level to 0, 0, 0. Set the land color to 104, 106, 104. Set the Mountain color to 255, 255, 255. *Figure ES_10*

Figure ES_10

Chapter 5: Materials in Depth

Step 12 Turn on the Glow channel to create a quick atmosphere. Deselect the Use Material Color checkbox. Set the Brightness to 80%. Set the Inner Strength to 8%, and the Outer to 40%. Set the Radius to 175 cm. *Figure ES_11*

Figure ES_11

Step 13 Drag this material and drop it on the Earth object.

Step 14 Add a Sky object. Double click in the Material Manager to create a new material and name it, Space.

Step 15 Turn off the Color and Specular Channels. In the Luminance channel, load the Surface>Starfield. *Figure ES_12*

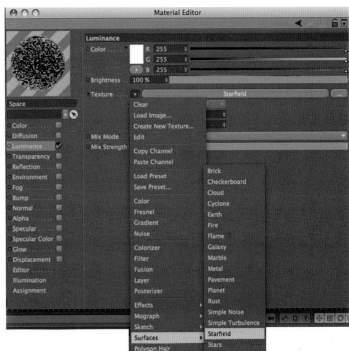

Figure ES_12

147

Step 16 Drop the material onto the Sky object, and set the U and V Lengths to 50%. Render the scene. *Figure ES_13*

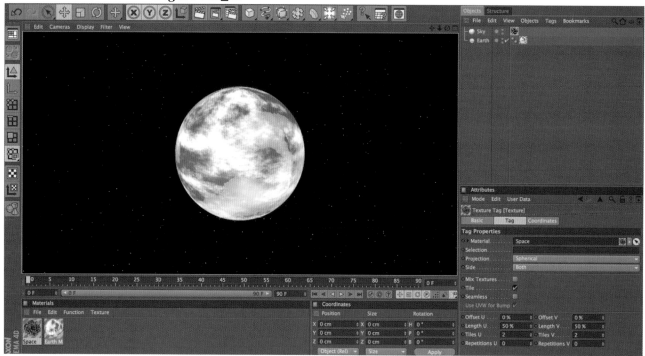

Figure ES_13

Step 17 Create another Sphere and name it Planet. Set the Radius to 5785. *Figure ES_14*

Figure ES_14

Chapter 5: Materials in Depth

Step 18 Create a Disc and set the Outer Radius to 14250 and Inner Radius to 7625. Set the Disc segments to 4 and the Rotation Segments to 36. *Figure ES_15*

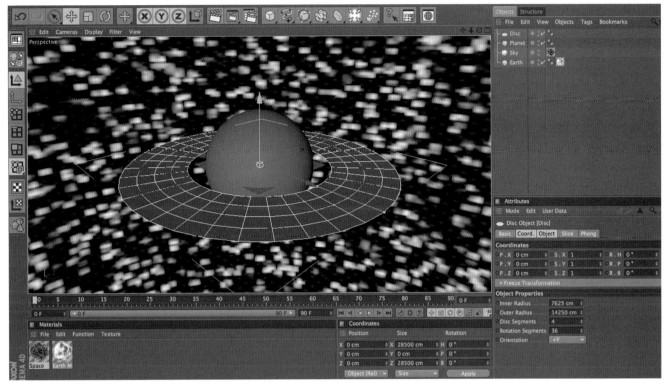

Figure ES_15

Step 19 Select both objects and press Opt+G to group. Rename the resulting group, Planet Group. Move this group to X 5500, Y 8000, Z 13500 and set the rotation to RH 15, RP 7 and RB - 25.

Step 20 Double click in the Material Manager to create a new material. Rename it Planet Mat., and disable the Specular Channel. In the Color Channel, use the texture drop-down and load Surfaces>Planet. *Figure ES_16*

Figure ES_16

149

Step 21 Click on the Planet surface and choose Uranus. *Figure ES_17*

Step 22 Enable Glow and set the Radius to 37. Drop this material on the Planet object.

Figure ES_17

Step 23 Double click in the Material Manager to load a new material and rename it, Ring Mat.

Step 24 Leave the Color Channel as is and enable the Luminance Channel. Set the Color to R 170, G 195 and B 255. Enable the Alpha Channel and load Surfaces>Planet. Click the Planet Shader and change it to, Saturn's Ring.
Finally, enable the Glow Channel.
Figure ES_18

Step 25 Change the viewport to your Top Camera (F2). In the viewport, change the display to Gouraud shading so the colors will become visible. *Figure ES_19*

Figure ES_18

Figure ES_19

Chapter 5: Materials in Depth

Step 26 Now drag the Ring Mat and drop it on the Disc object. *Figure ES_20*

Figure ES_20

Step 27 Time to complete the lighting and staging of this scene. Start by adding a light and position it at X - 9000, Y 38000, Z 86000 and rename it Sun. *Figure ES_21*

Figure ES_21

Step 28 This light will act as a physical representation of the Sun but, we don't actually want it emitting light. Put a check in the No Illumination box to create this effect.

Step 29 Go to the Lens tab of the Light.

Step 30 Raise the Scale to 400% and set the Glow to Sun1.
Figure ES_22

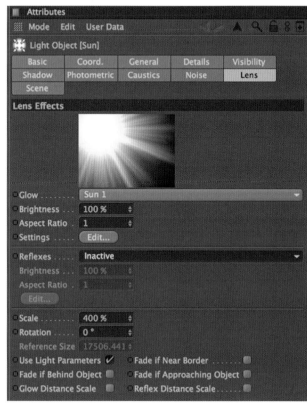

Figure ES_22

Step 31 Change the Glow Settings by clicking the Edit button. Set the Size to 14%, and set the Beams to 137 with Breaks 12 and Width 12%.

The checkboxes for Random Distribution, Random Beam Length and Star-like should all be checked.
Figure ES_23

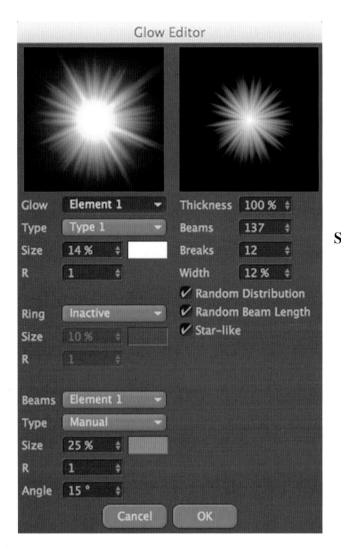

Figure ES_23

Chapter 5: Materials in Depth

Step 32 Activate the Reflexes and set to Star 2.
Figure ES_24

Figure ES_24

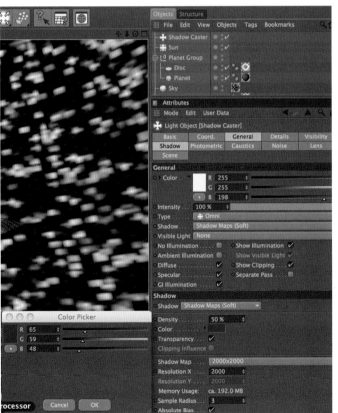

Step 33 Add another light and name it, Shadow Caster. Under the General tab, set R = 255, G = 255, B = 198. Activate the Shadow and set it to Shadow Maps (Soft). In the Shadow tab, lower the density to 50% and set the shadow Color to R = 65, G = 59, B = 48. Raise the Shadow Map size to 2000x2000.
Figure ES_25

Figure ES_25

153

Step 34 Move this light into place by setting its coordinates to X = - 45000, Y = 40000 and Z = 21000.

Step 35 Create one final light and name it, Back Light. Set the color to R = 112, G = 165, B = 255. Lower the Intensity to 51% and reposition to X = 31000, Y = - 300, and Z = - 70000.
Figure ES_26

Figure ES_26

Step 36 Create a new Camera and click the crosshair to the right in the Object Manager to look through this camera. In the Coordinates tab, set the Position values to X = 470, Y = - 1000 and Z = -10500. Set the Rotation P value to 12.5 degrees.

Step 37 Lastly, having added all of the lights, our Earth model is overlit. In the Material Manager, select the Earth Mat. and uncheck the Luminance Channel. Be sure to play around with the scale and brightness of the Lens effect. In the rendered final, my scale was lowered from 400% to around 200%.

Chapter 5: *Materials in Depth*

Step 38 To Render a 6" x 4" still, open the Render Settings. Under Output, choose the Print Preset of Landscape 6" x 4". With these basic primitive shapes, leave the anti-aliasing alone as no major quality gains will be achieved.

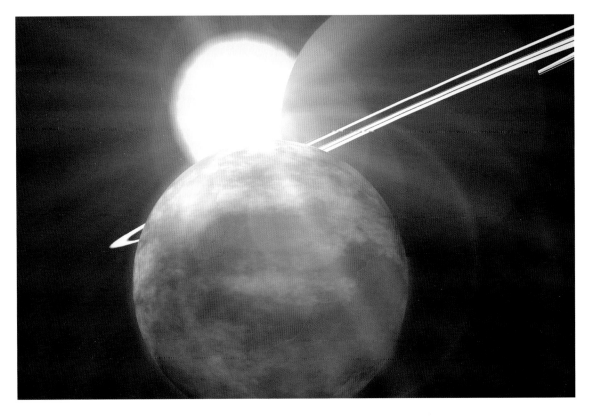

Island of Displacement

Step 1 Start this project by adding a Plane object from the parametric primitives drop-down. Change the Width and Height to 2500 each.
Figure Sub_Poly_Disp_01

Step 2 Now add a basic Sky object so we have background for our scene.

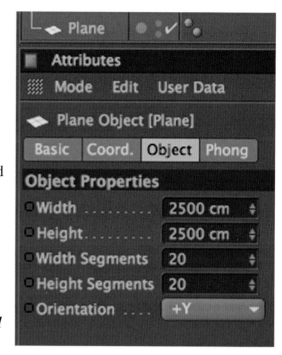

Figure Sub_Poly_Disp_01

Step 3 Double click in the Material Manager to create a new material, and rename it Island Mat.
Figure Sub_Poly_Disp_02

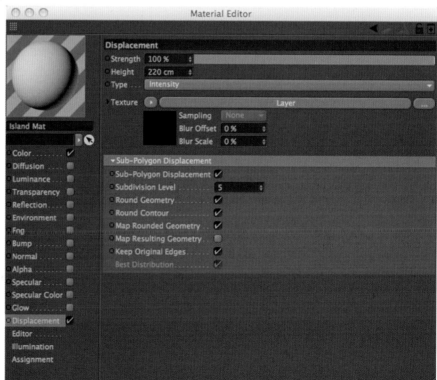

Figure Sub_Poly_Disp_02

Chapter 5: Materials in Depth

Step 4 Disable the Specular Channel by unchecking its box to the left.

Step 5 The first Channel we want to focus on is the Displacement Channel. In the Texture drop-down, add a Layer Shader.

Step 6 Set the Height to 220 and change the type to Intensity. Put a check in the Sub-Polygon Displacement box, set the Subdivision Level to 5, and check Round Geometry.

Step 7 Open the Layer shader by clicking on its tab. For the first layer, add a Noise Shader.
Figure Sub_Poly_Disp_03

Step 8 Click on the Noise thumbnail and choose 670 for the Seed. Set the Noise type to Wavy Turbulence and adjust the Octaves to 3.6. Make sure the Space is set to Texture and increase the Global Scale to 1044%.
Figure Sub_Poly_Disp_04

Figure Sub_Poly_Disp_03

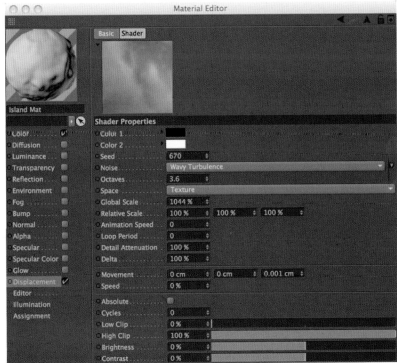

Figure Sub_Poly_Disp_04

157

Step 9 Add a Gradient Layer and use 2D - Circular as the Type. Ramp up the Turbulence to 11%, choose 1.5 for the Octaves and 98% for the Scale. Invert the colors by swapping the Black and White knots. Add a grey color knot (R 101, G 101, B 101) and drag it about 90% over to the left. Now drag the Black knot about 70% over to the left. *Figure Sub_Poly_Disp_05*

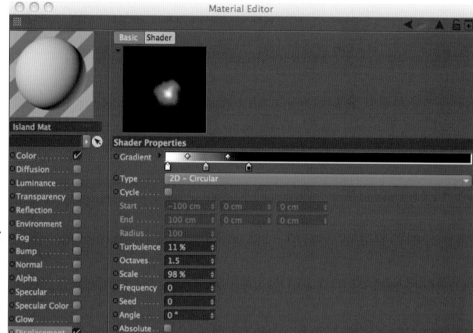

Figure Sub_Poly_Disp_05

Step 10 Back inside the Layer Shader, set the blend mode for this Gradient to Multiply.
Figure Sub_Poly_Disp_06

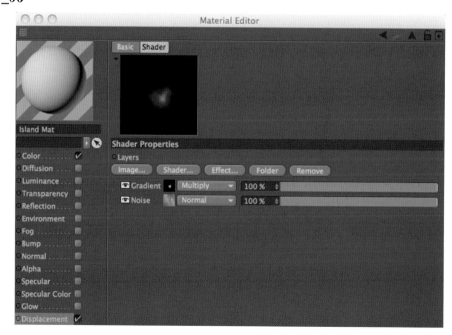

Figure Sub_Poly_Disp_06

Chapter 5: Materials in Depth

Step 11 For the Color Channel, I'm going to use this greyscale Layer Shader as a map to tell me where colors need to be painted.

Step 12 Copy and paste the Layer shader we've created from the Displacement Channel to the Color Channel. ***Figure Sub_Poly_Disp_07*** & ***Figure Sub_Poly_Disp_08***

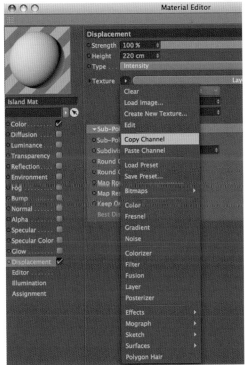

Figure Sub_Poly_Disp_07

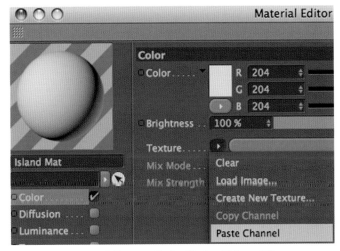

Figure Sub_Poly_Disp_08

Step 13 For the Color Channel, we need to add another Noise layer within the Layer Shader. Choose Displaced Turbulence from the Noise Type. Set the Octaves to 5 and the Global Scale to 425%. ***Figure Sub_Poly_Disp_09***

Figure Sub_Poly_Disp09

Step 14 Back out and add another Noise Layer to this Shader. Choose Noise for the Noise type. Set the Global Scale down to 8%.
Figure Sub_Poly_Disp_10

Figure Sub_Poly_Disp10

Step 15 Add a final layer of the Noise to the Shader. Set the Noise to Luka. Raise the Delta Value to 120% and raise the Relative Scale for the Y axis to 300%. Finally, lower the High Clip to 73%.
Figure Sub_Poly_Disp_11

Figure Sub_Poly_Disp_11

Chapter 5: Materials in Depth

Step 16 Click the Gradient layer of the shader to begin painting the color for this material.

See the figure listed to lay out the color knots in the correct locations. The layout of these knots is as follows:
- The knot on the right is going to be the sea, double click the knot and set the color to 14, 111, 117.
- For the shallow water, click just below the gradient bar and set color knot to 0, 238, 147.
- Click just to the left of this knot below the gradient bar and add a white color knot.
- Slightly to the left of the white knot, create a grey knot using 101, 101, 101.
- Click below the gradient again and set the new color to 7, 142, 7.
- Now, create a darker green knot with a color setting of 6, 54, 6.
- Finally, change the color of the far left knot to 93, 91, 91.

Move the knots to match *Figure Sub_PolyDisp_12* below.

Figure Sub_PolyDisp_12

Step 17 The Turbulence should be set to 11% with Octaves set to 7.3 and Scale at 98%.
Back out to the Layer Shader and set the layer order, blend modes and mix strengths to match *Figure Sub_PolyDisp_13*.

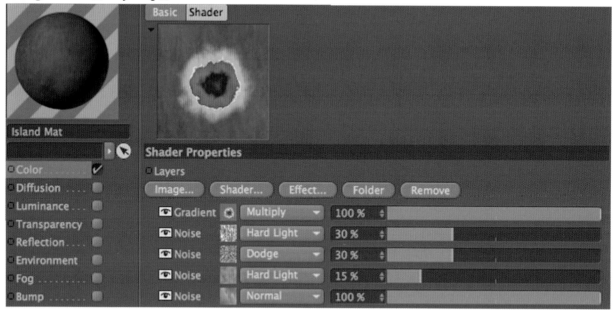

Figure Sub_PolyDisp_13

Step 18 Now we want the water areas of our texture to be reflective. Activate the Reflection Channel, copy the Gradient layer (only) of your Displacement Channel's Layer Shader and paste it into the Reflection Channel. Click on the Gradient to change its settings. Delete the grey knot and swap the original white knot color for black and vice versa, causing the gradient to invert. Adjust your knots to a similar configuration to *Figure Sub_PolyDisp_14*.

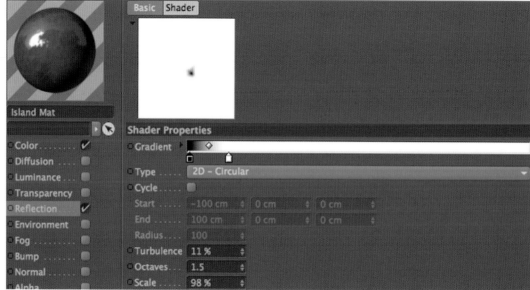

Figure Sub_PolyDisp_14

Chapter 5: Materials in Depth

Step 19 This Reflection map will limit which areas of the material will be reflective. Back in the Channel settings, set the mix mode to Multiply and lower the Brightness to 25%.
Figure Sub_PolyDisp_15

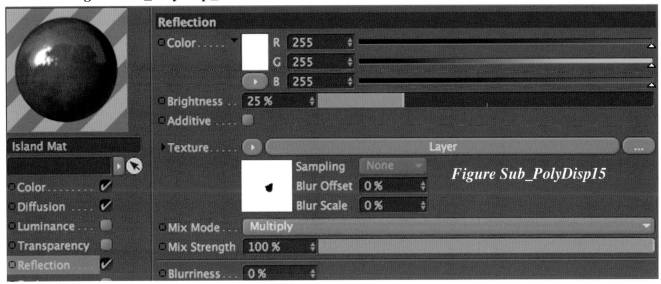

Figure Sub_PolyDisp15

Step 20 Now copy the Layer shader from the Displacement Channel and paste it into the Diffusion Channel. Inside the Layer Shader, set the black knot to white and remove the original white knot from the gradient. Back out and lower the Mix Strength to 18%.
Figure Sub_PolyDisp_16

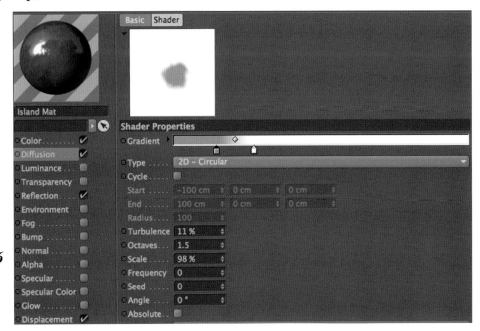

Figure Sub_PolyDisp_16

Step 21 In order for this scene to look proper, we'll need to give our Sky object a good material. Double click in the Material Manager and name the resulting material Sky Mat. Disable all channels with the exception of the Luminance Channel. Inside the Luminance Channel, use the texture loader to load the image, **DinoCloudscropped.tif** from the Sub_Poly_Island folder on the accompanying DVD. *Figure Sub_PolyDisp_17*.

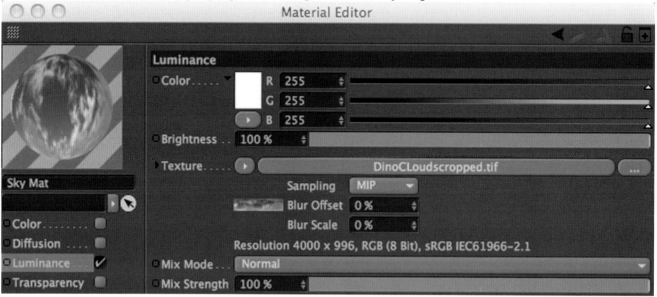

Figure Sub_PolyDisp_17

Step 22 Place this material on the Sky object. In the Attribute Manager, set the Offset U to 3% and Offset V to - 3%. Squash the texture a bit by setting the Length V to 54%. *Figure Sub_PolyDisp_18*.

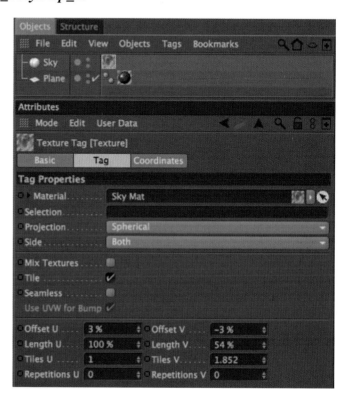

Figure Sub_PolyDisp_18.

Chapter 5: Materials in Depth

Step 23 Open the Render Settings and enable Global Illumination and Ambient Occlusion under the Effects tab. Set the GI Mode to Sky Sampler.
Figure Sub_PolyDisp_19

Figure Sub_PolyDisp_19

Step 24 Now we can add some lights to bring out details in the scene. Add a light and position it at X = 1500, Y = 5200 and Z = 1800. Set its color to a bright yellow such as R 255, G 255 and B 192. Enable Shadows and set it to Shadow Maps (Soft). In the Shadow tab, reduce the Density to 60% and raise the Shadow Map to 2000x2000. You may also wish to set a Color for the shadow to R 30, G 30, B 30.
Figure Sub_PolyDisp_20

Figure Sub_PolyDisp_20

165

Step 25 Create a second light and rename it, Back Light. Move it into position with the coordinates, X = - 1800, Y = 7000, Z = - 4000. Lower the Intensity to 47% and set its color to R 168, G 170, B 255. *Figure Sub_PolyDisp_21*

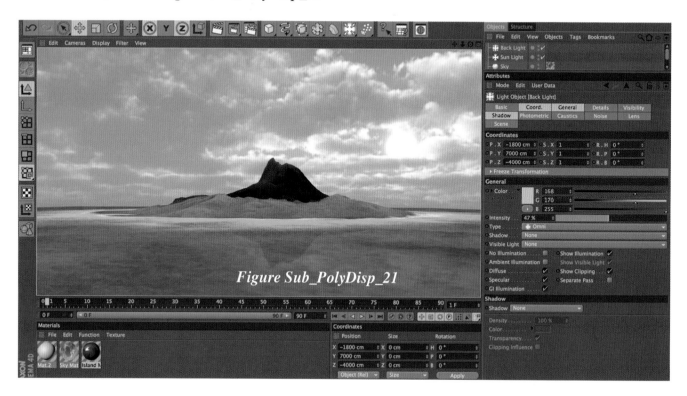

Figure Sub_PolyDisp_21

Step 26 To complete the staging, add a camera and click on the crosshair to its right in the Object Manager to make it our active camera. Reposition it to X = 275, Y = 20, Z = - 1175 and change its rotation to R.H 12 and R.P 3. Now you're ready to render.

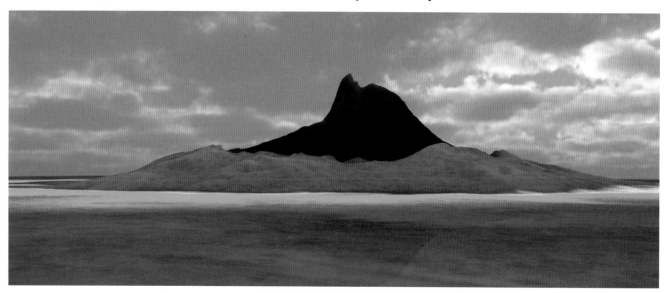

Chapter 6: Better Under Lights

6
Better under Lights

CINEMA 4D includes a default light every time you open a new scene. Light can be used to invoke drama, enhance modeling and spatial depth, paint a scene with color, influence textures, draw the viewer's eye to specific focal points and much more. Lights are also instrumental in creating mood, environment and visual effects. In this chapter, we will cover many of the different uses of light for effects and some of the basic light setups including Global Illumination.

Creating and Animating a SearchLight

Open the **LightHouse_Start.c4d** file located in the Better_Under_Lights folder.

Step 1 Add a light to the scene. Name this light Base Light. Move the Base Light up to P.Y 475. Raise the S.Y to 1.85. The Color needs to be R 255, G 255 and B 215. Set Shadow to Shadow Maps (Soft) and the Visible Light to Volumetric.
Figure LH_01

Figure LH_01

167

Step 2 In the Details tab, enable the Falloff and choose Linear. Set the Inner Radius to 25 and the Radius/Decay to 65. For Visibility, Type 9 in the Inner Distance parameter and 14 for Outer Distance. Ramp up the Brightness to 250%.
Figure LH_02

Figure LH_02

Step 3 Command (Control PC) + drag on this light to make a copy. Name the copy Search Light. Change the Type to Spot, turn off Shadows and change the Visible Light to Visible. In the Coordinates tab, reset the S.Y to 1.
Figure LH_03

Figure LH_03

Chapter 6: Better Under Lights

Step 4 In the Details tab, set the Inner Angle to 17.5 degrees, Outer Angle to 60 degrees and Aspect Ratio to 0.75. Make the Inner Radius 9 and rev up the Radius/Decay to 5300. In both the Details and Visibility tabs, set the Inner Distance to 9 and Outer to 5300. Lower the Brightness to 120%. *Figure LH_04*

Note: For extra effect, you can enable the Noise tab and set it to Visible.

Step 5 Now to animate the Search Light, click on the H in the Coordinates tab and Control click to the left of the R.H to set a keyframe with a value of 0 at frame 0. *Figure LH_05*

Figure LH_04

Figure LH_05

Step 6 Scroll to Frame 300. Set the R.H to 30 degrees and set a keyframe. *Figure LH_06*

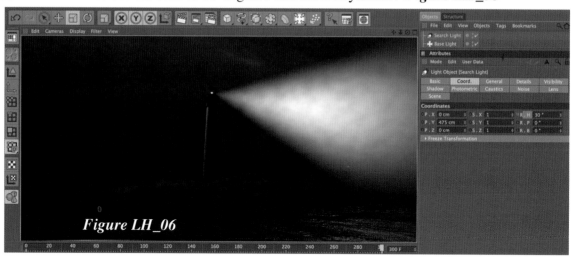

Figure LH_06

Step 7 Right click on the R.H parameter and choose Show Track. *Figure LH_07*

Figure LH_07

Step 8 Drag a marquee over the keyframes to select them and in the Attribute Manager, change the Interpolation from Spline to Linear. *Figure LH_08*

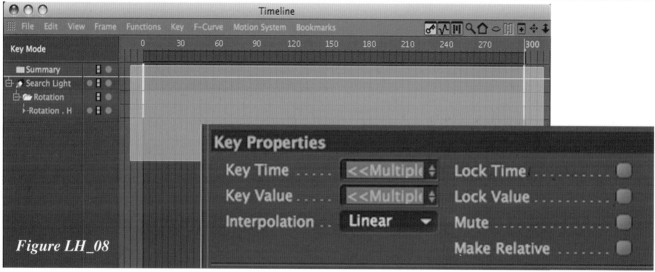

Figure LH_08

Chapter 6: Better Under Lights

Intro to GI:
Lighting with Objects

Open the **GI_Intro_Start.c4d** file located in the **Better_Under_Lights** folder.

Step 1 Select the Sphere, hold the Option (Alt PC) key and add a Cloner object to the scene.
Figure GI_Intro_01

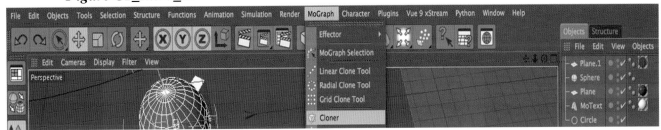

Figure GI_Intro_01

Step 2 In the Object tab, set the Mode to Object. Drag the Circle spline into the Object link. Set the Distribution to Even. *Figure GI_Intro_02*

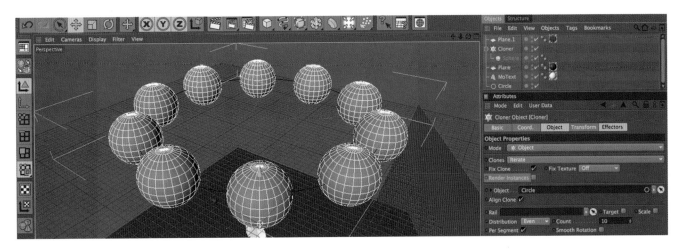

Figure GI_Intro_02

171

Step 3 Select the Lights Mat in the Material Manager. Go to the Luminance Channel. Click the Texture drop-down and choose Mograph>Color Shader. Apply this material to the Cloner.
Figure GI_Intro_03

Figure GI_Intro_03

Step 4 With the Cloner object selected, add a Random Effector. *Figure GI_Intro_04*

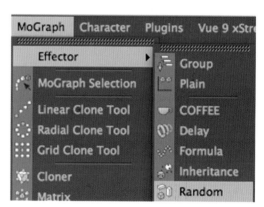

Figure GI_Intro_04

Step 5 Disable Position in the Parameter tab and set the Color Mode On.
Figure GI_Intro_05

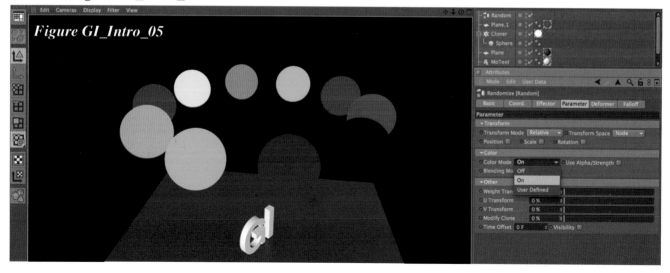

Figure GI_Intro_05

Chapter 6: Better Under Lights

Now that we have multicolored spheres placed above our scene, we can use the luminance of these shapes to light our scene. This is accomplished using a Render Effect called Global Illumination.

Step 6 Click on the Render Settings and add Global Illumination from the Effects pulldown.
Figure GI_Intro_06

Figure GI_Intro_06

Step 7 For this test, set the GI Mode to IR + QMC (Still Image). *Figure GI_Intro_07*

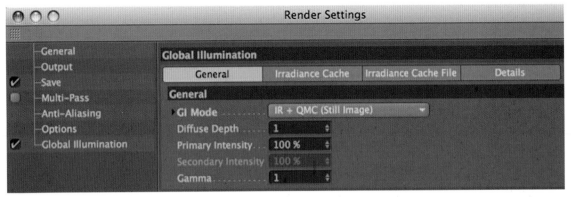

Figure GI_Intro_07

Step 8 While we are previewing, click the Irradiance Cache tab and set the Stochastic Samples and Record Density parameters to Low. Set the Smoothing to Minimal and Oversampling should be at Weak. We can up these values when we're ready for the final render.
Figure GI_Intro_08

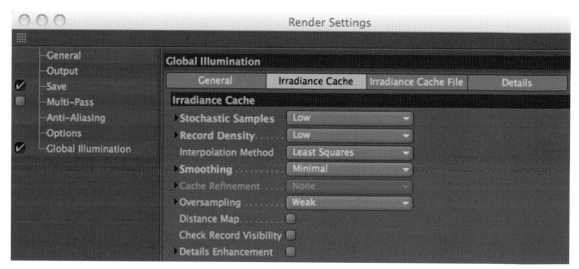

Figure GI_Intro_08

Step 9 Render the viewport again to see how the settings are affecting our scene.
Figure GI_Intro_09

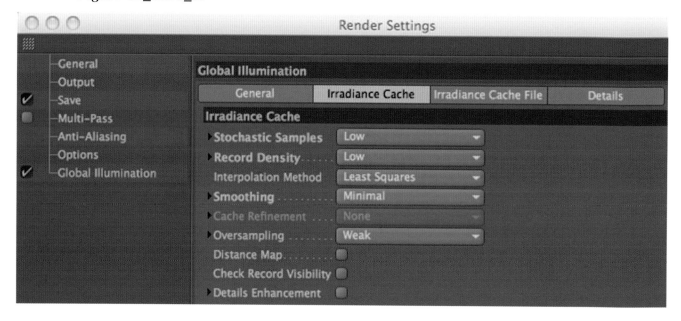

Figure GI_Intro_09

Chapter 6: Better Under Lights

Step 10 Move the Circle spline down to P.Y 550. Rotate it around to R.H to - 125 so that the green sphere will cast light on the faces of our letters. Render to see the result. *Figure GI_Intro_10*

Figure GI_Intro_10

Step 11 Look at the scene and you will notice that there is a red plane angled to face the text. Click on Render Settings and go into the General tab of the GI settings. Raise the Diffuse Depth to 2. Notice that the Secondary Intensity becomes available. Secondary Intensity refers to secondary levels of light bounce; that is, how much light is created by objects bouncing light off each other. Raise the Secondary Intensity to 165%. *Figure GI_Intro_11*

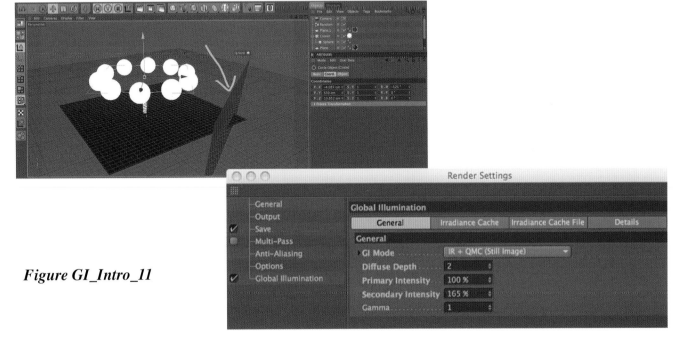

Figure GI_Intro_11

175

Step 12 Render the scene to see how the light is now bouncing off the red plane and lighting our text.
Figure GI_Intro_12

Figure GI_Intro_12

Take some time to add objects, scale the cloner spheres to various heights, etc., and see how GI updates to create the lighting. Remember that the materials of the objects in the scene create the lights. The Luminance Channel must be active for a material to generate light in GI renders.

Chapter 6: Better Under Lights

Lighting a Product

Drag over the Lighting_Products folder from the Better Under Lights folder onto your desktop.

Open the **Lighting_a_Product_GI_Start.c4d** file.

Step 1 You'll find a nice, simple setup here with a slightly reflective floor and product-focused environment. We will be utilizing GI in this scene, so the first thing you will want to do is turn on GI in the Effects of the Render Settings. *Figure Product_GI_01*

Figure Product_GI_01

Step 2 In the General tab of the Global Illumination settings, set the GI Mode to IR + QMC (Still Image). Raise the Diffuse Depth to 2, set Primary Intensity to 110% and move Secondary Intensity down to 65%.
Figure Product_GI_02

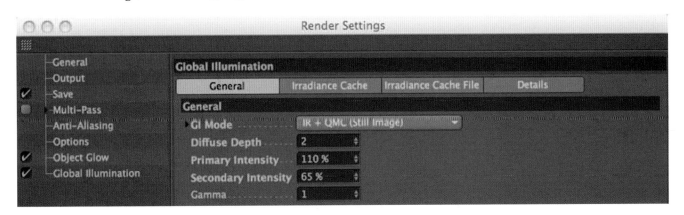

Figure Product_GI_02

177

Step 3 Add a Sky object to the scene.
Figure Product_GI_03

Figure Product_GI_03

Step 4 In the Material Manager, add the HDRI 017 preset from the Load Material Preset> Prime>Materials>HDRI>HDRI 017. Place the material onto the Sky.
Figure Product_GI_04

Figure Product_GI_04

Step 5 Right click on the Sky object and choose CINEMA 4D Tags>Compositing. *Figure Product_GI_05*

Figure Product_GI_05

Chapter 6: Better Under Lights

Step 6 Inside the tag, disable Seen by Camera and Receive Shadows. *Figure Product_GI_06*

Figure Product_GI_06

Step 7 Render the view to see the results of the current settings. It looks fairly decent with just the sky HDRI lighting the scene. It's a little dark and we don't want the reflection of the sky to be recognizable on the floor. *Figure Product_GI_07*

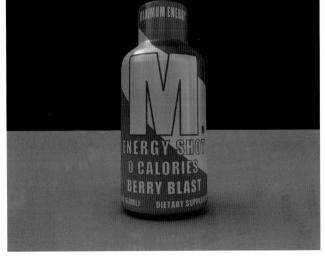

Figure Product_GI_07

Step 8 Double click on the HDRI 017 material and go to the Luminance Channel. Set the Blur Offset to 30% and Blur Scale to 20%. This is a more cost-effective alternative to blurring the reflection channel of the floor. *Figure Product_GI_08*

Figure Product_GI_08

Step 9 To better the lighting of this scene, add a Sphere. Position it to P.X 975, P.Y 1025 and P.Z - 55. Set the Radius for this object to 435. Double click in the Material Manager to make a new material. Disable all channels with the exception of the Luminance Channel. Set the Color to white and the Brightness up to 240%.
Figure Product_GI_09

Figure Product_GI_09

Step 10 Render the scene, as this Sphere acts as our key light and gives us an excellent highlight on the bottle. Notice the reflection of the bottle is clear while the Sky object is blurred out of recognition. *Figure Product_GI_10*

Figure Product_GI_10

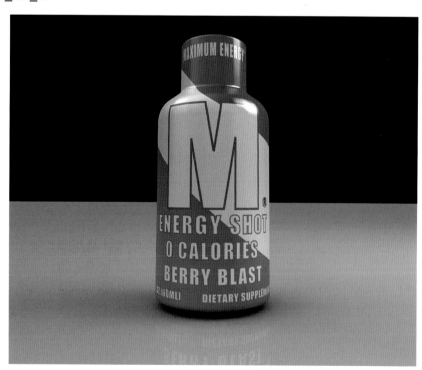

No GI...No Problem

Step 1 Lighting the old-fashioned way can produce solid results as well. Obviously, I've turned off GI for this example. If you are using the same file, open the render settings, select Global Illumination and press Delete.

Step 2 Add a Light to the scene. This will act as our key light. Set the Shadow to Area and move it into position at P.X 220, P.Y 410 and P.Z - 550. In the Shadow tab, set the color to a medium blue and set the Density to 50%. Raise the Minimum Samples to 40.
Figure Product_GI_11

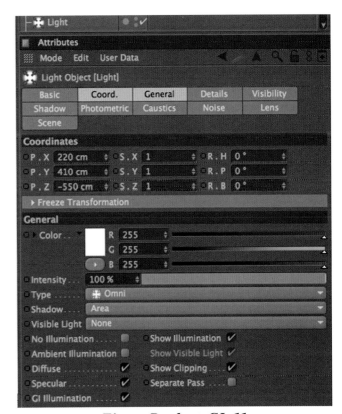

Figure Product_GI_11

Step 3 Copy the light and name it, Back Light. Turn off Shadows. Move it to P.X - 190, P.Y 250 and P.Z - 200. Set the Color to a light blue and lower the Intensity to 40%. In the Scene tab, drag the Floor object into the Exclude field to prevent overlighting the floor. ***Figure Product_GI_12***

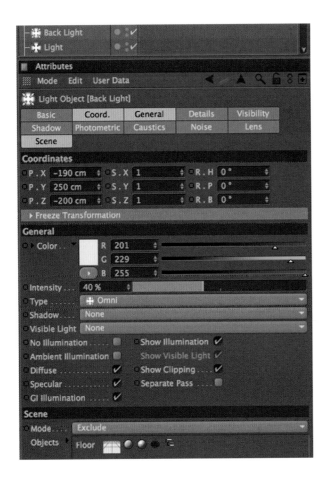

Figure Product_GI_12

Step 4 Copy the Back Light and position it at P.X 2400, P.Y 250, P.Z 5 and set its color to an extremely bright yellow. Name this light Fill Light. ***Figure Product_GI_13***

Render the scene to see the results.

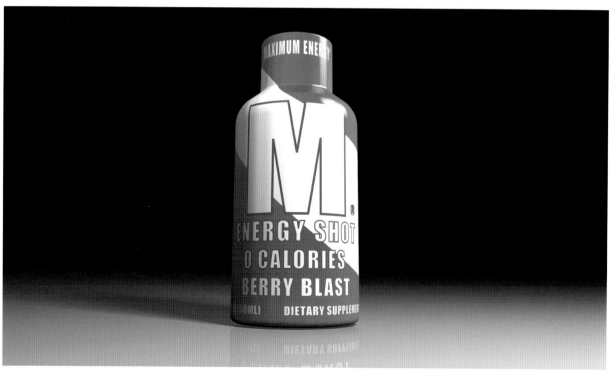

Chapter 7: Animation Basics

Animation Basics 7

Animation in CINEMA 4D is a cinch. As you will see in this chapter, as well as throughout the book, there are many ways to animate in C4D. Keyframes can be set to countless combinations of parameters to generate incredibly complex animated sequences. In this chapter we'll focus on the timeline, keyframe animation and F-Curves. We'll delve deeper using the Animation Menu, including its powerful Motion Layer system.

Butterfly Project

Step 1 Navigate to the Butterfly folder located in the Animation Basics folder on the DVD and open the file named **butterflystart.c4d**. For this project we will begin with an Illustrator file that has been opened and interpreted by CINEMA 4D to provide us with a starting spline shape.

Step 2 When opening shapes made in Illustrator, adjustments often need to be made to make the paths more workable. For this path we need to move it to the center of our space and reposition its axis. Press F4 to access the Front view and switch to the Object Axis tool.

Step 3 Move the axis on the X so that it lines up with the inside of the butterfly shape.
Figure bfly_01

Figure bfly_01

Note that Illustrator files must be saved as Illustrator version 8.

Step 4 Switch to the Model tool and reposition the butterfly spline object by setting all of its position values to 0. Press the O key to frame the object back into your view.
Figure bfly0_2

Figure bfly_02

Step 5 At this point it would be best to view the scene in a 3-dimensional view, so press F1 to jump back to the perspective view. You may find it necessary to press the O key to frame the butterfly spline back into view here as well.

Step 6 With the butterfly spline object selected, hold the Option /Alt (PC) key and add an Extrude NURBS from the NURBS pull down. In the Object tab, lower the Z movement from 20 m to 2 m. Change the name of the Extrude NURBS object to Wing.
Figure bfly_03

Figure bfly_03

Chapter 7: Animation Basics

Step 7 With the Wing object selected, hold the Option/Alt key as you add a Symmetry Object to the Scene.
Figure bfly_04

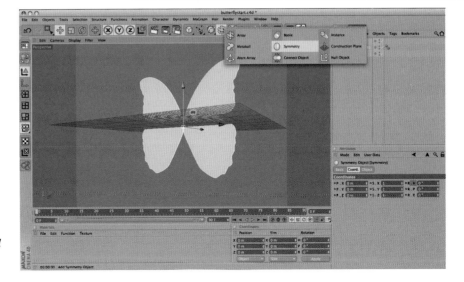

Figure bfly_04

Step 8 Double click in the Material Manager to create a new material. In the Color Channel, go to the Texture drop-down and choose Load Image. Open the **butterfly.tif** image located in the Animation Basics folder on the DVD.
Figure bfly_05

Step 9 In the Specular Channel, raise the Width to 100% and lower the Height to 2%.
Figure bfly_06

Figure bfly_05

Figure bfly_06

185

Step 10 Activate the Glow Channel and lower the Inner Glow to 12% and Outer Glow to 190%. **Figure bfly_07**

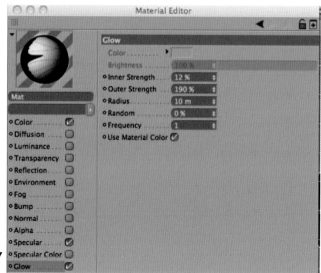

Figure bfly_07

Step 11 Press F4 to go back to the Front view and place the material on the Wing Object. Change the material Projection type in the Attribute Manager to Flat. **Figure bfly_08**

Step 12 Change the Display mode within the Viewport to Gouraud Shading. **Figure bfly_09**

Figure bfly_09

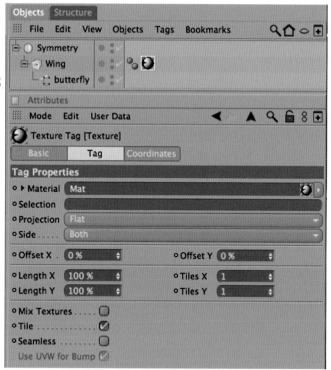

Figure bfly_08

Chapter 7: Animation Basics

Step 13 With the Wing object selected, switch to the Texture Axis tool. You can now use the transformation tools (Move, Scale & Rotate) to maneuver the texture to fit the left wing perfectly. You can also simply type the following values in the Coordinates Manager: Position X = -157.408, Y = 5.097, Scale X = 189.809, Y = 314.616.
Figure bfly_10

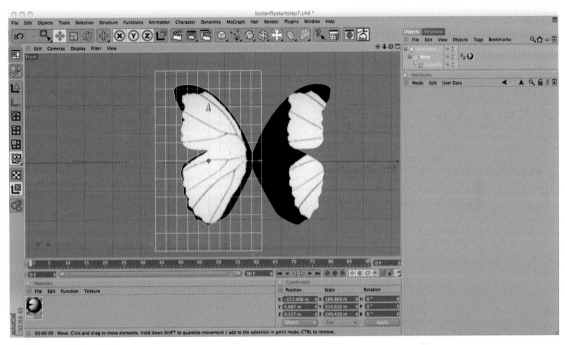

Figure bfly_10

Step 14 To keep the texture from slipping on the Symmetry when animating, right click on the Wing object and choose the Stick Texture Tag from CINEMA 4D Tags>Stick Texture.
Figure bfly_11

Figure bfly_11

187

Step 15 It is now time to set keyframes for the wings to fly. Switch to the Object Tool and activate the Rotate tool (shortcut 6) Grab the Green Band and rotate the wing about 60 degrees on the H. **Figure bfly_12**

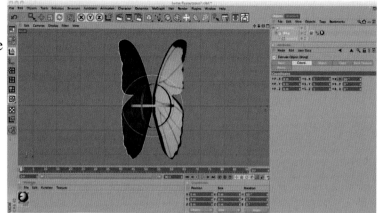

Figure bfly_12

Step 16 With the Wing Object selected, go to the Coordinates Tab of the Attribute Manager and mouse over to the R.H. Click on the H to highlight, then Control + Click on the ellipse to the Left of the R.H to set a keyframe. You should be at frame 0 in the timeline.
Figure bfly_13

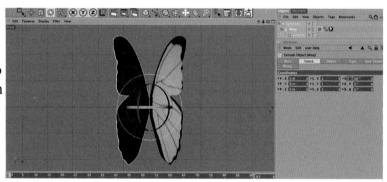

Figure bfly_13

Step 17 Navigate to Frame 60 in the Timeline and Control+click on the same R. H ellipse to set another keyframe. **Figure bfly_14**

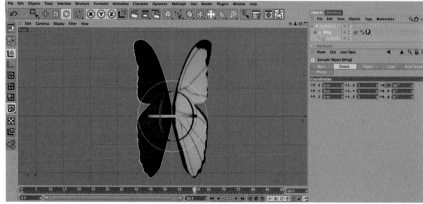

Figure bfly_14

Chapter 7: Animation Basics

Step 18 Go to frame 30 and change the R. H value to - 60 degrees and Control+Click on the ellipse to set a new keyframe. **Figure bfly_15**

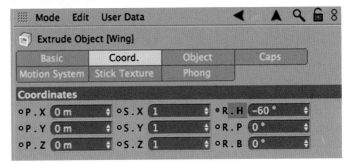

Figure bfly15

Step 19 With the Wing selected, go to Animation>Add Motion Clip. **Figure bfly_16**

Figure bfly_16

Step 20 In the Motion Clip window, set the End Length to 60. Uncheck Remove Included Animation from Original Object and disable all Include options with exception of Rotation. **Figurebfly_17**

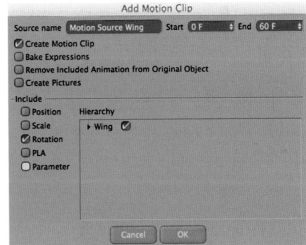

Figure bfly_17

Step 21 Click on the new Animation Layer tag that has been created to the right of the Wing object in the Object Manager and choose, Open in TL. **Figure bfly_18**

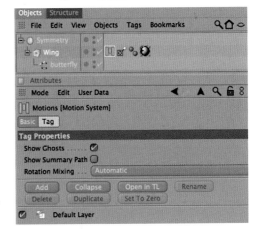

Figure bfly_18

189

Step 22 Select the Motion Clip in the Timeline to pull it up in the Attribute Manager. Set the loops to 10. **Figure bfly_19** Close the Animation Timeline window.

Figure bfly_19

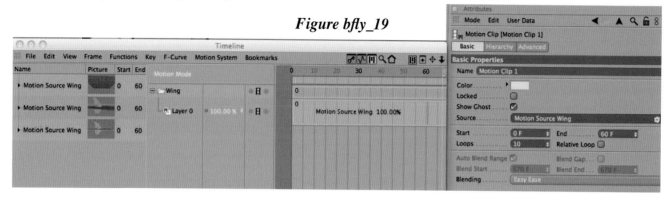

Step 23 Select the Symmetry object and press Option/Alt (PC) + G to place it beneath a Null object. Rename the new Null Butterfly.

Step 24 Rotate the Butterfly group down by setting its R. P. value to - 70 degrees.
Figure bfly_20

Figure bfly_20

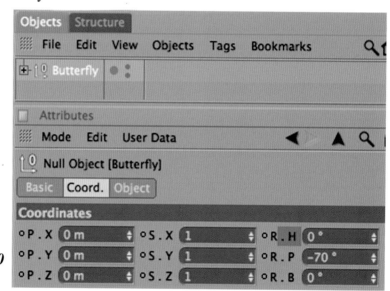

Step 25 Lengthen the time of this scene by increasing the end value for the timeline from 90 to 600. Be sure to drag the grey bar below out to 600, as well to ensure playback of the entire scene. *Figure bfly_21*

Figure bfly_21

Step 26 Press the playback button and you will see that the butterfly wing flap will continue for the entire scene.

Chapter 7: Animation Basics

Step 27 Add a Particle Emitter from the Emitter pull down. Make the butterfly group a child of the Emitter. **Figure bfly_22**

Figure bfly_22

Step 28 Select the Butterfly group, in the Attributes Manager, and set its scale values all down to 0.1. **Figure bfly_23**

Figure bfly_23

Step 29 Select the Emitter once again and raise the X and Y sizes to 150 m each and the Angle Horizontal and Vertical to 3 degrees each. Set the Speed Variation to 33% and up the Birthrate Editor and Renderer each to 15. Mark the checkbox for Show objects and Render Instances.
Figure bfly_24

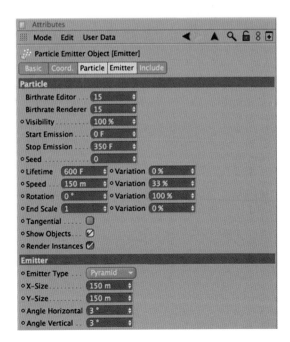

Figure bfly_24

191

Step 30 Now add a Gravity Object from the forces drop down and decrease the Acceleration to 50. Switch the Falloff Shape to Box and raise the Size to 250 on each axis.
Figure bfly_25

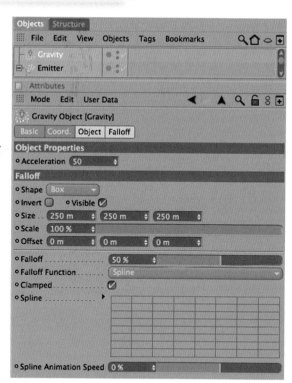

Figure bfly_25

Step 31 Move the Gravity Object to Z = 150 m
Figure bfly_26

Figure bfly_26

Step 32 Control drag on the Gravity Object in the Object Manager to duplicate it. Move the copy to X = 0, Y = - 800, Z = 1000. Set the Acceleration to - 100. Raise the size of the Box to 1000 m, 250 m and 1000 m. **Figure bfly_27**

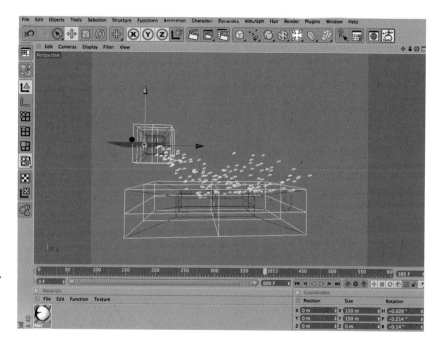

Figure bfly_27

Step 33 Add a Light to our scene. Set the Color to R = 195, G = 205, B = 255, and change the Shadow to Shadow Maps (Soft). Set the Visible Light to Inverse Volumetric. **Figure bfly_28**

Figure bfly_28

Step 34 In the Visibility tab, set the Outer Distance to 2500 m and up the Brightness to 300%. **Figure bfly_29**

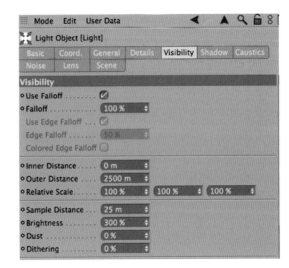

Figure bfly_29

Step 35 Go into the Noise tab and set the Noise to Visibility. Set the Velocity to 25%, the Brightness to 50% and Contrast to 60%. **Figure bfly_30**

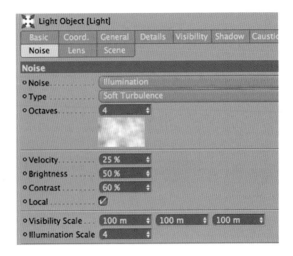

Figure bfly_30

Step 36 Make the butterfly material a little more interesting by double clicking on its thumbnail in the Material Manager and enabling the Luminance Channel. Set the Color to R = 30, G = 35, B = 255 and lower the Brightness to 30%. Load the **butterfly.tif** image as the Texture and set the Mix Mode to Add with a Mix Strength of 55%.
Figure bfly_31

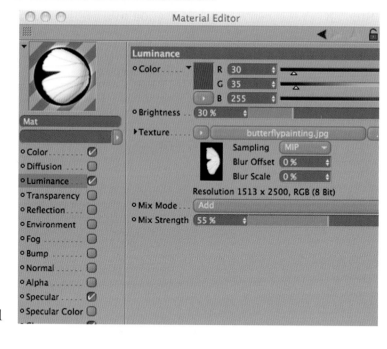

Figure bfly_31

Step 37 Add a camera and click on the crosshair to the right of the new Camera to look through it. Set the Coordinates to P.X = 0, P.Y = -300, P.Z = 2000 and rotate the R.H to 180 degrees. Click on the keyframe button to set a keyframe.
Figure bfly_32

Figure bfly_32

Chapter 7: Animation Basics

Step 38 Take a look at the animation by clicking and holding on the Render to Picture Viewer; choose Render Preview. **Figure bfly_33**

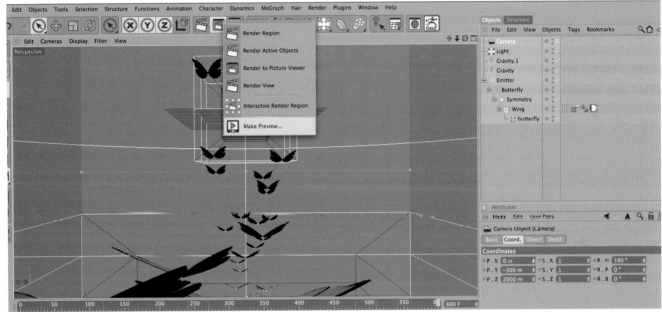

Figure bfly_33

Step 39 The settings in the Render Preview panel should read Full Render and All Frames. Choose your desired render size and click OK.
Figure bfly_34

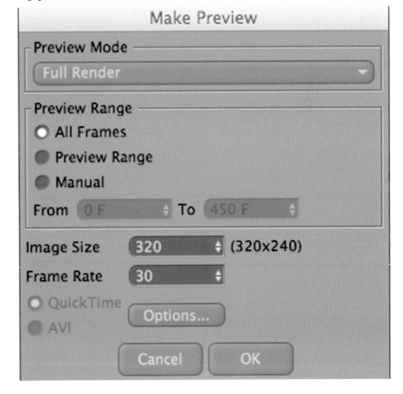

Figure bfly_34

195

Controlling Animation with Rail Splines & F-Curves

In the following exercise we will look at aligning objects to a spline and using a Rail Spline to control rotation and the F-Curves to control interpolation.

Open the **Rail_Spline_Spaceship_Start.c4d** file located in the Animation Basics folder.

Step 1 Right click on the Spaceship object and choose CINEMA 4D Tags>Align to Spline.
Figure Rail_Spline_01

Figure Rail_Spline_01

Step 2 In the tag, drag the Flight Path spline into the Spline Path field.
Figure Rail_Spline_02

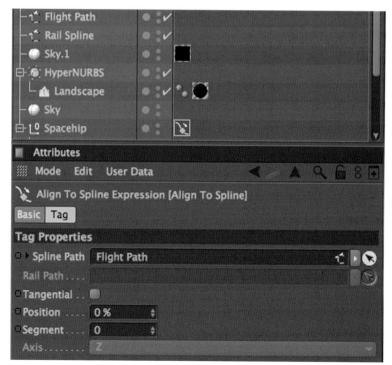

Figure Rail_Spline_02

Chapter 7: Animation Basics

Step 3 At frame 0, Control click to the left of the Position parameter to record a keyframe with a value of 0%. *Figure Rail_Spline_03*

Figure Rail_Spline_03

Step 4 Scroll to Frame 180 and set a value of 100% for the Position Parameter and Control+Click again to set a new keyframe.

Step 5 The problem with this animation is that the ship starts slow and then slows to a stop at the end. We want to control the speed along the path using the curve of the animation. Right click on the Position parameter and choose Show F-Curve. *Figure Rail_Spline_04*

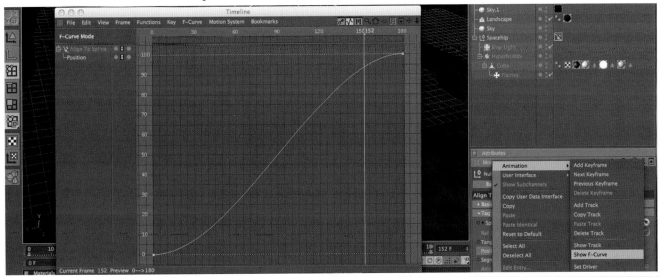

Figure Rail_Spline_04

Step 6 Notice in the F-Curve there is an ease in and ease out assigned to this animation. We want the ease in but then our ship should race through the rest of the scene. Select the end keyframe on the right, and drag the handle to point at the start keyframe. Now play the animation to see the change. *Figure Rail_Spline_05*

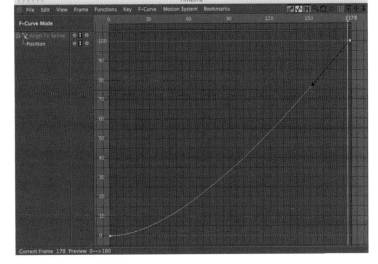

Figure Rail_Spline_05

197

Step 7 We still have an issue with the rotation of the ship as it does not fit the path. That is where the Rail Spline comes into play. Select the Align to Spline tag and place a check in the Tangential box. Now, drag the Rail Spline object and drop it into the Rail Path field. Play the animation to see the result. Take some time to look at the Flight Path and Rail Spline objects to see how the Rail Spline influences the rotation of the ship as it travels through the scene. *Figure Rail_Spline_06*

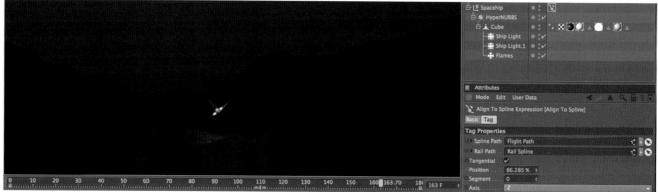

Figure Rail_Spline_06

If you would like to view the animation through multiple cameras placed in the scene, click the red X to the right of the Stage object.

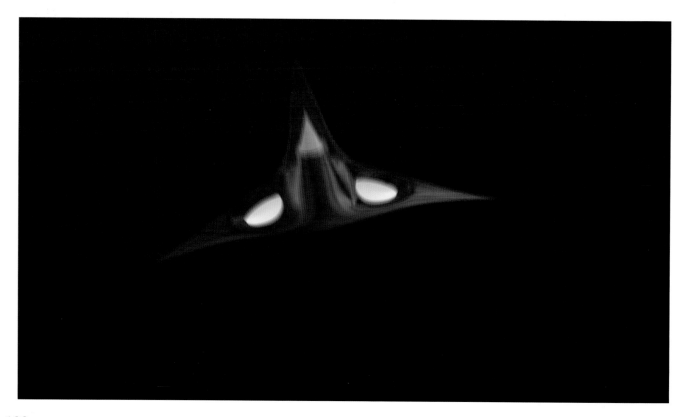

Chapter 8: Head Shots

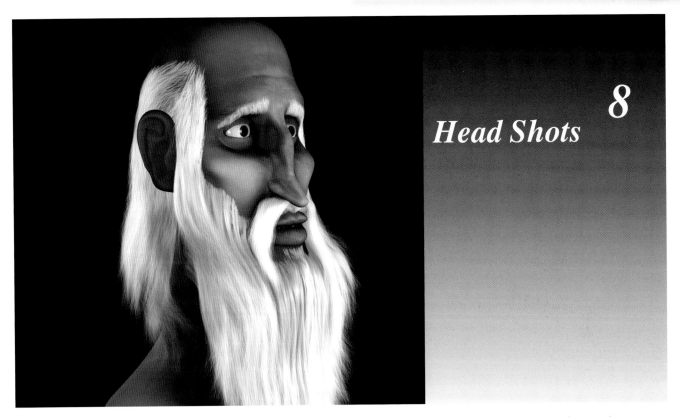

In the following exercise, we will look at an overview of the modeling process for creating a character head. On the accompanying DVD, you will find video tutorials covering the creation of important elements of the head model. The first thing to consider is that, when creating a symmetrical character, you only need create half the model and let a Symmetry object complete the task. There are many ways to model a head, including point-by-point modeling using background images and multiple views to match on all planes. For this model, we'll simply start with a cube.

Modeling a Character Head

Part 1: Getting the Basic Shape

Step 1 Add a Cube object. Set its size to X 200, Y 400 and Z 200. Raise the X Segments to 6 and the Y and Z Segments to 3 each. ***Figure HeadShots_01***

Figure HeadShots_01

In the early stages of creating characters, the practice of mirroring is a must. We will need to cut this model in half and replace it with a Symmetry object. The X Segmentation should be set to an even number, resulting in an edge loop at 0. This makes the mirroring process simple from the start. To perform the mirror, we need to first cut the cube in half.

Step 2 With the Cube selected, press the Make Editable button or press the C key shortcut.

Step 3 Switch to the Front View (F4) and select the Rectangle Selection tool. Switch to Points Mode and in the Attribute Manager, uncheck the Only Select Visible Elements function. Select all of the points to the left of the Y axis and press Delete. *Figure HeadShots_02*

Figure HeadShots_02

Step 4 With the cube selected, hold the Option key (Alt PC) and add a Symmetry object from the Modeling drop-down. *Figure HeadShots_03*

Figure HeadShots_03

Step 5 Press F1 to navigate back to the Perspective view and switch to the Live Selection tool and choose the Polygon tool. Select the top middle polys and drag them up to begin the doming of the head. *Figure HeadShots_04*

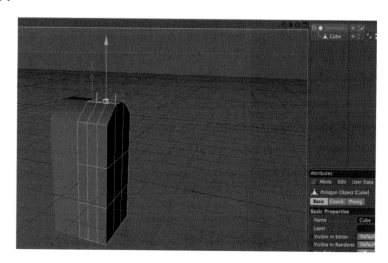

Figure HeadShots_04

Chapter 8: Head Shots

Step 6 Press the V key to pull up the hot menu, choose Loop select and select the Loop of polys at the top of the head. ***Figure HeadShots_05*** Press the K key to activate the Knife tool and set the Mode to Loop. Mouse over the inside edge at the origin to ensure you cut all the way through the polygon loop. ***Figure HeadShots_06***

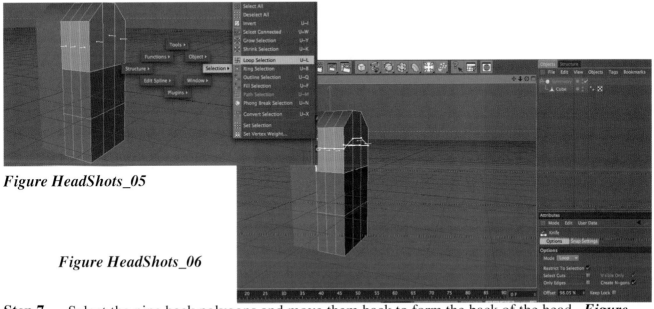

Figure HeadShots_05

Figure HeadShots_06

Step 7 Select the nine back polygons and move them back to form the back of the head. ***Figure HeadShots_07***

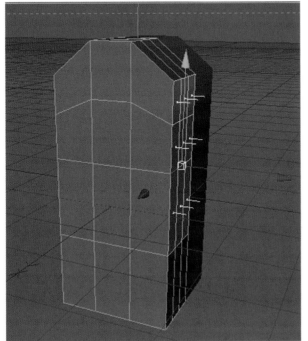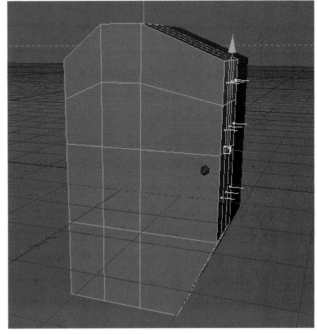

Figure HeadShots_07

201

Step 8 Select the four polys in *Figure HeadShots_08* and move them back further as shown.

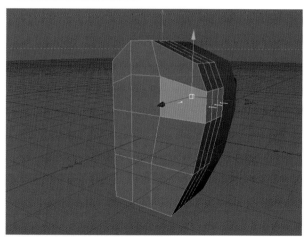

Figure HeadShots_08

Step 9 Select the back Vertical loop of polys on the side of the head and activate the Knife tool in Loop mode to cut a new edge through the center. **Figure HeadShots_09**

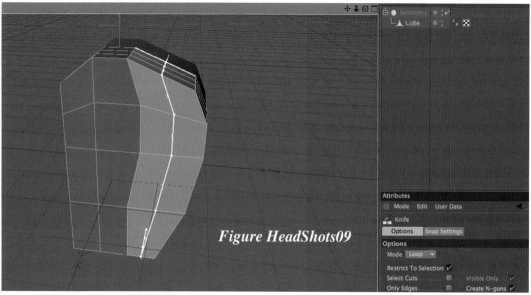

Figure HeadShots09

Step 10 Switch to the Points tool and adjust the top points of the new edge. Move them up and back a bit to make a smooth falloff at the back of the head.
Figure HeadShots_10

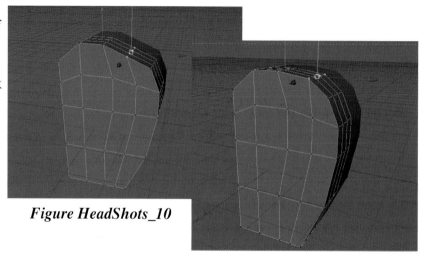

Figure HeadShots_10

Chapter 8: Head Shots

Step 11 It is time to see how the smooth mesh will be created. With the Symmetry selected, hold the Option key (Alt PC) and add a HyperNURBS object. *Figure HeadShots_11*

Figure HeadShots_11

Step 12 Switch to the Model tool and choose the Scale tool. Scale the entire shape on the Z by dragging on its axis handle until the shape is about 450 deep in the Coordinates Manager.
Figure HeadShots_12

Figure HeadShots_12

Step 13 Select these six polys and move them up on the Y to get a better head shape.
Figure HeadShots_13

Figure HeadShots_13

203

CINEMA 4D: The Artist's Project Sourcebook, Third Edition

Step 14 Select these four side polygons and move them from 100 on the X to 150 on the X.
Figure HeadShots_14

Step 15 Go back to the Point tool and begin to better arrange the shape. Use the Move and Selection tools to shape the side. Refer to the images in ***Figure HeadShots_15*** to see where to move points.

Step 16 Switch to the Polygon tool and loop select the second column of polys and use the Knife tool set to Loop mode to cut a new edge in the center.
Figure HeadShots_16

Figure HeadShots14

Figure HeadShots_15

Figure HeadShots_16

Chapter 8: Head Shots

Step 17 Switch back to Points and move them around to get even shapes as you begin to mold the crude mesh into a skull shape. *Figure HeadShots_17* shows the steps I took in shaping this mesh.

Figure HeadShots_17

Step 18 Select the bottom points of the shape and set their Y position to be around - 165 in the Coordinates Manager. The Y size for these points should be 0. *Figure HeadShots_18*

Figure HeadShots_18

205

Step 19 It is now time to split the neck from the chin. In the Polygon tool, select the front six bottom polygons and press the D key to pull up the Extrude tool. Extrude these polys 55 and then perform a second extrusion of 75. *Figure HeadShots_19*

Figure HeadShots_19

Step 20 Now we'll use the Scale tool to shrink down the last extruded polys. In the attributes of the Scale tool, active the Modeling Axis. Drag the Z value to - 100%. Use the Blue Z handle to scale these down to about 80 on the Z. If you numerically set this in the Coordinates Manager, you'll need to likewise adjust the Z position to match.
Figure HeadShots_20

Figure HeadShots_20

Chapter 8: Head Shots

Step 21 Notice when I reenable the HyperNURBS that I get a mess in the mesh. *Figure HeadShots_21*

Figure HeadShots_21

Step 22 Disable the HyperNURBS and the Symmetry by clicking on their green checks and turning them into red Xs. Select the new inner polys that were created when we performed the extrusions. Press delete to remove them from the mesh.
Figure HeadShots_22

Figure HeadShots_22

Step 23 Before extruding the neck, move these points forward to - 22 on the Z to avoid any overlapping of mesh when we extrude.
Figure HeadShots_23

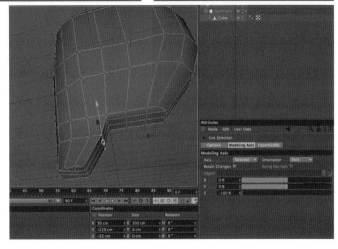

Figure HeadShots_23

207

Step 24 Select the nine polys that will make the neck. Press the D key and extrude these 55 and then perform a second extrusion of 60. *Figure HeadShots_24*

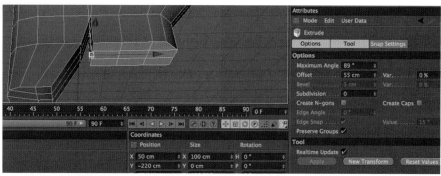

Figure HeadShots_24

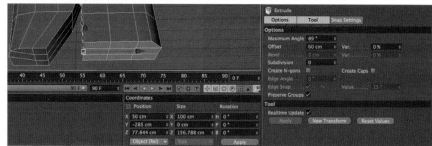

Step 25 Again, you will need to select the new polys in the middle of our head that were created in the extrusions and press Delete.
Figure HeadShots_25

Figure HeadShots_25

Step 26 Switch to the Point tool and press Command+A (Cntrl+A PC) to select all of the points in the object. Go to Functions>Optimize and choose OK for the list of parameters that appears.
Figure HeadShots_26

Figure HeadShots_26

Chapter 8: Head Shots

Step 27 Before we go any further, we need to create a selection set of the points that need to be at 0 for the Symmetry to work.

Press F4 to look through the Front views and choose the Rectangle Selection tool. Select the point loop that makes up the center edge of our model. Make sure that Only Select Visible Elements is disabled in the attributes of the tool. Now, go to Selection>Set Selection. Rename this selection, Origin Points.
Figure HeadShots_27

Figure HeadShots_27

Step 28 Select the bottom front polygons that make up the chin. Choose the Scale tool and set the Modeling Axis to - 100% on the X and make sure the Y and Z are zeroed out. Scale these polys down using the red X handle until they are about 65 wide on the X axis. The modeling axis set to - 100% on the X keeps us from having to readjust the position of the polys after scaling. *Figure HeadShots_28*

Figure HeadShots_28

Step 29 Loop select the center polygons closest to the origin. Press the K key to pull up the Knife tool and set it to Loop. Cut a new edge close to origin. This will be the nose.
Figure HeadShots_29

Figure HeadShots_29

Step 30 Select the Loop at the top of the face and use the Knife tool set to loop and cut a new edge.
Figure HeadShots_30

Figure HeadShots_30

Step 31 Select this loop and use the Knife tool set to loop to cut another edge.
Figure HeadShots_31

Figure HeadShots_31

Step 32 Select the loop in *Figure HeadShots_32* and cut it with the knife tool to create another edge to help shape the eye.

Figure HeadShots_32

Chapter 8: Head Shots

Step 33 Make another cut in this loop to help shape the bottom of the eye. *Figure HeadShots_33*

Note: This would be a good time to save the scene.

Step 34 Select these polys and press the D key to Extrude. Extrude these polygons 50. *Figure HeadShots_34*

Figure HeadShots_33

Figure HeadShots_34

Step 35 With these polygons selected, enable the Rotate tool and rotate these polys about - 20 degrees on the Heading. *Figure HeadShots_35*

Figure HeadShots_35

Step 36 Switch to the Edge Tool and select the edges in *Figure HeadShots_36* and move it down to P.Y = - 90.

Figure HeadShots_36

Step 37 Select this edge loop and move it down to P.Y = - 40. *Figure Headshots_37*

Figure HeadShots_37

Step 38 Loop select the polys that will make up the mouth and use the Knife tool set to Loop mode and cut a couple of new subdivisions. *Figure Headshots_38*

Figure Headshots_38

Chapter 8: Head Shots

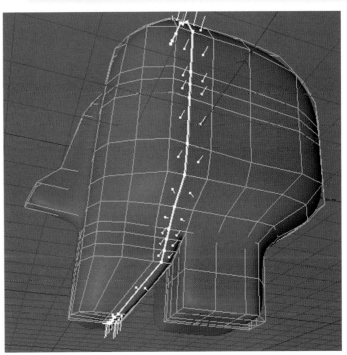

Step 39 Loop select the polygons where the face attaches to the neck. Use the Knife tool to cut two new edges in this loop. ***Figure HeadShots_39***

Step 40 Now might be a good time to switch to points; press Command+A (Cntrl+A PC) to select all points and run Functions>Optimize. Double click on the Origin Points selection tag. Add the points at the center of the symmetry that have been created by extrusions and knife cuts. Once you've selected these points, use the Selection>Set Selection to override the previous selection tag. You may also wish to save your scene incrementally.

Figure HeadShots_39

The basic shape is in place, and now the modeling switches to detail. The tools that will come into play now are the Extrude tool, Extrude Inner tool, the Magnet tool and the Brush tool.

Figure HeadShots_40

Note: The Brush tool set to Smear and the Magnet Tool will work similarly to pull and push as a soft selection to create organic forms. The Brush tool set to Smooth is excellent for fixing issues with unintended folds and for creating a clean, evenly spaced mesh.

Note: Both the Magnet and Brush tools are found in the Structure Menu.

213

CINEMA 4D: The Artist's Project Sourcebook, Third Edition

To help in the final shaping, I've provided a head shape image to use in the background. This would be the same workflow you would use to create your own character. These images could be line drawings, photographs, etc. The rest of this tutorial will focus more on general sculpting of the features. For more on character modeling, watch the **Modeling_Techniques** movie files located in the Head Shots chapter of the DVD_Support_Files folder on the accompanying DVD.

Step 41 Press F3 to go to the Right View. Click on the Edit Menu in the Viewport, Choose Edt>Configure. *Figure HeadShots_41*

Step 42 In the Attribute Manager, click on the Back Tab and click on the Image Field. Load the **Head_Side.tif** image from the Head Shots folder on the DVD. Position and Scale the image to Offset X 43 and Offset Y - 72. Raise the Size X to 1722 and Size Y will automatically update to 1291.5. In order to see our shape better, I've set the Transparency to 81%. *Figure HeadShots_42*

Figure HeadShots_41

Figure HeadShots_42

Step 43 Click on the Points tool and choose Structure>Magnet. Make sure there are no points selected and try to shape the polys to be similar to the background image provided. Make sure that Visible Only is unchecked in the Attribute Manager. *Figure HeadShots_43*

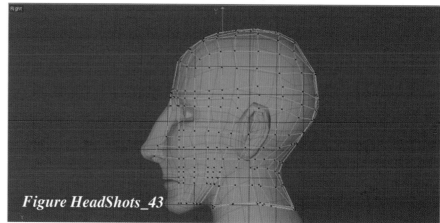

Figure HeadShots_43

Chapter 8: Head Shots

Step 44 Turn up the radius of the Magnet to around 250 and disable the HyperNURBS. Pull the Nose area out and the chin up a bit. ***Figure HeadShots_44***

Step 45 Now, choose the Structure> Brush tool. This is a great tool for organic modeling and one you will want to get very familiar with. Change the Mode to Smooth and paint over the points that connect the neck to the head and the back of the head and neck.
Figure HeadShots_45

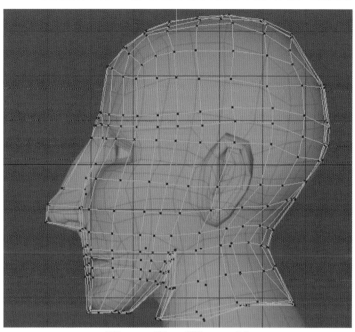

Figure HeadShots_44

Figure HeadShots_45

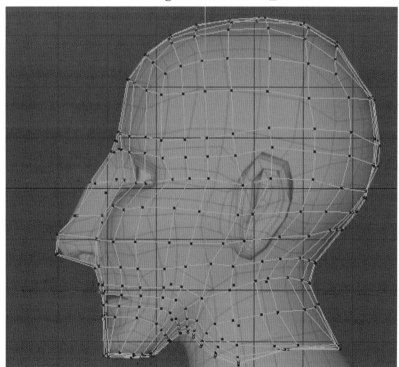

215

Step 46 Roll around the view and move the origin points to make the head shape correct. By default, the magnet may have created a crease at the top. The key to smoothing this area is to create more evenly spaced polygons by spreading the points out on the X axis. *Figure HeadShots_46*

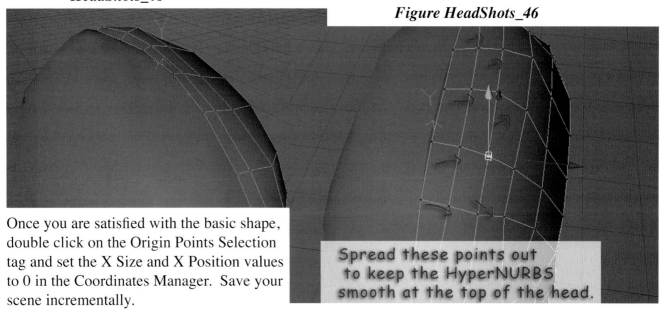

Figure HeadShots_46

Spread these points out to keep the HyperNURBS smooth at the top of the head.

Once you are satisfied with the basic shape, double click on the Origin Points Selection tag and set the X Size and X Position values to 0 in the Coordinates Manager. Save your scene incrementally.

Step 47 Press F4 to pull up the Front View. In the Viewport, click on the Edit Menu and choose Edit>Configure. Load the **Head_Front.tif** image for the Background here. Set the Size X to match our previous background image at 1722. Set the Offset X to 7 and Offset Y to - 72. Raise the Transparency to 80%. *Figure HeadShots_47*

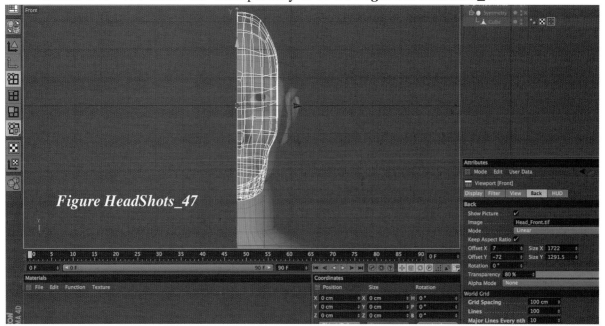

Figure HeadShots_47

Chapter 8: Head Shots

Step 48 Click on the Polygon tool and make a selection (I've selected 18 polys) on the side of the head and face similar to *Figure HeadShots_48*.

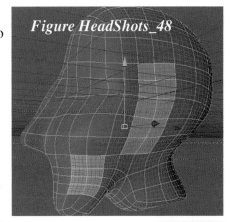

Figure HeadShots_48

Step 49 Activate the Move tool and enable Soft Selection in the Attribute Manager. Up the Radius to 400 and drag these polys out to the right until it matches the general width of the bg image. *Figure HeadShots_49*

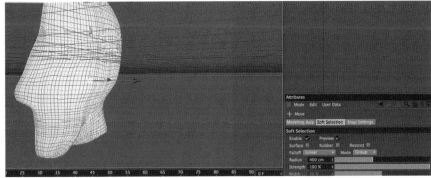

Figure HeadShots_49

Creating the Shape of the Eye

Step 50 In the Polygon tool, select the three polys that will serve as the base of the eye. Set the Z Size for these at 0 in the Coordinates Manager. Press the I key to pull up the Extrude Inner tool. Set the Offset to 3 to create the first new loop. Perform a second extrusion with the same value by choosing New Transform. *Figure HeadShots_50*

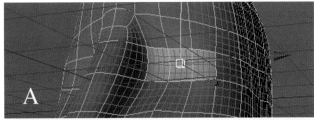

Figure HeadShots_50

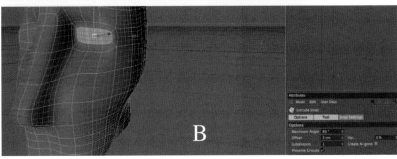

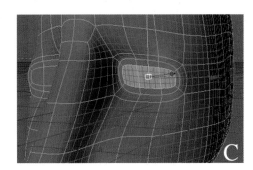

217

Step 51 Use points and the Move tool to get the basic eye shape. Switch back to polygons, press the D key and extrude back into the head with a value of - 5 and then make a second extrusion of - 105. Raise the Y size to 120 in the Coordinates Manager. *Figure HeadShots_51*

Figure HeadShots_51

Step 52 Add a Sphere object; as we will need to use its shape to figure the shape of the eye. Set the Radius to 58; the position in this example is P.X 91, P.Y 40, P.Z - 79. Use the Move and Magnet tools to reshape the points around the eye. If you are using the template image, be sure to check the right and front views to help line up the shape.
Figure HeadShots_52

Figure HeadShots_52

Chapter 8: Head Shots

Creating the Nose Shape

Step 53 Before we add the nostrils, we need to create another edge loop. Use the Loop Selection tool to select the second loop of polys from the center. Press the K key to activate the Knife tool. Make sure it is set to Loop mode and cut a new edge in the center of this loop. You may find it easiest to rotate the view around to the back to make this cut. ***Figure HeadShots_53***

Figure HeadShots_53

Step 54 Loop select the polys that make up the loop with our nostril polygon and use the Knife tool to cut it in half. If you are using the template, press F3 to go to the Right View and adjust the points around the tip of the nose and on the cheek to match the background image. You will want to disable the HyperNURBS to make it easier to match the mesh. ***Figure HeadShots_54***

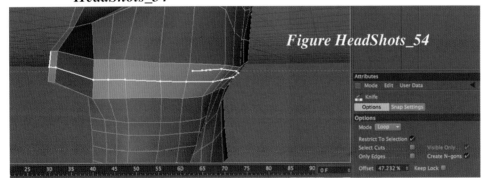

Figure HeadShots_54

Step 55 In the Polygon tool, loop select the polygons that reside under the nose. Use the Knife to loop cut a new edge just below the nose. ***Figure HeadShots_55***

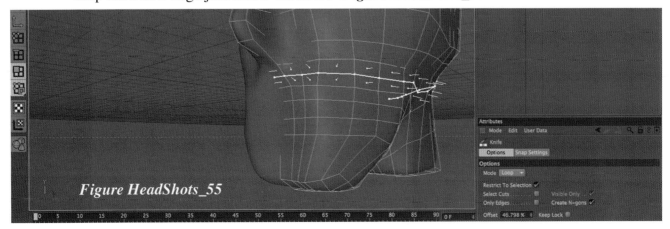

Figure HeadShots_55

Step 56 Select the two polygons to the side of the nose tip. Set their X size to 0 in the Coordinates Manager. Press the D key to access the Extrude tool. Extrude these polys with an offset of about 15. *Figure HeadShots_56*

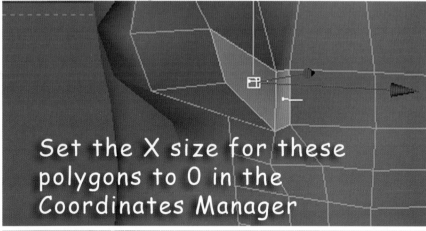

Figure HeadShots_56

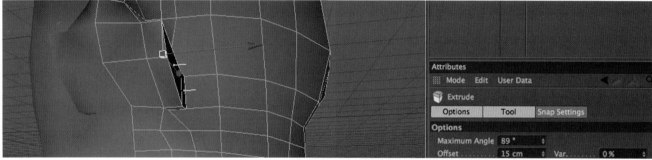

Step 57 Switch to Points and use the Move tool to make the proper base shape. *Figure HeadShots_57*

Figure HeadShots_57

Step 58 In Polygons, select the bottom two polygons of the nose. Press the I key to summon the Extrude Inner tool and extrude these with an offset of 7. *Figure HeadShots_58*

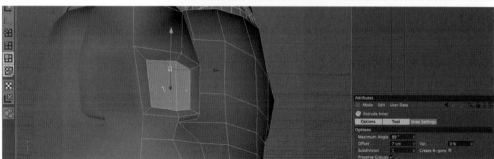

Figure HeadShots_58

Chapter 8: Head Shots

Step 59 Press the D key and extrude these up into the nose with an offset of - 7. Extrude again with an offset of - 15. After extruding, scale these polys down on the X to a size of 20, and set the Y size to 0. ***Figure HeadShots_59***

Figure HeadShots_59

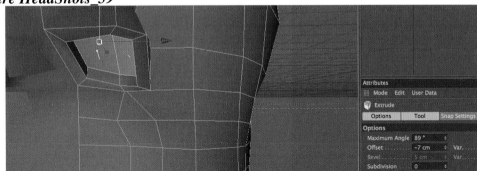

Step 60 Switch to points and select and move the points comprising the nose to match the background picture in the Right View. Select the points of the nostril and use the Move tool to move these in and up to make the desired shape. ***Figure HeadShots_60***

Figure HeadShots_60

221

Creating the shape of the mouth

Step 61 Go to the Polygon tool, and select the eight polygons that will serve as the starting point of the mouth. Set the Z size of these polygons to 0 in the Coordinates Manager.
Press the I key to inner extrude these polys. Perform the extrusion with an offset of 3.3. Select the two polys created in the center and delete them. Switch to points and delete the extra points remaining from the extrusion. *Figure HeadShots_61*

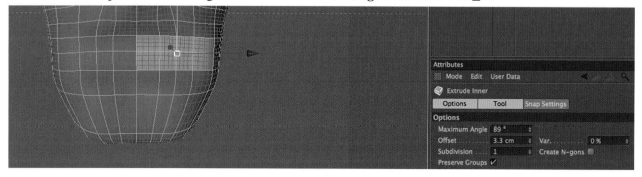

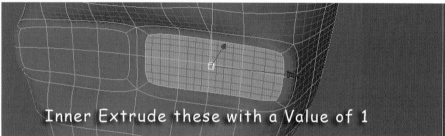

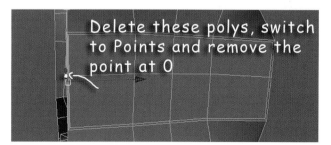

Figure HeadShots_61

Step 62 Grab the three points in the center of the mouth shape and set their X Size and Position to 0 in the Coordinates Manager. *Figure HeadShots_62*

Figure HeadShots_62

Chapter 8: Head Shots

Step 63 Move the mouth polys out in front of the face to help shape the lip. Perform an inner extrusion (I key) with an Offset of 3. *Figure HeadShots_63*

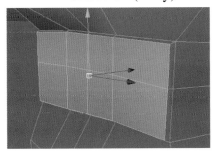

Figure HeadShots_63

Step 64 Perform two extrusions (D key) with Offsets of - 3 each to create new subdivisions for the lips. *Figure HeadShots_64*

Figure HeadShots_64

Step 65 Press the D key again and set the Offset to - 5. Scale the resulting extruded polys up to a Y scale of 35. Press the D key again and extrude this selection with an Offset of - 5. Scale the size of these polys up to 65. Extrude one more time with an Offset of - 60. *Figure HeadShots_65*

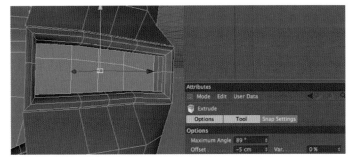

Figure HeadShots_65

Step 66 Select all of the inside polygons created by the extrusions. These destroy the appearance of our symmetry. Press Delete to get rid of them. Switch to points and press Cmd+A (Cntrl+A PC) to select all points and choose Functions>Optimize to remove extra points. Remember to keep up with the new origin points that have been created with the new extrusions.

Double click on the Origin Points Selection tag in the Object Manager. Shift+Select the new points that should be at 0 and choose Set Selection to override the previous. Set their size to S.X 0 in the Coordinates Manager. *Figure HeadShots_66*

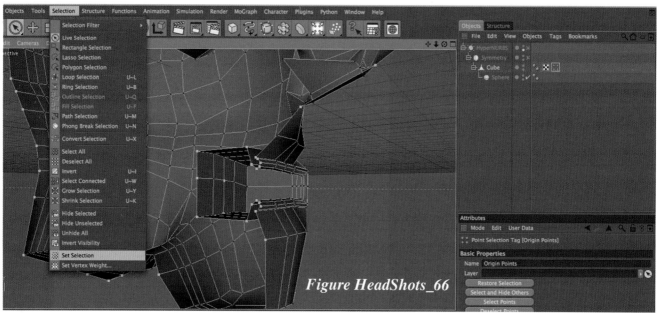

Figure HeadShots_66

Step 67 Use the Magnet and Move tools to pull out the points of the lip to create fuller lips and use the Brush tool, set to Smooth, to rid the lips of any rigid features.
Figure HeadShots_67

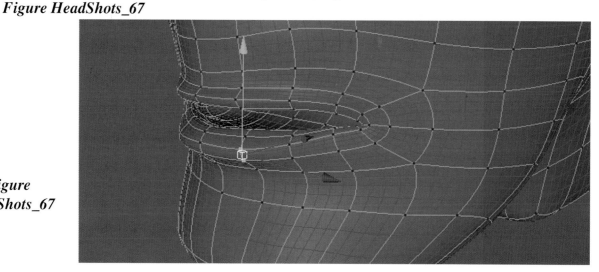

Figure HeadShots_67

Chapter 8: Head Shots

Creating the Ear Shape

It is time to focus on creating the ear. The same Extrusion and push/pull techniques will be used to complete the task, but first we must do a couple of steps to prep the mesh.

Step 68 To take pressure off the polygons that form the brow, loop select the polys in the respective area. Use the Knife tool to loop cut a new edge.
Figure HeadShots_68

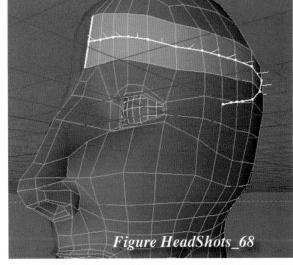
Figure HeadShots_68

Step 69 Loop select the polygons just above the eyes and use the Knife tool set to Loop in order to cut more detail.
Figure HeadShots_69

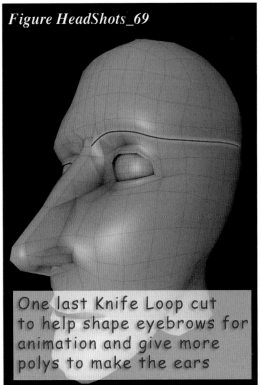
Figure HeadShots_69

One last Knife Loop cut to help shape eyebrows for animation and give more polys to make the ears

Step 70 Setting up the ear requires that you first adjust the points to get a general shape and position.
Figure HeadShots_70

Figure HeadShots_70

225

Step 71 Extrude these polys a couple of times with an Offset of about 10 each. Switch to Points and use the Move and Selection tools to reshape the extruded shapes into our base ear.
Figure HeadShots_71

Figure HeadShots_71

Step 72 With the extruded polygons selected, press the I key and inner extrude the selection three times with a value around 9 each for the Offset. **Figure HeadShots_72**

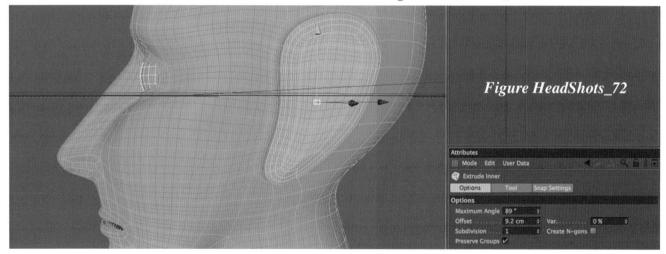

Figure HeadShots_72

Step 73 Loop select the first extruded group and hold the Shift key as you Fill Select the rest of the polys of the ear. (Selection>Fill Select) Use the Rotate tool to rotate the back of the ear out, giving the ear the right angle. **Figure HeadShots_73**

Figure HeadShots_73

Chapter 8: Head Shots

Step 74 Use the Move tool to move the ear out and then use the Points, Selection and Move tools to arrange the shape of the earlobes. *Figure HeadShots_74*

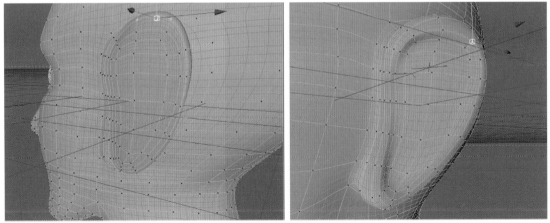

Figure HeadShots_74

Step 75 Pull the back of the ears out and work the shape of the bottom of the ear. Once your basic shape is set, select the polygon you would like to extrude into the ear. Extrude and rotate and extrude again to keep the newly formed polys from pushing through the mesh of the face. *Figure HeadShots_75*

Figure HeadShots_75

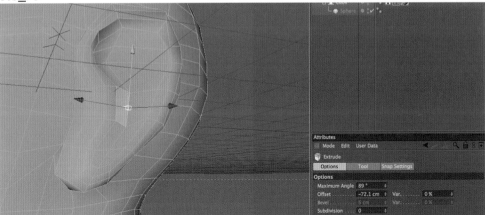

Step 76 After the extrusion, use the Move and Magnet tools to reshape the ear to finish out the shape. *Figure HeadShots_76*

Figure HeadShots_76

Step 77 Use the Brush tool to finalize the ear by smoothing the connection of the front ear to the face. A small brush with a Radius close to 25 and a very low Strength around 15 will give subtle smoothing values to the mesh. *Figure HeadShots_77*

Figure HeadShots_77

Step 78 To finalize the head mesh, select the bottom polys of the neck and set the Y Size to 0. *Figure HeadShots_78*

Figure HeadShots_78

Step 79 Extrude these polygons and use the Magnet, Selection and Move tools to expand these polys. *Figure HeadShots_79*

Use the Magnet tool to make any overall thickness changes to the neck. Be sure to select all of the additional origin points that have been created by cuts and extrusions and set the selection again.

Once you are finished with the Symmetrical modeling you may want to make the Symmetry editable and make custom changes to each side separately. Just remember to save a copy of your symmetry model first, so you can always go back to it.

Figure HeadShots_79

Chapter 8: Head Shots

Animating a Character with Pose Morph

Just as we used the Magnet and Brush tools to help shape the head, we can use these same tools to craft poses and morph between for animation.

Step 1 Open the **Morph_Start.c4d** file. You will see the main head model placed as a child of a HyperNURBS. There is also a folder made of poses that I used to help make the animation. The Pose Morph tag can be added to any object by Right clicking and choosing Character Tags>Pose Morph. *Figure Pose_Morph_01*

Figure Pose_Morph_01

Step 2 Click on the Morph tag to see how it works. The Edit menu lists all of the poses that have been stored for this model. The Left Eye Blink, Left Eye Sad and Left Eye Angry poses were all created by choosing Add Pose at the bottom of this menu. With the new pose selected, you can use the Magnet tool and the Brush tool to reshape the head into the configuration you want for that pose. Once you're finished, you can go to the animation menu and pull around on the sliders to see how the poses animate from one to another.

Step 3 Enable Animate and take a moment to drag the sliders and see how they interpolate based on the value of each pose. Notice that there are keyframe ellipses to the left of every pose. *Figure Pose_Morph_02*

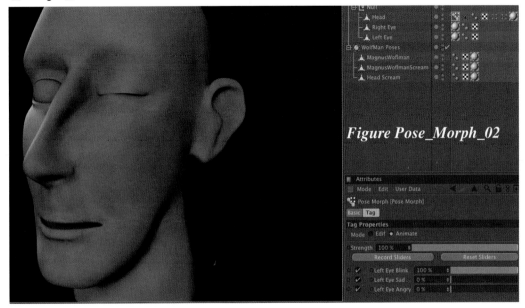
Figure Pose_Morph_02

Step 4 If you're working on a symmetrical model such as this, you can mirror the poses from one side to the other. That is what we will do now. Right click on the Left Eye Blink pose and select Copy. Right click in an empty space of the Edit list and choose Paste.
Figure Pose_Morph_03

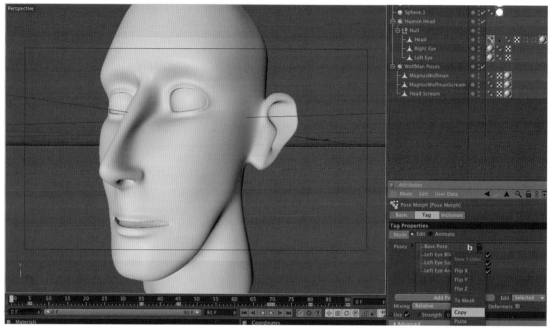

Figure Pose_Morph_03

Step 5 Double click on the copy and rename it Right Eye Blink. Right click on it and choose Flip X. Drag its Strength slider at the bottom to 100% to see the right eye close. *Figure Pose_Morph_04*

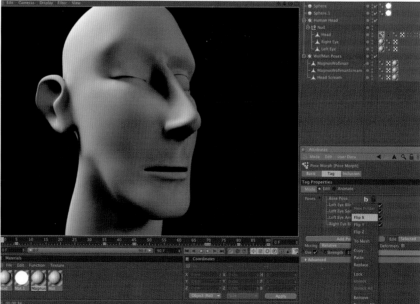

Figure Pose_Morph_04

Chapter 8: Head Shots

Step 6 Still in Edit mode within the Pose Morph Tag, drag the MagnusWolfman model and drop it as a Pose in the List. Choose Yes when the absolute dialogue appears. This is the second option for adding poses. Note that these outside models were created from the original head. They have the same points and polygons but have been reshaped in ZBrush. This makes it easy to have large transformations in a morph. Drop the Magnus WolfmanScream and the HeadScream models into the Edit menu in the same manner. *Figure Pose_Morph_05*

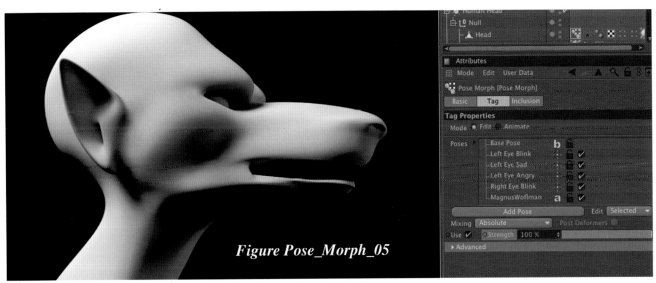

Figure Pose_Morph_05

Step 7 Click on Animate in the Pose Morph. Scroll to Frame 4, set the Left Eye Blink and Right Eye Blink values to 100% and Control Click on the keyframe ellipses to the left of their sliders. Control click on the Head Scream to set a keyframe for its value of 0% at Frame 4. *Figure Pose_Morph_06*

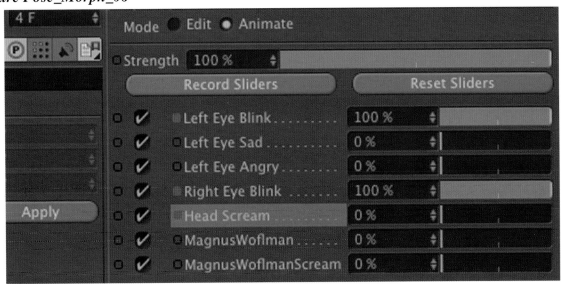

Figure Pose_Morph_06

231

Step 8 Scroll to Frame 10, lower the keyframes for the Left and Right Eye Blinks to 0% and Control click to set another keyframe for each.

Step 9 Scroll to Frame 35, and set a keyframe for the MagnusWolfmanScream pose with a value of 0%. *Figure Pose_Morph_07*

Figure Pose_Morph_07

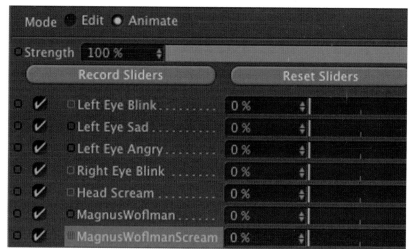

Step 10 Move to Frame 45, and set a keyframe for the Head Scream pose with a Strength value of 100%.

Step 11 Scrub to Frame 65, and set a keyframe for the MagnusWolfman pose at 0%.

Step 12 Move forward to Frame 70, and set a keyframe for the Head Scream pose at 0% and a keyframe for the MagnusWolfScream for 100%. *Figure Pose_Morph_08*

Figure Pose_Morph_08

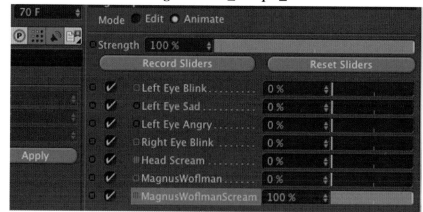

Step 13 Scroll to Frame 80, and set a keyframe for the MagnusWolfman pose at 100%

Step 14 Scroll to Frame 89, and set a Keyframe for the Magnus Wolfman Scream with a value of 0%.

Chapter 8: Head Shots

Step 15 Play the animation and watch as the human character transforms into a werewolf.
Figure Pose_Morph_09

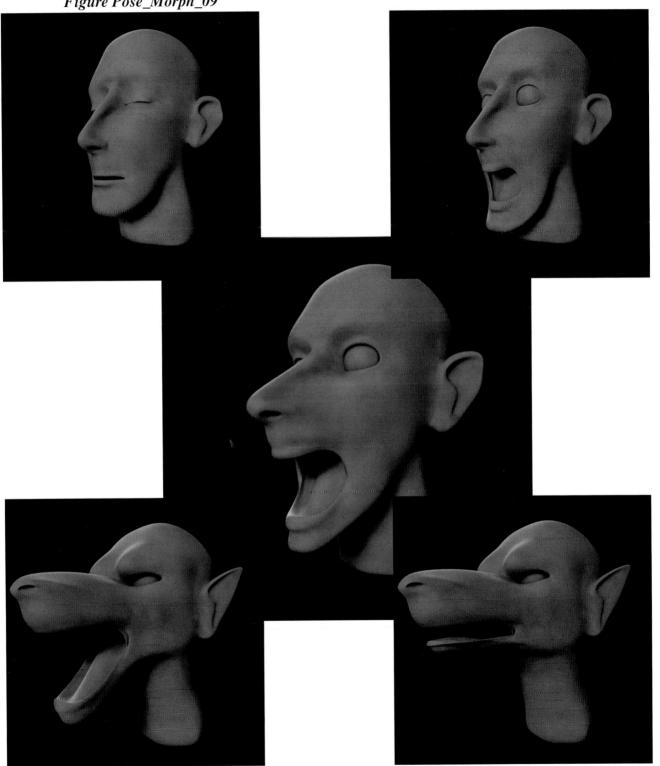

Rigging a Character 9

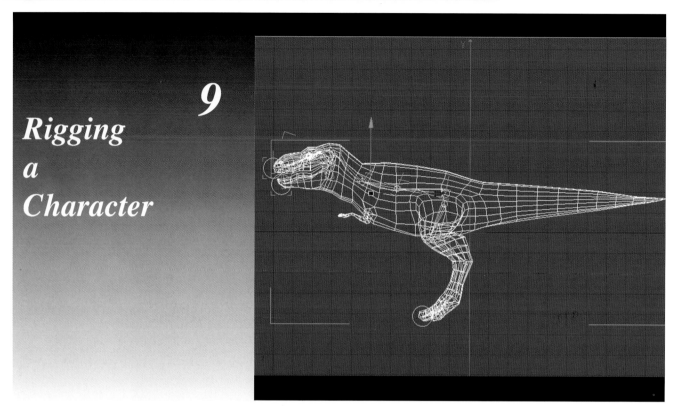

A successful character begins with solid conceptualization and then is made practical by a model that has an optimized geometric build suitable to bend and react correctly during animation. The next step is a solid rig that provides the controls animators need to take a great character or creature design to a great character or creature. I created the model for this exercise in the same way we built the head in the previous chapter, knowing during the construction of the model where extra subdivisions and edge loops would be necessary for smooth animation. In summary, great character animation is a full process, and the rig is just one of the major components to being successful.

Creating the Joints

Step 1 Open the **Dino_Rig_Start.c4d** file located in the Character Rigging folder on the DVD.

Chapter 9: Rigging a Character

Step 2 Go to the Right View (F3). Load the Joint Tool from the Character Menu. In the Attribute Manager, disable Root Null. *Figure Rigging_01*

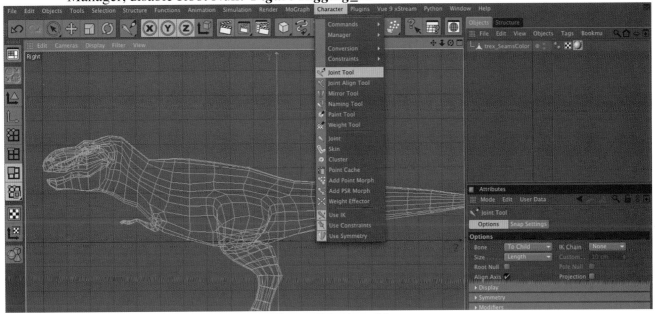

Figure Rigging_01

Step 3 Control click to create a new Joint in the five locations, as shown in *Figure Rigging_02*. This will create the hip, spine and neck of our rig.

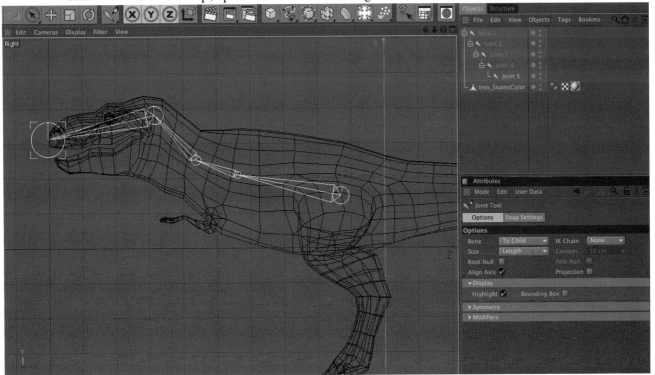

Figure Rigging_02

235

Note: *If you want to move a joint that you've placed but do not want to affect any other joint in the hierarchy, use the move tool and hold the Control key as you reposition the selected joint.*

Step 4 Rename the joints in order of creation: Hip, Mid Back, Shoulder, Neck and Upper Jaw.

Note: When renaming objects, double click the first to access the name and then, when ready to move to the next, use the arrow key to navigate to the other objects you want to rename.

Step 5 Select the Neck Joint, and then go to the Joint Tool and Control click two joints to become the lower jaw. Rename them Lower Jaw and Lower Jaw Tip. Drag them just below the Upper Jaw in the hierarchy. The Upper and Lower Jaws should be on the same level, subordinated under the Neck joint. ***Figure Rigging_03***

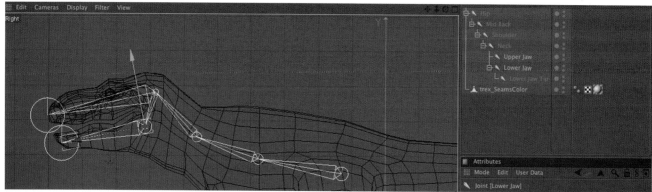

Figure Rigging_03

Step 6 Deselect all of the joints and choose the Joint tool. This time, enable Root Null. Add five joints according to ***Figure Rigging_04***. (I've hidden the other joints from the Editor to make it easier to see.) Rename the Root Null and joints in order of creation: L_Leg, L_Thigh, L_Knee, L_Ankle 1, L_Ankle 2, L_Foot, L_Toe Tip. ***Figure Rigging_04***

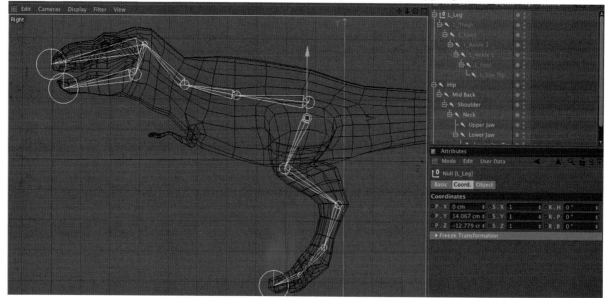

Figure Rigging_04

236

Step 7 In the Front view, Select the L_Leg and drag the entire hierarchy over to where the Thigh needs to be positioned. *Figure Rigging_05*

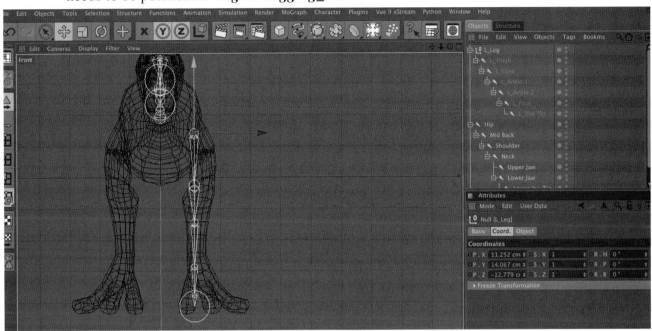

Figure Rigging_05

Step 8 Use the Control key to move the L_Knee and L_Ankle joints into place without affecting other joints in the hierarchy. Adjust the positions to match *Figure Rigging_06*.

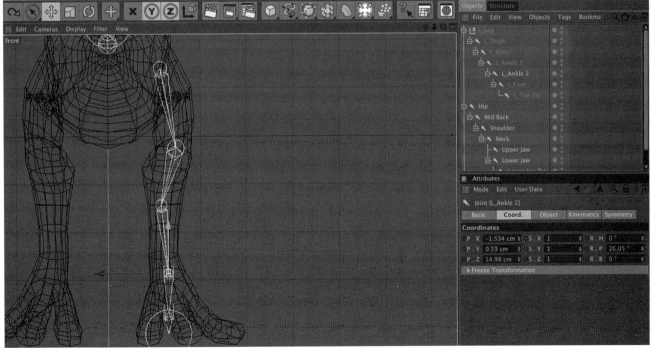

Figure Rigging_06

Step 9 Deselect all joints and choose the Joint tool again. Switch to the Right View (F3) and Control click to add 10 joints for the Tail. Rename them in order of creation, 1 through 10. Rename the Root Null, Tail. *Figure Rigging_07*

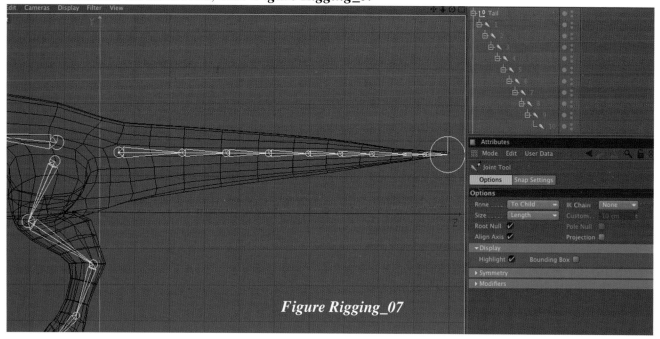

Figure Rigging_07

Step 10 Middle mouse button click on the joint named 1 to select all the joints in the hierarchy. Go to Character>Naming tool. Under Replace, type Tail_ into the Prefix field and press Replace Name. *Figure Rigging_08*

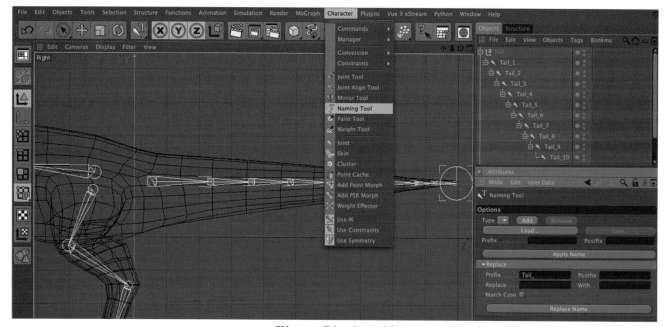

Figure Rigging_08

Step 11 Save your scene as *Dino_Rig_Joints.c4d*

We have completed the manual skeleton creation process. On the DVD, you'll see how to create IK chains and constraints then, we would mirror all of these setups to the right side of the model.

Mirroring/ Binding/ Weighting

Now that you have it saved, save an extra copy as *Dino_Rig_FK.c4d*.

Step 12 Select the L_Leg joint chain.

Step 13 Go to Character>Mirror Tool. Ensure that Children is enabled in the Tool tab. In the Naming tab, type L_ in the Replace field and R_ in the With field. Now click Mirror and your Right side will be built. *Figure Rigging_09*

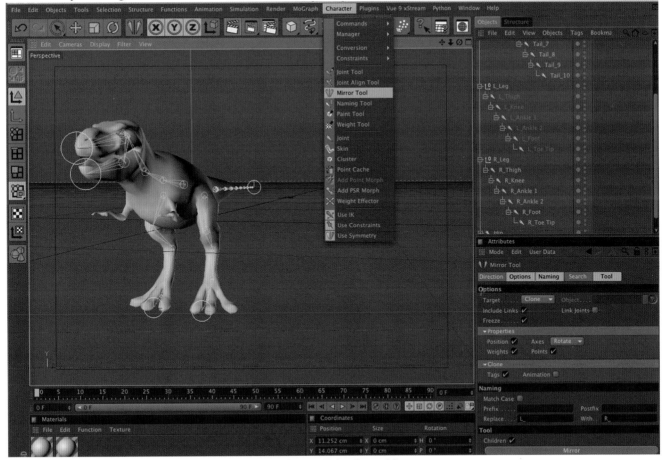

Figure Rigging_09

Step 14 Now drag the Tail, L_Leg and R_Leg groups and drop them as children of the Hip joint. Then move them down below the Mid Back so they don't interfere with the spine chain.
Figure Rigging_10

Figure Rigging_10

Note the Tail, L_Leg, R_Leg and Mid Back chains should all be equal in the hierarchy.

Step 15 Now for some quick alignment. Choose Character>Joint Align tool. Start with the Mid Back joint and press Align. Go to all of the remaining joints in the hierarchy and do the same to align those joints. For the joint chains placed beneath a Root Null, there is no need to try to align the Null but do align the joints. *Figure Rigging_11*

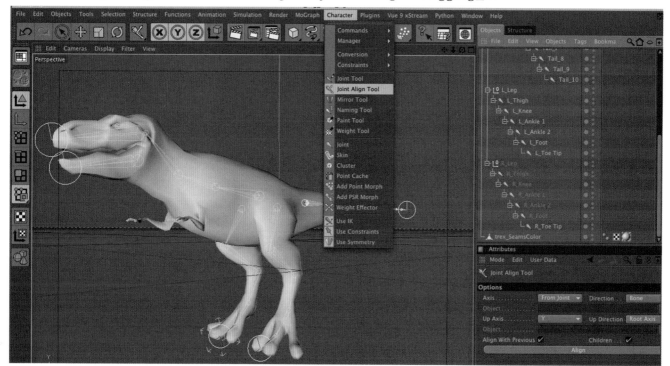

Figure Rigging_11

Chapter 9: Rigging a Character

Step 16 Select the Hip object and press Option (Alt PC) +G to create a null at its position. Rename the Null, T-Rex Skeleton.

Step 17 Middle Mouse button click on the Hip to select the entire hierarchy. Shift click on the T-Rex mesh and choose Character>Commands>Bind. *Figure Rigging_12*

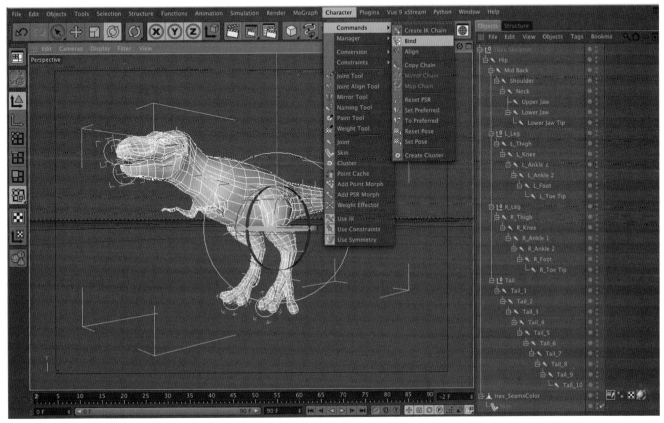

Figure Rigging_12

Step 18 Now select the Lower jaw and rotate it a bit to see how the mesh has been skinned over the skeletal rig. *Figure Rigging_13*

Figure Rigging_13

Step 19 Undo the rotation and choose Character>Weight tool. If you select the Lower Jaw joint now, you will see its influence on the mesh. Now, set the Weight Tool to a Strength Value of 0 and set the Mode to Abs (Absolute) and paint the upper mouth areas that you don't want this joint to affect. *Figure Rigging_14*

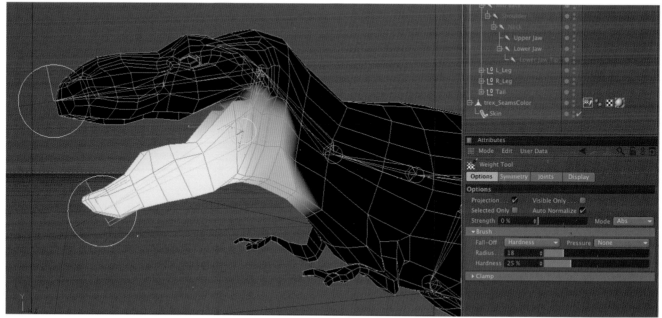

Figure Rigging_14

These are the basics of rigging a character. Be sure to check out the Rigging a Character folder on the DVD to learn how to set up a fully functional IK rig and control system!

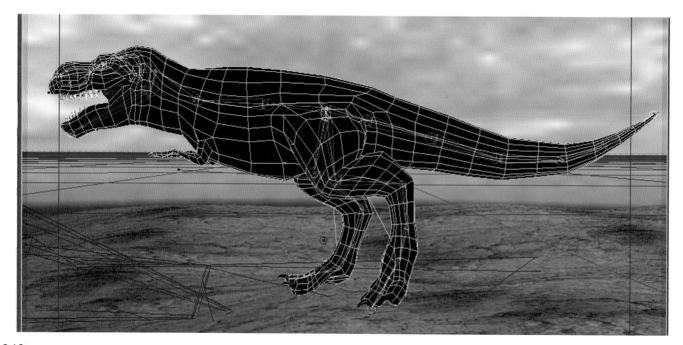

Chapter 10: Cameras in Control

Cameras in Control **10**

The creation of 3D worlds involves many integrated skills. You have already been trying on the roles of painter, sculptor, lighting director, and animator. Now, it's time to explore the world of director and cinematographer. We've implemented the use of cameras into a great many of our scenes, so in this chapter we're going to focus on camera specific functions, tools and workflows. Virtual cameras are at the very core of what makes 3D animation different from many other mediums. The ability not only to pan and zoom but also to swing around in three dimensions creates incredible control and results. You can add as many cameras to the scene as you wish and cut between them with a click of a button. This section is not a lesson in cinematography, but a study of the tools that allow you to take control and bring your cinematic visions to life.

Setting Up a Camera to Animate along a Helix

Open the **Helix_Cam_Start.c4d** file located in the Cameras in Control folder.

Step 1 Add a Helix spline from the spline pulldown. *Figure HCam_01*

Figure HCam_01

Step 2 Set the Height to 1095 and change the Plane to XZ. Move the Spline down to P.Y - 375.
Figure HCam_02

Figure HCam_02

244

Chapter 10: Cameras in Control

Step 3 Add a Camera to the scene. Right click on the new camera in the Object Manager and Choose CINEMA 4D Tags>Align to Spline. *Figure HCam_03*

Figure HCam_03

Step 4 At Frame 0, Control click on the keyframe ellipse to the left of the Position parameter to record a keyframe with a value of 0%. *Figure HCam_04*

Figure HCam_04

Step 5 Scroll to Frame 300, set the Position value to 100% and Control click to record. *Figure HCam_05*

Figure HCam_05

245

Step 6 Right click on the camera again and choose CINEMA 4D Tags>Target.
Figure HCam_06

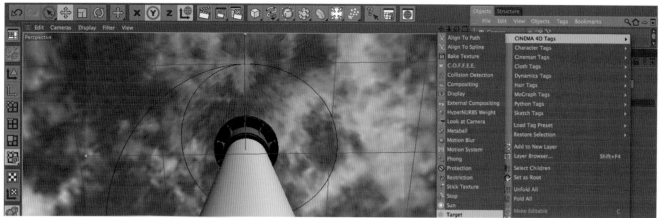

Figure HCam_06

Step 7 Drag the Light House group and drop it into the Target Object field. Play the animation to see the results. *Figure HCam_07*

Figure HCam_07

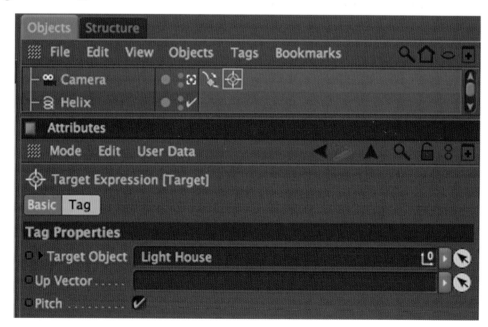

Note that the Axis of the Light House group can be moved to change the target should you desire a different focus during the animation.

Chapter 10: Cameras in Control

The Stage Object: Utilizing Multiple Cameras

Step 1 Open the **Stage_Object_Start.c4d** file from the Cameras in Control folder. In this project, you will see that three cameras have been placed within the scene. We would like to cut between all three during the render. Add a Stage Object to the scene.
Figure Stage_Object_01

Figure Stage_Object_01

Step 2 Scroll to Frame 119 and with the Stage object selected in the Object Manager, drag the Wide Shot Camera and drop it into the Camera field. Control click on the keyframe ellipse to the left of the field to set the first keyframe. *Figure Stage_Object_02*

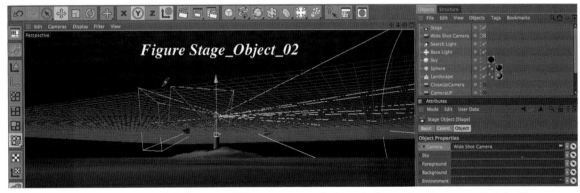

Figure Stage_Object_02

Step 3 Move to frame 120. Drag the CameraUP camera and drop it into the Camera field. Set a keyframe here. *Figure Stage_Object_03*

Figure Stage_Object_03

Step 4 Scroll to Frame 239, and set another keyframe with the same parameters set. *Figure Stage_Object_04*

Figure Stage_Object_04

Step 5 Nudge to Frame 240, drag the CloseUpCamera into the Camera field and set the final keyframe. Playback the animation. *Figure Stage_Object_05*

Figure Stage_Object_05

Chapter 10: Cameras in Control

Depth of Field

Step 1 Open the **DOFHelmets.c4d** from the Cameras in Control folder of the DVD. Select the DOF CAM and set a Target Distance of 720. This will be the area we want in focus for our render. For the Front Blur, set the Start at 0 and End at 700. For the Rear Blur set the Start at 0 and the end at 2000. *Figure DOF_01*

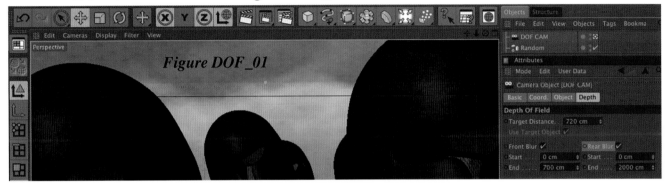

Figure DOF_01

Step 2 Open the Render Settings, Click on Effect and add Depth of Field. Set the Blur Strength to 12.5% and the Distance Blur to 1%. *Figure DOF_02*

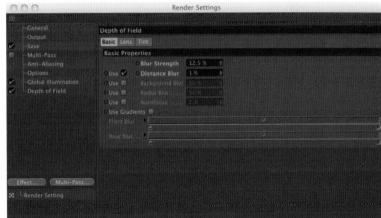

Figure DOF_02

Render the scene to see the results.

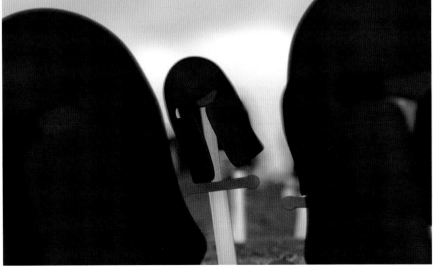

249

CINEMA 4D in Production

An Interview with Chris Smith

After a number of years working as an audio engineer and music producer, Chris co-created a feature film in 1998 during which he underwent a crash course in directing, cinematography, editing, sound design, as well as other facets of production and post production needed to finish the film. After deciding never to return to the world of feature film, Chris happily ventured back to the land of directing commercials. In 2001, he started his own production company Sugar Film Production. Since that time, Chris has directed and produced commercials for many of the world's top brands and continues to enjoy handling much of the post production on a lot of his own work.

How long have you worked in CINEMA 4D?

Since 2005.

Why did you choose to add C4D to your workflow?

I was on Maya for 4 years and tried a demo of C4D one day. I was immediately blown away by the balance of power and ease of use. For my purposes, it was perfect. I get an amazing amount of work done by using a well thought out, artistic workflow. The program itself doesn't stand in the way with un-needed steps or complexity. It also has the amazing graphical programming environment called Xpresso which solves most custom needs I could think of. In the last few years, I've used Xpresso quite extensively to make a good number of custom tools that help me considerably. Now that Python is included in r12, I've been using that quite a bit and hope to be taking custom tools to another level

Can you sum up the benefits of using 3D previsualizations over traditional preproduction techniques and standard storyboarding?

Storyboarding helps a lot to visualize the steps and story beats in a project. But when it comes down to testing exact framings, lenses, camera motions and timings, nothing can beat 'pre-creating' the shot beforehand in 3D. I often say I want to get my rough draft out of the way before I show up with real cameras and crew. I do that in C4D all the time. Sometimes I share it with others, sometimes I just use it to help define my shotlist for myself. There are many times where I will generate Quicktimes to show the DP or Key Grip so they can make that motion happen the best way possible with real equipment. Other times it allows me to place key props around and see where they should be in space. I'll figure this out in the computer first, then print a screen grab of the TOP camera view to show where everything goes on set for the Production Designer.

Besides being a director, you are also the author of the popular CS Tools plugin for C4D. What drove you to the creation of these incredible procedural tools?

I love 3D because it allows you to make anything you can imagine. However, the traditional way people animate or light scenes can be a fairly different process than the way one directs or lights a real film set. I haven't spent years developing the craft of keyframing. But I mixed my love of recreational programming and my experience in shooting TV commercials to create a new way of working in 3D --to make the experience in 3D closer to real life, where you are spending more time seeing your many results rather than just creating the first result. I made them primarily for previz because I will often have one night to create and show something. So after being frustrated with F-Curves only to get something that doesn't move like a real camera, I was thinking that a computer should be helping me and not hindering. So I started thinking about how to break things down into procedural steps that the computer can handle, and leave the artistic part to the user. So tool by tool I made things as I needed them and put them out there for free to share. I've taken some time off from CSTools as I learn more of Python, so I hope to make even more powerful and easier tools in the future. Very exciting!

Find out more about Chris Smith and Sugar Film Production at sugarfilmproduction.com

CINEMA 4D: The Artist's Project Sourcebook, Third Edition

11
The Art of Rendering

The worlds you have created in a virtual 3D space and framed in the eye of a camera must now be rendered to create a final product. In layman's terms, the computer produces a flat picture of the view through the camera for a still image of each sequential frame of a movie. The rendering can simulate the look of the real world with photographic clarity, taking into account lighting, reflections, shadows, and all the other influences of the environment. Alternately, scenes can be rendered with stylistic or even painterly strokes. The process of rendering is often a delicate balance between the level of quality you must have and the time it takes to render the project and how much time you have left before a deadline. By getting to know render settings, you can make the best use of your time and achieve the level of quality appropriate for your project.

Rather than restating the specifics of every setting available in the help system, this chapter will explore some of the most helpful uses of basic settings for the right balance of productivity and quality. In addition, it will focus on rendering methods that enhance the artistry of your work in CINEMA 4D. We will also delve into some of the more advanced rendering techniques, such as Multi-Pass rendering for post-render editing.

Investigating Render Settings

When you click the Render Settings icon, a dialog box with six tabs appears. Let's look at the most commonly used settings.

The General Tab

Render Engine

Full Render - Will use CINEMA 4D or the Advanced Render render engine to output a high quality render

Software Preview - The scene will render as it looks unrendered in the Viewport

Hardware Preview - Scene will render as it looks unrendered in OpenGL display mode

CineMan - Allows access to other render engines such as RenderMan

The Preview modes are great for checking animation and making sure the the basics of the scene are working properly before committing heavy resources to rendering high quality output. Should you choose Hardware Preview, a Hardware Preview tab will become available to customize the settings.

The Output Tab

The first option listed here is the Preset options. These are outputs categorized by type such as film/video or print.

When presets such as HDTV 1080 29.97 are chosen, the resolution is automatically updated to reflect the correct setting -- in this case 72 dpi, which is the standard for screen production. In the case of any print presets, the resolution will automatically update to the proper 300 dpi for print output. The resolution can be manually tweaked at any time.

Frame Rate and Frame Range are also included in this tab. Frame rate will automatically be set by the Preset option you choose. Whether it's 29.97 for NTSC or 25 for PAL or 24 fps for film, the rate can be altered to meet any special render requirements.

The Save Tab

An important part of exporting is the type of file you choose to save as. A format such as a Tif (Target Image Files) renders lossless by default and will preserve full quality. Tifs and PSD (Photoshop) files also allow for the exportation of Alpha Channels for Compositing in programs such as After Effects, Photoshop, Motion, Premiere and Final Cut Pro.

Many Quicktime codecs are available by default and more can be added based on other software on your system. The default Animation codec preserves the highest detail and results in the largest file size. Most Quicktime movie codecs support Alpha Channels including the H.264, which is a highly compressed but still good-quality codec. Note that H.264 movie files do not support Multi-Pass rendering. AVI options are available and will likewise have codecs specific to those loaded on your machine. I personally try to avoid using AVI unless the client's usage requires that AVI be used.

Anti-Aliasing Tab

None
No anti-aliasing is performed, which results in faster renders but jagged edges.

Geometry
This is the default mode and performs a smoothing effect on the Object edges.

Best
Ups the smoothing and includes color anti-aliasing, softens color contrasts and smoothes shadow edges as well.

Anti-Aliasing: NONE

Anti-Aliasing: GEOMETRY

Anti-Aliasing: BEST

Filter

Filter choices should be made based on whether you wish your images to be sharpened or blurred.

Still Image
The name says it all. This preset sharpens images and is not recommended for animation.

Animation
Blurs the anti-aliasing and prevents flicker when exporting animation.

Blend
Allows you to enter a value from 0 to 100% in the Softness parameter for a customizable effect.

Sinc
A sharp filter that produces higher quality results than Still Image and results in longer render times as well.

Catmull and **PAL/NTSC** are quick presets that offer lower quality, quick results.

One note to remember is the combination of other render settings that may impact the time/quality issue. For example, if you are using a high valued vector or scene motion blur, committing assets to render high quality anti-aliasing may be overkill, as the anti-aliasing will be blurred beyond recognition.

The Options Tab

The options parameters can be very important when dealing with both the quality and time required to produce your render. Transparency, Refraction, Reflection and Shadows are what they are. Most times you'll need them, sometimes not. Behind these parameters, there are more in-depth settings that determine the quality of how these key components render.

Reflection and Transparency are greatly affected by the values chosen for **Ray Threshold**, **Ray Depth** and **Reflection Depth**.

- **Ray Theshold** - Only a small percentage of the processed rays feed into the overall color and brightness of the final render. Any ray in which contributions fall below the percentage established by the threshold value will cease to move from the camera into the scene. This works as an optimization and can greatly reduce render times

- **Ray Depth** - Determines how many transparent objects, including those made transparent by the use of Alpha Channels, can be penetrated by the render. A low value can speed up your render so long as you don't have more transparent objects stacked in the scene than Ray Depth values. For instance, if you have a scene where you have eyeglasses looking through a drinking glass, out a window, you have three transparent objects stacked in your render. If you only have a Ray Depth value of 2, you will get a black render where the window is due to lack of Ray Depth. If you ever see transparent objects in your scene render black, simply raise your Ray Depth value.

- **Reflection Depth** - Works similar to Ray Depth but deals specifically with how many times a ray will be reflected and rendered. In most cases, the default value of 5 is sufficent. In very simple scenes, a value of 2 may suffice. In more complex scenes where you may have mirrors and many windows, you may find that you need to raise this value. Again, lack of Reflection Depth will lead to black renders where reflections should be seen. In that case, raise the Reflection Depth value.

- **Shadow Depth** - Determines the shadow depth calculated for visible shadow rays. A value of 15 is typically suitable unless you have many transparent, reflective or refractive elements in your scene. Similar to Reflection Depth in that, if you have a lot of reflections, you will need a higher shadow depth to catch the second, third, etc. level shadows produced by those reflections.

- **Level of Detail** - LOD can help reduce render time by lowering the subdivision level at which objects will be rendered. For example, let's say you were rendering an army for a background shot that would be slightly out of focus or just far enough away that little detail could be recognized. It would be a waste of time and resources to render these elements at full res and detail. You could lower the LOD of the scene to something like 30% and still maintain high enough quality detail at a much lower cost in terms of render time. LOD can also be applied to specific objects using the CINEMA 4D Tags>Display Tag.

Chapter 11: The Art of Rendering

- **Bucket Sequence** and **Size** - Bucket rendering has been the standard in many other 3D applications and with the Release of 11.5, C4D has joined the fray. The use of buckets is more efficient than the renderline method employed by older versions of C4D.

Automatic size is enabled by default and chooses what size the buckets should be for each render. If you have a very powerful machine, you may find a speed bump in rendering if you raise your bucket size. Take some time and experiment but note that improper bucket size, large or small, will slow down the render.

Effects

For a practical look at rendering, we will focus on some of the effects. The ever-important use of multi-pass rendering will be covered in the next section.

If you own an edition of CINEMA 4D that includes Advanced Render, you have a huge assortment of post effects to choose from. In the following projects, we'll take a look at some of the most popular.

Highlights

We'll start by looking at the post effect that created the preceding title graphic.
Open the **Highlights.c4d** file located in the Art of Rendering folder on the DVD.
This scene has a floor with a tiled reflective material and MoText lettering, with a brighter reflective material applied.

Step 1 Do a quick render of the view panel to see how this looks without the post effect applied.

257

Step 2 Open the Render Settings, click Effects, and add Highlights.
Figure HL_01

Figure HL_01

Step 3 In the Highlight settings, Lower the Threshold to 110% and the Flare Size to 12%. Click on the Preset dropdown and you will find many of the same presets we've used for Lens Effects in other projects. Select the Soft Streaks 1 preset and render the scene. Play with the Threshold and Flare Size values to compare the results. *Quick Tip: Different Presets require different values for the other parameters and a higher Threshold equates to less flares.*
Figure HL_02

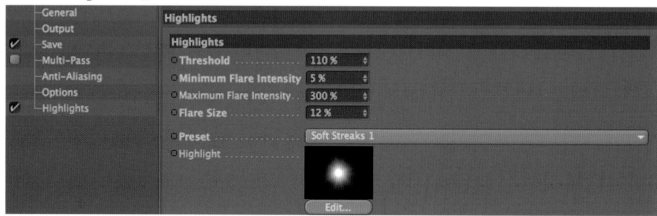

Figure HL_02

Quick Caustics

Open the **Quick_Caustics.c4d** file located in the Art of Rendering folder on the DVD.
The scene has been set up with two bottles that have transparent textures set to semi-accurate refraction values. It is the refraction that will cause the light dispersion and give us the caustics in the render.

Chapter 11: The Art of Rendering

Step 1 Click on the Render Settings button and choose Caustics from the Effects pulldown.
Figure Caustics_01

Figure Caustics_01

Step 2 In the Caustics settings, enable Surface Caustics and turn the Strength up to 250%.
Figure Caustics_02

Figure Caustics_02

Step 3 Select the SpotLight in the scene. Click on the Caustics tab and enable Surface Caustics. Ramp the Energy up to 750% and the Photons up to 50000. *Figure Caustics_03*

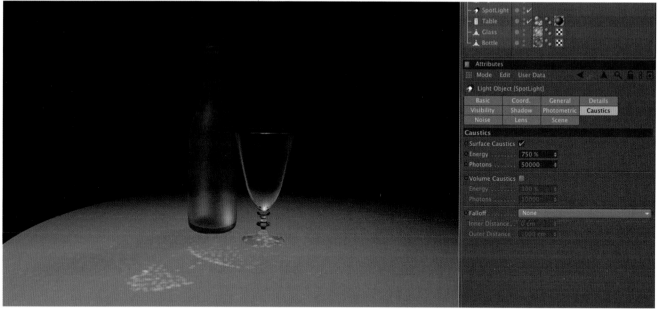

Figure Caustics_03

Cel Rendering

Open the **Cel_Render.c4d** file located in the Art of Rendering folder on the DVD.

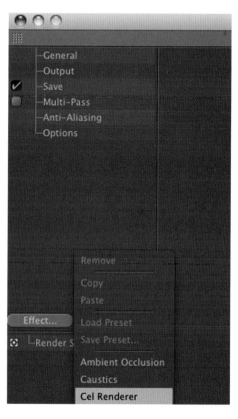

Step 1 Open the Render Settings and choose Cel Renderer from the Effects drop-down. *Figure Cel_01*

Step 2 Render the viewport and you'll see that only an outline of the bust renders with no color. If you turn on Color at this point, you get what looks like a regular render.

Figure Cel_01

Chapter 11: The Art of Rendering

Step 3 Place a check in the Edges checkbox and render the viewport. *Figure Cel_02*

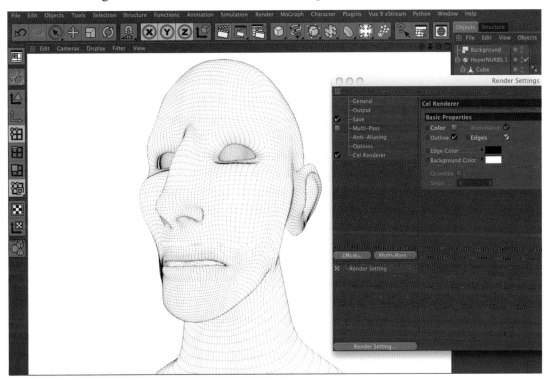

Figure Cel_02

Step 4 Change the Edge Color to Blue, enable Color and render the Viewport. *Figure Cel_03*

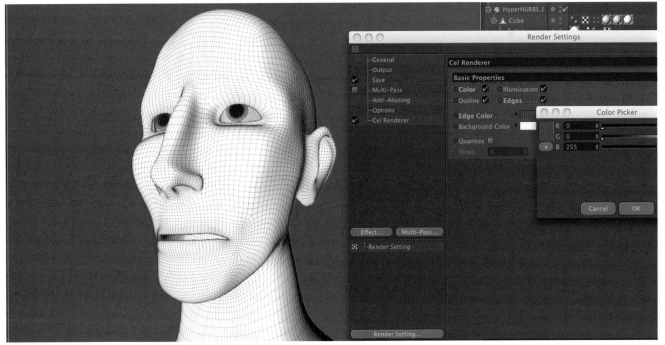

Figure Cel_03

Step 5 To add Cel shading to the render, click on the Quantize checkbox. The value listed pertains to the steps of shading provided. Render the viewport with a default value of 6. Now, lower the Quantize value to 3, turn off Outline and render a smooth Cel Shaded picture. *Figure Cel_04*

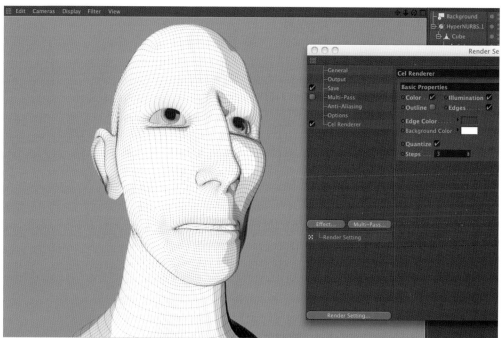

Figure Cel_04

Step 6 One last render option: turn off Color and set the Background to Black. *Figure Cel_05*

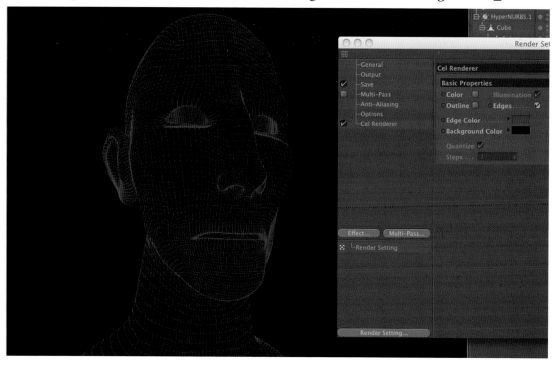

Figure Cel_05

Vector Motion Blur

Open the **V_M_B.c4d** file located in the Art of Rendering folder on the DVD.

Step 1 Open the Render Settings, click on effects and choose Vector Motion Blur. We are going to accept the default Vector Motion Blur settings and do our adjusting in the C4D tag that we are about to create for the Sphere. *Figure VMB_01*

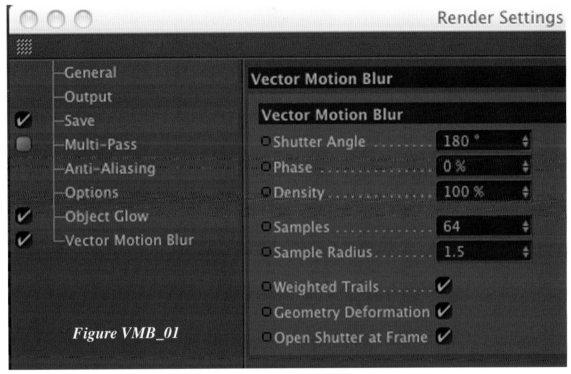

Figure VMB_01

Step 2 Right click on the Sphere in the Object Manager and choose CINEMA 4D Tags>Motion Blur. *Figure VMB_02*

Figure VMB_02

Step 3 Turn the Strength of the Motion Blur up to 250%. Render the viewport at any time in the scene and you will see no blurring. Motion blur is only calculated when rendered using the main Render Engine. You'll have to render a Full Render preview or Render a final output to see the results. ***Figure VMB_03***

Figure VMB_03

Sketch and Toon

In CINEMA 4D version 8, MAXON released Sketch and Toon as part of the Studio Bundle and as a stand-alone module. It has earned high praise for some time as one of the leading toon shaders available in the 3D market. We will just be able to scratch the surface in this exercise but will give you the basics of how to get started in using and experimenting with this incredible component.

Open the **SketchNToon.c4d** file located in the Art of Rendering folder on the DVD.

Contained in this scene is the same head model that we used for the Cel Renderer project. Sketch and Toon is in many ways similar to the Cel Renderer, but gives you an incredible amount of flexibility and control over how scenes are rendered.

Step 1 Go ahead and enable the Sketch and Toons effect in the Render Settings.

Chapter 11: The Art of Rendering

Step 2 Render the viewport to reveal a Cel shaded look. *Figure SAT_01*

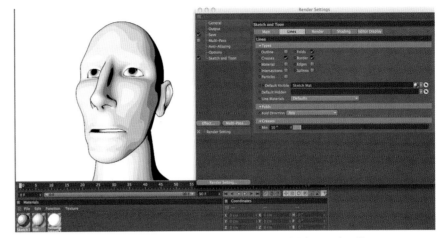

Figure SAT_01

Step 3 Click on the Shader tab of the Sketch and Toon settings. Change the Object shading parameter to Custom Color and set it to R 145, G 125 and B 105. Disable All Sketched Objects and drag the Sphere object from the Object Manager and drop it into the Exclude field. *Figure SAT_02*

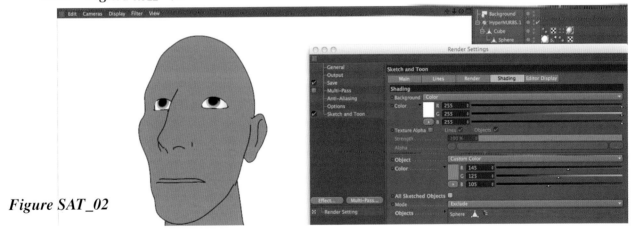

Figure SAT_02

Step 4 Add a Sketch preset material by going to the Material Manager and choosing Load Material Preset>Sketch>Pencil>(Rough Sketch). Drag the Material and drop it on the Cube in the Object Manager. *Figure SAT_03*

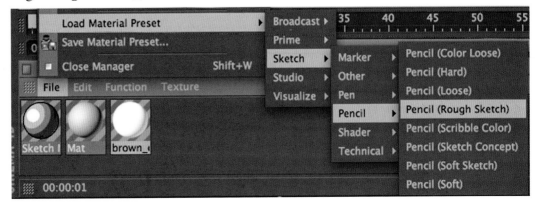

Figure SAT_03

Step 5 Double click the Pencil (Rough Sketch) material in the Material Manager and change the color in the Color Channel to R 20, G 20, B 20. Go to the Thickness channel and raise it to 4. Render the view to see the results. ***Figure SAT_04***

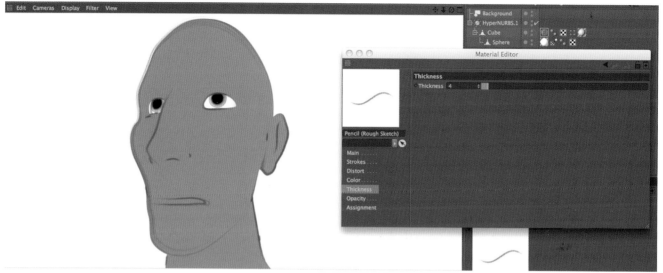

Figure SAT_04

Step 6 In the Sketch and Toons Shader settings, turn the Background off and the Object to Display Color and render the viewport. Be sure to experiment with both the settings in the Sketch and Toon render menu and in the Sketch and Toon materials that you can apply to your objects. ***Figure SAT_05***

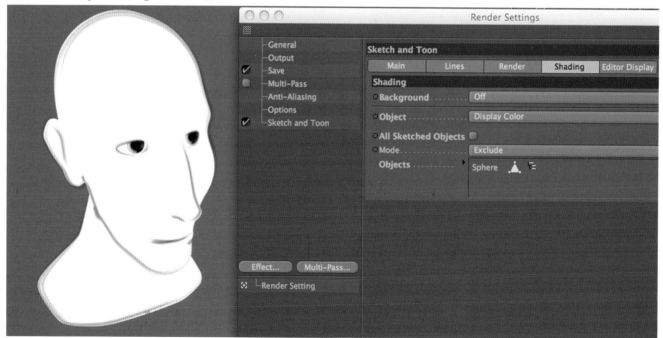

Figure SAT_05

Chapter 11: The Art of Rendering

Scene Motion Blur

Scene Motion Blur is much different than the Vector blur seen earlier. This high quality effect will blur all scene elements including those affected by Camera moves. The quality comes with a steep price as each frame is rendered at least five times in a stepped fashion, then blended together as a post effect to create the blur. To see this in action, open the **Scene_Motion_Blur_Start.c4d** file in the Art of Rendering chapter on the DVD. Click on Effects and choose Scene Motion Blur. In most cases, you may want to be cautious with the strength. In the scene we want a heavy effect, so set it at a value just over 100%. Depending on the capacity of your CPU you may want to take the samples down to 5.

QTVR Rendering

QTVR renders have for a long time been an excellent export option for CINEMA 4D. Choosing this option allows you to export Panoramic views of your 3D scene as well as Quick Time Virtual Reality movies that can be played and controlled in QuickTime. It renders a 360-degree movie from as many angles as you specify, allowing the viewer to zoom, pan and rotate around the seen. This is an excellent opportunity to put the camera controls in the hands of the viewer.

Scene Motion Blur Render

QTVR Panoramic Render

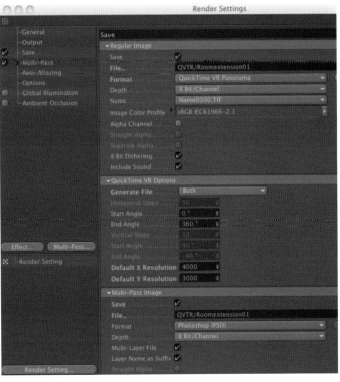

267

CINEMA 4D: The Artist's Project Sourcebook, Third Edition

Multi-Pass Rendering

Multi-Pass Rendering allows the separation of parameters, channels and effects in the rendering process. This allows flexibility in editing in other applications such as Photoshop, Premiere, After Effects, Final Cut Pro, Motion, etc.

Open the **Multi_Pass_Rendering_Start.c4d** file located in the Art of Rendering folder on the DVD.

Step 1 Open the Render Settings and enable Multi-Pass Rendering by clicking on its checkbox. We can now add channels to render by clicking on the Multi-Pass button at the bottom of the Render Settings. For this render we want to include: Diffuse, Specular, Shadow, Reflection, Ambient Occlusion, Global Illumination. *Figure MP_Rendering_01*

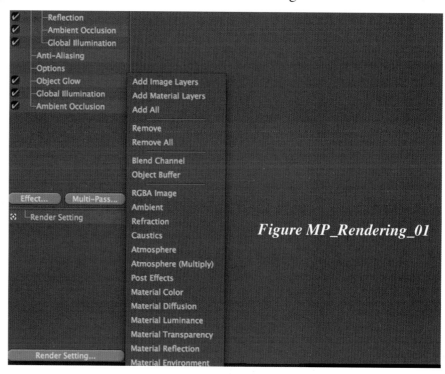

Figure MP_Rendering_01

Step 2 In the Save options, disable the Regular Image as we are only interested in the Multi-pass. Set the Format to Photoshop (PSD) and set the Depth to at least 16 bit.
Figure MP_Rendering_02

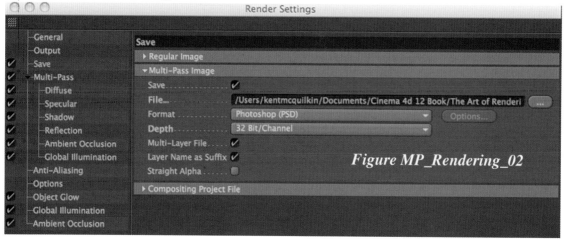

Figure MP_Rendering_02

Chapter 11: The Art of Rendering

Step 3 Press the Render to Picture View button and watch as the Render is composited. In the Layer Panel to the right, click on Single Pass. This mode breaks down every pass separately and gives you the blend modes aka Photoshop. ***Figure MP_Rendering_03***

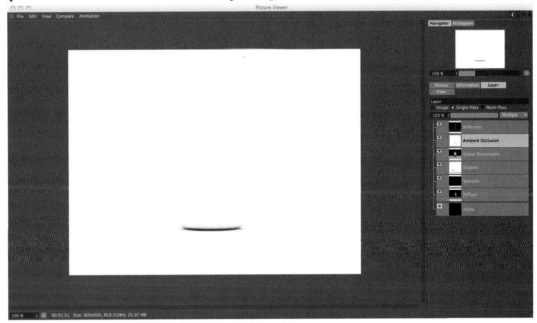
Figure MP_Rendering_03

Now that our image is rendered, open it in Photoshop for some editing.

Step 4 We'll make a few quick adjustments. First, Duplicate the Global Illumination layer. ***Figure MP_Rendering_04***

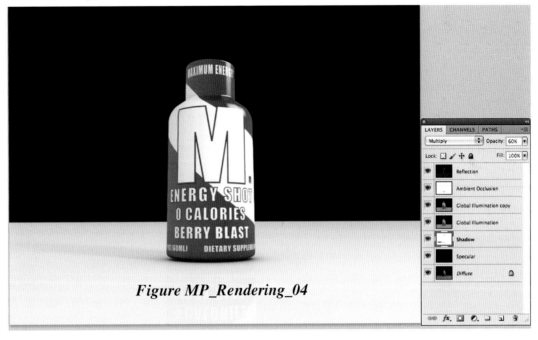
Figure MP_Rendering_04

269

Step 5 Lower the Opacity of the duplicate to 70% in the Layer Panel.

Step 6 Lighten the shadow by lowering the Opacity of the Shadow Layer to 60%.
Figure MP_Rendering_05

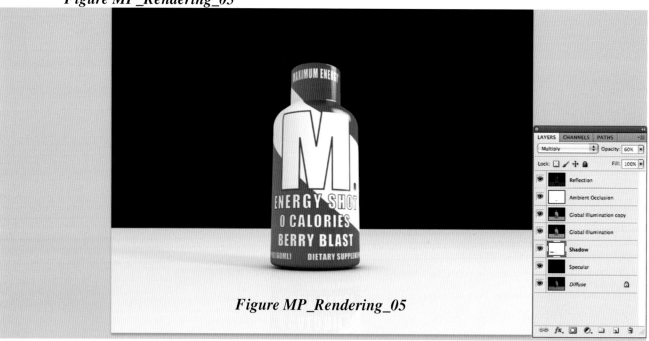

Figure MP_Rendering_05

Step 7 Now, let's suppose the client for this project wants a different color package. Add a Hue/Saturation Adjustment Layer at the top of the Layers Panel. *Figure MP_Rendering_06*

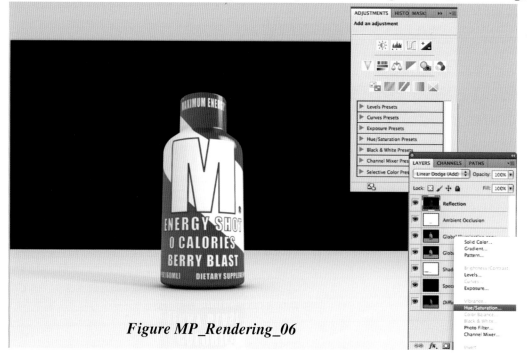

Figure MP_Rendering_06

Chapter 11: The Art of Rendering

Step 8 Set the Color that you want and enable Colorize at the bottom of the Adjustment Panel. *Figure MP_Rendering_07*

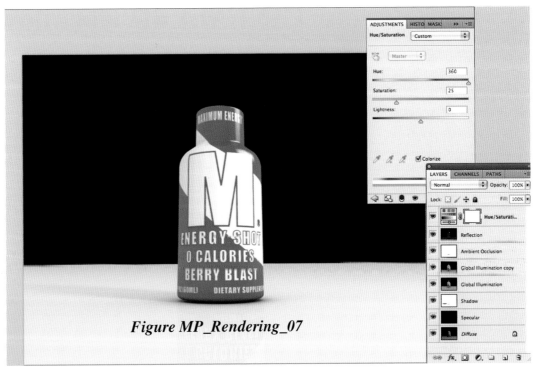

Figure MP_Rendering_07

Step 9 Finally, change the Blend Mode from Normal to Hue. *Figure MP_Rendering_08*

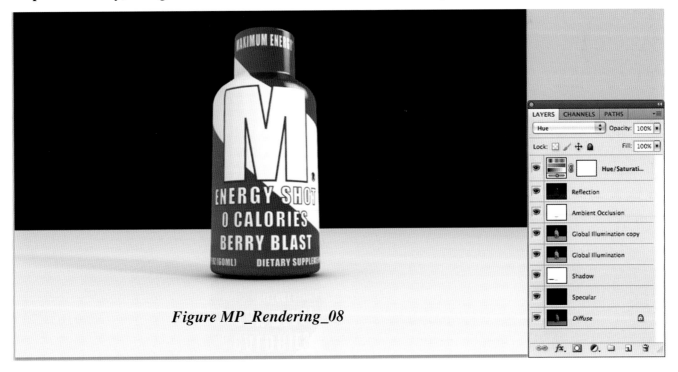

Figure MP_Rendering_08

CineMan: Integrate Pixar's RenderMan into your CINEMA 4D workflow

RenderMan has been one of the top render engines since its creation in the late 80s. It is hands down the most often-used renderer for animated and effect heavy films. In Release 11, MAXON included a new render option named CineMan. CineMan provides the translation to allow your CINEMA 4D scenes to render using RenderMan Server Pro.

The first step we will look at is setting up CineMan to find compliant rendering engines.

Open CINEMA 4D, go to the main Edit Menu and choose Preferences. Click the dropdown arrow beside Renderer. In the tag you will see Renderer with a drop down list of compatible rendering software. For Renderman Pro Server, choose PRMan.

Click on Render Settings and in the General tab, you will see the option for CineMan. Once you've selected CineMan as the renderer, you will see a CineMan tab appear at the bottom left of the settings window. Within this tab are the settings that will determine how CineMan will perform the render.

Chapter 11: The Art of Rendering

Of primary interest in the CineMan settings is the Quality tab. The two most influential settings for determining render time and quality are Pixel Samples and the Shading Rate. High Pixel Sampling leads to higher quality and slower renders. There will be a point where the sampling will become negligible and only serve to slow the render. The Shading Rate works conversely to sampling, in that the higher the value, the lower the quality. High shading rates equal faster renders as well. This is a setting that should be experimented with for every render, as often you'll find that you can greatly reduce render time without suffering any detectable loss of quality. The Pixel Filter mode determines if the render will be softer or sharper. Gaussian is softer while Catmull-Rom is a crisper filter mode.

The Features tab is where you will find Depth of Field and Motion Blur, both of which are superior to CINEMA 4D's native engine. These features are not post effects which lead to faster renders and high quality. Note that you do not need any Motion Blur tags placed on objects when using RenderMan. Similarly, no DOF settings need to be set up within your C4D cameras as the DOF can be controlled by the dialogue in this tab. But, if you like to set up your DOF in the camera, you can enable the Use Cameras Settings box. By rendering Motion Blur as part of the main render, RenderMan realizes that it can minimize many calculations because the detail is obscured by the blur. Because of this, you'll often find that scenes render more quickly when they have Motion Blurs enabled. Motion Factor is the setting that allows you to dictate how the number of shading samples should be adjusted in the areas that will be blurred. Focus Factor works in the same way for DOF.

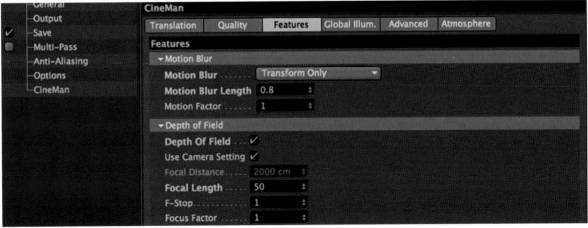

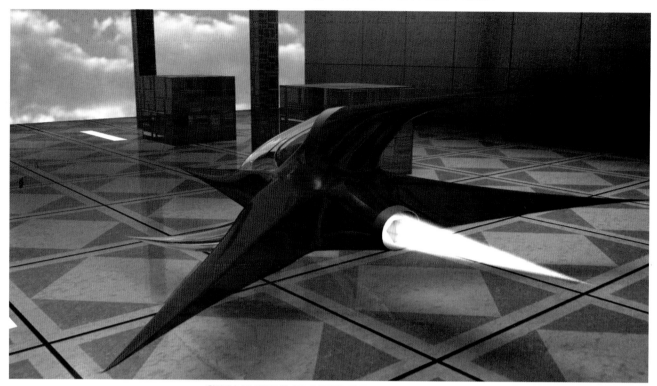

SHADING RATE SET TO 0.75

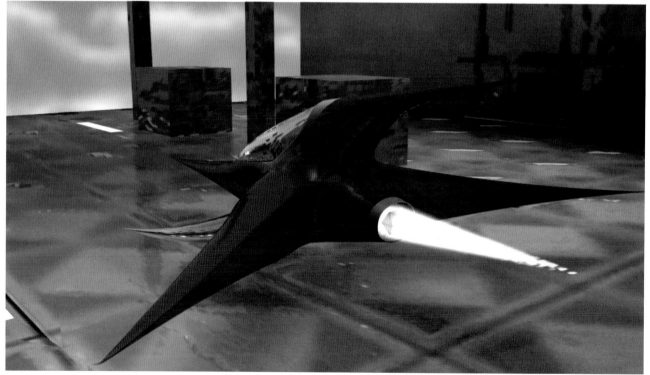

SHADING RATE SET TO 50

Chapter 12: A Jolt of Xpresso

A Jolt of Xpresso **12**

Xpresso is a node-based graphical interface for building expressions. For programmers, the possibilities are limitless. For the rest of us, Xpresso allows for automation and the creation of incredible animation by creating relationships between objects, tools, forces and the like. In this chapter and other sections scattered throughout the book, we'll cover many of the uses of Xpresso. Look at these and think of other uses that you can find from these expressions within your work.

School of Fish

Step 1 Open the **School_of_Fish_Start.c4d** scene in the Jolt_of_Xpresso project folder on the DVD. There is a fish in this scene with a Bend deformer applied to create the tail swish movement for animation. To create realistic and organic animation, we are going to use Xpresso to randomly alter the strength of this deformer, thus creating the tail swish animation.

Step 2 Right+Click the Bend deformer and choose, CINEMA 4D Tags>Xpresso. *Figure School_01*

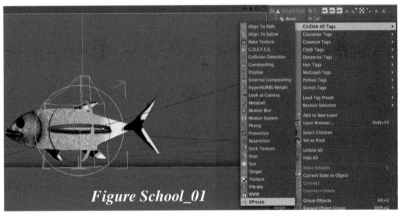

Figure School_01

275

If the Xpresso Editor doesn't open automatically, simply double click on the Xpresso tag now added to the right of the deformer.

Step 3 Drag the Bend deformer and drop it into the Xpresso Editor.
Figure School_02

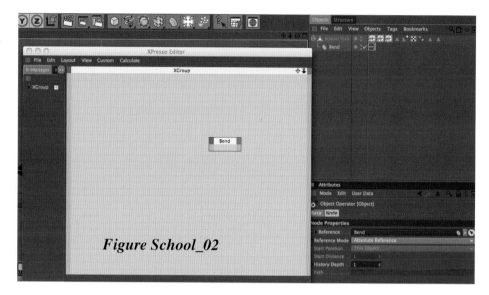

Figure School_02

Step 4 Right click in an empty space in the Xpresso Editor and choose New Node>Xpresso>General>Noise. *Figure School_03*

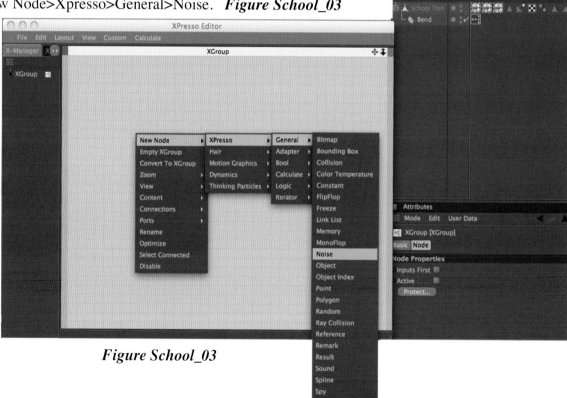

Figure School_03

Chapter 12: A Jolt of Xpresso

Step 5 Right click in an empty area again, this time choosing NewNode> Xpresso> Calculate> Range Mapper. *Figure School_04*

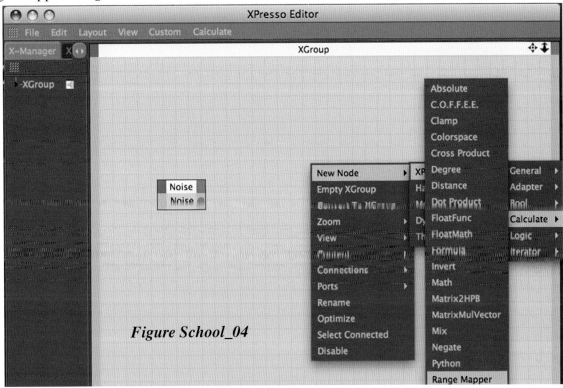

Figure School_04

Step 6 Click once on the blue square located on the left side of the Bend node. Choose Object Properties>Strength. *Figure School_05*

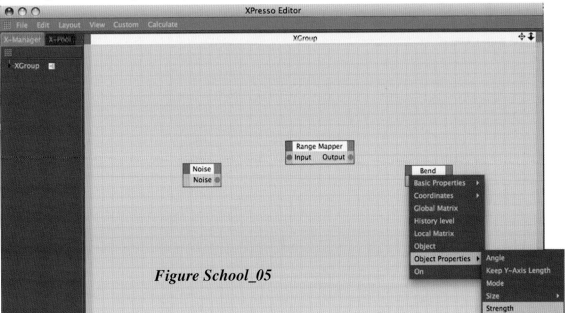

Figure School_05

Step 7 Drag from the Red Output ellipse on the Noise node and connect it to the Blue Input ellipse of the Range Mapper. Now drag from the Red Output ellipse of the Range Mapper node and connect it to the Blue ellipse of the Bend node. *Figure School_06*

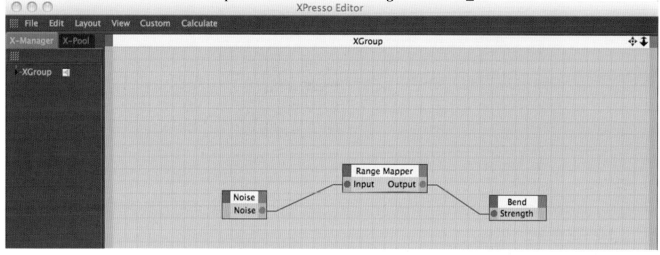

Figure School_06

Step 8 Select the Noise node in the Xpresso Editor and look at its settings in the Attribute Manager. Change the Noise Type to Fractal Brown Movement, the Octaves to 3, Scale to 5, Frequency to 4.5 and Amplitude to 2.5. *Figure School_07*

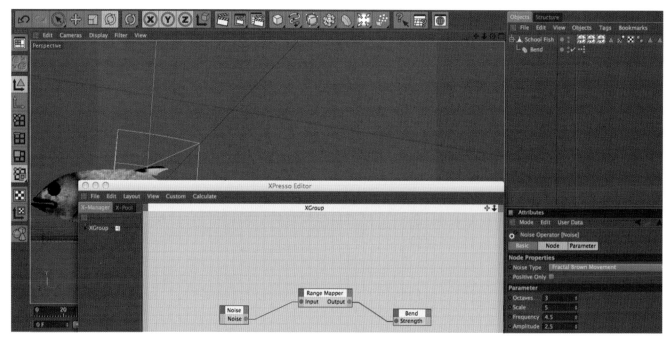

Figure School_07

Chapter 12: A Jolt of Xpresso

Step 9 With the tail deformation complete, Control+Drag on the Bend deformer to duplicate it within the Object Manager. Rename the copy Head Bend and rotate its Heading to -180 degrees. *Figure School_08*

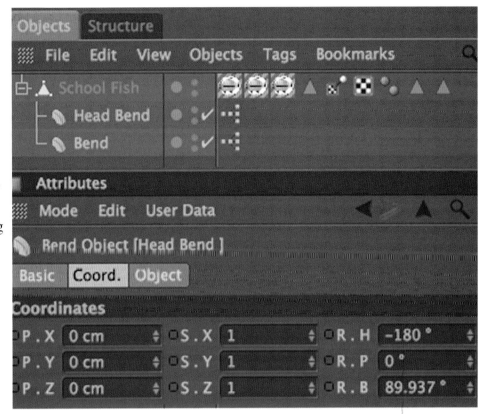

Figure School_08

Step 10 Double click the Head Bends' Xpresso tab to pull it up in the Xpresso Editor. Select the Noise Node and change the Noise Type to Wavy Turbulence in the Attribute Manager. Change the parameter to: Octaves 4, Scale 6, Frequency 5.5 and Amplitude - 0.5.
Figure School_09

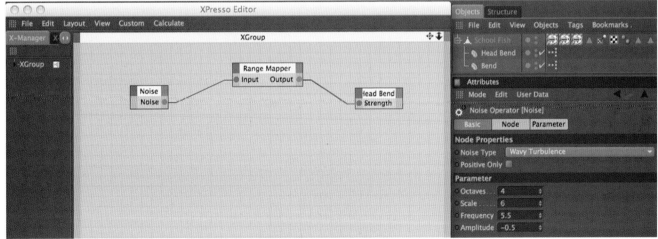

Figure School_09

279

To create a school of fish, we would like them all to be a little unique in their movement.

Step 11 Control+Drag on the School Fish group to duplicate it.

Step 12 Rename the copy, School Fish 2. Double click on the Xpresso tag for the Bend to open it in the Xpresso Editor. Change the Noise Parameter values to: Octaves 4, Scale 6, Frequency 4, Amplitude 2. There is no need to change the values for the Head Bend. **Figure School_10**

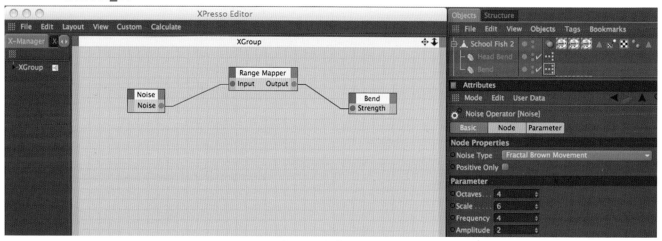

Figure School_10

Step 13 Continue to duplicate and make minor adjustments to the School Fish Object's Noise values in the same manner. Make as many copies as you like or have patience for. I made 10 duplicates for this example.

Step 14 Add a Cloner object. **Figure School_11**

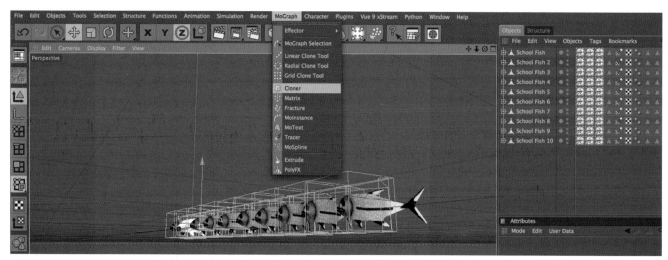

Figure School_11

Chapter 12: A Jolt of Xpresso

Step 15 Drop all of School Fish objects as children of the Cloner. In the Object tab of the Attribute Manager, change the mode from Linear to Object. *Figure School_12*

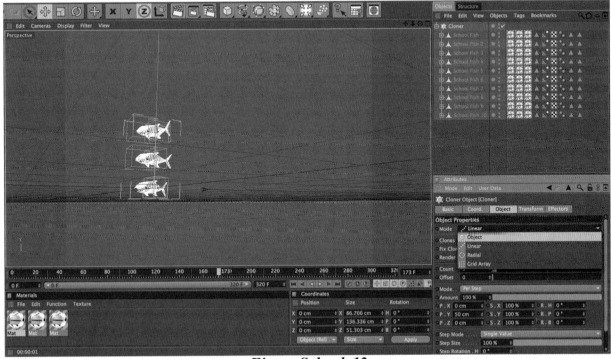

Figure School_12

Step 16 Add a Sphere Primitive, set the Radius to 375, Segments to 11 and Type to Hexahedron. In the Coordinates tab, set the Scale values to S.X 1.58, S.Y 0.44 and S.Z 0.95. *Figure School_13*

Figure School_13

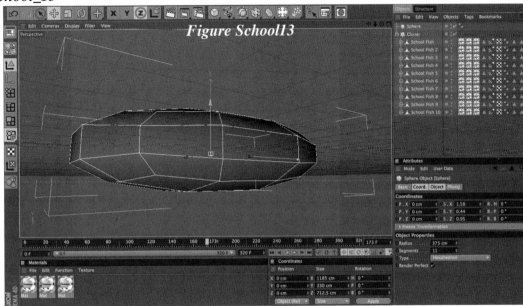

281

Step 17 Hide the Sphere by clicking on its traffic lights until both are red.

Step 18 Select back on the Cloner Object and drag the Sphere into the Object Link.

Step 19 Set the Clones to Sort and place a check in Render Instances. Change the Distribution to Volume and raise the Count to 100. Pick any Seed value that you think looks best.
Figure School_14

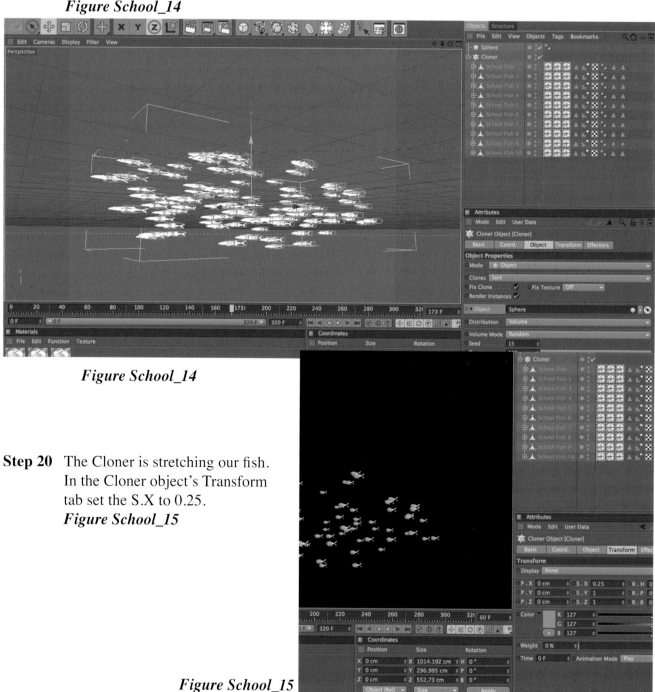

Figure School_14

Step 20 The Cloner is stretching our fish. In the Cloner object's Transform tab set the S.X to 0.25.
Figure School_15

Figure School_15

Chapter 12: A Jolt of Xpresso

Step 21 With the Cloner object selected, add a Random Effector. *Figure School_16*

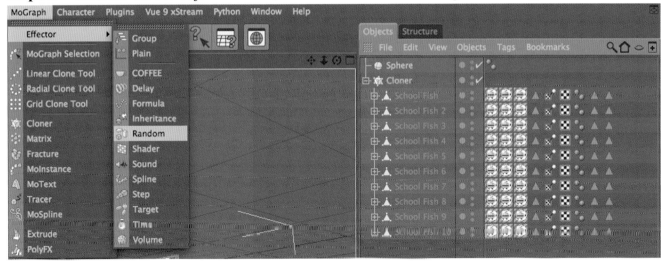

Figure School_16

Step 22 In the Attribute Manager, deactivate Position and check the boxes for Scale and Rotation. Set the Scale parameters to: S.X 0, S.Y 0.25 and S.Z 0.25. Set the Rotation to: R.H 5, R.P 3 and R.B 2 degrees. *Figure School_17*

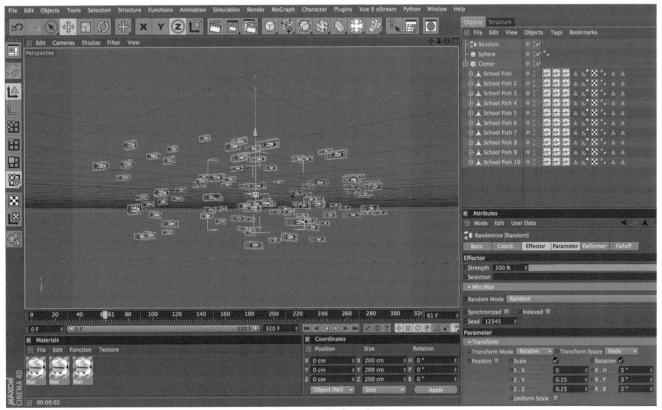

Figure School_17

283

Step 23 Select the Cloner object and add a Formula Effector. *Figure School_18*

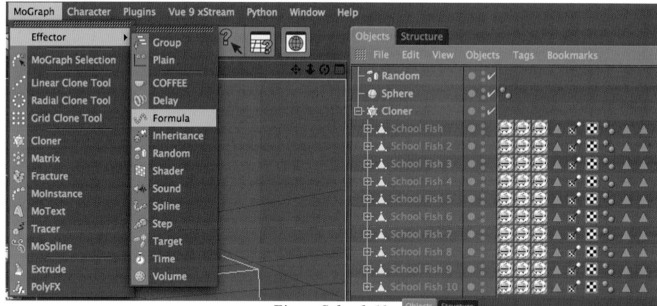

Figure School_18

Step 24 In the parameter tab of the Formula Effector, disable the Scale parameter and set the Position values to P.X 25, P.Y 25 and P.Z 10. In the Effector tab, lower the multiplier from 360 to 30. *Figure School_19*

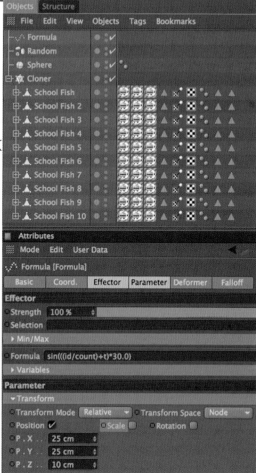

Figure School_19

Chapter 12: A Jolt of Xpresso

Thinking Particles: PBLURP

Thinking Particles is a system located within Xpresso that allows incredible control and creativity to generate complex geometric transformations and can be used in conjunction with the PyroCluster module to create advanced explosions and other visual effects. In this tutorial, we'll use it to morph geometry from one object to another. The PBLURP node is a thinking particle generator and will facilitate the morph transformation in our scene.

Open the ***PBlurp.c4d*** scene from the Jolt of Xpresso Folder on the DVD.

Step 1 Add a Particle Geometry object from the Simulation>Thinking Particles menu.
 Figure PBlurp_01

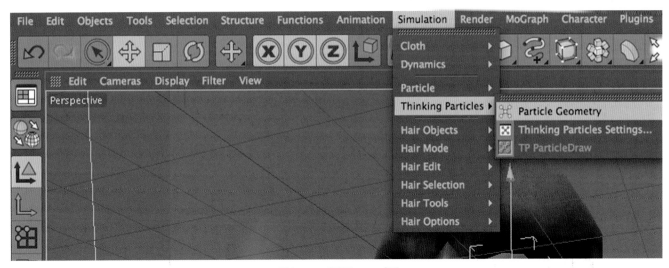

Figure PBlurp_01

Step 2 Right click on the Particle Geometry object in the Object Manager and choose CINEMA 4D Tags>Xpresso. *Figure PBlurp_02*

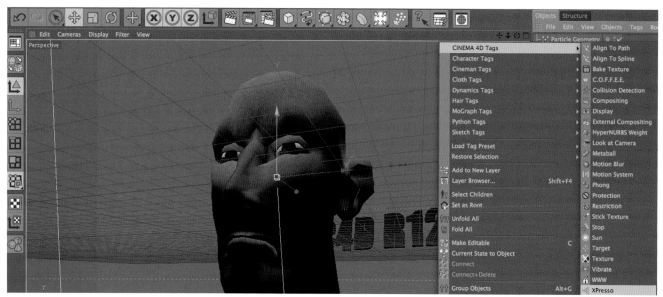

Figure PBlurp_02

Step 3 Right click in the Xpresso Editor and choose New Node>Thinking Particles>TP Generator>PBlurp. *Figure PBlurp_03*

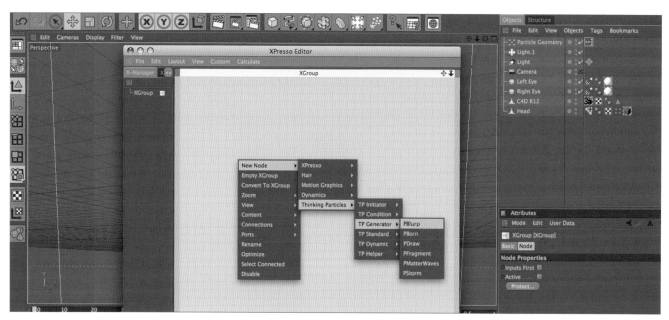

Figure PBlurp_03

Chapter 12: A Jolt of Xpresso

Step 4 Select the PBlurp object to see its parameters in the Attribute Manager. Drag the C4d R12 and Head objects into the Objects field. *Figure PBlurp_04*

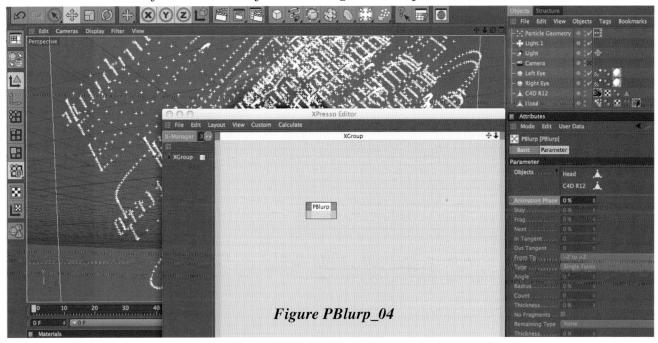

Figure PBlurp_04

Now we will add a Null object to make this transformation more interesting. Even though Null objects do not contain geometry, they can be used as place holders to alter the path and rotation of the morph effect taking place in the Particle Geometry calculation.

Step 5 Add a Null from the Objects menu. *Figure PBlurp_05*

Figure PBlurp_05

Step 6 Move the Null into place by setting it to
P.X - 700, P.Y 1200, P.Z 1600 and Rotate it to R.B
190 degrees. *Figure PBlurp_06*

Figure PBlurp_06

287

Step 7 Select the PBlurp in the Xpresso Editor (double click the Xpresso tag to the right of the Particle Geometry if it is not already open) and drag the Null object into Objects field. Make sure that the Head object is located on top, followed by the Null and then C4D R12.
Figure PBlurp_07

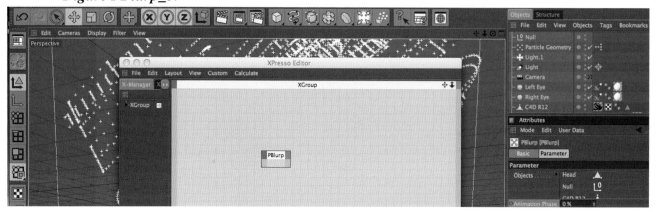

Figure PBlurp_07

Step 8 Select all three objects in the Object field and set the From to +Y to -Y. Set the Count to 75 and leave the thickness at 1%. *Figure PBlurp_08*

Figure PBlurp_08

Step 9 Make sure you are on Frame 0 and Control+Click on the ellipse to the left of Animation Phase to set a keyframe.
Figure PBlurp_09

Figure PBlurp_09

Chapter 12: *A Jolt of Xpresso*

Step 10 Scrub to frame 155, change the Animation Phase value to 100% and Control+Click again to set a second keyframe. ***Figure PBlurp_10***

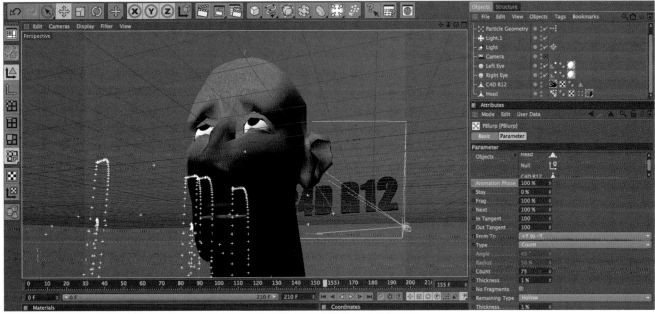

Figure PBlurp_10

Step 11 You can now hide our original C4D R12 and Head objects by clicking on their traffic lights in the Object Manager until they are red.
Figure PBlurp_11

Figure PBlurp_11

Click in the black crosshair icon to the right of the Camera in the Object Manager in order to look through it. Play and/or render the animation.

13
BodyPaint 3D: The Artist's Connection

BodyPaint has been a staple in the Hollywood digital painting workflow for almost a decade. From character and prop painting to digital mattes and integrated CG extensions, BodyPaint has been instrumental in bringing many of the biggest effects titles to life. What does this mean for you? BodyPaint gives you, the artist, a Photoshop-like workflow with the added ability to paint directly on 3-dimensional models. BodyPaint's power is exponentially enhanced by its ability to integrate directly into Photoshop.

Painting a Book in BodyPaint

For our first BodyPaint project, open the **BP_Book_Start.c4d** file located in the BodyPaint 3D folder. I have already laid out the UVs for this project, so you may begin focusing on the painting and editing tools available within BodyPaint.

Step 1 To begin, we need to open the BP UV edit layout.
Figure BP_Book_01

Figure BP_Book_01

Chapter 13: BodyPaint: The Artist's Connection

Step 2 Click on the BodyPaint Setup Wizard button to begin the process. Uncheck the Pages object as we don't wish to create a material for it at this time. Select Next to continue. *Figure BP_Book_02*

BodyPaint Setup Wizard

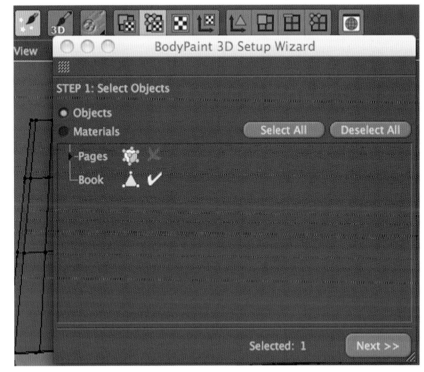

Figure BP_Book_02

Step 3 Uncheck the Recalculate UV, as I have already cleaned these up nicely for painting. Uncheck the Single Material mode for maximum flexibility in the creation and editing of this material. Click Next to move on to Step 3. *Figure BP_Book_03*

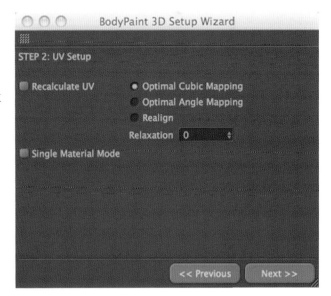

Figure BP_Book_03

291

Step 4 Click the checks for Color and Bump to start. In the Texture Size, set the Minimum and Maximum to 2048 to create a 2k texture. Select Next to complete the creation of these channels. Click Close to get rid of the review.
Figure BP_Book_04

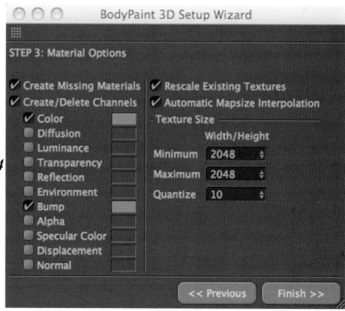

Figure BP_Book_04

We'll begin the painting by creating our Bump map. In the Material Manager, which will now be docked with the Object and Colors menus, you'll see the two channels we've created for painting. The Color is represented by the C and the Bump by the B. If your mesh is not visible in the Texture Manager to the right, choose, UV Mesh>Show Mesh.

Step 5 To the far right you will see the Swatches panel. Click on it to make it visible. Scroll down and you can select a scaly-looking material. Click on the Pen icon right of the Color thumbnail to disable painting in the channel. If you have done this correctly, you will see that the pen is grayed out. Click on the Bump thumbnail to make it active. A yellow box will appear. *Figure BP_Book_05*

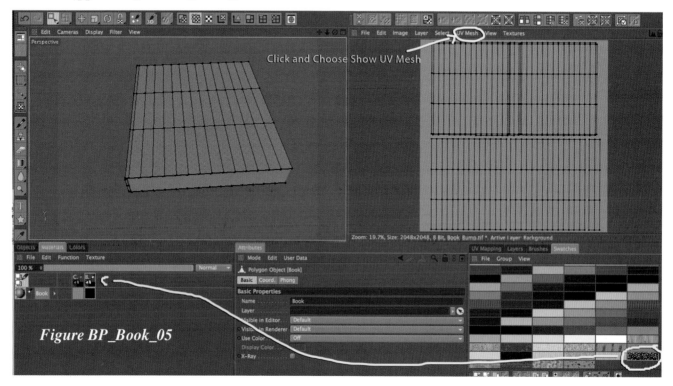

Figure BP_Book_05

Chapter 13: BodyPaint: The Artist's Connection

Step 6 Use the Rectangle Selection tool to select the top UVs located in the Texture view to the right. These UVs represent the outside cover of the book. *Figure BP_Book_06*

Figure BP_Book_06

Step 7 Click on the Fill Icon. In the Color tab, set the Scale down to 15%. Fill the Rectangle Selection. *Figure BP_Book_07*

Figure BP_Book_07

293

Step 8 Click on the Channels tab and deactivate the Bump Channel by clicking on its thumbnail. Do the same to activate the Color Channel. Click on the Swatches tab and select a dark red swatch to use. *Figure BP_Book_08*

Figure BP_Book_08

Step 9 Click on the Create New layer button within the Layers tab to create a new layer above our background. Name this layer Worn Areas. Create a new layer within the Bump Channel and name it the same. *Figure BP_Book_09*

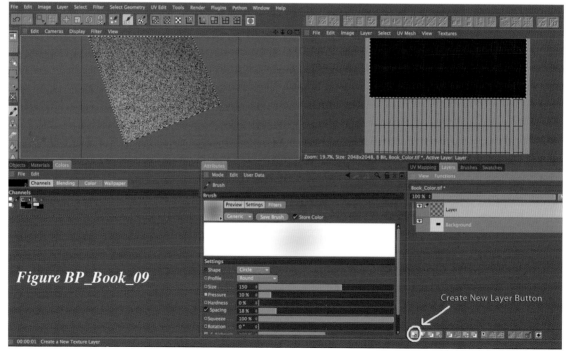

Figure BP_Book_09

Chapter 13: BodyPaint: The Artist's Connection

Step 10 In the Brushes tab, select the Rust bush from the Multibrushes>Non-Organic folder within the BodyPaint presets. *Figure BP_Book_10*

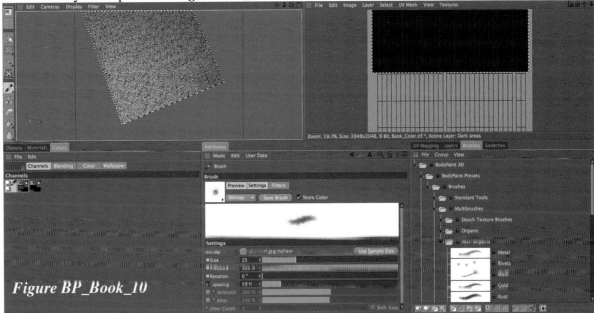

Figure BP_Book_10

Step 11 This is a Multibrush, meaning that it will paint in both the Color and Bump channels by default. This is good for what we are trying to accomplish here. Click on the Brush tool and set the Size up to 240, the pressure down to 30% and Spacing to 60% in the Attribute Manager. Use this brush to paint around the edges of and folds of the book. You have both the Color and Bump Channels enabled. If not, click on their thumbnail to make them active *Figure BP_Book_11*

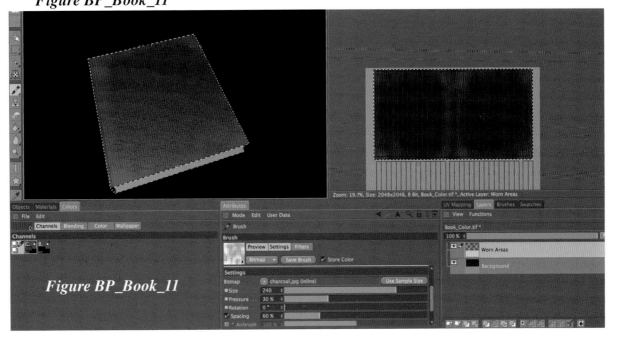

Figure BP_Book_11

295

A Multi-Channel brush can be set to work in multiple channels at the same time. When I painted in the Color Channel, I was likewise painting my Bump Map.

Step 12 Disable the Bump Channel and create a new layer in the Color Channel. Rename it Title. Click on the Type tool. Choose a light yellow color for the Type in the Swatches panel. In the Attribute Manager, set the Font to Papyrus and the size to 55. Set a Feather value of 0.1. Set it to Center align and place the type onto the front cover of the book. If you are not happy with the placement, use the Move tool to reposition the layer.
Figure BP_Book_12

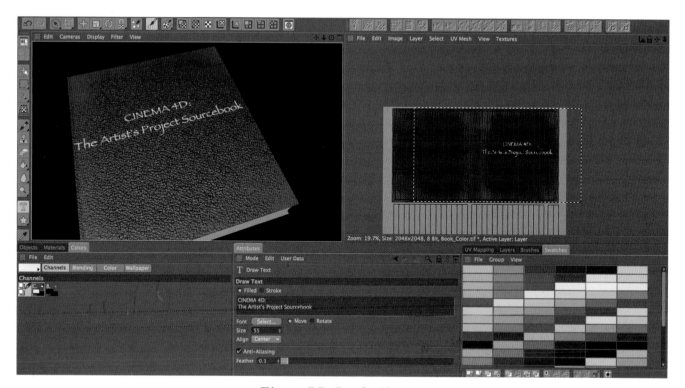

Figure BP_Book_12

Chapter 13: BodyPaint: The Artist's Connection

Step 13 Choose Select>Deselect All. Go to the Transform tool and use it to reshape your type to get a custom fit on the cover. Press Enter to accept the transformation.
Figure BP_Book_13

Figure BP_Book_13

Step 14 Add a new layer in the Color Channel and name it Lower Title Trim. Use the Rectangle selection tool to select a slim shape across the entire book face and Fill paint it with the same yellow color. *Figure BP_Book_14*

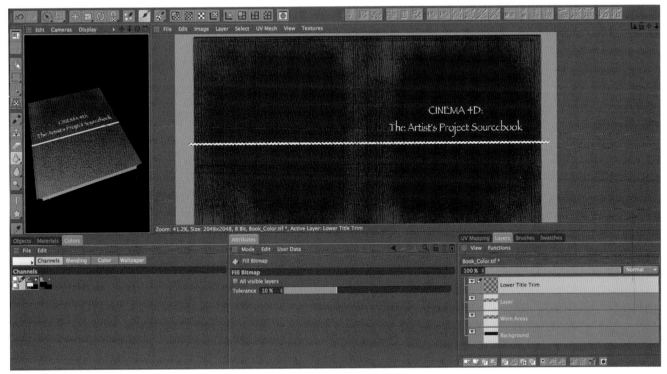

Figure BP_Book_14

Step 15 With the Lower Title Trim layer selected, click the copy selected layer button at the bottom of the Layers panel. *Figure BP_Book_15*

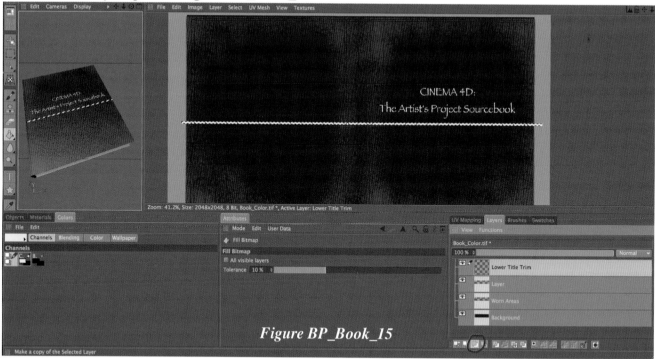

Figure BP_Book_15

Step 16 Rename the copy and Upper Title Trim, and use the Move or Transform tool to move it up above the Title. *Figure BP_Book_16*

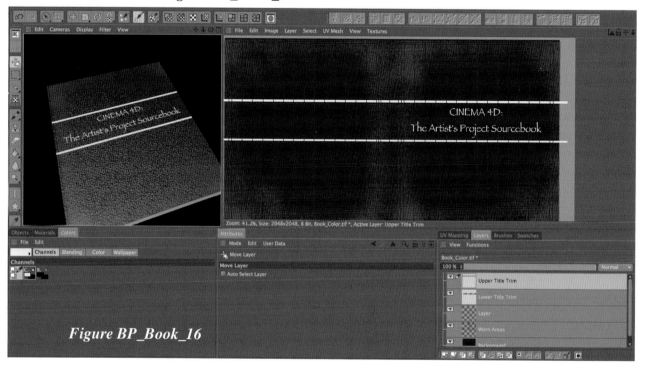

Figure BP_Book_16

Chapter 13: BodyPaint: The Artist's Connection

Step 17 Make two more copies of these layers and drag one to the top of the book and one to the bottom. *Figure BP_Book_17*

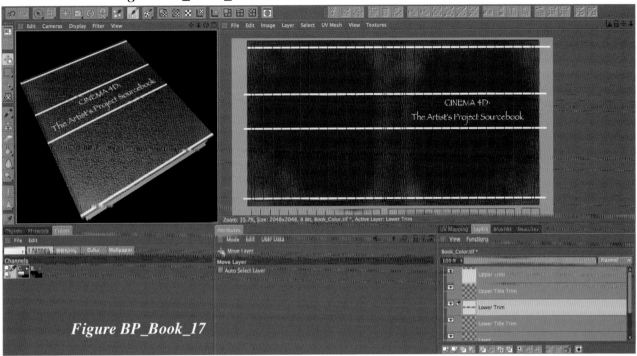

Figure BP_Book_17

Step 18 In order to weather the trim and type, you will need to select those layers and use the eraser tool set to the same Rust brush we used before. Set the Size large and the Pressure very low to create the worn effect. Be sure to disable the bump channel after selecting the Rust brush. *Figure BP_Book_18*

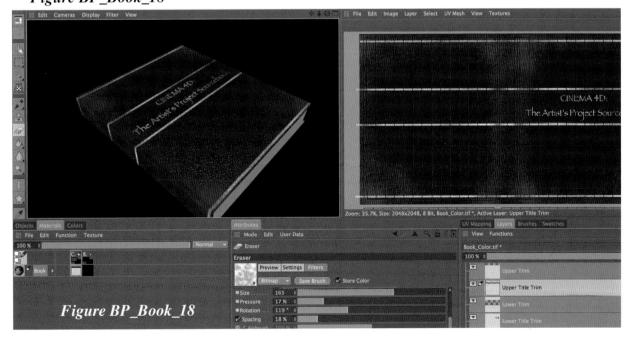

Figure BP_Book_18

299

CINEMA 4D: The Artist's Project Sourcebook, Third Edition

BodyPaint UV Editing
Unwrapping a head

Open the **UV_Head_Start.c4d** file from the DVD.

Step 1 Switch the layout to BodyPaint UV Edit mode. *Figure Head_Unwrap_01*

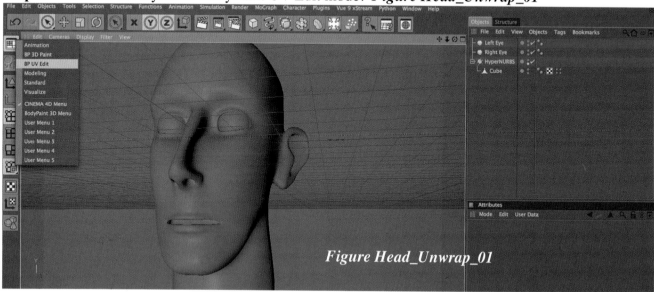

Figure Head_Unwrap_01

Step 2 To create a new texture, click on the Bodypaint Wizard. *Figure Head_Unwrap_02*

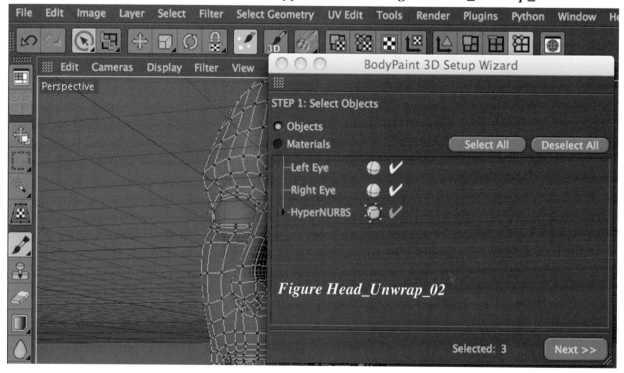

Figure Head_Unwrap_02

Chapter 13: BodyPaint: The Artist's Connection

Step 3 Click on the checks to the right of the Left and Right Eye objects to deselect them from receiving the UV wizard. The Cube and HyperNURBS should be checked.
 Figure Head_Unwrap_03

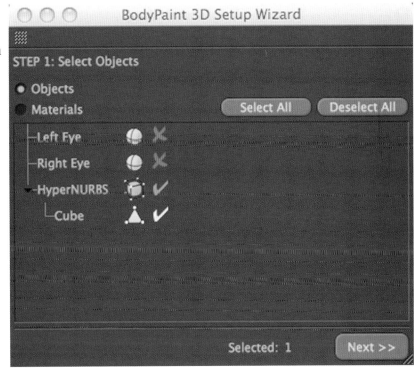

Figure Head_Unwrap_03

Step 4 Click Next to pull up the second step. Since we will be working on the UVs of this model, accept the default settings for this step and press Next. *Figure Head_Unwrap_04*

Figure Head_Unwrap_04

Step 5 For this example, we'll set up a medium-size map. Set Minimum and Maximum size to 2048 to gaurantee you get a 2k texture. Click Finish. *Figure Head_Unwrap_05*

Figure Head_Unwrap_05

Step 6 Now that a new material has been created, it's time to look at how the UVs will be mapped onto the object. To the right, you will see the Texture view. Click on UV Mesh>Show UV Mesh. *Figure Head_Unwrap_06*

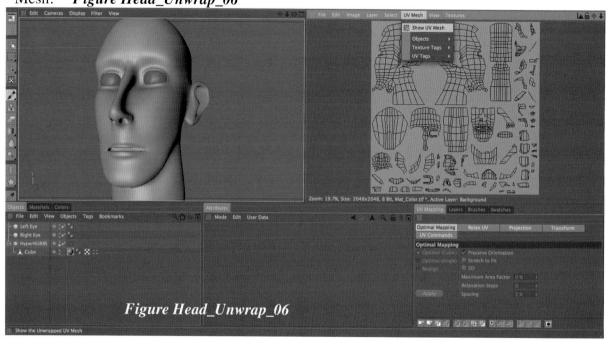

Figure Head_Unwrap_06

Chapter 13: BodyPaint: The Artist's Connection

When Mapping UVs for a model, you want to keep "like" colored shapes as continuous meshes in the UV. This limits the appearance of seams and mismatched colors. Since the head is going to be primarily the same color, we want to keep this as one mesh. Even doing so, we can't eliminate the necessity of having many seams. In order to control the placement of the seams, we are going to designate specific edges to be pulled apart for the UVs.

Step 7 In the Object Manager, select the Cube. Go to the top of the menu and change to Edges. To the upper left, you will find the Path Selection tool. Simply click and drag across the edges you want to select. Use it to map a T at the top of the forehead and drag down the center all of the way around and end at the front bottom of the neck.

Figure Head_Unwrap_07

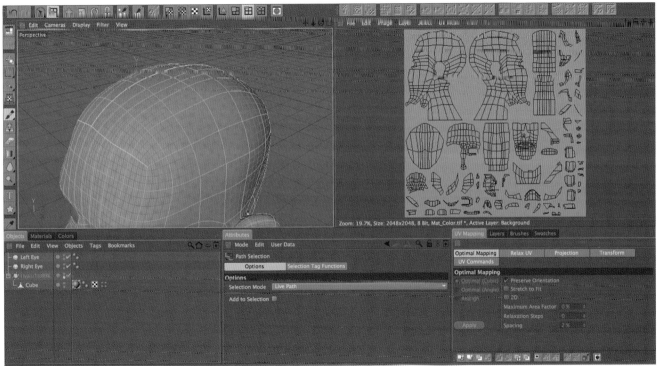

Figure Head_Unwrap_07

303

Step 8 With the edges selected and the Path Selection tool active, click on the Selection Tag Functions, set the Tag Name as Seam Edges and choose Set Selection.
Figure Head_Unwrap_08

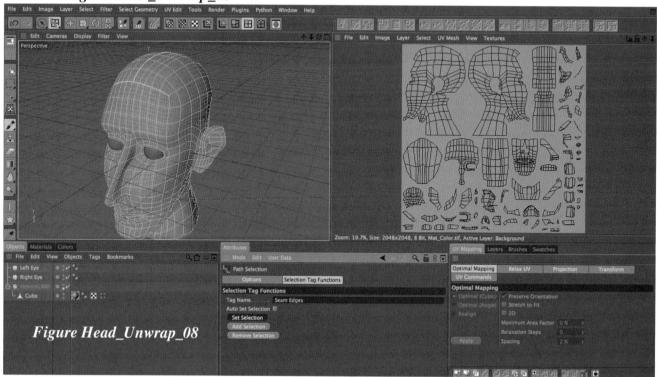

Figure Head_Unwrap_08

Step 9 Switch to points and select the points shown in *Figure Head_Unwrap_09*.

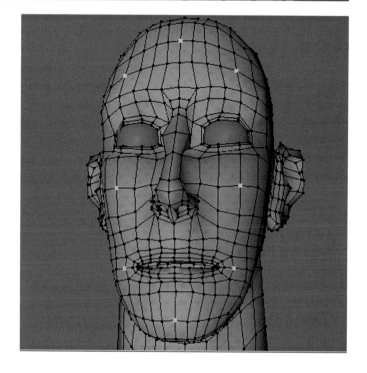

Figure Head_Unwrap_09

Step 10 Go to Select Geometry>Set Selection and name the selection tag Hold Points.
Figure Head_Unwrap_10

Figure Head_Unwrap_10

Step 11 Click on the UV Polygon Edit Tool and press Command (Cntrl PC)+A to select all.
Figure Head_Unwrap_11

Figure Head_Unwrap_11

Step 12 Click on the Projection tab within the UV Mapping Menu. Make sure that the character is facing straight into the camera in the Viewport, and choose Flat as the Projection type.
Figure Head_Unwrap_12

Figure Head_Unwrap_12

Step 13 In the UV Mapping menu, scroll to the Relax UV tab. Enable both Pin Point Selection and Cut Selected Edges. In both cases, click the Use Tag. Drag the Hold points into the Pin Point Selection link. Drag the Seam Edges into the Cut Selected Edges. Uncheck Pin Border Points. Set the Relax Mode to LSCM. Press Apply to unwrap the mesh. *Figure Head_Unwrap_13*

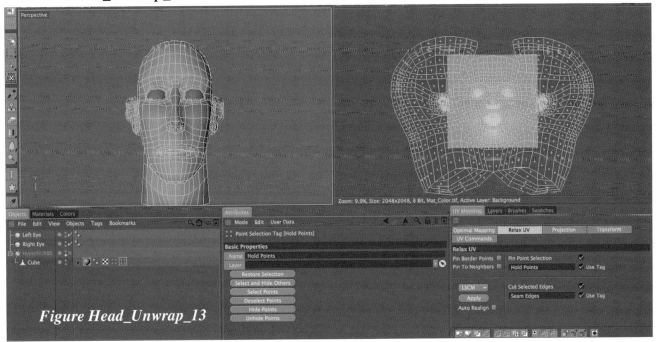

Figure Head_Unwrap_13

Step 14 The UVs have been successfully unwrapped but may be too large for our canvas. Click on the UV Commands tab and choose Fit UV to Canvas. This command can also be used if your unwrapped UVs are not sufficiently filling your canvas.
Figure Head_Unwrap_14

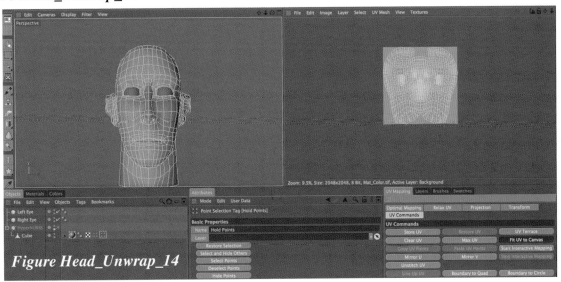

Figure Head_Unwrap_14

Painting a 3D head

If you walked thru the previous UV unwrap tutorial, open it to get started painting. If not, open the **Head_Paint_Start.c4d** file located in the BodyPaint 3D Folder. Set your workspace to UV Edit.

For this project, we are going to keep it as simple as possible. We are going to work with a limited palette. *Figure HeadPaint_01* shows the Colors we will be using for this project.

Figure HeadPaint_01

Step 1 The first step is to create the color map. Click on the BodyPaint 3D Setup Wizard. In Step 1, deselect everything but the Head. (The HyperNURBS will be selected as well because it is the parent to the Head.)
Figure HeadPaint_02

Figure HeadPaint_02

Chapter 13: BodyPaint: The Artist's Connection

Step 2 Uncheck the Recalculate UVs in Step 2 and press Continue.
Figure HeadPaint_03

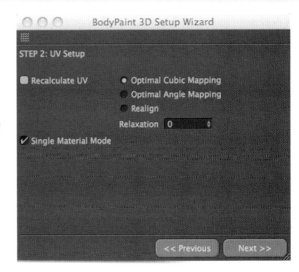

Figure HeadPaint_03

Step 3 Set the Minimum and Maximum Texture Size to 2048 and leave only the Color Channel active for creation. Press Continue to finish the origination of the Texture Map. *Figure HeadPaint_04*

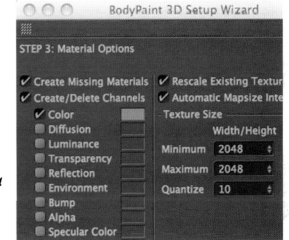

Figure HeadPaint_04

Step 4 In the Texture View to the right, click on the UV Mesh>Show UV Mesh.
Figure HeadPaint_05

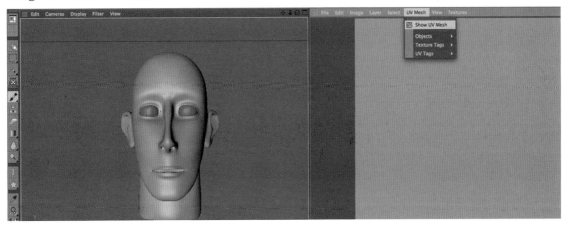

Figure HeadPaint_05

309

Step 5 Click on the Fill tool located below the Gradient tool on the left. Click on Color 1 swatch and Fill the background layer with this as our base color. *Figure HeadPaint_06*

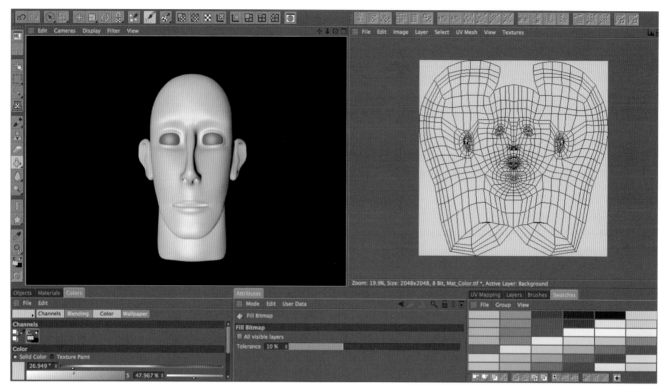

Figure HeadPaint_06

Step 6 Select the Layers tab and choose Create New Layer. Name the new layer, Shadows. Just as you would in Photoshop, it is good practice to use non-destructive painting and editing. *Figure HeadPaint_07*.

Figure HeadPaint_07

310

Chapter 13: BodyPaint: The Artist's Connection

Step 7 Click on the Brush tool and then click and hold on the thumbnail in the Attribute Manager to bring a list of brush presets. Choose the Darken brush, which looks very soft and semitransparent. Set the pressure down to around 2% and paint. You may also wish to Grab the Color 2 swatch and paint a bit with it as well. *Figure HeadPaint_08*

Figure HeadPaint_08

Step 8 Use this brush at various sizes to block out the dark areas on the face.
Figure HeadPaint_09

Figure HeadPaint_09

Step 9 Switch to the Eraser tool. Set it to the same Darken Brush. Lower its opacity to around 10% and soften the look of the painted areas. Note that you can also lower the opacity of the Layer in the Layers Panel. *Figure HeadPaint_10*

Figure HeadPaint_10

Step 10 With the Brush tool, choose the Color 3 swatch, add a new layer and name it Light Purple. Apply a little purple around the eyes and lips followed, as before, with a few dabs from the Eraser tool to back it down. Change Layer's blend mode to Hard Light. *Figure HeadPaint_11*

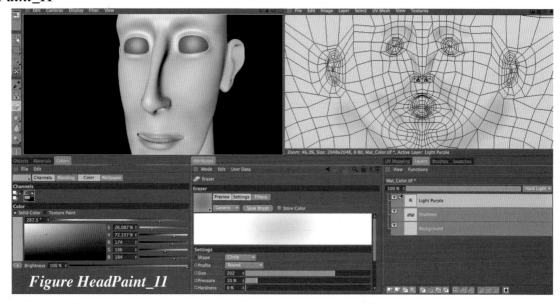

Figure HeadPaint_11

Chapter 13: BodyPaint: The Artist's Connection

Step 11 Add a new Layer and name it Lips. Choose the Brush tool and the Color 4 swatch and paint the areas of the lips with a hard basic brush, such as the second brush in the brushes pulldown. Paint liberally, as you would applying lipstick to a model. Use the eraser tool set to a similarly hard brush to remove any mistakes in shaping the lips. Once, complete, change the Blend mode in the layers panel to Soft Light and lower the opacity of the Lips layer to 50%. *Figure HeadPaint_12*

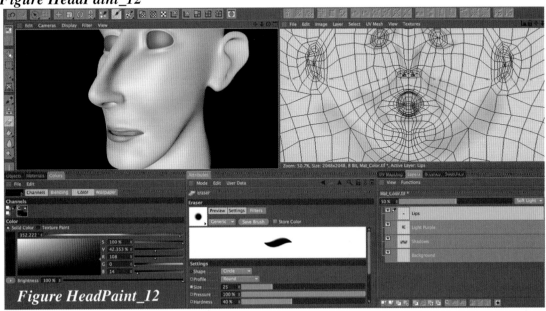

Figure HeadPaint_12

Step 12 Add a layer and name it Red vessels. Choose the Brush tool and the Color 5 swatch. This time grab the chalk brush from the brushes pulldown in the Attribute Manager. Raise the radius of this brush to around 50 and paint the cheeks, nose tip, eyes, mouth and ears. Use the Eraser Tool set to the Darken brush and a 10% opacity to better blend the outer areas of the paint. *Figure HeadPaint_13*

Figure HeadPaint_13

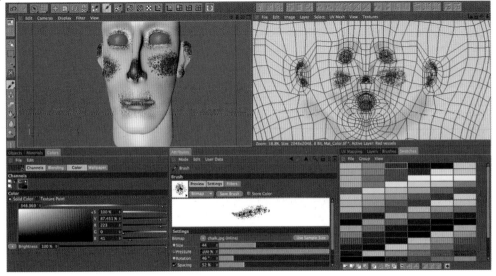

Step 13 With the Red vessels layer selected, go to Filter>Blur Gaussian Blur.
Figure HeadPaint_14

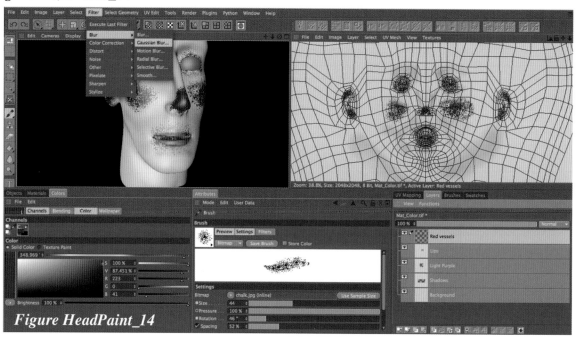

Figure HeadPaint_14

Step 14 Set the Horizontal and Vertical Radius values to 50. Check the Wrap texture box and press OK. *Figure HeadPaint_15*

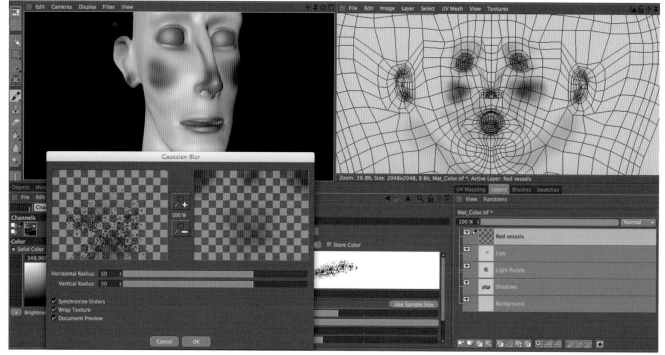

Figure HeadPaint_15

Chapter 13: BodyPaint: The Artist's Connection

Step 15 In the Layers panel, set the Blend Mode to Soft Light and lower the Opacity to 65%. *Figure HeadPaint_16*

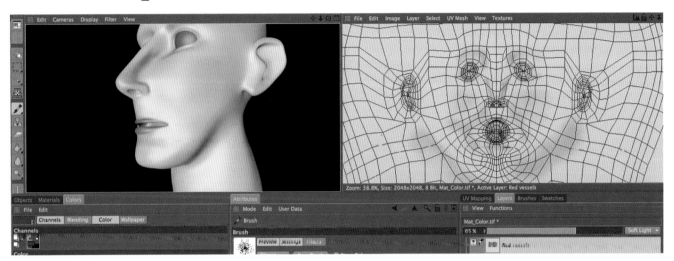

Figure HeadPaint_16

Step 16 Add a layer and name it, Cool. Choose the Brush tool and the Color 6 swatch. Use the Darken brush and paint around the eyes, mouth and beard to give them a colder color. Set the blend mode for this layer to Exclusion. *Figure HeadPaint_17*

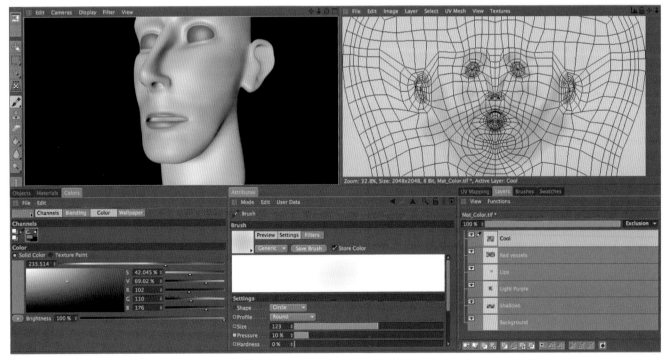

Figure HeadPaint_17

315

Step 17 Add another layer and name it Red 2. Use the chalk brush again with the Color 5 swatch this time with a pressure value of 10%. Paint the cheeks, nose and ears. Choose Filter>Blur>Gaussian Blur. Set the Horizontal and Vertical Radius values to 17 and press OK. Set the opacity level to 55% in the Layers panel. *Figure HeadPaint_18*

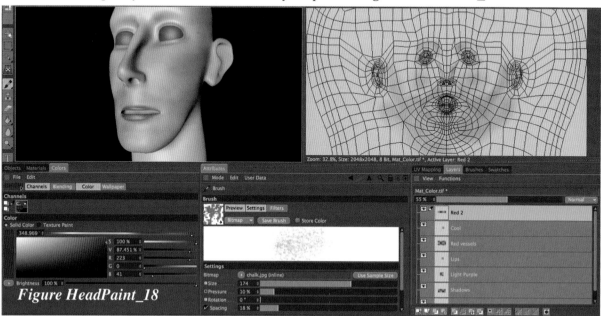

Figure HeadPaint_18

Step 18 Now, time for the eyebrows. Add a new layer named EyeBrows. Use the Hair 2 brush from the Brushes pulldown in the Attribute Manager. Choose the Color 7 (Black) swatch. Enable Projection Painting to keep the quality high as you rotate and zoom in and out, making brisk strokes to form the brows. You will notice that the layers in the Layer panel have been replaced with a temporary PP (Projection Painting Layer) as you work in this mode. *Figure HeadPaint_19*

Projection Painting

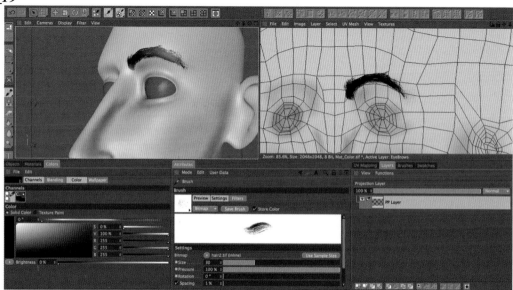

Figure HeadPaint_19

Step 19 Once satisfied, click the Projection Painting button again to flatten the temporary projection layer into your Eyebrows layer. Paint the other brow in this layer.
Figure HeadPaint_20

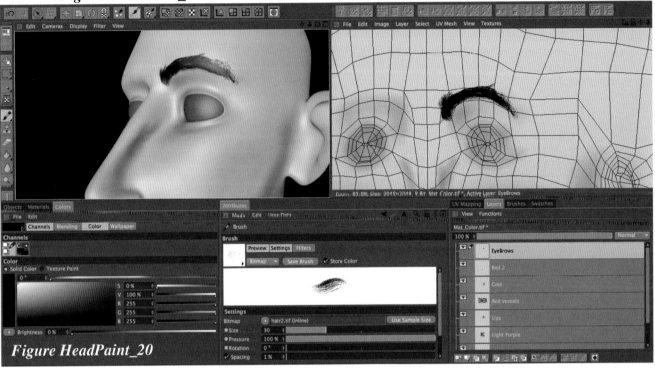

Figure HeadPaint_20

Step 20 Add a final layer named Stubble. Click on the Brush tool and select the brush thumbnail that resembles stubble. *Figure HeadPaint_21*

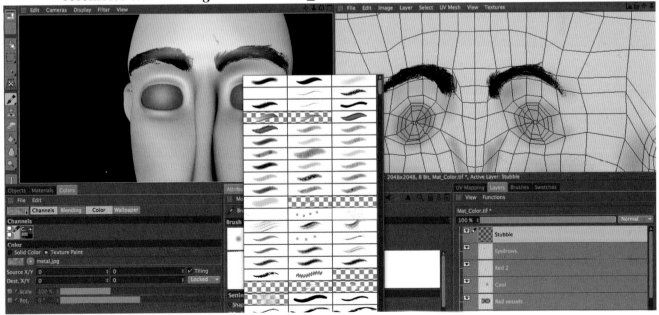

Figure HeadPaint_21

Step 21 Set the color for the brush to the Color 7 swatch (Black). I definitely recommend using Projection Painting to limit the distortion of the stubble as you paint along the UVs. Projection Painting helps overcome any UV shape issues that may cause typical painting methods to distort. Make sure, while using Projection Painting in this instance, that you paint only straight on and then rotate the view and paint again to keep it from wrapping irregularly around the surface. Zoom up close to get the finest detail from the brush. When done painting, lower the opacity of the stubble layer to blend better with the rest of the map. *Figure HeadPaint_22*

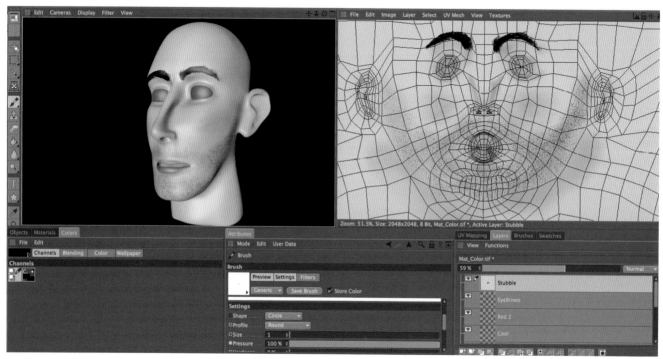

Figure HeadPaint_22

Step 22 Add some lights or perhaps even a HDRI textured sky and render to see how this quick paint job brings our character to life. *Figure HeadPaint_23*

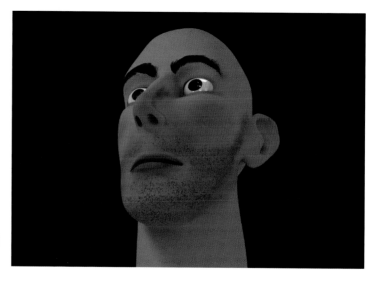

Figure HeadPaint_23

Chapter 13: BodyPaint: The Artist's Connection

The practice of projection painting is an effective and time-saving option for creating photorealistic textures. BodyPaint enables you to freeze your camera and save the layer for exporting to Photoshop. There, you can apply blend modes, masks, etc. and use other image elements to generate your texture. Once finished, you can save it and it will update automatically in BodyPaint. You can then choose to unfreeze your view and the projection layer will be applied. Below you will find captures of this in progress.

Enable Projection Painting **Freeze View**

Once Projection Painting has been enabled, a temporary PP layer is added to your Layers panel. You can now move the camera to the view that you would like to project from and Freeze the view. Save the layer, open it in Photoshop and do your editing. When finished, save it, go back to BodyPaint and it will update and bake it into the projection layer within the Layers panel.

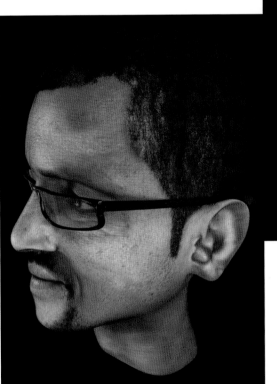

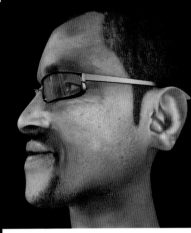

I textured this model using this method. All modeling was done in C4D and the hair was grown using CINEMA 4D's Hair Module which is part of the Studio Bundle.

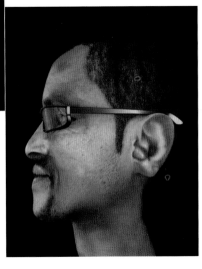

"Fikremarium Yoseph"

Projection Man

This once proprietary piece of CINEMA 4D has been used in many live action and animated blockbusters. It was finally released to the public as part of Release 11. Though projection painting has always been a powerful part of C4D, Projection Man brings all the necessary tools to the forefront, including Photoshop integration. In the following project, we'll look at setting up a basic Projection Man scene.

Copy the **Projectionman_Start** folder located in the **BodyPaint: The Artists' Connection/Projectionman** folder to your desktop or some other convenient location. Open the **Projectionman_Start.c4d** file.

In the scene, you will see that the basic modeling has been taken care of so we can focus on the projection and scene integration.

Step 1 Start by adding a Doodle Frame at Frame 0: Tools>Doodle>Add Doodle Frame.
Figure ProjectionMan_01

Figure ProjectionMan_01

Chapter 13: BodyPaint: The Artist's Connection

Step 2 Select the Doodle Object, raise the Size X and Size Y to the maximum 1024 each. Click on Load Bitmap and choose the **French_Building.jpg** located in the Projectionman_Start folder. *Figure ProjectionMan_02*

Figure ProjectionMan_02

Step 3 Right click on the Doodle object in the Object Manager and choose CINEMA 4D tags>Display tag. Within the tag, enable Visibility and set it to 20% to make it possible to line up the image with the geometry. Rotate and zoom your view until the geometric shape matches the angle of the Doodle image. (I lowered my visibility to 10% to make the printed step more discernible.) *Figure ProjectionMan_03*

Figure ProjectionMan_03

Step 4 Go to Window>ProjectionMan to pull up its interface. Right click the Plane object in the list. Choose New Camera Projection >Load Bitmap. ***Figure ProjectionMan_04***

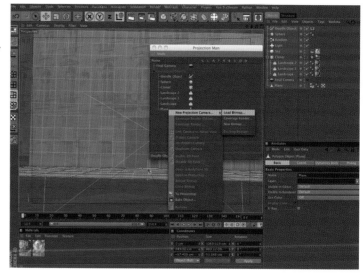

Figure ProjectionMan_04

Notice all objects are included in this list. If I had other objects that I wanted this image projected on, I would simply include them in the selection.

Step 5 In the Choose Layerset window, leave the Luminance at default and select Disabled for the Alpha. Click OK. ***Figure ProjectionMan_05***

Figure ProjectionMan_05

Chapter 13: BodyPaint: The Artist's Connection

Step 6 The image will be now projected onto the Plane object. Notice, that we have extra image space showing in the Doodle frame that lacks geometric coverage. To create the geometry for the front of the street, select the Polygon tool. The correct polygons should already be selected. If not, double click on the Selection Set to the right of the Plane object in the Object Manager. Select the Scale tool and enable the Modeling Axis with the Y value set to -100%. Scale the polygons out until they fill the screen. *Figure ProjectionMan_06*

Figure ProjectionMan_06

Use the green axis handle to Scale out the polys to fill the screen and complete the coverage.

Step 7 Render the view and the projection is complete. Now, to integrate scene elements into this projection, you may wish to go into the Display tag of the Doodle Frame and set the Visibility to 0%.

Step 8 Click on the crosshair to the right of the Final Camera. You'll see now that we can make this 2D set a 3D environment by moving another camera for our animation. I've switched to a different view and colored my Projection Camera (PCam) red to help illustrate what is happening in the scene. *Figure ProjectionMan_07*

(Since your Projection Cam is probably positioned slightly different than mine, you may find that slight tweaks are necessary for your Final Camera keyframes.) The Coordinates for my Projection Cam are (P.X - 30.491 P.Y 50.714, P.Z - 1099.199 and R.H 0.3, R.P 8.3 and R.B -0.9).

Figure ProjectionMan_07

323

Step 9 Now for object interaction, click on the red X to the right of the Cloner Object and select its Dynamics Body Tag to the right. In the Dynamics tab, put a check in the Enabled box and play the animation. ***Figure ProjectionMan_08***

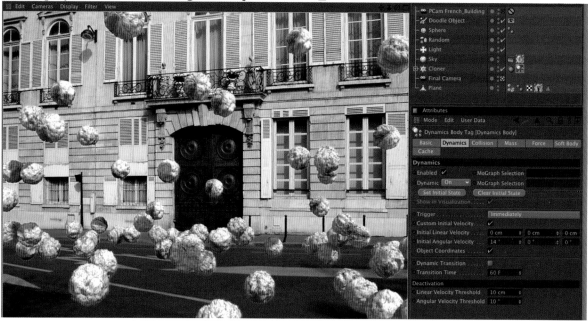

Figure ProjectionMan_08

Step 10 Notice that we get no shadows from the meteorites crashing into the scene. Double click on the PMat French_Building material thumbnail in the Material Manager. Typically, Luminance is the choice for loading projection images. In this case, we want interactive shadows. Click on the Texture drop-down in the Luminance Channel and choose, Copy Channel. Disable the Luminance Channel, and enable the Color Channel. Inside the Color Channel, click on the Texture drop-down and choose Paste Channel. Note that if you wanted to use the Color Channel rather than the Luminance as a standard practice, you can set it up in the Preferences of CINEMA 4D to be the default.

Figure ProjectionMan_09

Figure ProjectionMan_09

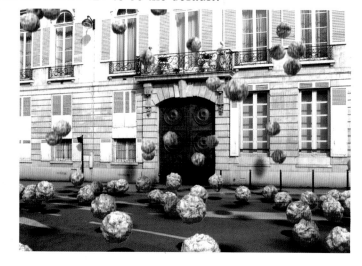

CINEMA 4D in Production

An Interview with Tom Quach

Tom Quach is a master in the field of texture and digital matte painting. As a texture artist for Sony Imageworks, Tom has worked on some of Hollywood's biggest films such as *The Matrix*, *Beowulf*, *Speed Racer* and *Watchmen*.

How long have you worked in CINEMA 4D?

It's been almost 5 years now.

What do you use CINEMA 4D for in your work?

I use it to set up and render 3D matte paintings.

Why did you choose to add C4D to your workflow?

Sony Imageworks tested multiple 3D paint packages and decided to go with C4D.

What applications do you use in conjunction with C4D?

I use Bodypaint, Photoshop, Zbrush and Maya.

What do like most about CINEMA 4D?

The ease of use, the user-friendly interface and the speed.

As a texture painter, do you paint both matte paintings and texture maps?

Yes, I get to do both. I also do some modeling and lookdev.

CINEMA 4D in Production

Can you give us a quick breakdown of your work flow (your process for painting textures). For example...do you get a model with UVs layered out and reference images to use for painting, etc.?

The first thing I do is to convert the model from Maya to C4D so that I can load it in BodyPaint. Then I would prepare my model for texturing by applying a blank canvas to each material group with a UV snapshot. Then I will transfer the maps to Photoshop and start painting. After painting a first pass, I will show it to the vfx sup and get notes. After a few back and forth with the vfx sup, I will fix the seams and publish my final version.

In your work, do you use BodyPaint's inhouse painting tools or do you export out to Photoshop to do most of the painting?

I mainly paint in Photoshop. But, I would touch up or fix seams directly in BodyPaint.

Do you layout UVs in your workflow?

It's usually done in modeling but sometimes I help out with the UVs.

Have you heard of Ptex? Do you think UV maps will continue to be important for painting textures?

Yes I did, I think it's amazing! Not having to deal with UVs is every texture painter's dream. I hope we don't have to deal with them in the future. It's time consuming and very restrictive. If the UVs are not layed out properly, it will affect my work and slow down my productivity.

In painting textures, what channels do you paint in? For example, Color, Bump, Normal, Specular, Diffusion, etc.

I always paint the color pass first and from it, I would create the others.

Can you give the readers some advice on how to be a successful texture artist?

To be a successful texture painter, you need to have a big texture library. It will make you more efficient and allow you to create better maps. Also, you need to be fast and be able to have a quick turnaround. The Vfx supervisor will always have lots of notes and tweaks for you to adjust. The faster you are, the more notes you address, the better your final result will look.

Images Courtesy of Tom Quach

If you would like to know more about Tom Quach, visit his website at www.tomquach.com

14
Tips on Type

3D text in C4D is as easy as it gets. As with other splines, multiple NURBS objects can be used to bring a new dimension to your type. The following projects will build up some basic 3D building and animating techniques available for Text Splines. You will also see the integration of Illustrator text into your 3D workflow. At the end of this chapter, the focus will shift to the MoText object that gives you some automated keyframeless animation possibilities as well as a few MoGraph techniques that will enhance traditional extruding techniques.

Extruding Text

Creating 3D type couldn't be much easier. Even better are the tools that allow you to take typography and motion graphics techniques beyond traditional limits and into the next dimension.

Step 1 Create a Text Spline. *Figure TextExtrude_01*

Figure TextExtrude_01

Chapter 14: Tips on Type

Step 2 Change the Font to Myriad Pro (Bold). *Figure TextExtrude_02*

Figure TextExtrude_02

Step 3 In the Attribute Manager, change the text in the Text Box to the desired wording.

Step 4 With the Text Selected in the Object Manager, hold Option (Alt PC) and click on the Extrude NURBS from the NURBS menu. *Figure TextExtrude_03*

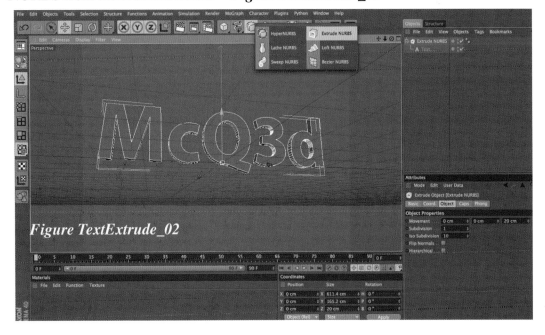

Figure TextExtrude_02

Step 5 With the Extrude NURBS object selected, click on the Caps tab in the Attribute Manager and set the Start and End to Fillet Caps with a Step of 1 and Radius of 2 for each. *Figure TextExtrude_04*

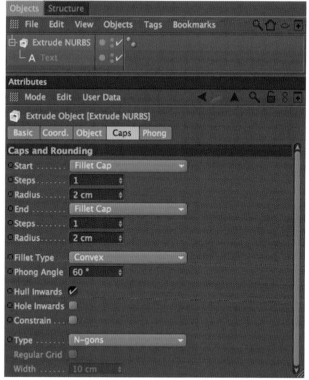

Figure TextExtrude_04

Step 6 Now we can apply materials to this text to add some pizzaz. Double click in the Material Manager to create a new material. Rename it Cap Mat.

Step 7 Set the Color to Red 255, 0, 0. In the Reflection Channel, set the Brightness to 25%, mark the Additive checkbox and raise the Blurriness value to 15%.
Figure TextExtrude_05

Figure TextExtrude_05

Step 8 In the Specular Channel, set the Width to 25% and the Height to 70%.

Chapter 14: Tips on Type

Step 9 Create a second Material, set its Color to R 255, G 255, B 0.
Activate the Glow Channel, set the Inner Strength to 75%, Outer Strength to 120% and lower the Radius to 8. *Figure TextExtrude_06*

Figure TextExtrude_06

Note: Materials without selections should be located to the left of all materials containing selection restrictions. Quick selection restrictions can be made in the texture tags for Extrude NURBS using the following:
R1 for Rounding 1 (Front),
R2 for Rounding 2 (Back)
C1 for Cap 1 (Front Cap) and
C2 for Cap 2 (Back Cap).
Once the Text Object has been made editable by pressing the C key, you'll have access to polygonal selections sets.

Step 10 Drag the yellow glow material onto the Extrude NURBS followed by the Cap Mat.

Step 11 With the Cap Mat Texture tag selected to the right of the Extrude NURBS in the Object Manager, type C1 in the Selection field. *Figure TextExtrude_07*

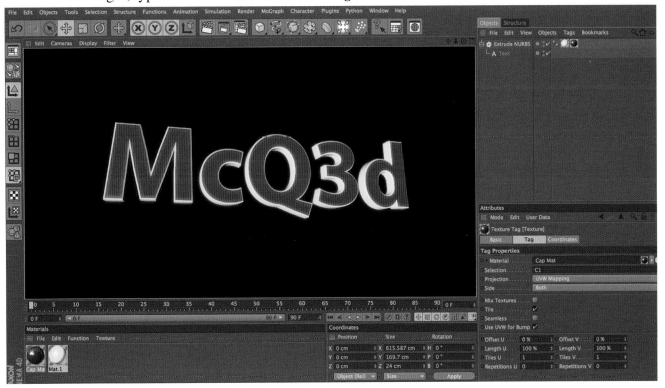

Figure TextExtrude_07

331

Deformers On Type

Open the **Deformers_On_Type.c4d** project from the Tips on Type Folder of the DVD or create a Text Spline subordinated beneath an Extrude NURBS per the previous exercise.

In *Figure DeformType_01*, the Extrude NURBS and Text Spline have been set to the default constructive settings. *Figure DeformType_02* has corrected constructive settings to enable the proper subdivision level for deformers to work correctly on the objects.

Figure DeformType_01 *Figure DeformType_02*

Step 1 With the Extrude NURBS selected, click on the Caps tab and change the Type at the bottom from N-gons to Quadrangles and check the Regular Grid.
Figure DeformType_03

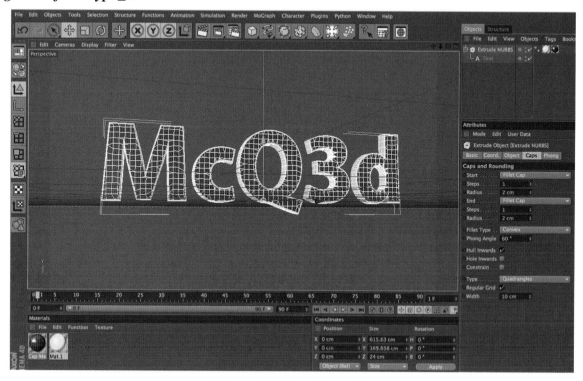

Figure DeformType_03

Chapter 14: Tips on Type

Step 2 Select the Text object. Set the Intermediate Points to Subdivided and match the Maximum Length value with the regular grid value of the Extrude NURBS. In this case that would be 10.
Figure DeformType_04

ON THE DVD

Want total control? Learn how to animate text the old-fashioned way. Keyframe the individual letters and materials to create a professional title animation.

Figure DeformType_04

Step 3 With the Extrude NURBS selected, press Option(Alt PC)+G to create a Null Group.

Step 4 With the Null selected, hold the Shift key and add a Bend Deformer.
Figure DeformType_05

Figure DeformType_05

Step 5 Move the Bend Deformer to P.Y 100 and drag on the orange strength handle or type in values for Strength and Angles in the Attribute Manager. ***Figure DeformType_06***

Figure DeformType_06

Step 6 Deactivate the Bend Deformer by clicking on the check to its right in the Object Manager.

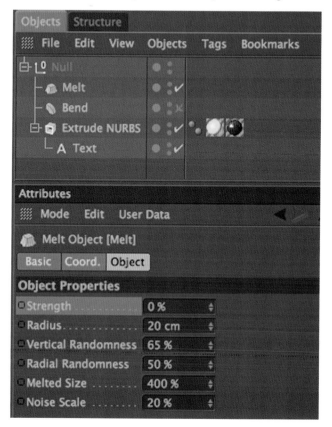

Step 7 With the Null object selected, hold the Shift key and add a Melt Deformer from the same Deformer menu.

Figure DeformType_07

Step 8 Set keyframes on the Strength parameter starting at Frame 5 with a value of 55%. (Control click on the ellipse to the left of the parameter to set a keyframe.)
Figure DeformType_08

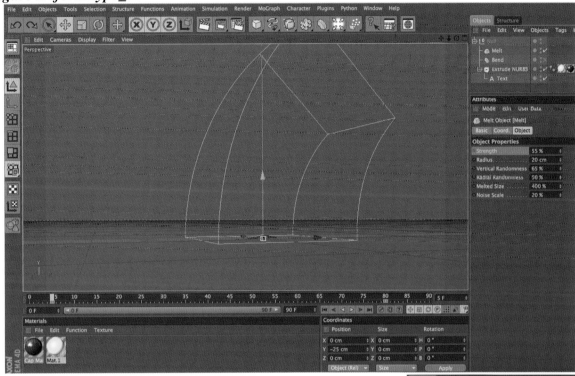

Figure DeformType_08

Step 9 Scroll to Frame 80 and set a second keyframe with a value of 0.2%. If you notice clipping, you may need to move the Melt object down slightly on the Y.
Figure DeformType_09

Figure DeformType_09

Step 10 Playback the animation to see the results.
Figure DeformType_10

Figure DeformType_10

Step 11 Deactivate the Melt by clicking on its checkbox to the right in the Object Manager.

Step 12 With the Null Object selected, hold the Shift key and add an ExplosionFx deformer. In the Attribute Manager, set the Time to 28%. In the Gravity tab, set the range to 540. Under Cluster set a Variation value of 35% for Thickness and Density. In the Explosion tab, you should have a Blast Speed of 50. Navigate to Frame 5 and set a keyframe for the Time Parameter. *Figure DeformType_11*

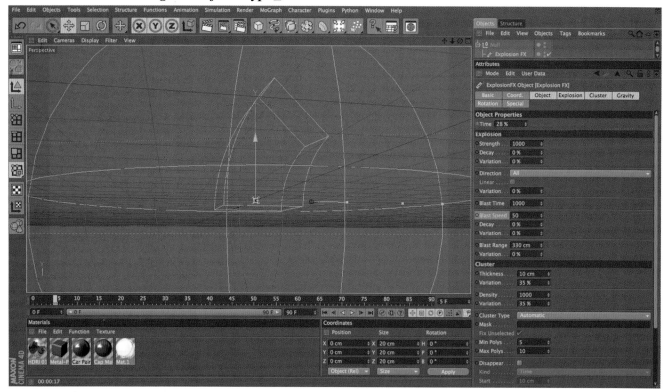

Figure DeformType_11

Step 13 Scroll to frame 80 and set a keyframe with a Time value of 0 and playback the animation.
Figure DeformType_12

Figure DeformType_12

Chapter 14: Tips on Type

Sweep Text

Open the **Sweep_Text_Start.c4d** project located on the DVD in Tips on Type Folder.

Step 1 Add a Sweep NURBS to the scene. Drag the Text and Spline objects into the Sweeps NURBS with the Text on top. Drag the Metal005 Material on to the Sweep NURBS.
Figure SweepText_01

Figure SweepText_01

Step 2 Scroll to Frame 105 in the Timeline. With the Sweep NURBS selected, Control+click on the ellipse to the left of the Start Growth to set a keyframe with a value of 0. Lower the End Scale to 30%. Both of the parameters will be found in the Object tab in the Atttribute Manager. ***Figure SweepText_02***

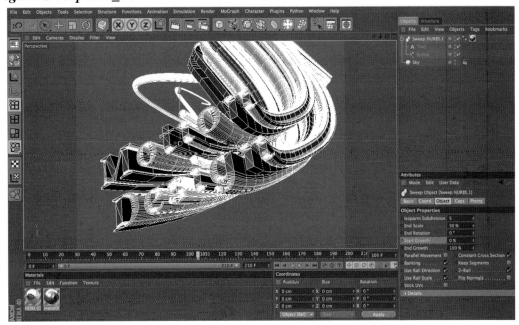

Figure SweepText_02

337

Step 3 Scroll to Frame 4 in the Timeline. Set the Start Growth at 100% and Control+click on the keyframe ellipse to set a second keyframe. *Figure SweepText_03*

Figure SweepText_03

Step 4 Finally, click on the Caps tab of the Sweep NURBS in the Attributes Manager. Set the Type at the bottom to Quadrangles and check Regular Grid. Set the Width to 20. *Figure SweepText_04*

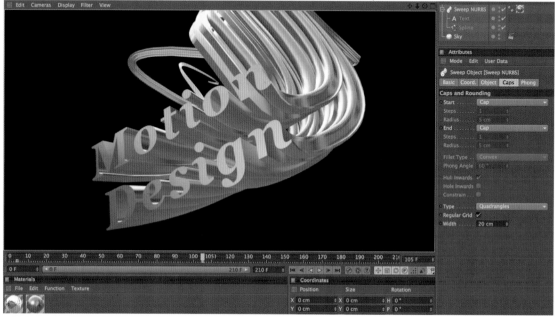

Figure SweepText_04

Click on the Render Settings and choose the name and location. You are ready to render.

Chapter 14: Tips on Type

Sweep Along Text

Open the **Sweep_Along_Text_Start.c4d** file located on the DVD in the Tips on Type Folder.

Step 1 Add a Sweep NURBS to the scene. *Figure SweepAlongText_01*

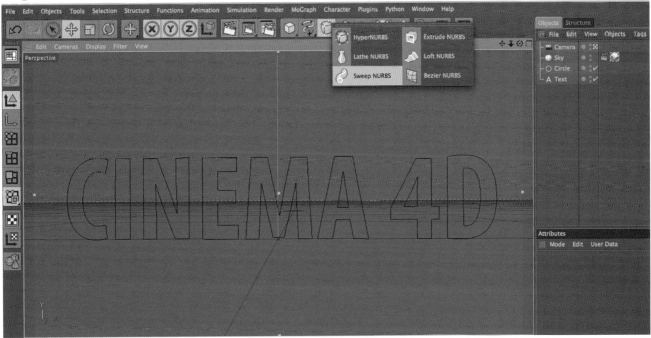

Figure SweepAlongText_01

Step 2 Drag the Circle and Text Splines into the Sweep NURBS object with Circle Spline on Top. Drag the Blue Glow Material and drop it on the Sweep NURBS. *Figure SweepAlongText_02*

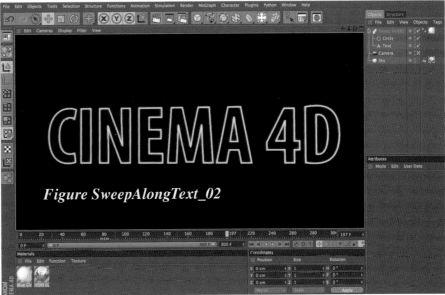

Figure SweepAlongText_02

Step 3 Click on Frame 100 in the Timeline, select the Sweep NURBS object and raise the Start Growth to 100%. Control click on the ellipse to its left to record a keyframe. Lower the End Growth to 0%. *Figure SweepAlongText_03*

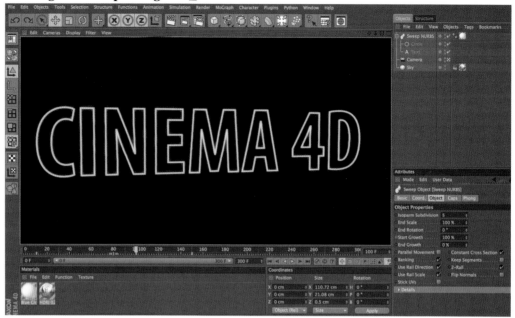

Figure SweepAlongText_03

Step 4 Move to Frame 10, lower the Start Growth to 0% and Control click the ellipse to set another keyframe. *Figure SweepAlongText_04*

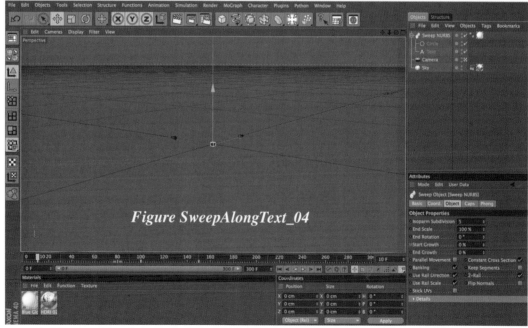

The Render Settings are laid out. Simply set the location and name you would like to use in the Save tab of the Render Settings and render the movie.

Chapter 14: Tips on Type

MoText Introduction

Keyframe free animation for text is possible using CINEMA 4D's MoText object. MoText allows the use of MoGraph's powerful Effectors to animate your type.

Step 1 Start the scene by adding a MoText Object. *Figure MoText_01*

Figure MoText_01

Step 2 Change the letters of the MoText object to read C4D and change the font to Impact.

Step 3 With the MoText object selected, add a Formula Effector from the Effectors drop-down within the MoGraph menu. *Figure MoText_02*

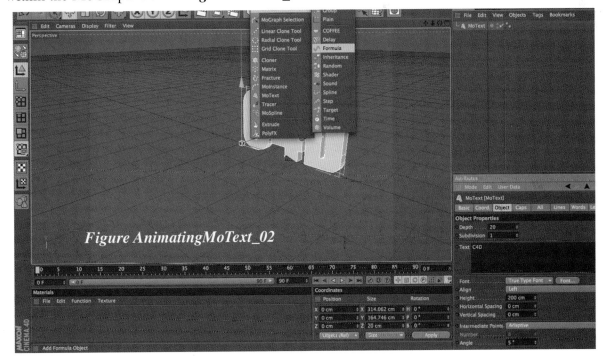

Figure AnimatingMoText_02

341

Step 4 With the Formula Effector selected in the Object Manager, go to the Parameter tab of the Attribute Manager. Put a check for the Position Parameters and set them to P.X 50, P.Y 300, P.Z 1000. Check the Rotation Parameters and set them to R.H 610, R.P 100 and R.B 450. Play the animation to see how this is affecting the type. *Figure MoText_03*

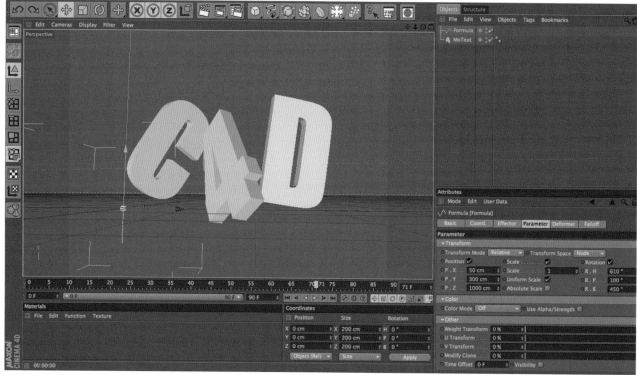

Figure MoText_03

Step 5 With the Formula Effector selected, create a quick animation by Control clicking on the ellipse to the left of the Strength parameter in the Effector tab of the Attribute Manager. Scroll to frame 80 and set a second keyframe with a Strength value of 0%. Play the animation to see the letters form our final title.

Step 6 Disable the Formula Effector by clicking on its check to the right in the Object Manager.

Step 7 Select the MoText object and add a Target Effector from the Effectors drop-down within the Mograph Menu. *Figure MoText_04*

Figure MoText_04

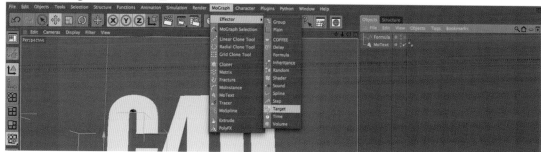

Chapter 14: Tips on Type

Step 8 Go to Frame 5 in the Timeline, move the Target Effector to P.X to - 35000 and the P.Z to 2500. Click on the X to the right of the P. and then Control+Click on the ellipse to the left of the P.X to set a keyframe for this parameter only. ***Figure MoText_05***

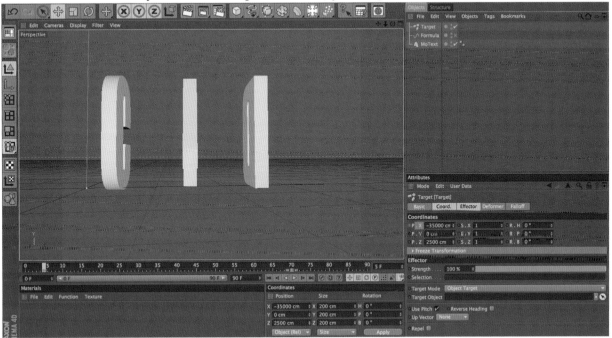

Figure MoText_05

Step 9 Scroll to Frame 70 in the Timeline, change the P.X to 0 and set another keyframe. ***Figure MoText_06***

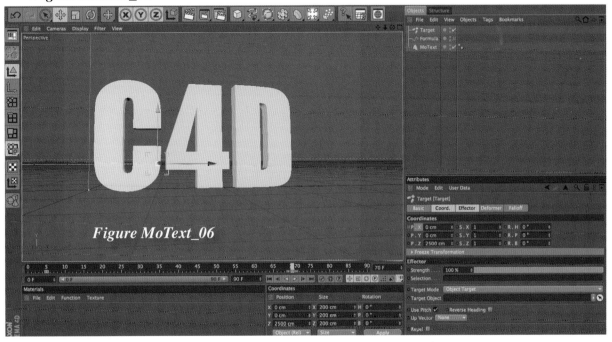

Figure MoText_06

343

Step 10 With the MoText object selected, add a Delay Effector from the same Effectors drop-down. *Figure MoText_07*

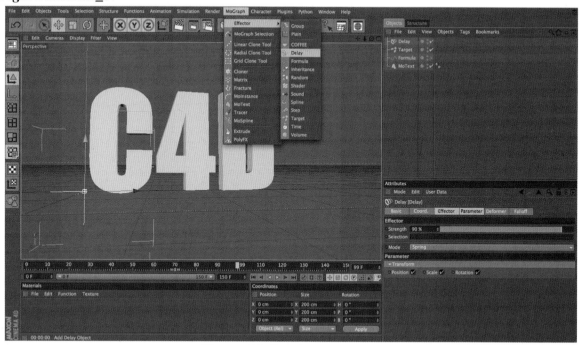

Figure MoText_07

Step 11 Select the Delay Effector, set the Strength to 90% and change the Mode to Spring to add bounce to our animation. *Figure MoText_08*

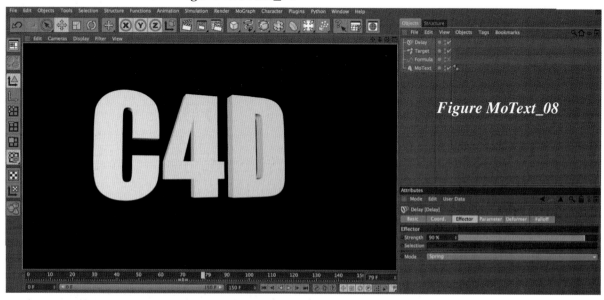

Figure MoText_08

Playback the animation to see the effect.

Chapter 14: Tips on Type

Animate MoText with the Random Effector

Open the **MoText_Random_Start.c4d** file from the Tips on Type>MoText_Random Folder.

Step 1 Select the MoText object and add a Random Effector from the Effectors pulldown. *Figure MoTextRandom_01*

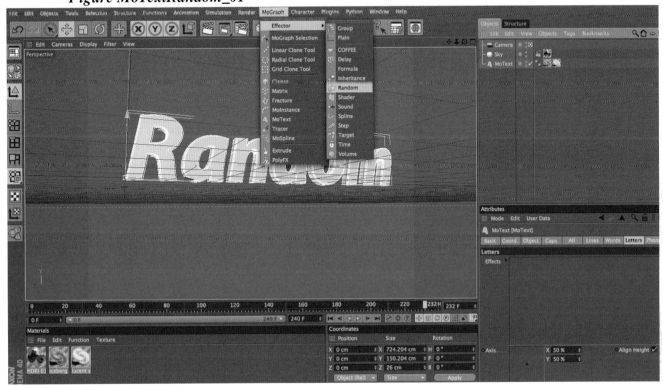

Figure MoTextRandom_01

Step 2 Scroll to Frame 10, and in the Transform settings of the Parameter tab, set the P.X to 20000, P.Y 50 and P.Z to 2555. Enable Rotation and set the R.H to 1240 and the R.P to 535. Control click on the ellipse to the left of Strength in the Effector tab to set a keyframe. *Figure MoTextRandom_02*

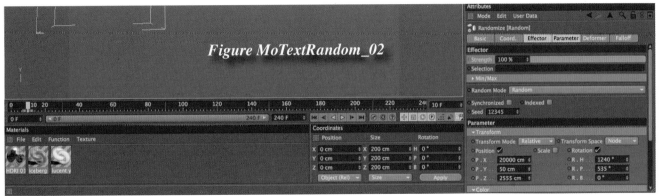

345

Step 3 Scroll to Frame 140, lower the Strength to 0 and Control+click on its ellipse again to set the new keyframe. *Figure MoTextRandom_03*

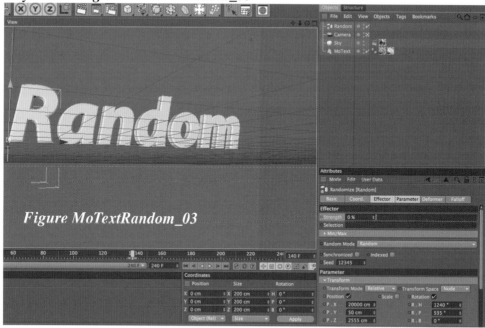

Figure MoTextRandom_03

Step 4 To smooth the animation, select the MoText object and add a Delay Effector from the Effectors drop-down. *Figure MoTextRandom_04*

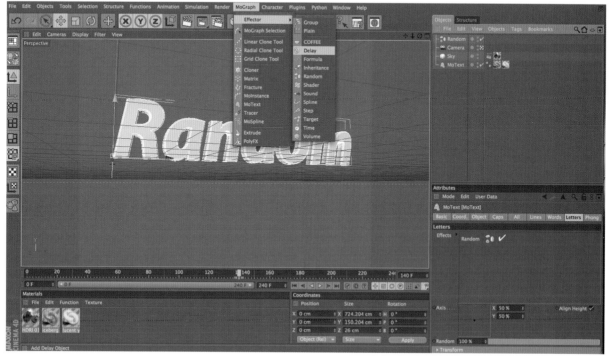

Figure MoTextRandom_04

Chapter 14: Tips on Type

Step 5 With the Delay Effector selected, change the Strength to 90% and the Mode to Blend within the Effector tab. *Figure MoTextRandom_05*

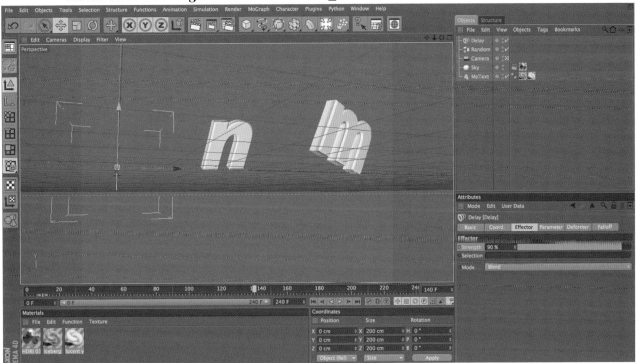

Figure MoTextRandom_05

Render the animation to see the effects of our changes.

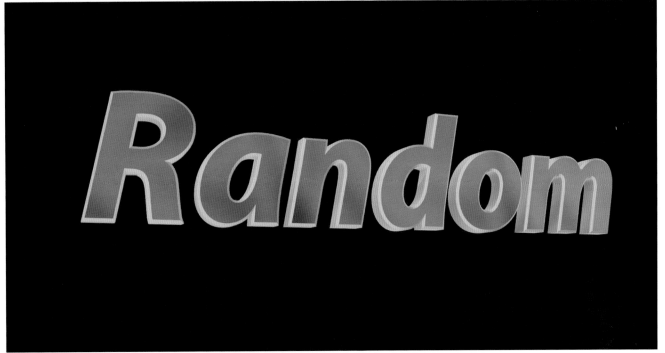

347

CINEMA 4D: The Artist's Project Sourcebook, Third Edition

Making Custom Fonts Spline Mask

Step 1 Open the **Spline_Mask_Start.c4d** file.
Figure SplineMask_01

Figure SplineMask_01

Step 2 Control+Drag on the DragonWing spline object to duplicate it. *Figure SplineMask_02*

Figure SplineMask_02

Step 3 To flip this shape, set the S.X to -135.349 in the Coordinate Manager. Move it into place at P.X 278 and press apply. *Figure SplineMask_03*

Figure SplineMask_03

Chapter 14: Tips on Type

Step 4 Now select the two dragonWing splines and the dragonTail spline. Select Functions>Connect+Delete. *Figure SplineMask_04*

Figure SplineMask_04

Step 5 Rename the spline Dragon.

Step 6 Add a Spline Mask Object from the Modeling menu and place the Dragon and Text splines as children of this Spline Mask. *Figure SplineMask_05*

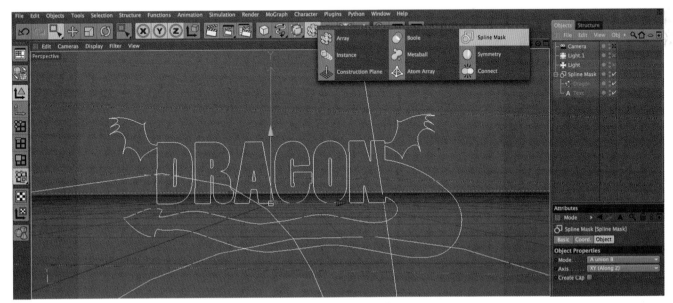

Figure SplineMask_05

Step 7 With the Spline Mask selected, hold the Option (Alt PC) key and add an Extrude NURBS.
Figure SplineMask_06

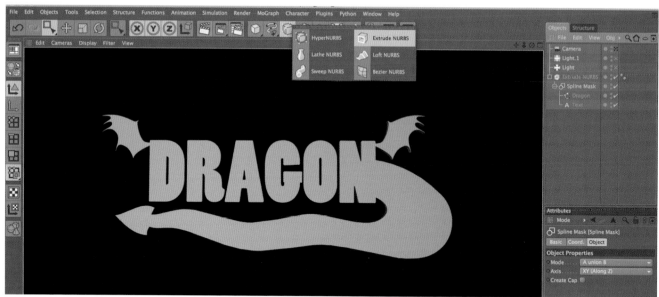

Figure SplineMask_06

Step 8 In the Object Tab of the Attribute Manager, set the Movement to Z 11. Under Caps, set the Start Cap to Fillet Cap with Steps and a Radius of 1. Change the Fillet Type to Engraved and at the bottom of the manager, change the Type to Quadrangles.
Figure SplineMask_07

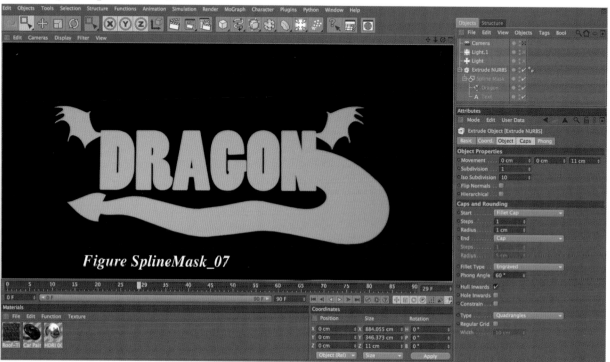

Chapter 14: Tips on Type

Step 9 Drag the Red Material and drop it on the Extrude NURBS, followed by the Green Material. Make sure the Green Material is to the right in the Object Manager. With the Green Material texture tag selected in the Object Manager, restrict this material by typing C1 in the Selection Field. Set the Projection to Cubic and lower the Length U and Length V values to 25%.
Figure SplineMask_08

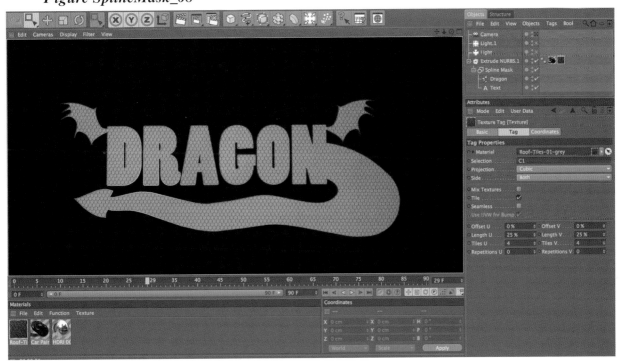

Figure SplineMask_08

Step 10 Turn on the Lights by clicking on the red X's to the right of each. Look through the camera created by clicking on the crosshairs to its right. It will turn white to indicate that it is in use. Render to see the final look. *Figure SplineMask_09*

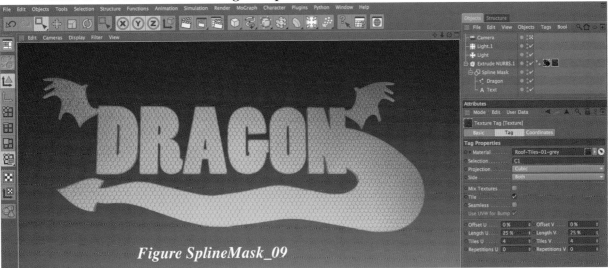

POLYFX

Open the **PolyFXStart.c4d** file located on the DVD in the Tips on Type Folder.

Here you will see that a simple scene has been laid out. The focus of this project is the extruded text located in the middle. You will notice that multiple materials are controlling the color of the Caps and Rounding of the Text and an HDRI image is helping to light the scene using Global Illumination in the Render Settings.

Step 1 For our project to be successful, we need to make the Extrude NURB editable. Select it in the Object Manager and Press the C key.

Step 2 Expand the hierarchy by clicking on the + boxes to show all of the children. We are going to reconnect these shapes, but in order for our Material restrictions to work properly, drag the orange Cap Mat texture tag from the Extrude NURBS parent and drag onto the Cap 1 object. *Figure PolyFX_01*

Figure PolyFX_01

Step 3 Shift click to select all of the objects that make up our extruded text and choose Functions>Connect+Delete. *Figure PolyFX_02*

Figure PolyFX_02

Chapter 14: Tips on Type

Step 4 Rename the resulting Extrude NURBS.1 to TYPE. With this object selected, hold the Shift key and add a PolyFX object from the MoGraph Menu. *Figure PolyFX_03*

Figure PolyFX_03

Step 5 With the newly added PolyFX object selected, add a Random Effector from Mograph>Effectors>Random Effector. *Figure PolyFX_04*

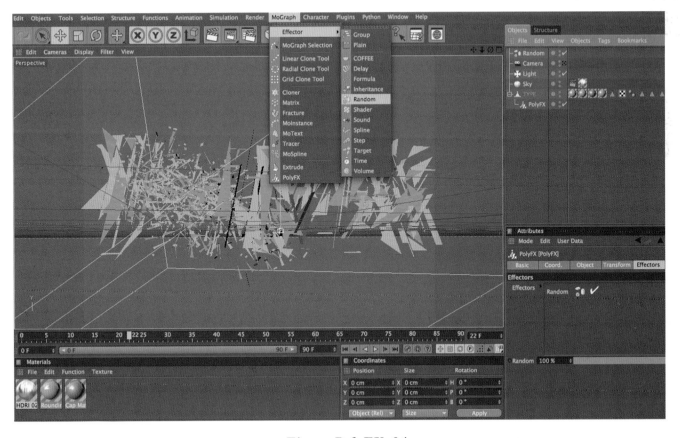

Figure PolyFX_04

353

Step 6 In the Parameter Tab, dial down the Position Values to P.X 3, P.Y 6 and P.Z 2. Enable Rotation and set the parameters to R.H 117 and R.B 204 degrees.
Figure PolyFX_05

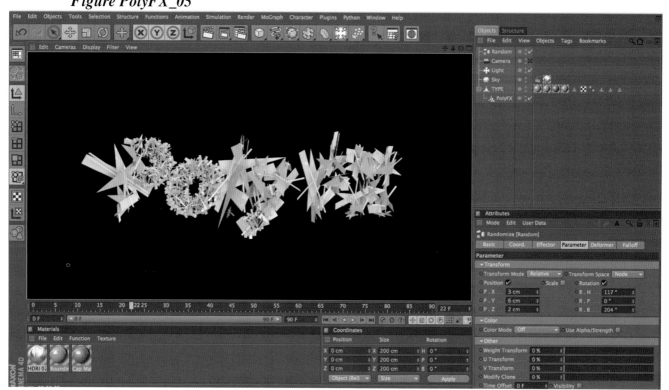

Figure PolyFX_05

You end up with a bit of an unrecognizable mess. Two things need to be done. The first will be to further subdivide the mesh of the TYPE object and then we will adjust the Random Effector to animate over the life of the scene.

Step 7 Disable the Random Effector by clicking on its checkbox to the right in the Object Manager.

Chapter 14: Tips on Type

Step 8 Select the TYPE object and switch to Polygons. Press the K key to activate the Knife tool. In the settings for the Knife tool, uncheck Visible Only. Use the Knife tool to drag cuts across the mesh. Cut it up as many times as you like to achieve the look you want but be mindful of render time and watch for texture errors to pop up if you make a bad cut. If so, simply press Command (Control PC)+Z to back out of that step. ***Figure PolyFX_06***

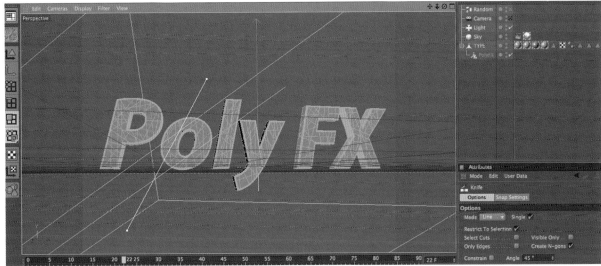

Figure PolyFX_06

Step 9 Re-enable the Random Effector and you should be able to discern the lettering with the extra subdivisions that have been made. It is now time to alter how the Random Effector is altering our shape. With the Random Effector selected, navigate to the Falloff tab. Set the Shape to Capsule, the size to 445, 285, 100 and change the Orientation to +X. Now to alter the falloff further, click in the Spline Graph at the bottom to add four control points. Drag the points to make the curve match the configuration in ***Figure PolyFX_07***.

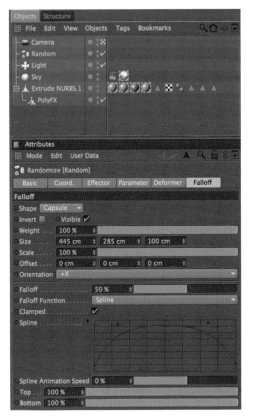

Figure PolyFX_07

Step 10 Move the Random Effector into a starting position of P.X - 1300, P.Y 50, P.Z - 25. Click on the X of P.X in the Coordinates tab of the Attribute Manager to isolate it for a keyframe. Scrub to frame 5 and Control + click on the ellipse to the left of the P.X to set a keyframe. ***Figure PolyFX_08***

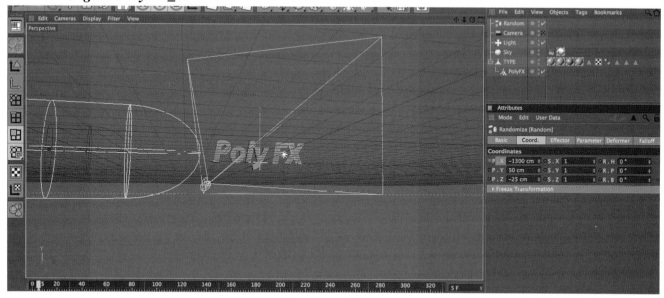

Figure PolyFX_08

Step 11 Scrub to frame 90, change the position of the Random Effector to P.X - 40 and Control+ Click on the ellipse again to set the ending keyframe. ***Figure PolyFX_09***

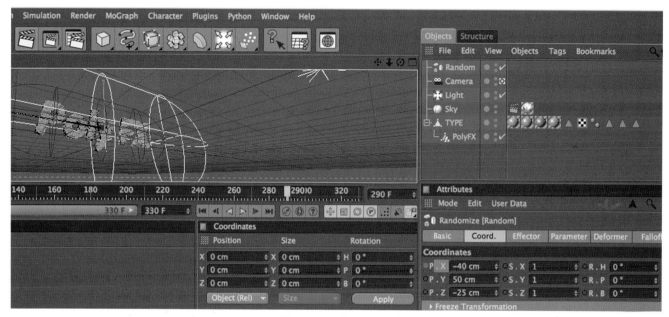

Figure PolyFX_09

Chapter 14: Tips on Type

Step 12 To soften the effect of the Random Effector, lower its Strength to 20% in the Effector Tab of the Attribute Manager. *Figure PolyFX_10*

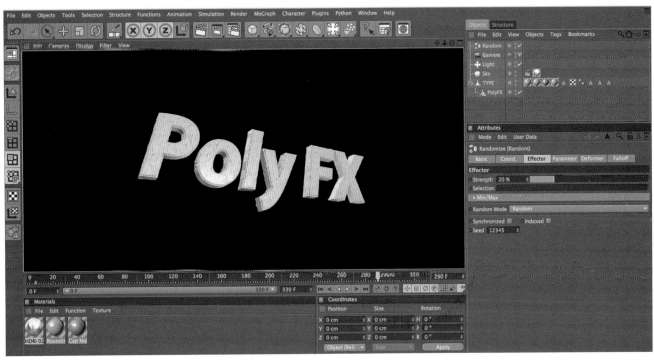

Figure PolyFX_10

Step 13 Click the white crosshair to the right of the Camera object and play back or render the animation.

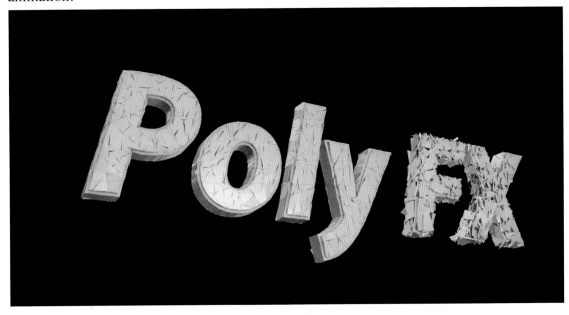

357

More out of MoGraph 15

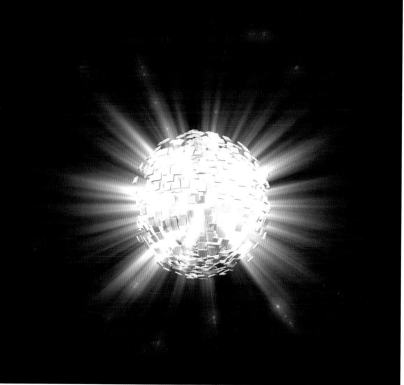

MoGraph is a special engine designed to generate all kinds of effects. A huge part of MoGraph is focused on Cloning. Cloning gives you the ability to mass produce objects or groups of objects instantly. MoGraph also gives you some incredible tools to create and control animation of those clones. The main tools that you will use to animate the Cloners are the Effectors. There are also some specialized MoGraph generators that allow you to break apart and animate components of your shapes. We've already looked at one in the PolyFx object and the other is the Fracture object. Lastly, in Release 11.5, a new Dynamics engine was added to create amazing new keyframe free animation of your Clones and special MoGraph objects. As you will see in the Dynamics chapter, the new dynamic tools have been expanded to include all objects. Before we cover the details of these numerous options, let's look at the basics of Cloners and Effectors. Clones are made simply by subordinating an object or many objects under a Cloner. You have quite a few options as to how the number and shape of the Cloners will be created. In the following example, we look at the major options for creating Cloners, many of which are covered in detail in this chapter. Note that even more Cloner examples can be found on the DVD in the More Out of MoGraph chapter.

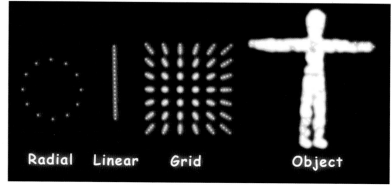

Chapter 15: More Out of MoGraph

Spline Effector

Open the **Spline_Effector_Start.c4d** project. You will see that the main attractions are the Head model and the CINEMA 4D text spline. If you play the animation, you will see that the Head object has been set to rotate. There is one other important object here, the Cube.

Step 1 Select the Cube and hold the Option (Alt PC) key as you add Cloner object from the MoGraph Menu. *Figure Spline_Effect_01*

Figure Spline_Effect_01

Step 2 In the Object tab, set the Mode to Object and drag the Head model into the Object field. Change the Distribution to Surface and raise the Count to 10,000. Since we have so many clones, be sure to enable Render Instances. *Figure Spline_Effect_02*

Figure Spline_Effect_02

Step 3 With the Cloner selected, add a Spline Effector from the MoGraph Effectors menu. Hide the head model by turning its stoplights red. *Figure Spline_Effect_03*

Figure Spline_Effect_03

359

Step 4 Inside the Effector tab of the Spline Effector, drag the CINEMA 4D text spline and drop it into the Spline field. Finally, change the Segment Mode to Full Spacing.

Figure Spline_Effect_04

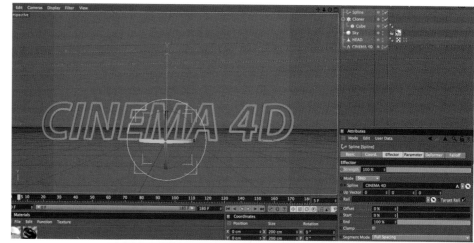

Figure Spline_Effect_04

Step 5 Scroll to Frame 40 in the Timeline and set a keyframe for the Strength parameter at 0%.
Figure Spline_Effect_05

Figure Spline_Effect_05

Step 6 Go to Frame 135, and set a second keyframe with a Strength value of 100%. Go ahead and drag the Metallic texture onto the Cloner to see how everything looks.
Figure Spline_Effect_06

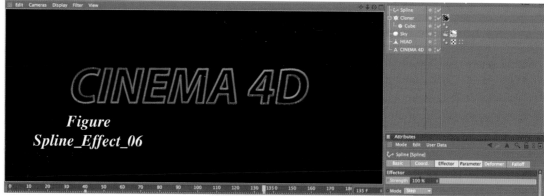

Figure Spline_Effect_06

Step 7 To make the animation a little more interesting, select the Cloner object and add a Delay Effector from the Effectors menu. Set the Mode to Spring and lower the strength to 35%.
Figure Spline_Effect_07

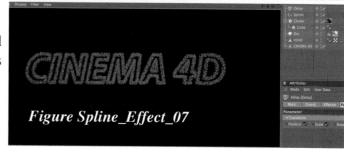

Figure Spline_Effect_07

Chapter 15: More Out of MoGraph

MoGraph Tracer

Step 1 Open the **Tracer_Start.c4d** file located in the More Out of Mograph Chapter.

Step 2 Add an Emitter to this scene. Set the Birthrate Editor and Renderer values to 30, and the Stop Emission value to Frame 200. Set the Speed to 160 with a Variation of 35% and set a Rotation value of 21 degrees. For the Emitter size, set the Y and X values to 325. If you were to play the animation, you would notice that the Sprite particles are flowing in the wrong direction. To solve this issue, rotate the Emitter to R. P 90.
Figure Tracer_01

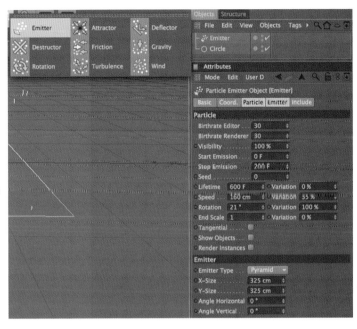

Figure Tracer_01

Step 3 Add a Sweep NURBS to the scene. To get a tapering down of the sweep as it emits from its origin, set the End Scale to 0%. *Figure Tracer_02*

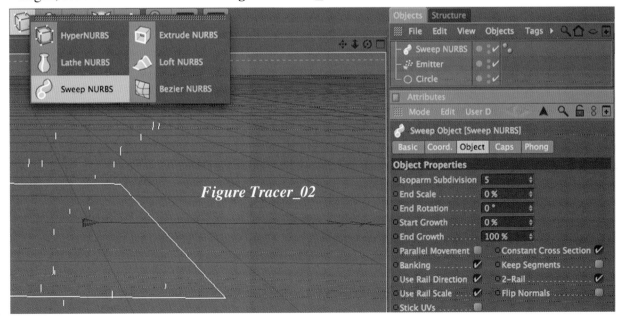

Figure Tracer_02

361

CINEMA 4D: The Artist's Project Sourcebook, Third Edition

Step 4 Drop the Circle Spline and the Emitter into the Sweep NURBS with the Spline on top. Select the Emitter, and hold the Option (Alt PC) as you add a Tracer Object.
Figure Tracer_03

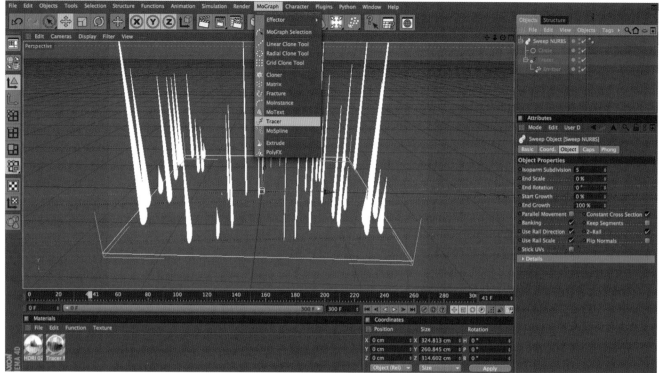

Figure Tracer_03

Play the animation and you will now see that the Tracer in combination with the Sweep NURBS is resulting in some animation, but we need to make it more organic.

Step 5 With the Tracer object selected, hold the Shift key and add a Twist deformer. Set the Size to 385, 1000, 600. Set the Angle to 550 degrees and in the Coordinates tab, set the P.Z to 460. *Figure Tracer_04*

Play the animation to see the splines grow. Now we want to stylize this even further by having the splines grow into the shape of a sphere.

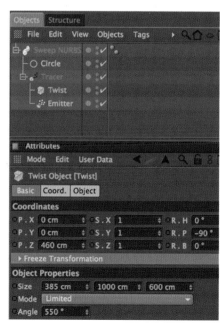

Figure Tracer_04

Chapter 15: More Out of MoGraph

Step 6 With the Tracer object selected, hold the Shift key and add a Spherify Deformer from the Deformer menu. In the Coordinates, correct its position value to P.Z 300. In the Object tab, up the Radius to 350 and the Strength to 100%. Play the animation. *Figure Tracer_05*

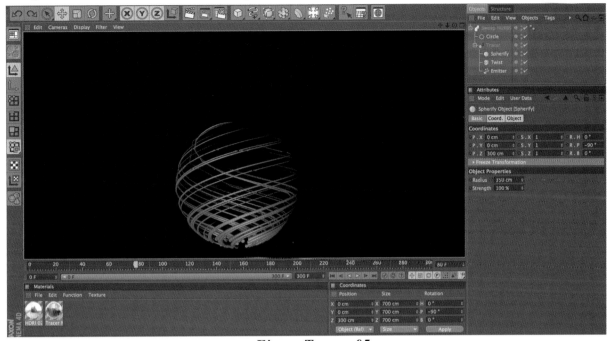

Figure Tracer_05

Step 7 The objects are working together correctly but, as the spline wraps around the top of the Spherify deformer, it begins to look edgy and less organic. To fix this, select the Tracer object and within the Object tab, set the Type to B-Spline and the Intermediate Points to Natural with a Number of 4. *Figure Tracer_06*

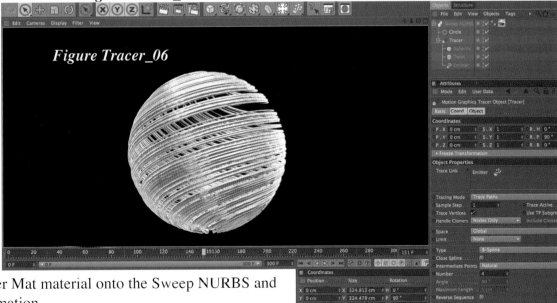

Drag the Tracer Mat material onto the Sweep NURBS and render the animation.

363

MoGraph Sound Effector

Drag and drop the Sound effector audio files from the More Out of MoGraph>Sound Effector folder on the DVD to your desktop or other easily found location.

Step 1 Add a Cube primitive, and set its size to 6.85 for each axis.

Step 2 Add a Cloner Object, set to Grid Array with Count values of 30, 30, 1. Click the checkbox for Render Instances. *Figure Sound_01*

Figure Sound01

Step 3 Access the MoGraph Selection tool and set it to Rectangle. *Figure Sound_02*

Figure Sound_02

Step 4 Draw two 5-column selections down the left and right. As with other selection tools, hold the Shift key to add to existing selections, and the Control key to remove. *Figure Sound_03*

Step 5 Switch the Mograph Selection tool to Brush and draw a V to connect the initial selections. Notice a MoGraph Selection tag has automatically been added. *Figure Sound_04*

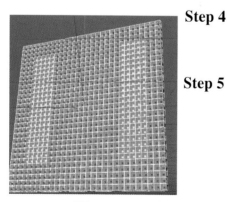

Figure Sound_03

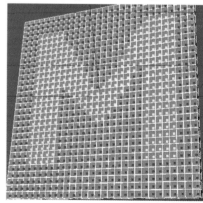

Figure Sound_04

Chapter 15: More Out of MoGraph

Step 6 Control+Drag on the MoGraph selection tag to duplicate and select Invert. Name this tag MoGraph Selection 2 *Figure Sound_05*

Figure Sound_05

Step 7 With the Cloner selected and the original Mograph Selection tag highlighted, add a Sound Effector. *Figure Sound_06*

Step 8 In the Effector tab, set the Sound File by navigating to the location of the **Sound_Effector_01.aif**. Play the animation; if it doesn't work correctly, you may need to drag the MoGraph Selection tag and drop it into the Selection field. *Figure Sound_07*

Figure Sound_06

Figure Sound_07

Step 9 In the Parameter tab, set the Position to P.X 0, P.Y 0 and P.Z -9. Set the Scale to S.Z 12.25 and the Rotation values to R.H 15, R.P 5 and R.B 15. Under Falloff, set the Shape to Sphere. *Figure Sound_08*

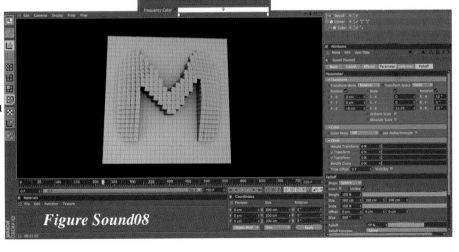

Figure Sound08

Step 10 If you are not hearing sound, click on the speaker button located on the right, just below the timeline. *Figure Sound_09*

Figure Sound_09

Step 11 With the Cloner object selected and the Mograph Selection 2 tag highlighted, add a second Sound Effector. If it doesn't automatically update, drag the MoGraph Selection 2 tag into the Selection field. Click on the Sound File link and navigate to the location of the **soundeffector2elementB.aif** file.

Step 12 In the Parameter setting, use the position of P.Z - 2.5 and set the Scale to S.Z 7. In Rotation, set the R.H 15, R.P 5, and R.B 15. In the Falloff tab, set the Shape to Box. *Figure Sound_10*

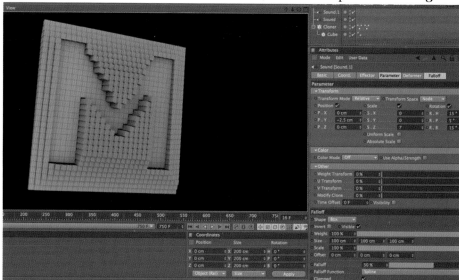

Figure Sound_10

Step 13 Add a material to the cloner and you are ready to render.

Note: Should you find that one or both of the Sound Effectors is not affecting your Cloner, make sure that they have been added to the Effectors tab of the Cloner.

Chapter 15: More Out of MoGraph

MoSpline

Open the **MoSpline_Start.c4d** file located in the More Out of MoGraph Folder on the DVD.

Step 1 From the Mograph Menu, add a MoSpline object.
Figure MoSpline_01

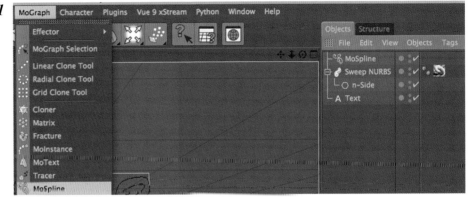

Figure MoSpline_01

Step 2 As you can see, there are Text Spline, Sweep NURBS and an n-side spline primitive placed in the scene. If you've worked through the Tips on Type folder, you know that we can animate the drawing of text by placing it along with another spline shape, beneath a Sweep NURBS. In this case you need to add the MoSpline object to the Sweep NURBS. It needs to be placed below the n-Side object within the Sweep NURBS. *Figure MoSpline_02*

Figure MoSpline_02

Step 3 Select the MoSpline object in the Object Manager. In the Attribute Manager, click on the Object tab and set the Mode to Spline. By default this would draw similar to the Sweep NURBS, change the Grow Mode to Separate Segments to have each character draw independently. Move to Frame 5 in the Timeline and Control click a keyframe to the left of the End Parameter set to a value of 0%. Scroll to Frame 135 and set a second keyframe with a value of 100%. *Figure MoSpline_03*

Figure MoSpline_03

367

Step 4 The animation is set but the MoSpline has no object reference. Select the Spline Tab and drag the Text Spline from the Object Manager into the Source Spline field. Raise the Width value to 15. Play the animation. *Figure MoSpline_04*

Figure MoSpline_04

Render the final animation.

Even More Out of MoGraph on the DVD
Learn to do something everyone wants to know: how to grow your money. Unfortunately, its only in the computer. Use the Time, Formula, Step, Random and Delay Effectors in conjunction with Rigid Body Dynamics to create this scene.

FINAL RENDER

An Interview with Rob Garrott

Rob is an Art Director, Animator, and Editor with 17 years of hands-on experience working for ad agencies and television networks. He has designed and produced broadcast projects for many of the top brands, everything from tv-guide ads to network on-air graphics packages, generic promos, and sales tapes. In addition to a busy working schedule, he is an instructor at the Art Center College of Design in Pasadena, CA teaching 3D Motion Graphics, Compositing, and Motion Design. Rob can frequently be found on Cineversity Live and has a must-see C4D/AE motion graphics tutorial series on Lynda.com.

To see more works by Rob Garrott, go to www.bendingpixels.com.

How long have you worked in CINEMA 4D?

I started using C4D with the very first version that shipped here in the States. I forget the number, but it's been 12 years or so.

What do you use CINEMA 4D for in your work?

I started 3D using Electric Image. With no built-in modeler, and really unreliable stability and support, it was a painful process. I was on the Macintosh, and there really weren't any other options until C4D came along. I had seen a demo of C4D at Macworld. It was still in German at the time, but I could see that it had everything I was looking for. Paul Babb had left Electric Image to start MAXON USA, and he sent me a copy. And I've been using it ever since. I've tried all the other major players. But for Broadcast Graphics, it is really the best choice.

What applications do you use in conjunction with C4D?

After Effects, Photoshop, and Illustrator. Final Cut Pro, SynthEyes, and just about anything else that the project calls for. C4D is really a very large hammer in my very large toolbox. It is supposed to be used as part of a much larger workflow. That's the great thing about what MAXON has created. They've made C4D so it would fit into any kind of workflow you could come up with. It's not supposed to be the end in itself.

CINEMA 4D in Production

As a motion graphics artist, what are your responsibilities?

That really depends on the job. I've been a freelancer for almost 11 years now, and sometimes I'm the agency and creative director, and sometimes I'm a production artist working in the trenches. On some jobs I'm working out of my own studio, and other times I'm working on site. Above all I have to be flexible, and willing to do whatever it takes to make a deadline. Not only do I have to be creative and artistic, but I also have to repair my own computer systems and keep them up to date with upgrades, hardware and backups.

You utilize a great deal of live action footage in your work. What is the most challenging aspect of integrating 3D with those elements?

Number one is camera alignment. That's where SynthEyes comes in. There are several other Tracking packages, but SE is by far the least expensive. It has a quirky workflow, but all the features of the others at 1/10th the price. I don't do much true VFX work, so I'm not usually concerned with matching 3D exactly into a scene. Usually I'm putting an actor into a graphic environment where lights and color aren't nearly as important. You still pay attention to it, but it's more a matter of style and design rather that physical correctness.

Can you give our readers a shortlist of key techniques and skills vital to the creation of professional level motion graphics?

Like I mentioned above, timing and keyframe manipulation are the most important. Never rely on the finished output of any 3D package. You should always pass it thru a compositing package to tweak it. So a thorough understanding of compositing and layers is crucial. A motion graphics piece is really like a moving jigsaw puzzle, and you're creating all the parts!

In an environment of ever changing technologies and software players, do you feel that CINEMA 4D will continue to play a large role in your work?

Absolutely. There has been a lot of consolidation in the 3D world, and that always leads to stagnation. The great thing about C4D is that MAXON is a very small company and because of that they're very nimble and able to respond to user needs much more rapidly than a big company that has to manage 10 other large pieces of software. There are some key things that C4D is not good at, but it's very good at working with others, so if there is something you need in another package, you can export a scene file out to that package and get something back into C4D. It's a very flexible part of any workflow.

CINEMA 4D in Production

Hooper The Guinea Pig
Images courtesy of Point 360/EdenFX
Rob Garrott = Animator

Super Dave Spiketacular Main Title
Images courtesy of Point 360/EdenFX
Rob Garrott = Designer/Animator

Lynda.com Designing a Promo Tutorial Series (Shark Zone)
Images courtesy of Lynda.com
Rob Garrott = Creative Director, Designer, Animator, Instructor

16 After Effects Integration

For motion graphics artists, special effects artists, matte painters and compositors, integration into After Effects from 3D programs is a must. As with Photoshop, After Effects has the ability to allow the editing of our 3D scenes without having to rerender the work. This saves a huge amount of time and preserves consistency as well. In this chapter, we will focus on one of the largest areas where, CINEMA 4D and After Effects are used, motion graphics. The exercise in this chapter is set to show the fundamental workings of the C4D AE plugin and how the two softwares are linked to allow the editing of 3D scenes in post. If After Effects integration is of interest to you, make sure you check out the folder of the same name on the DVD. It is loaded with information on going from C4D to AE as well as a walkthrough of installing the AE plugin provided with C4D for After Effects.

Setting Up a Simple Scene for AE Integration

In this chapter, we will cover the three major steps of integrating After Effects with C4D in your workflow. For those less familiar with this partnership, CINEMA's AE plugin allows 3D data along with other composition-based layers and assets to be exported to After Effects and edited in post. In simpler terms, After Effects will be able to edit many of the components of your 3D scene without having to be rerendered. This is a huge help to graphics houses that often run multiple versions of spots using a 3D packaged scene.

Chapter 16: After Effects Integration

Whether you're facing tight deadlines or just want to be flexible and efficient in your workflow, the AE plugin is a must. One other note is that, just as Photoshop allows for visual enhancement of your C4D multipass renders, After Effects is equally equipped to make specialized enhancements to your 3D compositions.

The three steps that will be covered are:
- creating a 3D scene with assets and materials that lend themselves well to being edited in post
- creating tags and render settings to output the correct file structure for masking and recording 3D data as well as multipass compositing layers for editing in AE.
- importing the composite from C4D into After Effects and simple editing techniques to edit/enhance 3D scenes.

AE Integration on the DVD Part 1:
Setting Up a Simple Scene for AE Integration

Part 1 is located on the DVD. This project was built with the thought that it will be used to run as several variations and will be subject to change. Things to keep in mind are: size of final output, aspect ratio for assets that will be integrated in AE and how elements of the 3D scene may be impacted by AE elements.

To have a complete picture of how to design projects for integration into After Effects you will definitely want to check out Part 1 on the DVD.

EVEN MORE
See how to use Cloners in conjunction with After Effects on the DVD as well.

Captures from Part 1 on DVD

CINEMA 4D: The Artist's Project Sourcebook, Third Edition

Part 2: Setting Up Tags and Render Settings

Continue with the file you built in Part 1 or open the **AESimpleSetup_Part2_Start.c4d** file located in the After Effects Integration folder.

Step 1 Before going further, we need to clarify our naming for when we pull the scene over to After Effects. Rename the Screen located in the Right Monitor object Right Screen. Rename the Screen located in the Left Monitor object Left Screen.

Step 2 Select the three Screen objects, right click and choose CINEMA 4D tags>External Compositing. The Anchor Point should be set to Center. Enable Solid and set the Size X to 1920 and Size Y to 1080. *Figure AE_Part2_01*

Figure AE_Part2_01

Step 3 For the Colors, set the Left Screen to Red, Screen to Green and Right Screen to Blue. *Figure AE_Part2_02*

C4D now will create Solids to track the positioning of these objects in 3D space when we export our composite to After Effects.

Figure AE_Part2_02

374

Chapter 16: After Effects Integration

Step 4 Select all three Screen objects, Right click and choose CINEMA 4D Tags>Compositing. *Figure AE_Part2_03*

Figure AE_Part2_03

Step 5 Click on the Object Buffer tab of the Screen objects' Compositing tag and set the Enable for Object Buffer 1. Since the Screen object is revealed first, we will keep it named properly in the Object Buffers. *Figure AE_Part2_04*

Figure AE_Part2_04

Step 6 The Left Screen is revealed second, so enable Object Buffer 2 for it.

Step 7 Finally, enable Object Buffer 3 for the Right Screen's Compositing Tag.

These buffers will act as our masking areas for integration of footage in AE.
Now, it's time to set up the render to ensure we include everything we need in the export.

375

Step 8 Open the Render Settings and enable Multi-Pass. Click on the Multi-Pass button on the bottom right and choose Object Buffer from the drop down. *Figure AE_Part2_05*

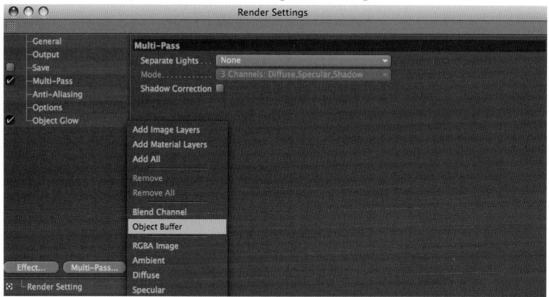

Figure AE_Part2_05

Step 9 You will need to do this three times and set the first as Group ID 1, the second as Group ID 2 and the third as Group ID 3. These render settings Object Buffer passes are directly linked to the Object Buffers we enabled in the Compositing Tags. *Figure AE_Part2_06*

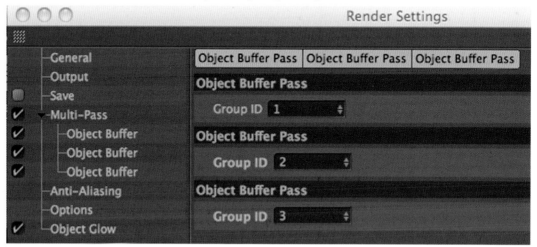

Figure AE_Part2_06

For this example, these buffers are all we need from the Multi-Pass. For more on Multi-Pass editing, check out Multi-Pass rendering in the Art of Rendering chapter and take a look at the Multi-Pass editing video located in the After Effects Integration folder on the accompanying DVD.

Chapter 16: After Effects Integration

Step 10 Go to the Save option. I typically render to PSD or Tiff sequences for maximum quality retention. Though it might be tempting to simplify and create Quicktime movies, they do not embed color profiles and will be interpreted incorrectly in external applications if you have Linear Workflow enabled within C4D. If you want to export to Quicktime, you can turn off Linear Workflow in the Project Settings. Save as a Tiff (PSD layers) sequence and set these options the same for both the Regular Image and Multi-Pass Image. Linear Workflow requires at least 16 bits of depth; set yours to 32 for both the image sequences. Name the files accordingly and designate the location for output. Finally, scroll to the bottom and choose to save the Compositing Project File and enable Include 3D Data to record the tracking information from our Solids. *Figure AE_Part2_07*

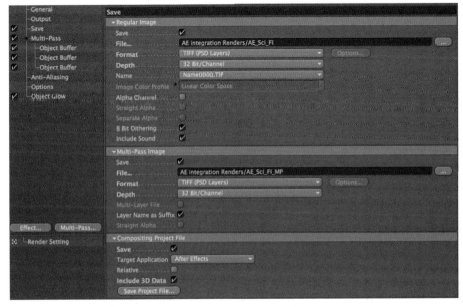

Note: Be sure to save these in a convenient location as this method will create a large number of files.

Figure AE_Part2_07

Step 11 In the Output settings, set the Frame Range to All Frames.

Step 12 You can toggle the Anti-Aliasing to the desired quality. I've chosen Best, set the Filter to Animation and ramped up the Min Level to 4 x 4 and Max to 8 x 8. Since we have no Refraction taking place where Alpha Channels will be generated, I've chosen to leave Consider Multi-Passes disabled. If your machine suffers low render times, lower the Min and Max levels. *Figure AE_Part2_08*

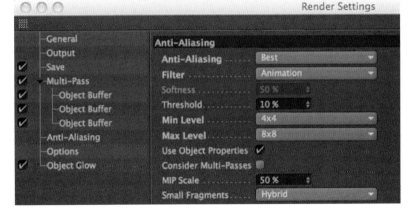

Figure AE_Part2_08

Part 3: Importing and Compositing in AE

Open the AE_Simple_Integration_Part3 folder to see the rendered results from C4D. You can use these files or your own, if you have completed Parts 1 and 2 of this exercise. If you are using the folder from the DVD, I suggest copying this entire folder to your hard drive. Note the rendered files provided on the disk are compressed Quicktime movies due to the file size necessary for storage.

Step 1 The Compositing Project File that you saved from CINEMA 4D is a special comp that needs to be imported into After Effects. Open After Effects and choose **File>Import**. Navigate to the **AE_Sci_Fi.aec** file and press Open. It will take a few seconds to load. *Figure AE_Part3_01*

*Note: If you rendered a Tiff or PSD sequence with Linear Workflow enabled, you will need to go to the Color Settings within the Projects Settings (File>Project Settings) of After Effects and set the bit depth to the proper value (16 or 32 bits per channel). In the same Color Settings, select the correct Working Space and place a check in the Linearize Working Space parameter. For more information, check out the **LinearWorkFlow_MultiPass_AfterEffects.mov** file in the Advanced_After_Effects_Integration folder within the DVD Movies section on the DVD.*

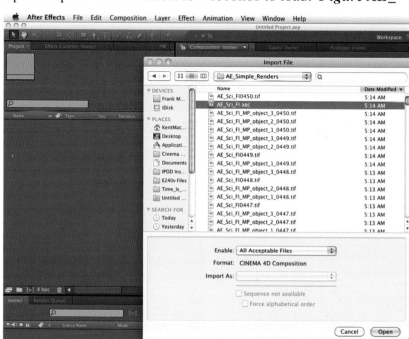

Figure AE_Part3_01

Step 2 Inside the Project Panel, you will see three folders. The topmost folder holds our main render and the Comp that we will use for the production. Had we chosen to break this down into Multi-Pass renders, they would be included in this folder as well. (See Multi-Pass editing in After Effects on the DVD.) *Figure AE_Part3_02*

Chapter 16: After Effects Integration

Step 3 The second group holds our solids and the bottom folder houses our Object Buffer passes. When Multi-Pass channels are rendered, a full RGB layer is included here for reference as well. In *Figure AE_Part3_03* I'm viewing the Object Buffer 3 pass that we made. You can see the cloner particles blocking our buffer, which will be instrumental in our final comp.

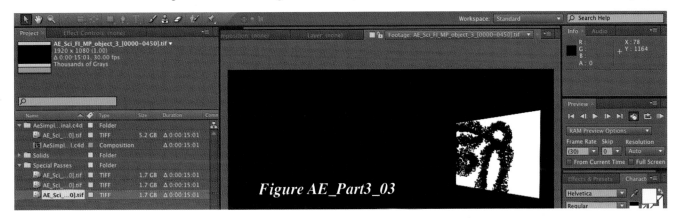

Step 4 Double click on the **AESImpleSetup_Part2_Final.c4d** comp file located at the bottom of the Top folder. You will see the scene with our color-coordinated solids in place and reacting correctly in the 3D scene. *Figure AE_Part3_04*

Figure AE_Part3_04

379

CINEMA 4D: The Artist's Project Sourcebook, Third Edition

Step 5 We now need to import our video footage that we want displayed on our screens. In the Project Panel, right click and choose Import>File. Navigate to location of the AE_Screen_Movies folder and select the three Screen movies listed. Click open to bring them into our project.
Figure AE_Part3_05

Note: These are included in the project folder of the disk by default. I suggest that you copy the AE_Screen_Movies folder to somewhere such as your desktop if you did not pullover the entire AE_Simple_Integration_Part3 folder.

Figure AE_Part3_05

Step 6 Select the Screen.mov file in the Project Panel and the Screen layer in the Composition located in the Timeline at the bottom. *Figure AE_Part3_06*

Figure AE_Part3_06

Chapter 16: After Effects Integration

Step 7 Press CMD + Option + / or Cntrl + Alt + / (PC) to swap the footage. You can also hold CMD + Option (Cntrl+Alt PC), while you drag the Screen.mov and drop it on top of the Screen layer. *Figure AE_Part3_07*

Figure AE_Part3_07

Step 8 Repeat these steps for the Left_Screen.mov and the Left Screen layer. Finally, repeat for the Right_Screen.mov and the Right Screen layer. *Figure AE_Part3_08*

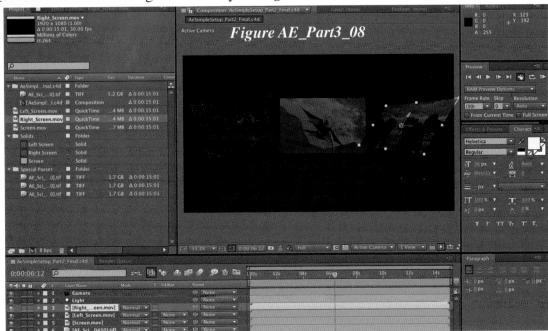

381

Note that these solids are 3D layers which allows the footage we've swapped in to react to the lights and 3D animation that exist in the comp. All other layers were created in the 3D scene originally and thus, do not need to be treated as 3D layers now. If you scroll through the playback, you will notice that these layers are reacting to the camera but are not fully integrated into the scene. For example, our cloner particles should obstruct our screens during the animation. This is where our Object Buffer passes come into play.

Step 9 From the Special Passes folder located in the Project Panel, drag the AE_Sci_FI_MP_Object_1 layer and drop it in the timeline just above the Screen.mov layer.

Figure AE_Part3_09

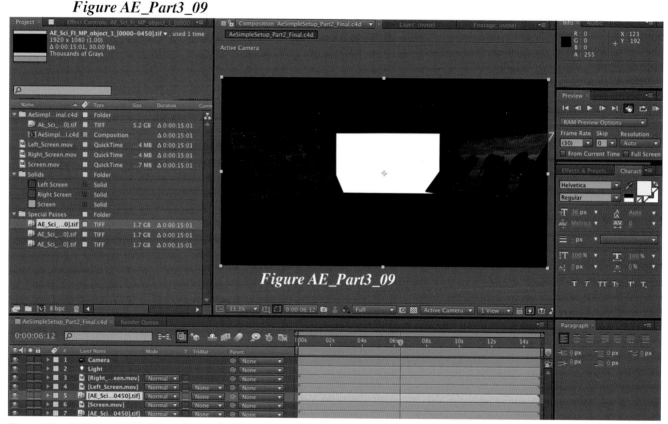

Figure AE_Part3_09

Step 10 Click on the Toggle Switches / Modes button at the bottom of the Timeline to pull up Track Matte options. Click on the Track Matte pop up for the Screen.mov layer and choose Luma Matte and the Object buffer layer above. *Figure AE_Part3_10*

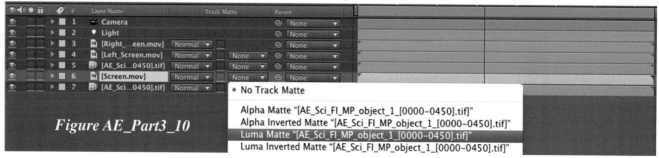

Figure AE_Part3_10

Chapter 16: After Effects Integration

Step 11 Scroll through the animation and you will see that the footage now is integrated in the depth of the scene. *Figure AE_Part3_11*

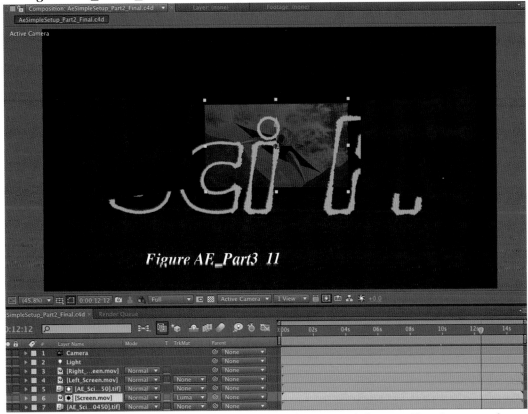

Figure AE_Part3_11

Step 12 Repeat the steps for the Left_Screen and the Object Buffer 2 special pass. Do the same for the Right_Screen and the Object Buffer 3 special pass. *Figure AE_Part3_12*

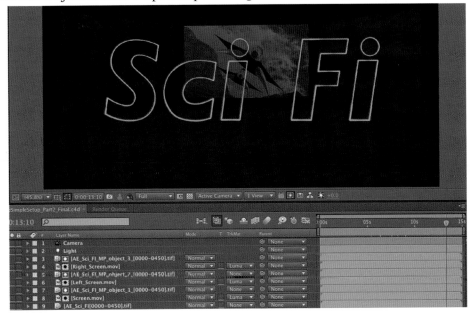

Figure AE_Part3_12

Step 13 Click on the arrow to the left of the Screen.mov layer, uncollapse the Material Options and raise their Diffuse and Specular values from 50 to 100%. Turn the Shininess value down to 2%. *Figure AE_Part3_13*

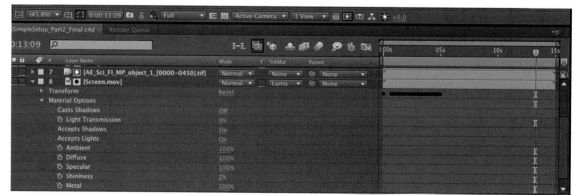

Figure AE_Part3_13

Step 14 Do the same for each of the other Screen movie layers, but lower their Shininess values down to 1%. *Figure AE_Part3_14*

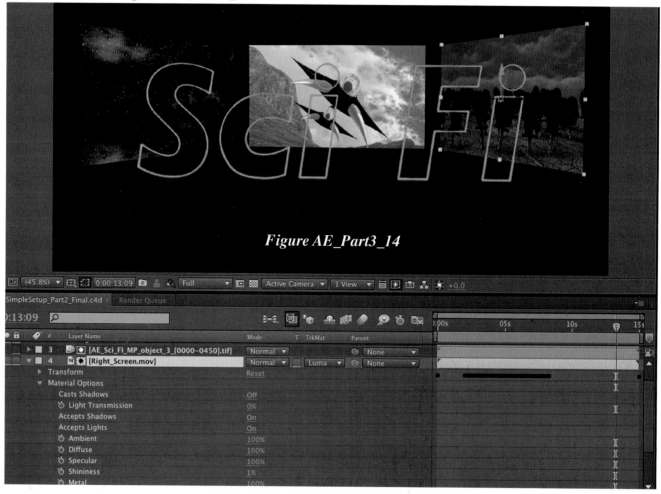

Figure AE_Part3_14

Chapter 16: After Effects Integration

Step 15 Finally, for a bit of tweaking: Select the AE_Sci_FI layer and choose Effects>Color Correction>Curves. *Figure AE_Part3_15*

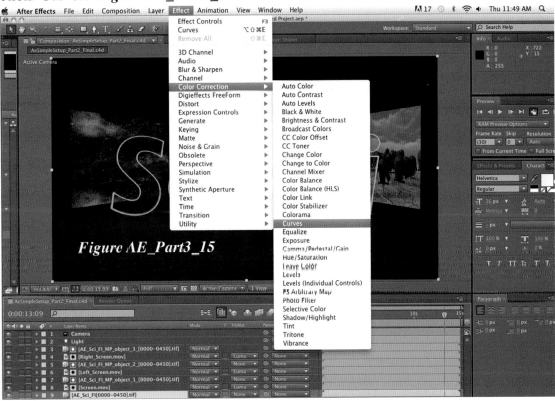

Step 16 Click on the curve to create a control point about a quarter of the way up the curve. Drag it up to the left to create the beginnings of a soft curve. Add another symmetrical point and move it out to match the previous to create a nice curve. *Figure AE_Part3_16*

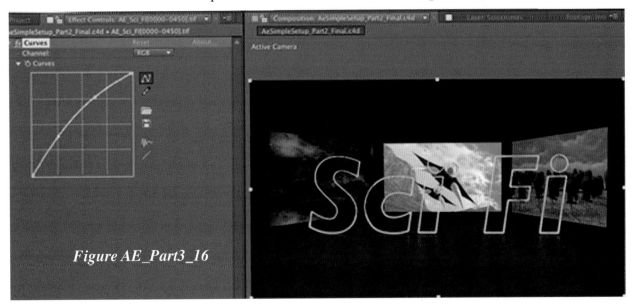

385

CINEMA 4D: The Artist's Project Sourcebook, Third Edition

17
Dynamics and Special Effects

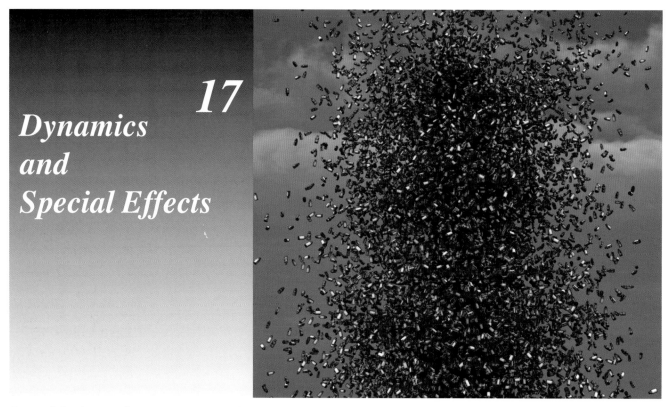

One of the largest improvements to CINEMA 4D R12 is in the dynamics engine that drives the Rigid and Soft Body dynamics. The relationship between these engines and the MoGraph elements are especially rewarding. Along with checking out the latest and greatest in dynamic simulations, we'll also take a look at some of the best special effects options in the Hair and Cloth engines as well as CINEMA 4D's particle-effects powerhouse, PyroCluster.

Rigid Body Dynamics

Step 1 Start by adding a Cube. Set its X, Y and Z sizes to 5 each.

Step 2 Add a Plane Object and leave the settings at default.

Step 3 Select the Cube and hold the Option (Alt PC) key as you add a Cloner object.

Step 4 Add a Sphere set to a radius of 75. Change the Type to Hexahedron. Place the Sphere at P.Y 300.
Figure RB_Basics_01

Figure RB_Basics_01

386

Chapter 17: Dynamics and Special Effects

Step 5 Select the Cloner Object and change the Mode to Object. Drag the Sphere into the Object Link. Click on the traffic lights to the right of the Sphere in the Object Manager to hide it.
Figure RB_Basics_02

Figure RB_Basics_02

Step 6 Select the Cloner Object and go to Simulation>Dynamics>Create Rigid Body.
Figure RB_Basics_03

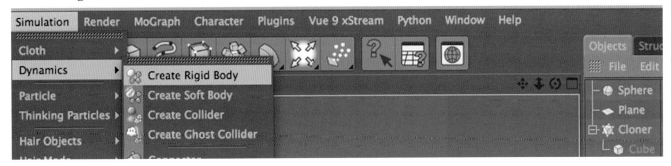

FIgure RB_Basics_03

Press the play button and watch as gravity pulls the Cloner group down and it falls through the Plane.

Step 7 Select the Plane object and add a Simulation>Dynamics>Create Collider tag. *Figure RB_Basics_04*

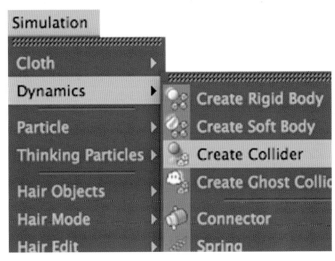

Figure RB_Basics_04

387

Play the animation again and watch as the Cloner calculates a collision with the Plane.

Step 8 Select the Rigid Body tag on the Cloner object. Go to the Collision tab and raise the Bounce from 50% to 90% and watch how this changes the reaction of the Cloner during the collision. *Figure RB_Basics_05*

In the same Collision tab, raise the Collision Noise up to 25% and watch as the collision becomes more random and more interesting. Lengthen the animation to 300 frames to see more of what is happening.

Step 9 Now, let's say that we did not want this Cloner to act as one object but as the many components that form it. In the Collision tab, change the Individual Elements parameter to All and play the animation. *Figure RB_Basics_06*

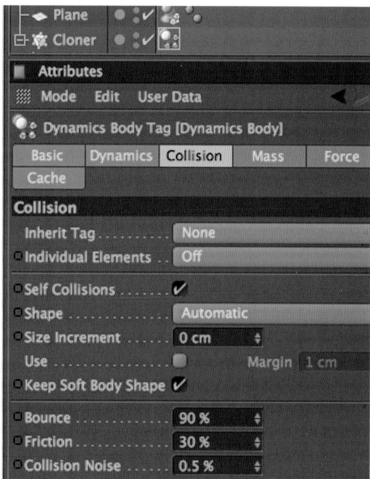

Figure RB_Basics_05

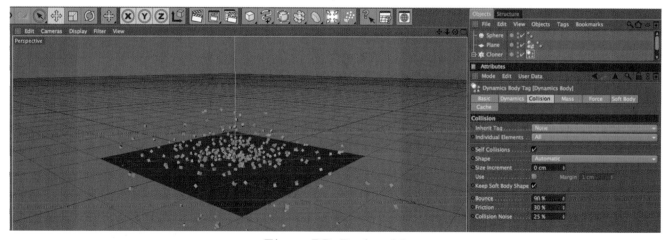

Figure RB_Basics_06

Step 10 Scroll to Frame 30, select the Plane object and click the record keyframe button.

Step 11 Go to Frame 40 and set the R.P. to 40 degrees, the P.Y to 50 and P.Z to - 45.
Figure RB_Basics_07

Figure RB_Basics_07

Play the animation and watch as the dynamics calculations have updated to reflect the changes.

The Fracture Object

Open the **Letter_Fracture_Start.c4d** file located in the Dynamics Folder of the DVD.

In this scene, you will see four parts that make up the letter E. This once was a single object but was cut into pieces using a booles. After applying the booles, they were each set to Make Single Object and made editable.

Step 1 We want to connect these pieces back together and control them breaking apart. To connect these objects, select them and choose Functions>Connect+Delete. *Figure Fracture_01*

Figure Fracture_01

Step 2 Select the resulting object, hold the Option (Alt PC) key and add a Fracture Object from the MoGraph menu. Drag the Ice Pearl material and drop it onto the E. *Figure Fracture_02*

Figure Fracture_02

Step 3 With the Fracture object selected, add a Rigid Body tag from the Simulation>Dynamics Menu. *Figure Fracture_03*

Figure Fracture_03

Step 4 Select the Plane object and add a Collider tag from the same Simulation>Dynamics menu.

Chapter 17: Dynamics and Special Effects

Step 5 Finally, select the Disc object and add a Soft Body tag. ***Figure Fracture_04***

Figure Fracture_04

Step 6 Play the animation to see the Disk fall and flop over the E. Notice that it does not do a good job of colliding with the Plane. ***Figure Fracture_05***

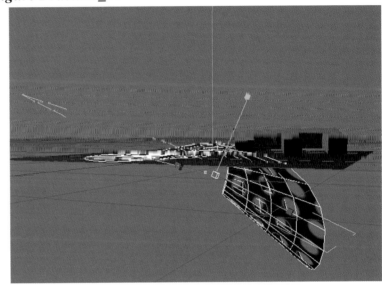

Figure Fracture_05

Step 7 To fix this error, select the Collider tag of the Plane object. In the Collision tab, raise the Size Increment to 50. ***Figure Fracture_06***

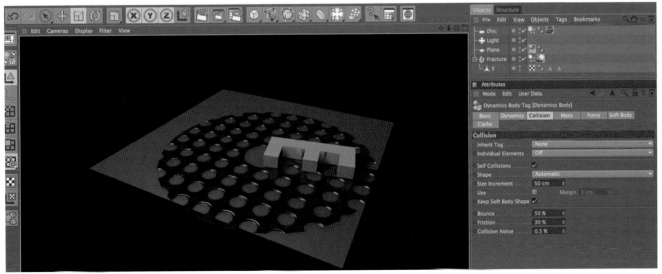

Figure Fracture_06

391

Step 8 Let's suppose we would like the E object to fracture into the pieces that we started with at the beginning of the exercise. Select the Rigid Body tag of the Fracture object, go to the Dynamics tab and set the Trigger to On Collision. Now, go to the Collision tab and set the Individual Elements to All. *Figure Fracture_07*

Figure Fracture_07

Step 9 Select the Fracture object and in the Object tab, set the Mode to Explode Segments. Play the animation to see the results. *Figure Fracture_08*

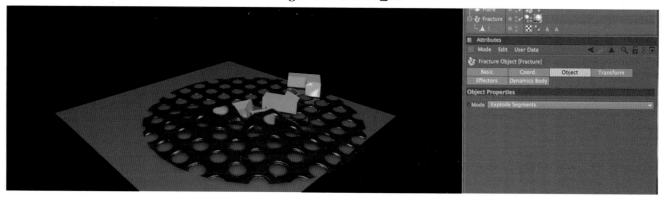

Figure Fracture_08

Step 10 A pretty cool animation, but there is still one more iteration to view. Change the Mode to Explode Segments & Connect. Play the animation and watch as small segments break off but the E is still intact. *Figure Fracture_09*

Figure Fracture_09

Cloth Dynamics

Step 1 Add a Sphere primitive to the scene and raise the Segments to 72.

Step 2 Add a Plane primitive, set the Width and Height to 400 and the Width and Height Segments to 60 each. Move the Plane to P.Y 200.

Step 3 Proper subdivision is key for deformations whether they are tool or dynamics based.

Step 4 Add a Cloth tag to the Plane object. *Figure Cloth_01*

Figure Cloth_01

Step 5 Add a Cloth Collider to the Sphere object. *Figure Cloth_02*

Figure Cloth_02

Step 6 Lengthen the animation by changing the End Frame from 90 to 300.

Step 7 If you play the animation, you will see no results. The Cloth tag requires that the object for which the tag is applied be editable. Select the Plane and press the C key to make it editable. Play the animation again.

Step 8 Now, we'll customize the cloth dynamics to achieve the look we want. Lower the Stiffness to 75%, set the Flexion up to 25% and lower the bounce to 5%. Play the animation.
Figure Cloth_03

Figure Cloth_03

Step 9 Click on the Expert tab, and put a check in Self Collision.

Step 10 Go to the Dresser tab, play the animation and pause it at a frame where the cloth deformation is pleasing. (If the cloth is slipping off the Sphere, click on the Collider tag of the Sphere and raise the Friction to 100%.) Press the Set button to the right of the Init State. ***Figure Cloth_04***

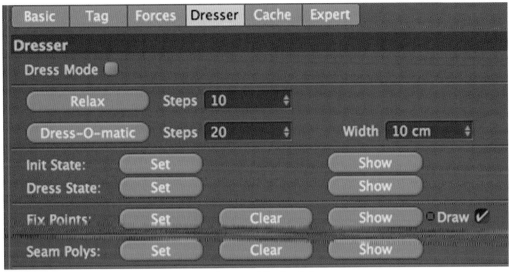

Figure Cloth_04

Step 11 Click the Go to Start button in the timeline. Play the animation again and you'll have a much less dramatic fall. Play it back until the cloth looks relaxed and press the Init State Set button again to reset the Initial State. Prep the cloth for animation by setting its Stiffness to 75% and Flexion to 100%. Raise the Friction to 95% in the Tag tab of the Cloth Tag. ***Figure Cloth_05***

Figure Cloth_05

Step 12 Click on the Traffic Lights to the right of the Sphere to hide them in the Editor and Rendered. They will turn red to indicate that they will not be visible.

Step 13 Go to Frame 90. Select the Sphere and click the Record Keyframe button. Scroll to Frame 180, set the P.Y to 375, the R.H to - 360 degrees and the R.B to 65 degrees. Click the Record Keyframe button for these values. Scroll to Frame 275 and set the Position values to P.X 300, P.Y - 100 and P.Z 500. Finally, set the Rotation to R.H 0, R.P 0 and R.B to - 53 and record a keyframe for these values.

Until you set the cloth dynamics to Cache, you may have to save the scene, close it and reopen to keep the cloth from falling without catching the Sphere.

Step 14 Go to the Cache tab, place a check in Cache mode and choose Calculate Cache. Once it is complete, you can seamlessly playback the animation.

Step 15 Double click in the Material Manager to create a new material. Disable Color, enable Luminance and Glow. In the Glow channel, lower the Inner Strength to 0 and the Outer Strength to 110%. Drop the material onto the Plane and render the animation.
Figure Cloth_06

*Note: For more on cloth creation and animation, check out the **Cloth_Ghoul.mov** located in the Dynamics folder of the DVD.*

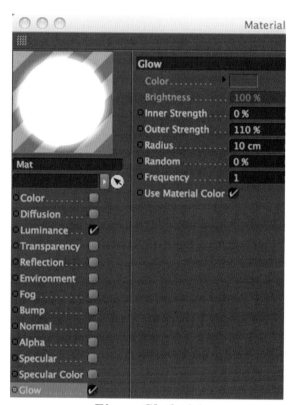

Figure Cloth_06

Cloner Soft Body Dynamics and Baking the Dynamic Calculations

Open the **Soft_Cloner_Start.c4d** file from the Dynamics folder on the DVD. You will see a Cloner object located above a Sphere. The Sphere has already had a Collision tag added to it.

Step 1 Select the Cloner object and add a Soft Body Dynamics Tag. *Figure CS_01*

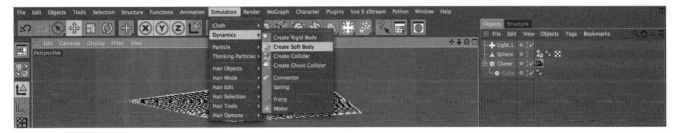

Figure CS_01

Step 2 In the Collision tab of the Dynamics Body Tag, set the Individual Elements to All. In the Soft Body tab, set the Soft Body as Made of Clones. Play the animation.
Figure CS_02

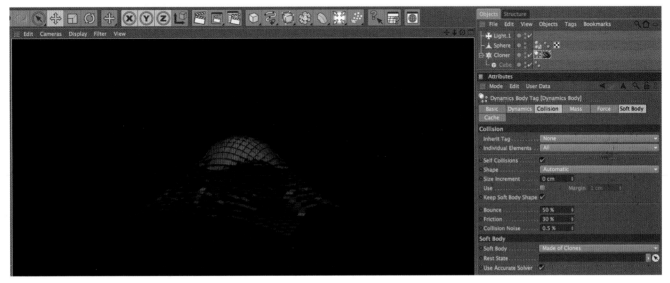

Figure CS_02

Step 3 The result is a very rigid animation. In the Springs panel of the Soft Body tab, lower Structural to 0. Play the animation and you will see a much more cloth-like animation. *Figure CS_03*

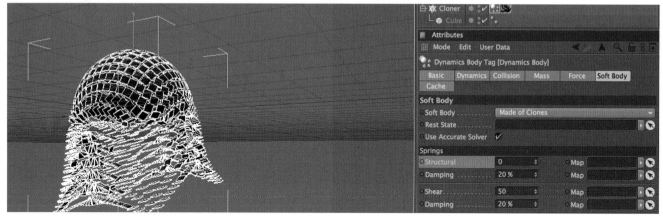

Figure CS_03

Step 4 We are happy with the results. We want to be able to play this smoothly and want to ensure that what we render is what we see in the viewport. Remember that if you use multiple CPUs to render, the results may vary in the calculation results. To solve this issue, we can Bake the simulation and save it as a Cache file. Click on the Cache tab of the Soft Body and choose Bake. It will now calculate the dynamics and as long as Use Cached Data is checked, it will use this Cache file to control the dynamics. Playback the animation and you will see a much smoother playback. This will also speed your render. *Figure CS_04*

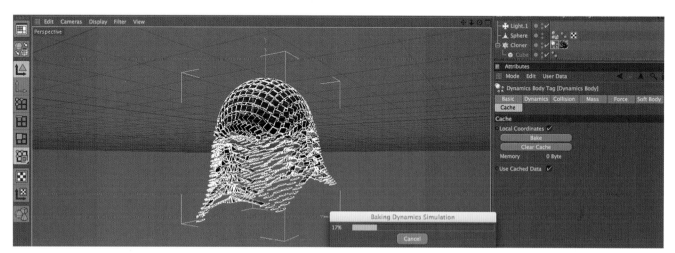

Figure CS_04

Note: All Dynamics, whether Rigid or Soft, can be cached in this way.

Chapter 17: Dynamics and Special Effects

PyroCluster

PyroCluster is your connection to creating incredible particle effects such as flames, explosions, clouds, steam, smoke and haze. PyroCluster is a 3D volume effect and requires a few special scene elements and often some tweaks and tricks to render in a timely manner. In the following exercise, we will take a look at creating a PyroCluster animation as well as break down how to optimize and use it in conjunction with other elements.

Open the **PyroCluster_Start.c4d** file.

Step 1 Add an emitter and place it just inside the back of the spaceship's exhaust port. Drag it as a child of the Spaceship object. Rotate the emitter to R.H 180 degrees. Raise the Birthrate Editor and Renderer to 450. Set the Stop Emission to 300 F. Set the Lifetime to 150 with a Variation of 25%. Set the Speed to 5 with a Variation of 55%. Raise the End Scale to 7. In the Emitter Tab, set the X-Size to 10.25 and the Y-Size to 7. *Figure Pyro_01*

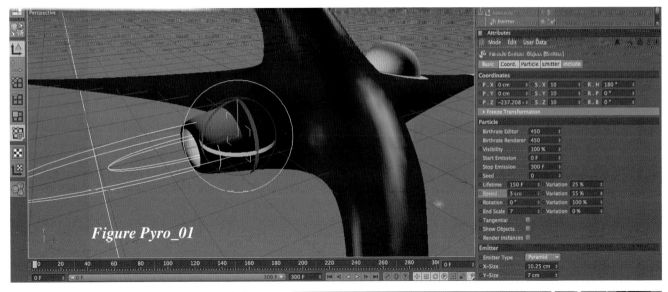

Figure Pyro_01

Step 2 Add a PyroCluster material from the Material Manager. File>Shader>PyroCluster. *Figure Pyro_02*

Figure Pyro_02

399

Step 3 Add a PyroCluster Volume Tracer from the same preset pulldown.

Step 4 Drag the PyroCluster material onto the Emitter.

Step 5 For the PyroCluster to be seen, we need to have an Environment object to display the volume. Add an Environment object and drop the PyroCluster Volume Tracer material onto it in the Object Manager. You'll now be able to render the PyroCluster particles.
Figure Pyro_03

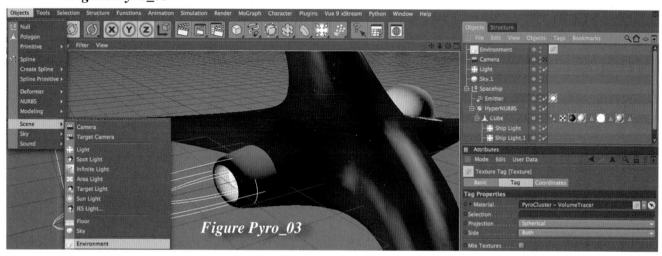

Figure Pyro_03

Step 6 To speed the render, double click on the PyroCluster Volume Tracer Material in the Material Manager. Change the Render Mode from Crispy to User. Raise the World Step size to 6.
Figure Pyro_04

Figure Pyro_04

Step 7 Double click on the Shape tab. Raise the Radius to 175 and enable the Preview checkbox. *Figure Pyro_05*

Figure Pyro_05

Chapter 17: Dynamics and Special Effects

Step 8 In the Age tab, double click on the left knot and set the color to black. Drag the white knot over to the left to get a sharp rise in size. This will be visible in Viewport now that we've enabled Preview in the Shape tab. *Figure Pyro_06*

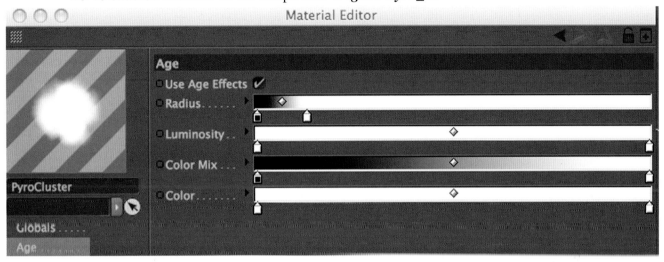

Figure Pyro_06

Render the animation. If you like, you can click on the crosshair to the right of the Camera provided.

A tip about optimizing PyroCluster renders: the World Step Size is the key. Higher values lead to faster renders and sometimes there are immense amounts of time saved with little or no loss of quality. Check out the optimizing PyroCluster video on the DVD.

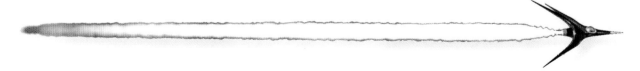

Creating a Fantasy Landscape with Hair

For this introduction to the Hair Module, we'll look at the standard procedures for growing, customizing and coloring hair.

Open the **Fantasy_Landscape_Start.c4d** project from within the Dynamics & Special Effects chapter folder on the DVD.

Step 1 Double click on the Selection tag of the Landscape object in the Objects Manager. Go to Simulation>Hair Objects>Add Hair. *Figure FL_01*

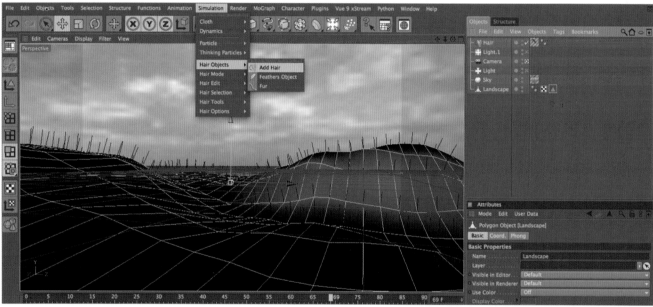

Figure FL_01

Step 2 In the Hair object settings, click on the Hair tab and set the Hair Count to 350000. Select the Fill Hairs tab and set the Count to 500000.
Figure FL_02

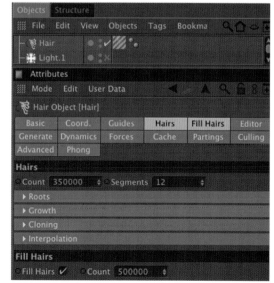

Figure FL_02

Chapter 17: Dynamics and Special Effects

Step 3 Click on the Hair Material in the Materials Manager. In the Color Channel, expand the Roots parameter. Click the Texture drop-down and load the **polkadotgrasstex** image located in the Fantasy_Landscape_with_Hair tex folder on the DVD. *Figure FL_03*

Step 4 In the Thickness channel, set the Root to 0.4 and the Tip to 0.35. In the Curve Graph, click to add a control point on the first column and fourth row. Click the arrow at the top left to open more options. Turn the Tension down to 25%. *Figure FL_04*

Match the Curve in *Figure FL_04*

Figure FL_04

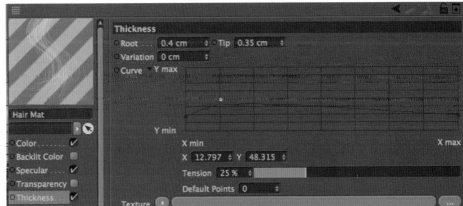

Step 5 Enable the Frizz Channel, and set the Frizz to 30%. Enable Kink and set the Kink to 5%. Finally, enable Bend and set the Bend to 30%.

Step 6 Enable the lights in the scene by clicking on the x's to the right of the lights in the Object Manager.

Step 7 Double click on the Sky Mat. Enable the Luminance Channel, click on the Texture drop-down and change it to Layer. Click on the Layer tab to open its settings. Click on the Shader tab and add a Color layer. Click on the color layer's thumbnail and change the Color to R 255, G 0, B 255. Click the black arrow at the top to back out and change the blend mode to Hue. *Figure FL_05*

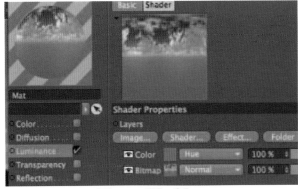

Figure FL_05

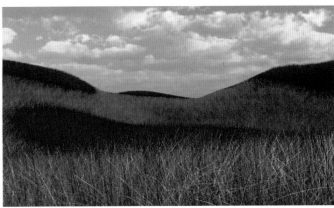

Headdress Project

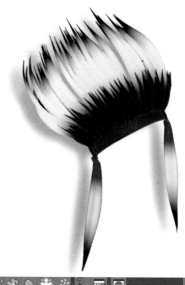

Step 1 Open the **Headdress_Start.c4d** file from the Dynamics and Special Effects chapter folder on the DVD.
I have already set up the selections for the objects. Select the Band object and double click on the Outer Feathers selection tag.
Figure Headdress_01

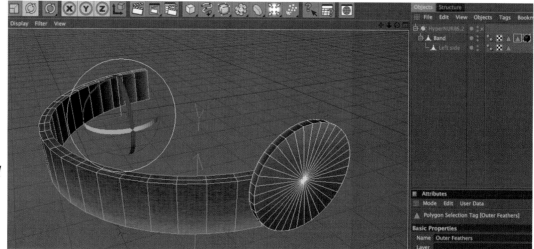

Figure Headdress_01

Step 2 Add a hair object: Simulation>Hair Objects>Add Hair. ***Figure Headdress_02***

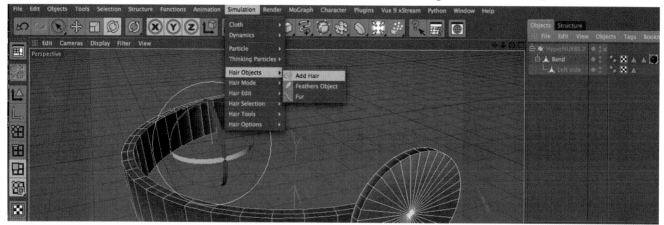

Figure Headdress_02

Chapter 17: Dynamics and Special Effects

Step 3 Add a feather object, Simulation>Hair Objects>Add Feathers Object. Place the Hair object as a child of the Feathers object. *Figure Headdress_03*

Figure Headdress_03

Step 4 In the Hair object, click on the Guides tab. Set the Root to Polygon Area and up the Count to 100. *Figure Headdress_04*

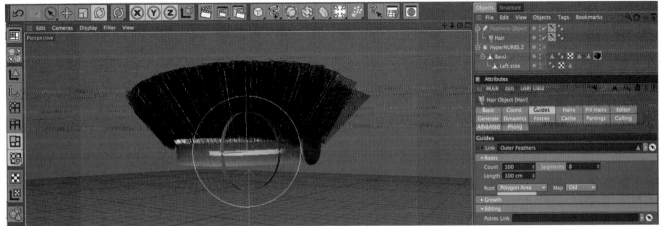

Figure Headdress_04

Step 5 In the Generate tab, uncheck Render Hairs. *Figure Headdress_05*

Figure Headdress_05

Step 6 Now it is time to craft the shape of our feathers. Select the Feather object and go to the Shape tab. Use the Shape curves to shape the feather as it extends from Root to Tip. If you click on the black arrows at the top left of each graph, you can manage the Tension. This acts similar to a B spline, relaxing the curve from the points. Configure your Shape curves to look similar to *Figure Headdress_06* but be sure to play with the graphs and see how they impact the look of the feathers. To give the feather a 3D look, adjust the Cross Section curves to add curvature to the objects. Finally, adjust the Curve graphs to give the shapes even more natural detail.
Figure Headdress_06

Figure Headdress_06

Step 7 Now, to adjust the Feather Material. In the Color parameter, make the Left knot a dark red and change the right knot to a bright red. Raise the influence of the dark red by dragging its knot to the center of the gradient.
Figure Headdress_07

Figure Headdress_07

Chapter 17: Dynamics and Special Effects

Step 8 In the Specular Channel, change the color to dark red, and lower the Primary Specular Strength to 20% with a Sharpness of 15. Lower the Secondary Specular Strength to 15% with a Sharpness of 11. Lastly, lower the Back Specular to 48%. *Figure Headdress_08*

Figure Headdress_08

Step 9 With these feathers in place, Control+drag a copy of these feathers. Rename the Feather object Inner Feathers and the Hair to Inner Hair. Replace the link within the Inner Hair object, to the Inner Feathers set selection of the Band Object. Lower the Count to 70 and raise the Length to 300. Finally, increase the Segments to 18. *Figure Headdress_09*

Figure Headdress_09

CINEMA 4D: The Artist's Project Sourcebook, Third Edition

Step 10 Click on the Blue tab on the left of the Right Camera Node and Choose Coordinates>Position>Position X.

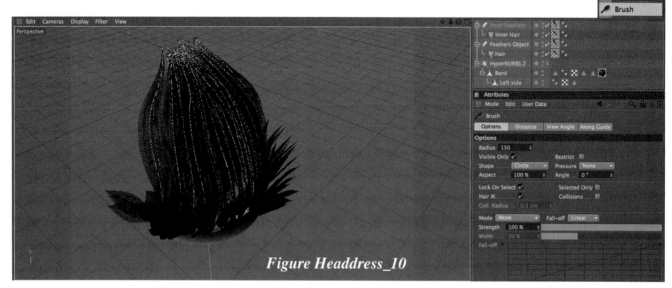

Figure Headdress_10

Step 11 For the material, click on the unused brown default Hair Material in the Material Manager. In the Color Channel, click the Texture Loader and choose Gradient from the drop-down. *Figure Headdress_11*

Figure Headdress_11

408

Step 12 Click on the Gradient to go inside its settings. Set the leftmost knot to a bright blue and drag it to the right a bit to give it a more solid presence. Click just below the gradient bar to add a knot to the right of the blue. Set its color to white. Control+drag on the knot to duplicate it and move it out to the right. Finally, change the rightmost knot to brown and move it to the left a bit. Set the Type to 2D - V. *Figure Headdress_12*

Figure Headdress_12

Step 13 In the Specular Channel, set the color to brown. Lower the Strength to 20% with a Sharpness of 15. The Secondary Strength should be lowered to 15% with a Sharpness of 10. Lower the Back Specular to 48%. *Figure Headdress_13*

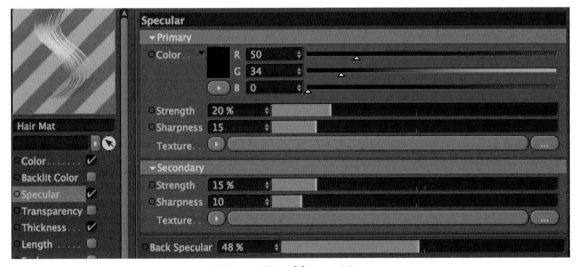

Figure Headdress_13

Step 14 Place this material onto the Inner Feather object by dropping it right on top of the existing Texture tag. Note that despite changing the Gradient mode to 2D - V, the material is not mapping properly to the feathers. To correct this, select the Inner Feather's Texture tag and set the Hair UVs to Feather. *Figure Headdress_14*

Figure Headdress_14

Step 15 For the final touches on the Inner Feathers, select it and go to the Object tab. Under Gaps, set the Gap to 7 with a Variation of 3 and Occurrence of 14%. *Figure Headdress_15*

Figure Headdress_15

Chapter 17: Dynamics and Special Effects

Step 16 Select the Feathers object and set a Gap of 5 with a Variation of 2 and Occurrence of 17%.
Figure Headdress_16

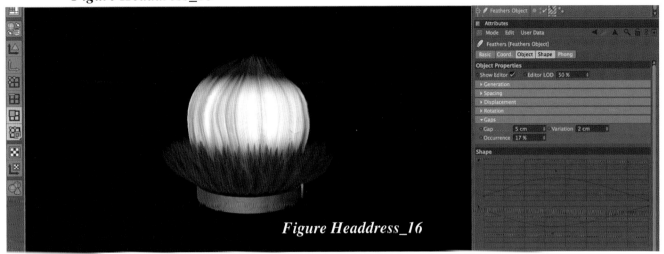

Figure Headdress_16

Step 17 Now, take the Brush tool and brush the red outer feathers to conform to the shape of the Inner Feathers. You'll want to turn down the Brush radius to around 100 and remember that, as with most transformation tools, you can lock any axis when you want to focus on any specific direction. You must have the subordinated Hair object selected to use the Brush.
Figure Headdress_17

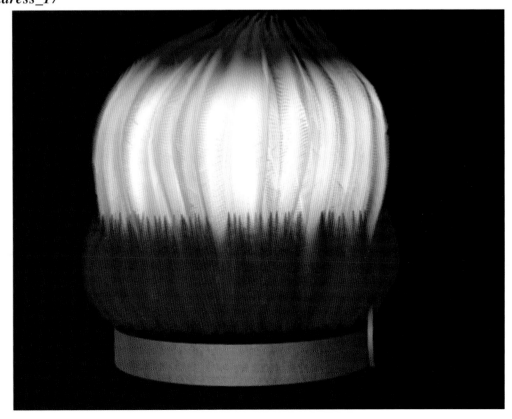

Figure Headdress_17

Step 18 For the last bit, Control+Drag a copy of the Inner Feathers object group. Rename the copy Left Feather and the subordinated Hair object to Left Hair. In the Guide tab of the Left Hair object, set the Link to the side feather selection set of the Left side object. Set the Count down to 3. *Figure Headdress_18*

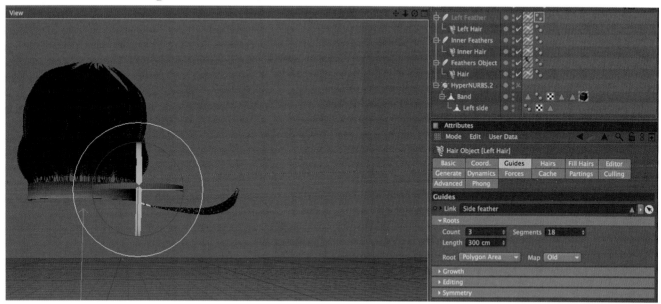

Figure Headdress_18

Step 19 Use the Brush tool to shape this new feather set appropriately. You can also use the Rotate tool located in the Hair Tools menu to reorient the feathers. Make sure when you rotate that the Pivot is set to Root. *Figure Headdress_19*

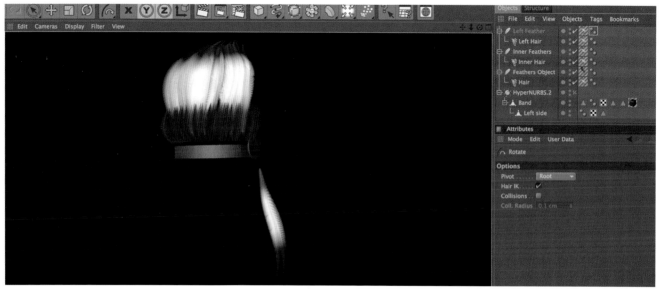

Figure Headdress_19

Chapter 17: Dynamics and Special Effects

Step 20 Drag the Left Feather group and drop it as a child of the Left Side object. Control+Drag on the Left Side group to duplicate it and rename the copy Right Side. Move the Right Side group to P.X. = 113.769 and set the R.B = 90 degrees. *Figure Headdress_20*

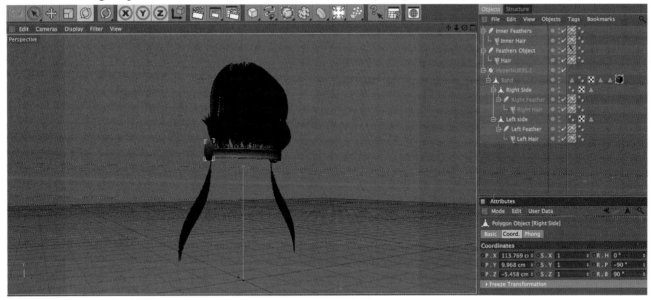

Figure Headdress_20

Step 21 The feathers are complete and now a quick fix will get them ready for animation and dynamics simulation. Select each of the Hair objects subordinated under the Feathers. In the Dynamics tab of each, enable Rigid. Now you are ready to animate. Note that if you want a smooth bend for the Side Feathers when they interact with colliders, you may wish to deactivate Rigid.
Figure Headdress_21

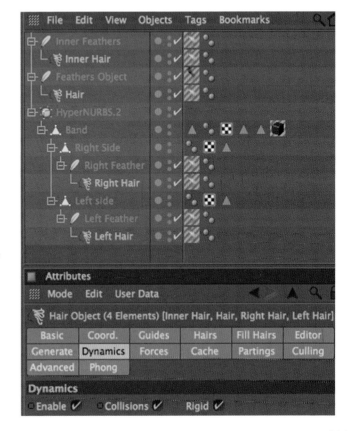

Figure Headdress_21

More on the DVD: Grow a MoHawk

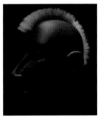 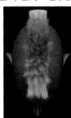 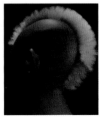

413

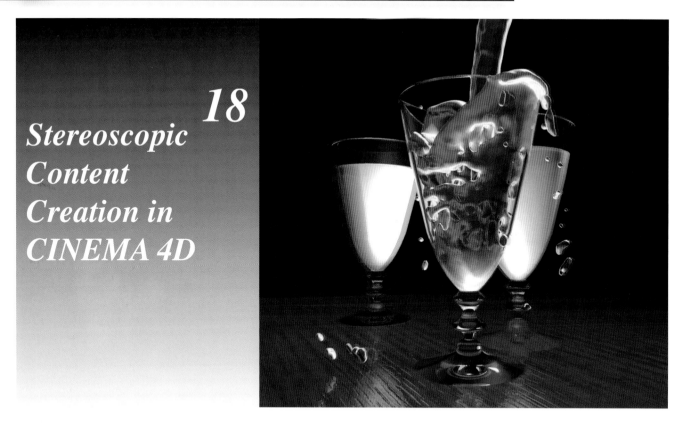

18
Stereoscopic Content Creation in CINEMA 4D

What we hear of today as 3D is not the traditional 3D those of us who have been in the computer graphics field for the past decade or more have come to get used to. 3D now refers to Stereoscopic 3D. Stereoscopic 3D is about retaining depth in the final output. In this chapter, we will go through how to create a 3D camera rig in CINEMA 4D using XPresso. We'll then shift to shooting with the rig and how to converge the Left and Right camera renders to make a Stereoscopic image using Photoshop. Finally, we'll look at some of the settings involved in getting the best results and a Stereoscopic plugin for C4D that brings extra control and automated stereo output.

Creating a Stereoscopic Rig

Step 1 Add a Camera to the Scene. Zero out all of its position and rotation coordinates.
Figure Stereo_01

Figure Stereo_01

414

Chapter 18: Stereoscopic Content Creation in CINEMA 4D

Step 2 Control+drag on the camera to duplicate it. Name the copy Left Camera and place it as a child of the original.

Step 3 Control Drag a copy of the Left Camera and rename it Right Camera.
Figure Stereo_02

Figure Stereo_02

Step 4 The first thing we need to do is set up a movement partnership between the Left and Right cameras. We at times may wish to exaggerate the effect by pulling our interocular distance to a higher value but want this to work intuitively. Select the Right Camera and Right click choosing CINEMA 4D Tags> XPresso.
Figure Stereo_03

Step 5 Double click on the Xpresso tag to open the XPresso Editor. Drag the Right Camera and Left Camera objects into the editor.

Step 6 Click on the Red tab on the right of the Left Camera Node and choose Coordinates>Position>Position .X.
Figure Stereo_04

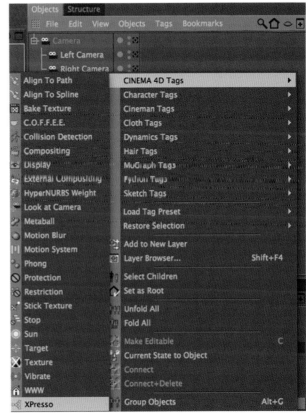

Figure Stereo_03

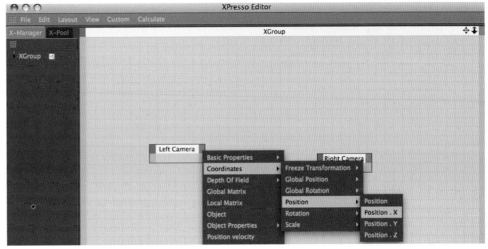

Figure Stereo_04

Step 7 Click on the Blue tab on the left of the Right Camera Node and Choose Coordinates>Position>Position .X.

Step 8 Right click in the Editor and choose>New Node>XPresso>Calculate>Range Mapper. *Figure Stereo_05*

Step 9 Connect the Left Camera's Position X output to the Input of the Range Mapper and connect its Output to the input of the Right Camera's Position .X tab.

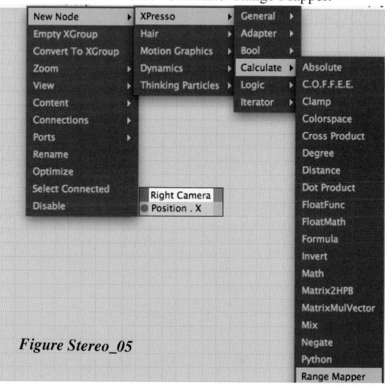

Figure Stereo_05

Step 10 Select the Range Mapper node to pull up its settings in the Attribute Manager. Set the Output Lower to 0 and Output Upper to -1. *Figure Stereo_06*

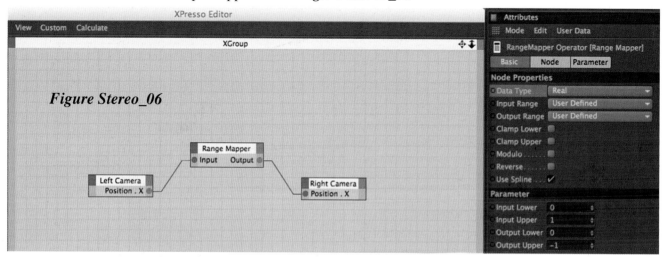

Figure Stereo_06

Note that you may often find that you want to be able to move the cameras independently to get the best effect in a particular scene. In these situations, disconnect the nodes in the XPresso editor or delete the XPresso tag for the rig.

Chapter 18: Stereoscopic Content Creation in CINEMA 4D

Step 11 With the controls set, we need to set up our original interocular distance. We will start with a value of 69mm.

Step 12 Click on the Left Camera and type - 69 mm/2 in the P.X parameter in the Coordinates tab. It should calculate the value and give you - 3.45 cm for the final position. Click on the Right camera and you will see it has inversely been set to P.X 3.45 cm. ***Figure Stereo_07***

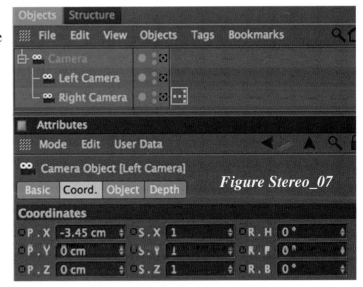

Step 13 To keep the scene labeled correctly, select the Left Camera and in the Basic tab of the Attribute Manager, enable Use Color and set the color to red. Do the same for the Right Camera and set it to blue. Finally, repeat the steps and color the original Camera to white. ***Figure Stereo_08***

Figure Stereo_08

Step 14 We need to set up our Zero Parallax. Create a Rectangle Spline and set its size to 1920 x 1080 and move it to P.Z 600 and set its Display Color to Black. Name the spline Zero Parallax.
 Figure Stereo_09

Figure Stereo_09

Step 15 Select all three cameras and in the Object Manager, choose Tags>CINEMA 4D>Target. *Figure Stereo_10*

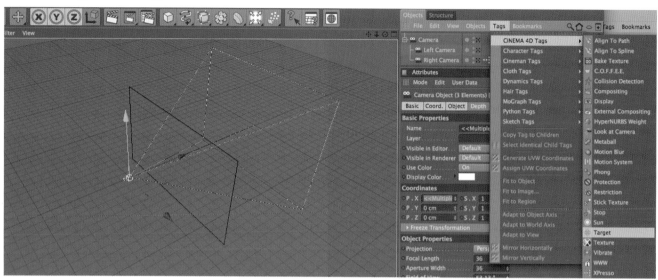

Figure Stereo_10

Step 16 With all three tags selected, drag the Zero Parallax into the Target Object field. *Figure Stereo_11*

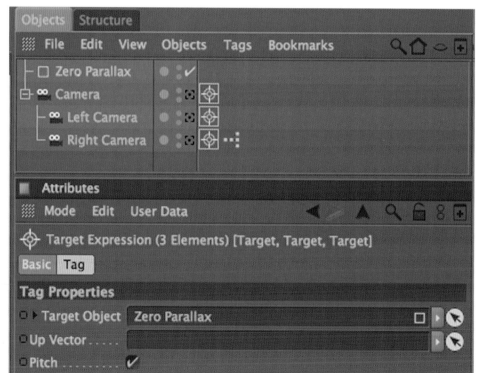

Figure Stereo_11

Save this scene as StereoRig.c4d and now you will have a 3D ready camera rig whenever you need it.

Chapter 18: Stereoscopic Content Creation in CINEMA 4D

Creating a Stereoscopic Scene

Open the **Stereo_Output_Start.c4d** file located in the Stereoscopic_Content_Creation_in_C4D folder on the DVD.

Step 1 The first thing we need to do here is check out our interocular distance as well as our Zero Parallax to get the best stereoscopic results. To do this, let's set up our view to look through all of our cameras. In the Viewport, choose Panels> 3 Views Top Split. *Figure SS_Output_01*

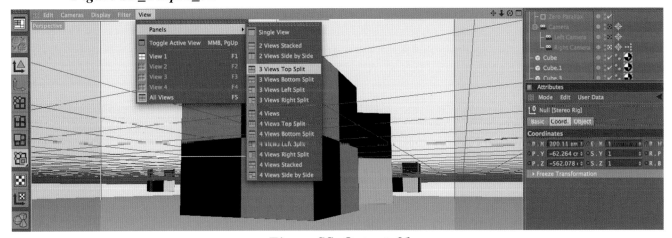

Figure SS_Output_01

Step 2 Now, to see through our three cameras, select the top left panel and choose Cameras>Perspective. Then, choose Cameras>Scene Cameras>Left Camera. Finally, choose Display>Gouraud Shading to show the detail we want in the panel. Repeat the steps for the right top panel and choose the Right Camera. *Figure SS_Output_02*

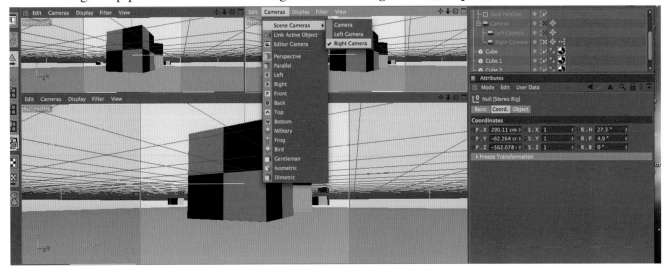

Figure SS_Output_02

419

The other easy way to check is to toggle back and forth from the Left and Right Cameras using their crosshair tags in the Object Manager. When you toggle these views, you will notice a slight difference in perspective. The combination of the two will give us our stereo image.

Step 3 Move the Left Camera to - 7.5. Now toggle the views and you will see a noticeable separation between the two perspectives.
This would be a good number to test our render. Click on the Render Settings and set the Output size to 1920 x 1440. Make sure the Range is set to Current Frame. In the Save tab, use the name LeftCamera7point5. Turn the Anti-Aliasing up to Best. Jagged edges lead to bad stereo renders.

Step 4 Make sure you are looking through your Left Camera and in the main View window, check to ensure that it is set to Use as Render View and render the image.
Figure SS_Output_03

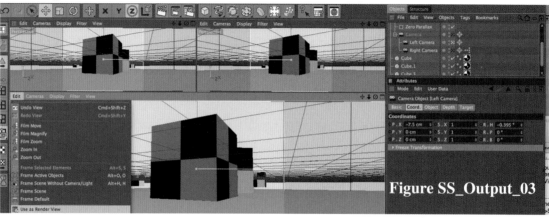

Figure SS_Output_03

Step 5 Switch the Camera in the main View to the Right Camera. Change the save name to RightCamera7point5 and render it in the same fashion. Compare the renders.
Figure SS_Output_04

Figure SS_Output_04

Left Camera at P.X -7.5 **Right Camera at P.X 7.5**

Chapter 18: Stereoscopic Content Creation in CINEMA 4D

Step 6 Let's do a more conservative interocular distance and set the Left Camera to - 5.5. Change the name of the Render in the Settings to RightCamera5point5 and go ahead with rendering this camera first since it is already active. Switch to the Left Camera, change the Save name to LeftCamera5point5 and render it as well. Compare the Renders. Next we'll turn these images into one stereoscopic comp.
Figure SS_Output_05

Figure SS_Output_05

Left Camera at P.X - 5.5　　　　　　　　　**Right Camera at P.X 5.5**

Compositing Stereo Images in Photoshop

If you completed the previous exercise, open your LeftCamera7point5 and RightCamera7point5 renders in Photoshop. If not, you can access these in the project folder on the DVD.

Step 1 Select the Left image and click on its Red Channel in the Channels panel. Press Command+A or Cntrl+A to select all of the image.
Figure Stereo_PSD_01

Figure Stereo_PSD_01

Step 2 Choose the **RightCamera7point5.tif** file and click on its Red Channel in the Channels Panel and press Command+V or Cntrl+V on a PC to paste the Red Channel from the left image into here. *Figure Stereo_PSD_02*

Figure Stereo_PSD_02

Step 3 Put on your glasses, click on the RGB Channel to show all and enjoy the result. Unfortunately, we are seeing a little disjointedness and noise in the stereo image. Let's try the other renders.
Figure Stereo_PSD_03

Figure Stereo_PSD_03

Chapter 18: Stereoscopic Content Creation in CINEMA 4D

Step 4 Follow the same steps for the **LeftCamera5point5.tif** and **RightCamera5point5.tif** and, voila, we have a smooth and impressive stereo image. *Figure Stereo_PSD_04*

Figure Stereo_PSD_04

SVI Stereo 3D Editor Plugin 2.3

This Stereoscopic plugin delivers when it comes to streamlining stereoscopic output into your 3D workflow. The SVI plugin provides stereo rendering options from Side-by-Side for output to TV or film, to the old anaglyph blue/cyan/green and red, and to Auto_Stereoscopic outputs that don't require glasses.

A seven day trial version of this software is available on the DVD. You can use it to complete these exercises and decide if it is worthwhile for your workflow.

CINEMA 4D: The Artist's Project Sourcebook, Third Edition

To create a Stereo Camera using SVI, right click the camera you want to set up. Choose SVI Stereo Camera. This tag is where you will set up the strength of the stereo effect. **Figure SVI_01**

Figure SVI_01

SVI is a post effect and has to be enabled in the Render Settings. Open the Render Settings and choose Effects>SVI Stereo_Render Settings. These settings affect how the stereo camera will output. Most important in this window are the Interlacing Modes. The SVI modes correlate to Auto-Stereoscopic Monitors that don't require glasses. You will also see the stereo standard Side-by-Side options and classic Anaglyph stereo options as well. The anaglyphic is especially helpful if you are working on a laptop or other machine that is not connected to a stereo monitor. You can check and tweak the stereo settings in anaglyph and then output to client specified requirements. **Figure SVI_02**

Inside the Camera tag settings is where the work gets done. You'll have a Near setting and a Far setting. In most cases, you will want to place the Near Plane just in front of the nearest object in the shot and vice versa for the Far Plane. The Relative Deviation value is the key to controlling the degree of the stereoscopic effect. A higher Relative Deviation value lowers the interocular distance and will lessen the effect.
Figure SVI_03

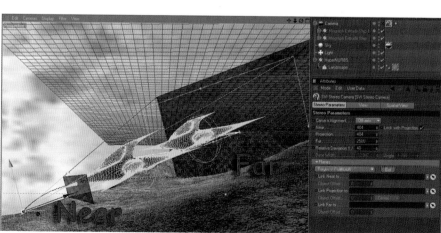

Figure SVI_02

Another nice feature here is the Camera Test, which allows you to access all of the stereo cameras applied to your camera. In the case of a side-by-side or anaglyph, this value will be two. If you render for auto-stereo output, this value can go much higher.

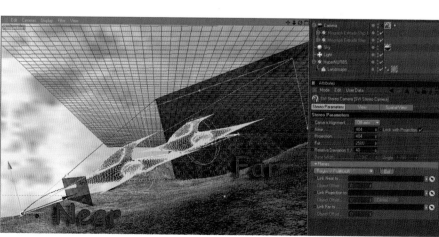

Figure SVI_03

Chapter 18: Stereoscopic Content Creation in CINEMA 4D

Look at the settings for the following scene to see how they create stereoscopic renders.

Open the **SVI_Canyon_Run.c4d** file within the Stereoscopic_Content_Creation_in_C4D folder.

In this scene, I placed the Projection Plane intersecting halfway up the nose of the ship to ensure that the point of the ship would pull off from the rest of the scene. I moved the Far Plane well back in the scene and pulled the Near Plane in front of the ships to minimize the separation of the cameras. These settings work to moderate the stereo effect and give optimum results. Be sure to adjust the Relative Deviation to see how it amplifies or lowers the stereo effect. **Figure SVI_04**

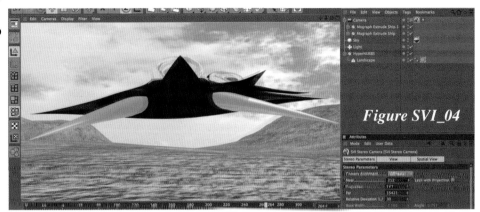

Figure SVI_04

Follow these steps if you don't have the SVI Stereo plugin. Use your own rig to create the stereo renders.

Move the Stereo Rig group to P.X 3498, P.Y - 1663 and P.Z - 4198. Rotate the group R.H 40 and R.P 19 degrees. *Figure No_SVI_01*

Move the Camera to P.Z 16. Move the Left Camera to P.X - 1.314. Finally, move the Zero Parallax object to P.Z 544. *Figure No_SVI_02*

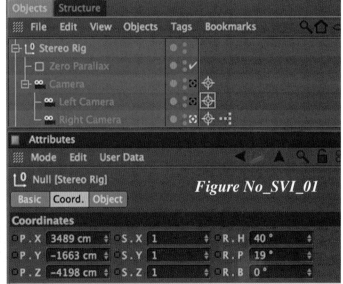

Figure No_SVI_01

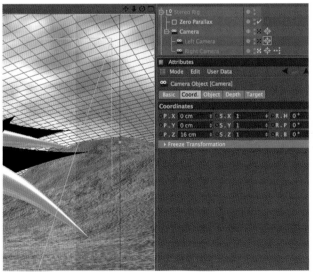

Figure No_SVI_02

Render both Left and Right Camera views and composite them as we covered in the previous exercise.

425

Final Renders from SVI

Be sure to check out the Asteroid scene on the DVD and experiment with SVI or your own Stereo Rig. For even more on creating quality stereo imagery in CINEMA 4D, check out the tutorials, resources and images of Phil McNally on **www.captain3d.com**.

Chapter 19: C4D and Friends / A Look at Vue 9 Xstream Integration

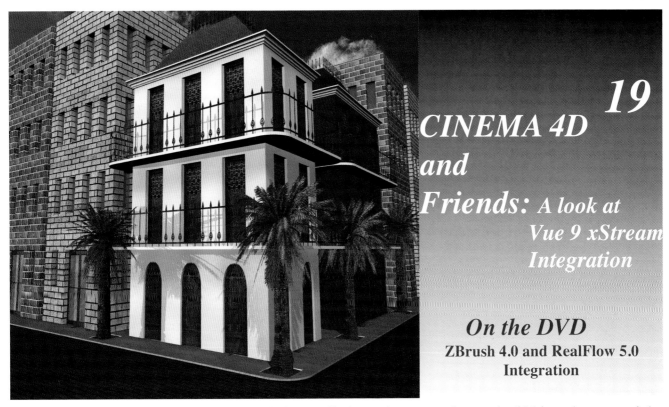

CINEMA 4D and Friends: *A look at Vue 9 xStream Integration*

On the DVD
ZBrush 4.0 and RealFlow 5.0 Integration

The ultimate toolset for creating and rendering realistic environments is now in 64 bit and can run right inside CINEMA 4D. Unlike most large 3D applications that coordinate between C4D and themselves, Vue 9 xStream runs right inside C4D natively. The controls of both packages are at your fingertips. The integration allows full control over lights, cameras and even advanced render settings such as GI. I've used Vue xStream in conjunction with C4D since version 6 and there is no doubt that version 9 is by far the most efficient and cooperative e-on has released. If you've watched any large-scale effects movies with digital matte paintings and interactive 3D environments, you've seen Vue in action. Now, enjoy implementing it into your CINEMA 4D workflow.

Vue 9 xStream Integration

In this project we will take a quick look at how easy it is to bring in Vue objects and have them interact with your CINEMA 4D scene. *(This project requires Vue 9 xSTREAM, a PLE version of Vue can be found on the DVD.)*

Open the **Vue9_scene_start.c4d file** located in the CINEMA 4D and Friends folder on the DVD. Better yet, you may wish to copy the project folder to your CPU and open it from there.

Step 1 Let's quickly look at the Vue/CINEMA 4D setup. Choose Vue 9 xStream> File>Options. Choose Yes when the Vue dialogue appears informing you that it will change CINEMA 4D's default viewports, grid size and clipping planes. Here, you can fine tune how Vue runs within C4D. Take a minute to look at the settings and then click on the Render Options. Here, you can limit what aspects of Vue 9 xStream render in this scene. For example, if you already have a Sky in your scene you will most likely want to deactivate Render atmosphere and Render Sky. In this case, I want to use Vue to create my sky and atmosphere so click OK.
Figure Vue_01

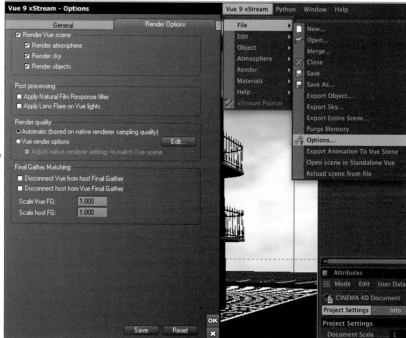

Figure Vue_01

Step 2 After choosing OK, you'll notice Vue has already placed scene elements into our project. Add a Vue atmosphere preset by choosing Vue 9 xStream>Atmosphere>Load Atmosphere. Choose the Sunset preset from the Physical Atmosphere list.
Figure Vue_02

Figure Vue_02

Step 3 Click on the Ground object and type in - 1 for its P.Y value to ensure that it doesn't interfere with our street.

Step 4 Now, to add an object. Click Vue 9 xStream>Object>Create>From Plant Species. Choose the Date Palm. *Figure Vue_03*

Figure Vue_03

Step 5 The tree will be far too large and protruding out of the middle of our building. In the Coordinates Manager, set the S.X, S.Y and S.Z values all to 0.02. Move the tree to something close to P.X - 173 and P.Z - 250. You can use the Move and Rotate tools as you would for any object to place the tree exactly where you want it. The Scale works in the Coordinates and is efficient because the axes for the Vue objects are placed at their bottom by default. *Figure Vue_04*

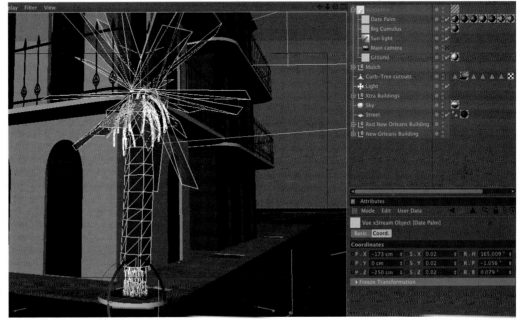

Figure Vue 04

CINEMA 4D: The Artist's Project Sourcebook, Third Edition

Step 6 Add another Palm by clicking on Vue 9xStream>Object>Create>Plant. It will load the most recently used plant, which is our Palm. It uses seed type calculations to randomize the exact look of the tree. If you don't like it, delete it and add another. Or you can fine tune the look of any Vue object by going into its editing dialogue. With the new Palm selected, go to Vue 9 xStream>Object> Edit Object. Here you can edit all kinds of Parameters and save the results if you want to use the same plant again.
Figure Vue_05

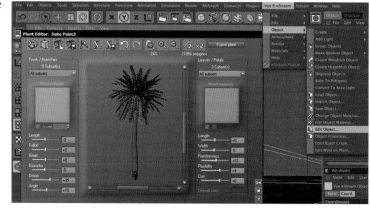

Figure Vue_05

Step 7 Repeat these steps to add a couple more Palms to the scene. Use the traffic lights to unhide the Xtra buildings group. You can use Vue lights to add detail to your scenes and control them as you would CINEMA 4D's native lights.
Figure Vue_06

Note: Under Render Quality, you can fine tune the specifics of how Vue will work with the C4D render engine by enabling Vue render options and clicking Edit.

MORE ON THE DVD

RealFlow, ZBrush Integration

2D/3D animation with Toonz and Flipbook Pro

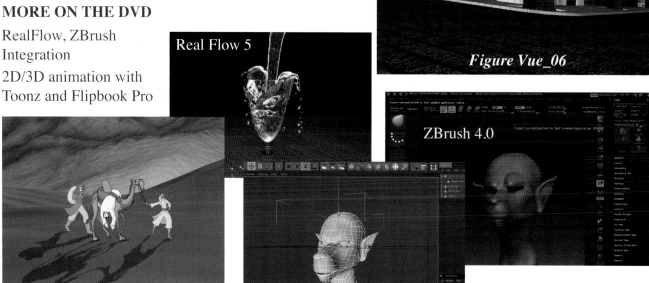

Figure Vue_06

Index

2D (two-dimensional) shaders, 138
3D (three-dimensional) shaders, 138
4-up view, 57

A
accessing
 Extrude Tool, 59
 Layer Browser, 6–7
 multiple tabs in Attribute Manager, 31
 views, 57
Adobe After Effects (AE)
 exporting files, 254
 integration, 372–385
 importing and compositing, 378–385
 setting up simple scene, 372–373
 setting up tags and render settings, 374–377
Adobe Illustrator
 Butterfly project, 183
 integrating text into 3D workflow, 328
 Skull Mask Extrude, 100
Adobe Photoshop
 compositing stereo images in, 421–423
 exporting files, 254
 integrating BodyPaint, 290
 Projection Man integration, 320
Advanced Render, 257
After Effects. *See* Adobe After Effects
Age tab, Material Editor, 401
Align to Spline tag, 196, 198
aligning objects, 196
Alpha Channel
 exportation for Compositing programs, 254
 Nukei Shader and, 139
 transparency and, 256
Ambient Occlusion setting, Render Settings box, 126
Ambient Occlusion Shader, 142

animation, 183–198
 See also character animation
 Butterfly project, 183–195
 controlling with Rail Splines and F-Curves, 196–198
 defined, 4
 Helix spline, 244–246
 MoText with Random Effector, 345–348
Animation Column, Layers Browser, 7
Animation filter, 255
Anistropy Channel, Material Manager, 11–12
Anti-Aliasing Tab, Render Settings box, 48, 88, 99, 109, 254
Array Object, 20
assets, Content Browser, 5
Attribute Manager
 City building project, 63–65
 Desert Scene project, 30–32
 dropping material onto object, 37
 extruding text, 329
 Greek pool project, 15–27
 MoGraphMace, 52
 Object tab, 15–16
 PBlurp object parameters, 287
 placing and adjusting materials, 137
 rotating text, 342
 School of Fish project, 283
 Search Light project, 170
 viewing Lathe NURBS parameters, 92
Auto-Stereoscopic Monitors, 424
Axis handles, hiding, 89

B
Babb, Paul, 369
Back Light, 154, 166–167, 181–182
baking dynamic calculations, 397–398
Banji Shader, 135, 138
Banzi Shader, 138
Base Light, 167
Bend deformer
 altering with Xpresso, 275–284

Bend and Boolean Lock Project, 120
 extruding text, 333–334
Bend node, Xpresso Editor, 278
Best option, Render Settings box, 254
Bezier NURBS, 110–117
binding, 239–242
biological class shader, 138
Bitmap Shader, 140
Blend filter, 255
Blend Mode
 Multi-Pass Rendering, 269, 271
 painting 3D head, 315
BodyPaint 3D
 painting book, 290–299
 Projection Man project, 320–327
 Setup Wizard, 291
 UV editing, 300–319
 painting 3D head, 308–319
 unwrapping head, 300–307
Booles/Boolean
 defined, 118
 Keyhole Extrude NURBS and, 122–123
brick material, City building project, 69
Brick Shader, 142
Bridge tool, 72–73
Brush tool
 creating ear shape, 228
 headdress project, 411–412
 painting 3D head, 311–313, 315
 painting book in BodyPaint, 295
 poses and morph, 229
 Structure Menu, 213, 215
Brushes tab, BodyPaint, 295
Bucket rendering, 257
buffers, 375–376
Bump Channel, Material Manager
 Greek Pool project, 25
 MoGraphMace, 54
 Noise shader, 140
 Wind Deformer Flag project, 130
Bump map, 292, 296
Butterfly project, 183–195

C

Cache tab, Soft Body tab, 396, 398
Camera Test feature, 424
cameras
 Butterfly project, 194
 CameraUP, 247
 CloseUp, 248
 compositing stereo images in Photoshop, 421–423
 depth of field, 249–251
 freezing, 319
 moving independently, 416
 multiple, 247–248
 Pyramid, 44–46
 setting up to animate along Helix spline, 244–246
 Wide Shot, 247
CameraUP camera, 247
Catmull-Rom mode, CineMan, 273
caustics, 258–260
Cel Rendering effect, 260–262
Chalk brush, 316
ChanLum Shader, 141
channel shaders, 140–142
 Ambient Occlusion, 142
 Bitmap, 140
 Brick, 142
 ChanLum, 141
 Colorizer, 141
 Distortion, 142
 Filter, 141
 Fresnel, 141
 Fusion, 141
 Gradient, 141
 Layer, 141
 Noise, 140
 Pavement, 140
 Ripple, 142
Channels, Material Editor, 136
Channels tab, BodyPaint, 294
character animation
 Cube object, 199
 Edge Tool, 212
 Front View, 200
 HyperNURBS object, 203
 Knife tool, 204, 210
 Knife Tool, 212–213
 Live Selection tool, 200
 looping polygons, 212–213
 mirroring, 200
 Model tool, 203
 Move tool, 204
 Perspective view, 200
 Point Tool, 204, 205
 Polygon tool, 200, 204
 Rectangle Selection tool, 200, 209
 rigging, 234–242
 creating joints, 234–239
 mirroring/ binding/ weighting, 239–242
 Rotate tool, 211
 Scale tool, 203, 209
character head
 ear, 225–228
 eye, 217–218
 getting basic shape, 199–217
 mouth, 222–224
 nose, 219–221
Cheen Shader, 138
chin, 206
Choose Layerset window, 322
CineMan, 272–274
CineMan setting, Render Settings box, 253
Circle spline, 120, 174
City Building project, 57–69
Cloner object
 adding to scene, 171
 MoGraph Mace, 51–52
 School of Fish project, 282–284
 Soft Body dynamics, 397–398
 Sound Effectors, 366
 Spline effector, 359
Cloning, MoGraph, 358
CloseUp Camera, 248
Cloth Collider, 393
Cloth dynamics, 393–396
Cloth NURBS, 115
Cloth tag, cloth dynamics, 393–394
clouds, 399
Collider tag, 390, 395
Collision tab, Dynamics Body Tag, 388, 397
color
 headdress project, 406–409
 MoGraph Mace, 54–56
 Ornament project, 11
Color Channel, Material Manager
 Butterfly project, 185
 City Building project, 61
 Desert Landscape project, 33, 36–37, 41
 Greek Pool project, 24–27
 hair, 403
 Island of Displacement project, 159
 modeling spaceship, 81
 texturing Pyramid primitive, 36
 Wind Deformer Flag project, 130–132
Colorizer Shader, 141
compositing
 After Effects integration, 378–385
 stereo images in Photoshop, 421–423
Compositing tag, 95, 117, 178
Content Browser, 5
control points
 hair, 403
 importing and compositing in AE, 385
 PolyFX, 355
 Shovel project, 110–112
Coordinates Manager
 City Building project, 66
 setting control points, 112
 Vase project, 90–91
 Wind Deformer Flag project, 128
Coordinates tab, Attribute Manager
 Butterfly project, 188
 City Building project, 66
 Desert Landscape project, 41, 44, 46
 Greek Pool project, 21
 Lock project, 119, 125
 MoGraph Tracer, 362
 Planet Texturing project, 154
 PolyFX, 356
 School of Fish project, 281
 Search Light project, 169
 Shovel project, 113
 stereoscopic content, 417
 Vase project, 96
CS Tools plugin, C4D, 251
Cube object, 199
curves, 385
custom fonts, 348–351
Cylinder primitive, 10

Index

D

Danel Shader, 139
Darken brush, 311–313, 315
Deformer Column, Layers Browser, 7
deformers, 118–135
 Bend, 120, 275–284, 333–334
 Lock project, 118–126
 Melt, 334–335
 MetaBall object, 133–135
 on type, 332–336
 Wind deformer flag, 127–133
Delay Effector, 344, 346–347
depth, retaining in final output, 414
Depth of Field (DOF), 249–251, 273
deselecting
 joints, 236
 polygons, 60
Desert Scene project, 29–49
Details tab, Attributes Manager, 168
Diffuse Channel, Material Manager, 11, 135
Displacement Channel, Material Manager
 Island of Displacement project, 157
 Noise shader, 140
Display tag, 256, 321
Distortion Shader, 142
Document Undo Depth option, Preferences panel, 8
DOF (Depth of Field), 249–251, 273
door, modeling, 60, 65
doors, City building project, 60–61
Dresser tab, cloth dynamics, 395
duplicating
 Gravity Object, 192
 light, 103–104
 objects, 16–17, 21–22, 43
dynamics, 386–413
 baking dynamic calculations, 397–398
 Cloth, 393–396
 fantasy landscape, creating with hair, 402–403
 Fracture object, 389–392
 Headdress Project, 404–413
 PyroCluster, 399–401
 Rigid Body, 386–387
 Soft Body, for Cloner object, 397–398

E

ear, 225–233
ease-in, F-curve, 197
ease-out, F-curve, 197
Edge Tool, 212
Edges checkbox, Cel shading, 261
effectors
 Delay, 344, 346–347
 Formula, 284, 341–342
 gravity, 134
 MoGraph, 358–360
 Random, 51–52, 172, 345–348, 353–357
 Sound, 364–366
 Spline, 359–360
 Target, 342–343
effects
 See also special effects
 defined, 4
 rendering, 257–267
 Cel Rendering, 260–262
 Highlights, 257–258
 QTVR Rendering, 267
 Quick Caustics, 258–260
 Scene Motion Blur, 267
 Sketch and Toon, 264–266
 Vector Motion Blur, 263–264
emitters
 MoGraph Tracer, 361–362
 Particle Emitter, 191
 simulating water flow, 133
Environment Channel, Material Manager, 81–82, 85
Environment object, 400
Eraser tool, 311–313
Expert tab, cloth dynamics, 394
ExplosionFx deformer, 336
explosions effect, 399
Expressions Column, Layers Browser, 7
Extrude Inner tool, 213
Extrude NURBS
 Butterfly project, 184
 general discussion, 99–109
 Lock Project, 119
 text, 329–330
Extrude Tool
 accessing, 59
 creating nose shape, 220–221
 head shots, 213
 modeling spaceship, 75–76
 splitting chin from neck, 206
extruding
 ear shape, 227
 text, 328–331
Eye Light, 105, 107
eyebrows, 316–317
eyes, 101, 217–218

F

fantasy landscape, creating with hair, 402–403
Far setting, Camera tag, 424
F-Curves, 196–198
Feather value, Attribute Manager, 296
feathers, headdress, 406–413
Feature tab, CineMan, 273
Fill hair, 402
Fill Light, 182
Fill tool, 310
Fillet Caps, 10, 113, 330
Filter Shader
 defined, 141
 Planet Texturing project, 145
filters, 255
Final Cut Pro program, 254
Fit UV to Canvas command, UV Mapping Menu, 307
flames, 399
Floor object, 23, 67, 181
Focus Factor setting, CineMan, 273
Fog Shader, 140
fonts, custom, 348–351
Formula Effector
 keyframe free animation for text, 341–342
 School of Fish project, 284
4-up view, 57
fractal landscapes, 140
Fracture object, 389–392
Frame Range setting, Render Settings box, 253
Frame Rate setting, Render Settings box, 253
frames, 104–108. *See also* keyframes
Fresnel Shader, 141
Frizz Channel, Materials Manager, 403

Front Blur, DOF CAM, 249
Front view
 Butterfly project, 183, 186
 modeling character head, 200
 Shovel project, 110
 Vase project, 90
Full Render setting, Render Settings box, 253
function keys, accessing views with, 57
Fusion Channel, 139
Fusion Shader, 141

G

Garrott, Rob, 369
Gaussian mode, CineMan, 273
General Tab, Render Settings box, 253
Generator Column, Layers Browser, 7
generators, 7
Geometry option, Render Settings box, 254
Global Illumination (GI)
 versus Ambient Occlusion Shader, 142
 Bezier NURBS, 117
 lighting with objects, 171–176
 multicolored spheres, 173
Glow Channel, Material Manager
 Butterfly project, 186
 modeling spaceship, 83–84
 Planet Texturing project, 147
Glow Editor, 152
Gouraud shading, 150
Gradient layer, 161
Gradient Shader, 141
gravity effector, 134
Gravity Object, Butterfly project, 192
Greek Pool project, 15–28
Greyscale values, Noise shader, 140
grouping lights, 104
groups
 Butterfly, 190–191
 cloning and, 358
 Column Middle, 20
 Cube, 71
 Cylinder Middle, 20
 Extrude NURBS, 122
 HyperNURBS, 117

Keyhole Extrude NURBS, 122
Light House, 246
shapes, 13
Symmetry, 20

H

H.264 movie files, 254
hair, 319, 402–403
Hardware Preview setting, Render Settings box, 253
haze, 399
HDRI (High Dynamic Range Images) lighting, 179, 318
HDTV 1080 29.97 preset, 253
head shots
 modeling character head, 199–228
 creating ear shape, 225–228
 eye, 217–218
 getting basic shape, 199–217
 mouth, 222–224
 nose, 219–221
 Pose Morph, 229–233
Headdress Project, 404–413
Helix spline, 244–246
High Dynamic Range Images (HDRI) lighting, 179, 318
Highlights effect, 257–258
Hue/ Saturation Adjustment Layer, Layers Panel, 270–271
HyperNURBS
 Desert Scene project, 30
 disabling, 75, 207
 modeling character head, 203
 Shovel project, 115
 smoothing shapes, 133, 135
 Wind deformer flag, 132

I

illumination. *See* Global Illumination; lights
Illustrator. *See* Adobe Illustrator
images
 Bitmap Shader, 140
 filter choices, 255
 head shape, 214
 projection, loading, 324
 saving in Tex folder, 49
 texture, 35
importing
 After Effects integration, 378–385

Illustrator files, 100
Inner Extrude tool
 creating nose shape, 220–221
 creating shape of eye, 217
 making polygons, 61
Interlacing Modes, Render Settings box, 424
interocular distances, 419–421
interpolation, controlling, 196
Inverse Volumetric, 193
Irradiance Cache tab, Render Settings box, 174
Island of Displacement project, 155–166

J

Joint Tool, 235
joints, 234–239
 adding, 235–239
 aligning, 240
 binding, 241
 mirroring, 239
 renaming, 236
 weighting, 242

K

keyframes
 Butterfly project, 188–189
 generating complex animated sequences, 183
 poses and morph, 231–233
 setting, 14
Keyhole Extrude NURBS, 122, 124
Knife tool
 creating ear shape, 225
 creating nose shape, 219
 head shots, 201–202
 modeling character head, 204, 210, 212–213
 modeling spaceship, 80–81
 PolyFX, 355

L

Landscape primitive, 29–30, 35, 138, 140
Lathe NURBS, 91–92
Layer Browser, 6–7
Layer Shader, 141, 159
Layers tab, BodyPaint, 294
Lens tab, Attribute Manager, 42–43

Index

Level of Detail (LOD) values, Render Settings box, 256
lights
 Back, 154, 166–167, 181–182
 Butterfly project, 193
 City building project, 67–68
 creating and animating SearchLight, 167–170
 defined, 4
 Desert Scene project, 39–41
 Eye, 105, 107
 Fill, 182
 with Global Illumination, 171–176
 grouping, 104
 HDRI, 179, 318
 Island of Displacement project, 165–166
 lighting product, 177–180
 Lock Project, 125–126
 modeling spaceship, 85–87
 MoGraphMace, 56
 Mouth, 105–106
 Nose, 105–106
 Planet Texturing project, 151–154
 Secondary Intensity, 175
 Shadow Caster, 153
 Skull Mask Extrude, 102–103, 105
 Vase project, 96
 without Global Illumination, 181–182
Linear Spline tool, 89
Linear Workflow, 377
live action footage, integrating with 3D, 370
Live Selection Tool
 Lock Project, 121
 modeling character head, 200
Lock Column, Layers Browser, 7
LOD (Level of Detail) values, Render Settings box, 256
Loop Selection tool
 creating nose shape, 219
 and Shift key, 82
looping polygons
 creating nose shape, 219
 modeling character head, 212–213
Luminance Channel, Material Manager
 Butterfly project, 194
 generating light in GI renders, 176

Greek Pool project, 27
Island of Displacement project, 164
modeling spaceship, 83

M
Mabel Shader, 139
Magnet tool
 creating ear shape, 227–228
 creating mouth shape, 224
 head shots, 213
 poses and morph, 229
 reshaping points around eye, 218
Make Editable Button, Object Manager, 101, 200
Managers Column, Layers Browser, 7
manual skeleton creation process, 234–236
mapping UVs for model, 303
Material Editor, 136. *See also* Material Manager
Material Manager
 adding Sketch preset material, 265
 Bend and Boolean Lock Project, 123
 BodyPaint, 292
 Butterfly project, 185, 194
 City building project, 62–65, 69
 Desert Scene project, 32
 extruding text, 330–331
 Greek pool project, 24–27
 Hair Material option, 403
 Island of Displacement project, 156
 lighting product, 178
 modeling spaceship, 81–82
 MoGraphMace, 54–55
 ornament project, 11–12
 Planet Texturing project, 143
 PyroCluster, 399–400
 Search Light project, 172
 Shader presets, 135
 Shovel project, 114
 Vase project, 92–94
 Wind Deformer Flag project, 130–132
materials
 Butterfly project, 194
 Headdress project, 410
 Island of Displacement project, 155–166
 Lock Project, 123
 placing and adjusting, 137
 Planet texturing project, 142–154
 PolyFX, 352
 shaders, 138–142
 channel, 140–142
 volumetric, 138–140
 Wind Deformer Flag project, 130–132
MAXON, 2, 264, 272, 370
MAXON USA, 369
Melt Deformer, 334–335
MetaBall object, 133–135
mirroring, 200, 230, 239–242
Model tool
 Butterfly project, 184
 City Building project, 66
 modeling character head, 203
modeling
 character head, 199–228
 ear, 225–228
 eye, 217–218
 getting basic shape, 199–217
 mouth, 222–224
 nose, 219–221
 defined, 4
 spaceship, 70–88
modeling helpers, 118–135
 Lock project, 118–126
 MetaBall object, 133–135
 Wind deformer flag, 127–133
MoGraph
 Mace, 50–56
 MoSpline, 367–371
 sound effector, 364–366
 Spline Effector, 359–360
 Tracer object, 361–363
MoSpline object
 adding to Sweep NURBS, 367
 MoGraph, 367–371
MoText object
 animating with Random Effector, 345–348
 overview, 341–344
Motion Blur setting, CineMan, 273
Motion Blur tags, 273
Motion Clip window, 189–190
Motion Factor setting, CineMan, 273
motion graphics, 372

435

Motion program, 254
mouth, 101, 222–224
Mouth Light, 105–106
Move tool
 activating, 74
 Butterfly project, 187
 creating ear shape, 226–227
 creating mouth shape, 224
 creating nose shape, 221
 creating shape of eye, 218
 modeling character head, 204
 reshaping points around eye, 218
Multibrush, 295
Multi-Channel brush, 296
Multi-Pass button, Render Settings box, 376
Multi-Pass rendering, 252, 254, 268–271

N

Near setting, Camera tag, 424
neck, 206
No Illumination checkbox, Attribute Manager, 42
Noise Channel, Attributes Manager, 86
Noise node, Xpresso Editor, 278–279
Noise option, Material Manager, 33–34
Noise Shader, 140, 157
non-destructive painting, 310
None option, Render Settings box, 254
nose, 101, 219–221
Nose Light, 105–106
n-Side object, 118–119
Nukei Shader, 139
Null object, 287–288
NURBS
 See also HyperNURBS
 Bezier, 110, 114–115
 Cloth, 115
 Extrude, 99–109, 119, 184, 329–330
 Keyhole Extrude, 122–124
 Lathe, 91–92
 saving paths from Illustrator, 100
 Shovel project, 110–117
 Skull Mask Extrude, 99–109
 Sweep, 337–338, 361–362, 367
 text, 328
 Vase project, 89–98

O

Object Axis tool, 66
Object Buffers, 375–376
Object Manager
 Greek pool project, 15–27
 Make Editable Button, 101
 MoGraphMace, 52–53
 Rigid Body dynamics, 387–388
Object tab, Attribute Manager, 15–16
objects
 City Building project, 57–69
 lighting with, 171–176
 MoGraph Mace, 50–56
 renaming, 236
 Spaceship project, 70–88
Only Select Visible Elements option, Selection tool, 58, 72
optimizing PyroCluster renders, 401
Options Tab, Render Settings box, 255–257
origin points
 moving to correct head shape, 216
 parametric primitives, 9
Origin Points Selection tag, Object Manager, 224
ornament project, 10–14
Orthographic views, 57, 74
Output tab, Render Settings box, 47, 253

P

painting 3D head, 308–319
Panoramic view, 267
parameters
 Cheen Shader, 138
 Wind Deformer Flag project, 129
parametric primitives, 9, 138
Particle Emitter, 191
Path Selection tool, 303–304
paths, saved from Illustrator, 100
Pavement Shader, 140
PBLURP node, 285–289
PCam (Projection Camera), 323
Perspective view
 Butterfly project, 184
 modeling character head, 200
 modeling spaceship, 73
 Shovel project, 111
 Vase project, 91
photorealistic textures, 319
Photoshop. *See* Adobe Photoshop
Photoshop (PSD) files, 254, 268, 377
Physical Atmosphere list, Vue 9 xstream, 428
Picture Viewer, 49
Pixar RenderMan, 272
Pixel Filter mode, CineMan, 273
Pixel Samples setting, CineMan, 273
Plane object, 156
Planet texturing project, 142–154
plugins
 CS Tools, 251
 SVI Stereo 3D Editor Plugin 2.3, 423–426
points
 Bend and Boolean Lock Project, 121
 Wind Deformer Flag project, 127–128
Points tool, 204, 205, 214
PolyFX, 352–357
Polygon tool
 City Building project, 57
 creating mouth shape, 222
 creating shape of eye, 217
 modeling character head, 200, 204
 splitting chin from neck, 206
Polygonal Primitive drop down
 adding cylinder object, 15–16
 adding Pyramid object, 31
 adding Tube object, 21–22
polygons
 deselecting, 60
 looping
 creating nose shape, 219
 modeling character head, 212–213
Pose Morph, 229–233. *See also* character animation
position
 lights, 96–97, 105
 points, 90
Position parameter
 City Building project, 66
 controlling animation speed, 197
 Pyramid Camera, 45
PP (Projection Painting), 316–319

Index

Preferences, 8
Premiere program, 254
Preset options, Render Settings box, 253
Presets listing, Content Browser, 5
Preview modes, Render Settings box, 253
Primary Intensity lighting, 177
primitives
 See also specific primitives by name
 Desert Scene project, 29–49
 Greek Pool project, 15–28
 Ornament project, 10–14
print presets, 253
product, lighting, 177–180
Projection Camera (PCam), 323
Projection Man project, 320–327
Projection Painting (PP), 316–319
Projection tab, UV Mapping Menu, 306
projections, mapping materials with, 137
PSD (Photoshop) files, 254, 268, 377
Pyramid Camera, 44–46
Pyramid primitive, 35–36
PyroCluster, 285, 399–401
Python, 250–251

Q

QTVR Rendering effect, 267
Quach, Tom, 325–327
Quality tab, CineMan, 273
Quantize checkbox, Cel shading, 262
Quick Caustics effect, 258–260
Quicktime
 codecs, 254
 exporting, 377
 Virtual Reality movies, 267

R

Rail Splines, 196–198
Random Beam Length checkbox, Glow Editor, 152
Random Distribution checkbox, Glow Editor, 152
Random Effector, 51–52, 172, 345–348, 353–357
Range Mapper node, Xpresso Editor, 278

Ray Depth values, Render Settings box, 256
Ray Threshold values, Render Settings box, 256
RealFlow, 430
Rear Blur, 249
Recalculate UV checkbox, BodyPaint Setup Wizard, 291
Rectangle Selection tool
 BodyPaint, 293
 modeling character head, 200, 209
 Spaceship project, 72–73
Rectangle spline, 101, 121
Reflection Channel, Material Manager
 City building project, 63
 Greek Pool project, 25
 Island of Displacement project, 162
 Vase project, 98
Reflection Depth values, Render Settings box, 256
Reflection setting, Render Settings box, 255–256
reflections
 Vase project, 95
 water, 162–163
refraction, 258
Refraction setting, Render Settings box, 255
Relax UV tab, UV Mapping Menu, 307
renaming objects, 104, 236
Render Column, Layers Browser, 7
Render Preview panel, Butterfly project, 195
Render Settings box
 After Effects integration, 374–377
 Anti-Aliasing Tab, 48, 88, 99, 109, 254
 Desert Scene project, 48
 enabling SVI, 424
 filters, 255
 General Tab, 253
 Global Illumination Render Effect, 173
 Lock Project, 126
 Options Tab, 255–257
 Output Tab, 47, 253
 Save Tab, 254
rendering, 252–274

 See also Render Settings box
 CineMan, 272–274
 defined, 4
 effects, 257–267
 Cel Rendering, 260–262
 highlights, 257–258
 QTVR Rendering, 267
 Quick Caustics, 258–260
 Scene Motion Blur, 267
 Sketch and Toon, 264–266
 Vector Motion Blur, 263–264
 Metaball animation, 135
 Multi-Pass, 268–271
 paths from Illustrator, 100
resolution, 253
rigging character
 creating joints, 234–239
 mirroring/ binding/ weighting, 239–242
Rigid Body dynamics, 386–387
Ripple Shader, 142
Rotate tool
 Butterfly project, 187
 creating ear shape, 226
 Headdress project, 412
 modeling character head, 211
 Spaceship project, 77
rotation, controlling, 196
Rotation Parameters, Attribute Manager, 342
Rust brush, BodyPaint, 299
Rust Shader, 54

S

sand, 33–35
Save Tab, Render Settings box, 254
saving
 Illustrator files, 100
 images in Tex folder, 49
Scale tool
 Butterfly project, 187
 modeling character head, 203, 209
 Spaceship project, 77
 splitting chin from neck, 206
Scene Camera, 45, 419
Scene Motion Blur effect, 267
School of Fish project, 275–284
SE (SynthEyes), 370
seams, 138, 303
Search Light, 167–170

437

Secondary Intensity, 175, 177
Selection tool
 Live, 121, 200
 Loop, 82, 219
 Path, 303–304
 Rectangle, 72–73, 200, 209, 293
selections
 City Building project, 57–65
 extruding text, 331
 head shots, 209, 213
 Headdress project, 404–412
 MoGraph Sound Effector, 364–366
 placing and adjusting materials, 137
Set Selection option, Selection Menu, 59–60, 137, 209, 213, 224
Setup Wizard, BodyPaint, 291
Shader tab, Sketch and Toon settings, 265
shaders
 channel, 140–142
 Ambient Occlusion, 142
 Bitmap, 140
 Brick, 142
 ChanLum, 141
 Colorizer, 141
 Distortion, 142
 Filter, 141
 Fresnel, 141
 Fusion, 141
 Gradient, 141
 Layer, 141
 Noise, 140
 Pavement, 140
 Ripple, 142
 ornament project, 10
 Rust, 54
 volumetric, 138–140
 Banji, 135, 138
 Banzi, 138
 Cheen, 138
 Danel, 139
 Fog, 140
 Mabel, 139
 Nukei, 139
 Terrain, 140
Shading Rate setting, CineMan, 273
Shadow Caster light, 153
Shadow Depth values, Render

Settings box, 256
shadows
 Bend and Boolean Lock Project, 125–126
 City building project, 67–68
 Desert Scene project, 40
 Island of Displacement project, 165–166
 lighting product, 181
 MoGraphMace, 56
 Planet Texturing project, 153
 Vase project, 97
Shadows setting, Render Settings box, 255
Shape tab, Attributes Manager, 406
shapes, 50–88
 City Building project, 57–69
 MoGraph Mace, 50–56
 Spaceship project, 70–88
Shift key
 accessing multiple tabs in Attribute Manager, 31
 Loop Selection, 82
 retaining and adding to selections, 58
shovel, 110–117
Sinc filter, 255
Single Material mode checkbox, BodyPaint Setup Wizard, 291
skeleton creation process, 234–236
Sketch and Toon effect, 264–266
skull mask, 99–109
Sky object
 adding to desert scene, 32
 applying material to, 39
 City Building project, 68
 Island of Displacement project, 156, 164
 Metaball, 135
 Planet Texturing project, 147–148
 Product lighting project, 178, 180
 Shovel project, 116
 Vase project, 93–94
Smith, Chris, 250
smoke, 399
smoothing
 Bezier NURBS, 115
 Cel shading, 262
 Desert Landscape project, 30
 ear, 228

 head shots, 202–203, 213, 215–216
 lips, 224
 Metaball, 135
 Render Settings box, 254
 text, 346
Soft Body dynamics, 397–398
Soft Interpolation, 91
Soft Selection, 74, 213, 217
Software Preview setting, Render Settings box, 253
solids, 382
Solo Column, Layers Browser, 7
Sound Effectors
 Cloner and, 366
 MoGraph, 364–366
Spaceship project, 70–88
special effects, 386–413
 See also effects
 baking dynamic calculations, 397–398
 Cloth dynamics, 393–396
 fantasy landscape, creating with hair, 402–403
 Fracture object, 389–392
 Headdress Project, 404–413
 PyroCluster, 399–401
 Rigid Body dynamics, 386–387
 Soft Body dynamics, for Cloner object, 397–398
Specular Channel, Material Manager
 Butterfly project, 185
 sand, 34
 texturing Pyramid primitive, 36
 Wind Deformer Flag project, 131
speed, controlling, 197
Sphere primitive
 lighting product, 180
 ornament project, 10
Spherify Deformer, 363
Spline Effector, MoGraph, 359–360
Spline Mask
 Lock Project, 122
 making custom fonts, 348–351
splines
 aligning objects to, 196
 Helix, 244–246
 Rail, 196–198
 Rectangle, 101, 121
 text, 348–351
 Zero Parallax, 417–418

Index

Springs panel, Soft Body tab, 398
Stage object, 247–248
staging, 4, 66
Star-like checkbox, Glow Editor, 152
steam, 399
stereoscopic content, 414–426
 compositing stereo images in Photoshop, 421–423
 rig, 414–418
 scene, 419–421
 SVI Stereo 3D Editor Plugin 2.3, 423–426
Stick Texture tag, 132, 187
Still Image filter, 255
storyboarding, 251
Structure Menu, 213
Subsurface Scattering effect, 141
Sugar Film Production, 250
surfaces
 combining, 139
 in parametric state, 9
 Subsurface Scattering effect, 141
Surfaces pull-down menu, Material Editor
 Greek Pool project, 25
 Planet Texturing project, 143–147, 149–150
 Spaceship project, 81, 85, 87
 Vase project, 130
SVI Stereo 3D Editor Plugin 2.3, 423–426
Swatches panel, BodyPaint, 292
Sweep Along NURBS, 339–340
Sweep NURBS
 adding MoSpline object to, 367
 MoGraph Tracer and, 361–362
 text, 337–338
Symmetrical modeling, 228
Symmetry tool, 207
SynthEyes (SE), 370

T
tags
 Align to Spline, 196
 Compositing, 95, 117, 178
 Display, 256, 321
 Motion Blur, 273
 placing and adjusting materials, 137
 Pose Morph, 229
 setting up, 374–377
 Stick Texture, 132, 187
 Target, 246
 texture, 331
 Xpresso, 275–276, 415
Target Distance, DOF CAM, 249
Target Effector, 342–343
Target Image Files (TIF), 254, 377
Target tag, 246
Terrain Shader, 140
text, 328–357
 animating MoText with Random Effector, 345–348
 deformers on type, 332–336
 extruding, 328–331
 making custom fonts Spline Mask, 348–351
 MoText Introduction, 341–344
 PolyFX, 352–357
 Sweep Along Text, 339–340
 Sweep Text, 337–338
Texture Axis tool, 137, 187
Texture tags, 331
Texture tool, 137
textures
 Butterfly project, 187
 City building project, 62
 defined, 4
 Island of Displacement project, 164
 Offset and Length values, 65
 photorealistic, 319
 placing and adjusting materials, 137
 Pyramid primitive, 35–36
Thickness channel, Materials Manager, 403
Thinking Particles system, PBLURP node, 285–289
three-dimensional (3D) shaders, 138
TIF (Target Image Files), 254, 377
tiling, 69, 130–131, 137, 257
Timeline, 46, 183, 188–190, 367, 382
toggling camera views, 420
Torus primitive, Ornament project, 10–11
Tracer object, MoGraph, 361–363
Transform tool, BodyPaint, 297
translucency, 141
transparency
 Banji Shader, 138
 Fresnel shader, 141
Transparency setting, Render Settings box, 255–256
Turbulence parameter
 Fog Shader Fog, 140
 Island of Displacement project, 162
two-dimensional (2D) shaders, 138
type. See text

U
Units settings, Preferences panel, 8
unwrapping UVs, 300–307
UV Commands tab, UV Mapping Menu, 307
UV editing, BodyPaint 3D, 300–319
 painting 3D head, 308–319
 unwrapping head, 300–307
UV Mapping Menu
 Projection tab, 306
 Relax UV tab, 307
UV Polygon Edit Tool, 306
UVW materials, 137

V
Vase project, 89–98
Vector Motion Blur effect, 263–264
Veining parameter, Mabel shader, 139
viewport controls, Pyramid Camera, 46
views
 4-up, 57
 Front, 90, 110, 183, 186, 200
 Orthographic, 57, 74
 Panoramic, 267
 Perspective, 73, 91, 111, 184, 200
 toggling, 420
virtual cameras, 243. See also cameras
Visibility Column, Layers Browser, 7
Visibility parameter, 103, 107
Visualize materials, Material Manager, 55

439

volumetric shaders, 138–140
 Banji, 138
 Banzi, 138
 Cheen, 138
 Danel, 139
 Fog, 140
 Mabel, 139
 Nukei, 139
 Terrain, 140
Vue 9 xStream Integration, 427–430

W
water
 flow, 133
 reflective texture, 162–163
weighting, 239–242
Wide Shot Camera, 247
Wind deformer flag, 127–133
windows, City building project, 59
wood presets, Material Manager, 55
wood shader, 138

X
Xpresso
 Chris Smith's comments on, 250
 School of Fish, 275–284
 Thinking Particles system, 285–289
Xpresso tag, 275–276, 415

Z
Zero Parallax spline, 417–418